2001

I Tell My Heart

This book is dedicated to the memory of Robert Carlen (1906–1990),
whose early advocacy of Horace Pippin introduced his art to a national audience.

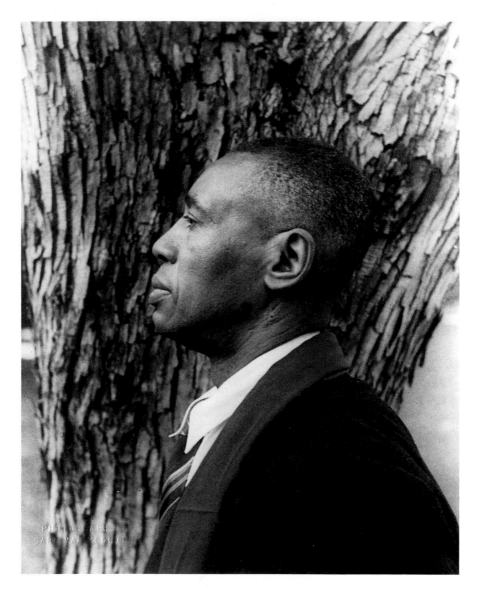

Carl Van Vechten (1880–1964).
Horace Pippin, February 4, 1940.
Silver gelatin print, 10 × 8 in.
Collection Peter Paone and Alma Alabilikian;
reproduced with permission of the Estate of Carl Van Vechten,
Joseph Solomon Executor

I Tell My Heart
The Art of Horace Pippin

Judith E. Stein

Contributors

JUDITH E. STEIN
CORNEL WEST
JUDITH WILSON
LYNDA ROSCOE HARTIGAN
RICHARD J. POWELL
MARK F. BOCKRATH AND BARBARA A. BUCKLEY
ANNE MONAHAN

PENNSYLVANIA ACADEMY OF THE FINE ARTS, PHILADELPHIA

IN ASSOCIATION WITH UNIVERSE PUBLISHING

This book is published in conjunction with the exhibition
"I Tell My Heart: The Art of Horace Pippin,"
organized by the Pennsylvania Academy of the Fine Arts, Philadelphia.

Planning was partially underwritten by The Pew Charitable Trusts.

**The exhibition and its national tour are sponsored by
Philip Morris Companies Inc.**

EXHIBITION TOUR

Pennsylvania Academy of the Fine Arts
January 21–April 17, 1994

The Art Institute of Chicago
April 30–July 10, 1994

Cincinnati Art Museum
July 31–October 9, 1994

The Baltimore Museum of Art
October 26, 1994–January 1, 1995

The Metropolitan Museum of Art, New York
February 1–April 30, 1995

FRONT COVER
Detail of *Man on a Bench* (fig. 140)
BACK COVER
Arnold Newman (1918–). *Horace Pippin against a door*, 1946.
Silver gelatin print, 14 × 11 in.
Collection Arnold Newman
SECTION OPENER FIGURES
I. THE ARTIST IN CONTEXT: Detail of *Self-Portrait* (fig. 98)
II. THE ART IN CONTEXT: Detail of *The End of the War: Starting Home* (fig. 36)
III. MATERIALS AND TECHNIQUES: Detail of *The Holy Mountain IV* (fig. 171)
IV. RESOURCES AND REFERENCES: Detail of *The Trial of John Brown* (fig. 56)

First published in the United States of America in 1993 by
UNIVERSE PUBLISHING
300 Park Avenue South
New York, NY 10010

© 1993 Pennsylvania Academy of the Fine Arts
118 North Broad Street
Philadelphia, PA 19102

94 95 96 97 98 99 / 10 9 8 7 6 5 4 3 2

Printed in Hong Kong

Library of Congress Cataloging-in-Publication Data
I tell my heart : the art of Horace Pippin / Judith E. Stein, et al.
 p. cm.
 Includes bibliographical references and index.
 ISBN 0-87663-785-3
 1. Pippin, Horace, 1888–1946—Criticism and interpretation. 2. Pippin, Horace, 1888–1946—
Catalogues raisoneés. I. Stein, Judith E.
ND237.P65I18 1993
759.13—dc20 93-2080
 CIP

Design by Douglas & Voss Group, New York

Contents

Sponsor's Statement

THIS RETROSPECTIVE, the most comprehensive exhibition of Horace Pippin's work yet assembled, presents a body of work by a uniquely American artist, called in his own day "one of the most original painters ever discovered."

Though Pippin had no formal artistic training, he had an innate understanding of color, composition, and form. He created canvases that are simultaneously as elemental as they are complex modern works and that demonstrate his participation in the movement toward abstraction in American art.

Within Pippin's vast subject matter—war scenes, portraits, landscapes and nature paintings, biblical and historical themes—is found his expression of his heritage. Pippin utilized the stories he had heard as a child to create paintings with historical and biblical subjects. In scenes of war and family life he chronicled the experience of being African-American as he lived it.

Philip Morris' support of this exhibition reflects our interest in artists whose singular vision has contributed to the legacy of our rich American culture.

GEORGE L. KNOX III
Vice President
Public Affairs
Philip Morris Companies Inc.

Celebrating 35 years of support for the arts

Foreword

HORACE PIPPIN IS WIDELY REGARDED as one of the twentieth century's foremost African-American artists. His relationship with the Pennsylvania Academy of the Fine Arts began when he was invited to participate in the Academy's annual exhibition in 1943. At that show he won the purchase prize for *John Brown Going to His Hanging*. Subsequently, his work appeared in the annuals from 1944 to 1947. In 1946 *The Milkman of Goshen* was recognized as "a significant oil painting" by the awarding of the J. Henry Schiedt Memorial Prize.

During his lifetime, Pippin's work had the distinction of being included in other major annual exhibitions at museums across the country, such as the Art Institute of Chicago and the Corcoran Gallery in Washington, D.C. He also participated in exhibitions that focused on the achievements of African-American artists. He first came to national attention in 1938 at the Museum of Modern Art when the exhibition "Masters of Popular Painting" included Pippin along with other European and American "folk artists" like Henri Rousseau and Edward Hicks. It is no coincidence that, during the highly nationalistic war years, Pippin found a patron in Albert C. Barnes, the renowned American collector of such early twentieth-century artists as Henri Matisse, Paul Cézanne, Maurice Prendergast, and Georges Roualt. Barnes appreciated Pippin's work for its bold design and color, qualities that he found "distinctly American." The broad characterization that was applied to Pippin during his lifetime—as exemplar of the American spirit, folk artist, *and* African-American artist—has, since his death, largely devolved into isolated categories in which he is seen as belonging to one *or* another. Today, however, with the benefit of a broader view of art history, we recognize that Pippin embraces not one but all these categories. *I Tell My Heart: The Art of Horace Pippin* seeks to reestablish him in that broader context.

The Pennsylvania Academy continually looks for new ways to share its diverse heritage of American art with regional as well as national audiences. Among its rich holdings is an impressive bequest by David J. Grossman of seven of Pippin's paintings. This was the impetus for our decision to look deeply into the work of this provocative artist, to mount the retrospective exhibition, and to accompany it with a comprehensive publication.

I Tell My Heart: The Art of Horace Pippin builds upon Selden Rodman's 1947 book on Pippin. We have expanded the checklist to encompass 136 documented works and have illustrated 119 of them, many of which have never been reproduced. A diverse group of distinguished scholars have freshly considered Pippin's life and work. The curator, Judith Stein, analyzes the contemporary dialogue regarding primitivism and modernism. From letters and remarks quoted in period publications, she also constructs an enlarged picture of Pippin as an artist and as a man. The Barnes Foundation granted her unprecedented access to its archives where she uncovered details of the relationship between Barnes, Pippin, and his dealer Robert Carlen; and

The Warped Table, 1940. Oil on canvas board, 12 × 16 in. Pennsylvania Academy of the Fine Arts, Philadelphia, Bequest of David J. Grossman, in honor of Mr. and Mrs. Charles J. Grossman and Mr. and Mrs. Meyer Speiser (1979.1.1)

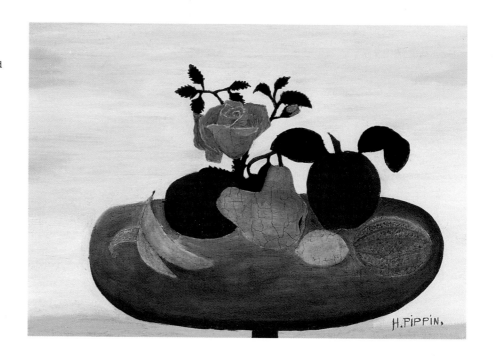

the Guggenheim Foundation furnished her with previously unreleased files regarding Pippin's 1941 application for a fellowship. The Princeton University professor Cornel West discusses the Emersonian celebration of the ordinary in Pippin's work and reconfigures the artist's significance vis-à-vis American and African-American cultural history. The University of Virginia professor Judith Wilson discusses Pippin's depictions of World War I black soldiers and scenes of everyday life. The National Museum of American Art curator Lynda Roscoe Hartigan sheds new light on Pippin's landscapes, portraits, and still lifes. The Duke University professor Richard J. Powell explores Pippin's biblically inspired paintings and his series on Abraham Lincoln and John Brown. The conservators Mark F. Bockrath and Barbara A. Buckley relate their discoveries about Pippin's process and technique. The exhibition coordinator, Anne Monahan, who uncovered new facts about Pippin's early life, provides a detailed chronology, exhibition history, and bibliography.

We are indebted to the staff of Universe Publishing for designing and producing this publication for the Pennsylvania Academy. We are grateful also to the many institutions and individuals who so generously gave permission to reproduce their works. Those who shared their Pippins during the exhibition deserve special thanks.

The Pennsylvania Academy is pleased to have been able to arrange for this exhibition to travel to the Art Institute of Chicago, the Cincinnati Art Museum, the Baltimore Museum of Art, and the Metropolitan Museum of Art in New York.

Special thanks to the Pew Charitable Trusts in Philadelphia, which funded the preliminary planning of this project. We are deeply grateful to the Philip Morris Companies Inc. for corporate sponsorship of the exhibition tour. Stephanie French and Karen Brosius of Philip Morris were wonderfully helpful and patient.

Finally, I would like to thank Harold A. Sorgenti, chairman of the board of the Pennsylvania Academy; Edna S. Tuttleman, former chair of the Academy's museum committee; and Mrs. C. Graham Berwind, Jr., current chair of the museum committee, for their encouragement in so many special ways.

LINDA BANTEL
The Edna S. Tuttleman Director of the Museum
Pennsylvania Academy of the Fine Arts

Acknowledgments

JUDITH E. STEIN &
ANNE MONAHAN

FOUR YEARS AGO we began the task of assembling the material in this book by compiling a list of known works by Horace Pippin. We never dreamed that ultimately we would be able to locate almost all of them, so scattered were they in the years since they were painted. We are pleased to be able to offer such a complete visual record of the achievements of one of the most intriguing artists of the twentieth century.

Our first acknowledgement is to the redoubtable Robert Carlen, the artist's principal dealer during his lifetime, who was responsible for marketing the work of Horace Pippin to a national audience. His enterprising spirit infused our quest for paintings long considered lost. His wife Alice Carlen and daughters Nancy Carlen and Susan Carlen Brown provided support in countless ways.

In the forty-seven years since Pippin's death, his paintings were dispersed all over the United States and abroad. The monumental task of relocating them has been facilitated by numerous individuals. Josh Butler of Butler & Company, and his associate Jennifer Thompson, deserve their names up in lights for their pro bono services in the search for heirs of Pippin's early collectors. Terry Dintenfass and Marie Erskine of Terry Dintenfass, Inc. in New York, as well as Janet Fleisher and John Ollman, Director of Janet Fleisher Gallery in Philadelphia graciously shared information gathered in their capacities as contemporary dealers of Pippin's works. Dr. Martin Bush, President of ACA Galleries; Debra Force, Senior Vice President at Christie's; and Peter Rathbone, Senior Vice President, Susan Pritchard and Holly Goetz of Sotheby's were instrumental in helping us locate several important paintings.

Selden Rodman and Carole Cleaver Rodman, in whose footsteps we follow, generously responded to our inquiries. We are fortunate to have been able to talk with many who knew the artist personally: Mr. and Mrs. John Bruyn, Mr. Warren Burton, Mr. Claude Clark, Mr. Joseph Fugett, Jr., Mr. Devere Kauffman, Miss Emma F. Milby and Mrs. Carita Ponzo, and Dr. Matthew T. Moore; and consult with his contemporaries: Mr. Jacob Lawrence and Miss Gwendolyn Knight, Mr. and Mrs. Philip Jamison, and Ms. Ann Wyeth McCoy.

It is to our authors—Mark F. Bockrath and Barbara A. Buckley, David C. Driskell, Lynda Roscoe Hartigan, Richard J. Powell, Cornel West, and Judith Wilson—that we owe our deepest appreciation for their insightful scholarship and fresh approaches to Horace Pippin. Karen Love Cooler compiled initial data for both the bibliography and exhibition history, based largely on material contributed by Lynn Moody Igoe. Our research was facilitated by numerous individuals, including: Derrick Joshua Beard; Esme E. Bhan, Research Associate, Moreland Spingarn Research Center, Howard University; Margaret Bleeker Blades, Curator, Chester County His-

torical Society; Charles L. Blockson, Charles L. Blockson Afro-American Collection, Temple University; Margaret T. Burroughs, President, The Culture Fund, Inc.; Amina Dickerson, Director of Education and Public Programs, Chicago Historical Society; Laurel Tucker Duplessis, Head of the Art and Artifact Division, and her associate Tammi Vance Lawson, of The Schomburg Center for Research in Black Culture, New York Public Library; Kathleen A. Foster; Ann Gibson, Stonybrook University; Richard Glanton and Nicholas King of The Barnes Foundation; W. Wilson Goode; Leslie King Hammond, Dean of Graduate Studies, Maryland Institute College of Art; Steven Loring Jones; June Kelly of the June Kelly Gallery; Mary E. Lyons; Mary Murphy, Sam Corini, and Charles Stuckey of the Art Institute of Chicago; Clive Phillpot, Librarian, Museum of Modern Art; Bernice Johnson Regan; Lowery Sims, Associate Curator, The Metropolitan Museum of Art; G. Thomas Tanselle, Vice President, S. J. Guggenheim Foundation; Ella King Torrey, Director, Pew Fellowships in the Arts; Richard J. Wattenmaker, Paul Karlstrom, and Catherine Stover, of the Archives of American Art; Alice R. Yelen, New Orleans Museum of Art.

The bounty of reproductions in this book were harvested by a variety of individuals, most notably photographers Rick Echelmeyer and Jacob Burckhardt. Many others expedited our work, including: Cona Clark, Philadelphia Museum of Art; Dale Connelly, National Archives; Suzanne D. Gaadts, Brandywine River Museum; Pamela C. Powell, Chester County Historical Society; and Judy Throm, Archives of American Art.

Research on the artist's early life was aided by: Ron Bally, Village of Goshen Registrar; Eulie Costello, Goshen Historical Society; James Curry, Governor's Veterans Outreach Center; Harold Jonas; Rosemary Phillips, Chester County Historical Society; Cecelia Walker and Val Eisman, Goshen Town Clerk's office.

Universe Publishing editors Adele Ursone and Manuela Soares, and associate editors Bonnie Eldon and Ellie Eisenstat patiently guided the manuscript through many unpredictable shoals. Kay Douglas and Tom Voss conceived of an elegant design to marry text and image.

As with all such multi-faceted projects, many people at the Pennsylvania Academy contributed their special talents. Accolades are due to: Director Linda Bantel and her assistant Naida Das who oversaw all aspects of this project; Photography Coordinator Robert A. Harman and his assistants Waqas Wajahat and Barbara Katus, who pulled many rabbits out of hats; Chief Registrar Gale Rawson and Associate Registrar Elyssa B. Kane for supervising the complex logistics involved in crating, shipping, and insuring the works of art; Jacolyn A. Mott and Susan James-Gadzinski for their expert editorial assistance; Conservator Mark F. Bockrath who readied several of Pippin's works for exhibition; Librarian Marietta Boyer and Archivist Cheryl Leibold for research support; Education Specialist Judy Ringold for her energy and ideas for programs and exhibition format; Audience Development Manager Amy Giles and Public Information Officer Marion McParland for their skillful promotional efforts; Preparators Tim Gilfillan and Michael Gallagher for their talents in exhibition design and art handling; and Keith Chandler for his diligent support which facilitated the work of his colleagues.

JUDITH E. STEIN, curator of "I Tell My Heart: The Art of Horace Pippin," is an adjunct curator at the Pennsylvania Academy of the Fine Arts, Philadelphia.

ANNE MONAHAN is the exhibition coordinator of "I Tell My Heart: The Art of Horace Pippin."

Lenders to the Exhibition

Albright-Knox Art Gallery, Buffalo, New York
Allen Memorial Art Museum, Oberlin College, Ohio
Archives of American Art, Smithsonian Institution, Washington, D. C.
The Art Institute of Chicago
The Baltimore Museum of Art
Robert Brady Museum, Cuernavaca, Mexico
Brandywine River Museum, Chadds Ford, Pennsylvania
The Butler Institute of American Art, Youngstown, Ohio
Mrs. Robert Carlen
The Carnegie Museum of Art, Pittsburgh
Chester County Historical Society, West Chester, Pennsylvania
Cincinnati Art Museum
The Crispo Collection, Charleston, South Carolina
Mr. and Mrs. Daniel W. Dietrich II
Terry Dintenfass, Inc., New York
Ann R. Feldman
The Fine Arts Museums of San Francisco
Fort Wayne Museum of Art, Indiana
Marjorie and Herbert Fried
Ann and James Harithas
Leon Hecht and Robert Pincus-Witten
Hirshhorn Museum and Sculpture Garden, Smithsonian Institution, Washington, D. C.
The Howard University Gallery of Art, Washington, D. C.
Mr. and Mrs. Philip Jamison
Rose W. Kaplan
Dr. and Mrs. Harmon Kelley
Marjorie S. Loggia
The Menil Collection, Houston
The Metropolitan Museum of Art, New York
Mrs. Robert Montgomery
Vincent B. Murphy, Jr.
Museum of Art, Rhode Island School of Design, Providence
Museum of Fine Arts, Boston
The Museum of Modern Art, New York
National Gallery of Art, Washington, D.C.
New Jersey State Museum, Trenton
Pennsylvania Academy of the Fine Arts, Philadelphia
Philadelphia Museum of Art
The Phillips Collection, Washington, D.C.
The Regis Collection, Minneapolis
Reynolda House Museum of American Art, Winston-Salem, North Carolina
The Schomburg Center for Research in Black Culture, The New York Public Library, New York
Janet and Joseph Shein
Marvin and Alice Sinkoff
The State Museum of Pennsylvania, Harrisburg
Anne Strick
Mr. and Mrs. Charles G. Sunstein
Maurice C. and Patricia L. Thompson
Wellesley College Museum, Massachusetts
Whitney Museum of American Art, New York
Wichita Art Museum, Kansas
Private collections

Introduction

DAVID C. DRISKELL

FEW PAINTERS on the American scene came to art with the apparent handicaps of Horace Pippin. Unlike many artists of his generation, he was born into a family of common laborers and domestics. His birth on February 22, 1888 occurred during the painful post-slavery period. It was a time in American history when black skin all but doomed someone to a position of virtual servitude. As if these things were not enough to stifle a creative mind, Pippin suffered permanent injury to his right shoulder in battle in France during World War I, yet he managed to keep alive his creativity as a painter.

There were not many artists in Pippin's generation who were satisfied to utilize their native gifts and pursue the craft of painting free from the influences of the academy. But this he did. It was as though he had clearly resolved to seek the benefits of self-esteem rather than critical praise in his ardent pursuit of the American Dream. He was comfortable being Horace Pippin, an artist with a different view of the world. Thus, he did not labor to embellish his art with the formulae often prescribed by friends and patrons and those theoreticians whose advice, if followed, would have made Pippin over in their own image.

An artist of African ancestry, Pippin was often reminded by friends and patrons of his obligation to the race, and particularly to the notion art should serve the lofty ambition of extolling culture and providing elevating visions in the interest of societal good. And while race was not expected to be at all times the principal factor in Pippin's work, it nonetheless was expected to be an element. Thus, from the outset, black figures, some of whom seemed autobiographical in nature, moved in and out of Pippin's early canvasses, helping to recount his memories of war unencumbered by the racial realities of the segregated society he knew at home. Yet, when one stops to analyze Pippin's paintings, what is outstanding—beyond the question of race—is the larger statement of an absolute talent that has been genuinely motivated by the sight of a sensuous world.

In his paintings—created between 1930 and 1946—Pippin relied strongly on the lore of local people, including their interpretations of the Bible, as well as on the history he read and the memories of his own experiences at home and abroad. These sources fed his perceptive mind, thereby enhancing those qualities that set his art apart from that of the other African-Americans of his time. Throughout his career as a painter, Pippin remained at ease with the black experience at a time when many of his fellow artists were struggling to throw off the yoke of bondage evident in their art while at the same time attempting to make that art acceptable in style and form to an unyielding Euro-modernist art theory.

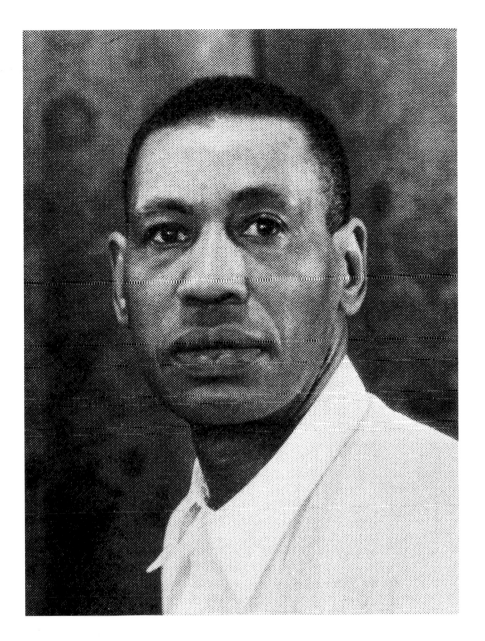

Photographer unknown, *Horace Pippin*, c. 1938. From *Masters of Popular Painting* by Holger Cahill et. al.

That Pippin was able to achieve a measure of success in his lifetime from the sale of his art was neither an accident of history nor a gesture of goodwill on the part of benevolent whites. He received strong support from Alain Locke, the nation's first African-American Rhodes scholar, who also served as Pippin's staunch advocate in his developing years. It was Locke who urged Pippin to remain true to the craft of painting long before his name became a household word among collectors of "naive" art. "I Tell My Heart: The Art of Horace Pippin" celebrates the genius of a man who became one of the nation's most celebrated painters outside the academy. In so doing, this exhibition reveals, with consummate skill, those lasting qualities in the art of Horace Pippin, art from the hand of a gentle soul who shall continue to live among those who inhabit "The Holy Mountain."

DAVID C. DRISKELL is Professor of Art at the University of Maryland, College Park.

I

THE ARTIST IN CONTEXT

An American Original

*Pictures just come to my
mind, and I tell my heart to
go ahead.*
　　　　　—HORACE PIPPIN

JUDITH E. STEIN

Between 1930 and 1950, the question of what constituted the authentic expression of the American spirit in the visual arts was answered in several ways. In the thirties, the native-scene painters who celebrated the nation's regional landscape were acclaimed as the best examples of indigenous talent. Beginning in the late forties, those artists newly identified as Abstract Expressionists were thought best to embody essential American values. Yet between the heyday of the Regionalists and the ascendancy of the Action Painters, the richly varied category of unschooled art was regarded by many as most representative of the American character.

In an essay accompanying Horace Pippin's first solo show in Philadelphia in January 1940, the well-known art collector Dr. Albert C. Barnes described his work as having "the individual savor of its soil: Pippin's art is distinctly American; [in] its ruggedness, vivid drama, stark simplicity, picturesqueness and accentuated rhythms." That Pippin was an African American was a factor that underscored the uniqueness of his contribution. To Barnes, Pippin's paintings "have their musical counterparts in the Spirituals of the American Negro." Labeling Pippin as "the first important Negro painter to appear on the American scene," Barnes awarded him and the self-taught painter John Kane the distinction of creating "the most individual and unadulterated painting authentically expressive of the American spirit that has been produced in our generation." Who was Horace Pippin? How did the disabled World War I veteran emerge from obscurity to a position of prominence in the history of twentieth-century American painting?

Horace Pippin was born in West Chester, Pennsylvania, on Washington's birthday, 1888. Because of the poor record keeping of that time, the exact circumstances of his birth are today unknown. In answer to a biographical questionnaire during his lifetime, Pippin listed his mother as Harriet Johnson Pippin and his father as Horace Pippin. Selden Rodman and Carole Cleaver's 1972 book on Pippin cites his mother as Christine Pippin (1855–1925), a domestic servant born in Charleston, West Virginia, who was the daughter of Harriet Irwin Pippin (1834–1908). Harriet Pippin's obituary notice in the Goshen, New York *Independent Republican*, named three children, including a daughter Christine and a son Horace.[1] Whether Harriet, who was listed as a widow of 45 years in the census of 1880, was Pippin's birth mother, or was his de facto mother cannot be determined. The ages given for nineteenth-century census purposes are well-known to be estimates. In 1891 the Pippin family moved to the resort town of Goshen, New York. Christine worked as a domestic servant outside the home, while Harriet likely cared for Horace. Christine later married Benedict Green with whom she had four

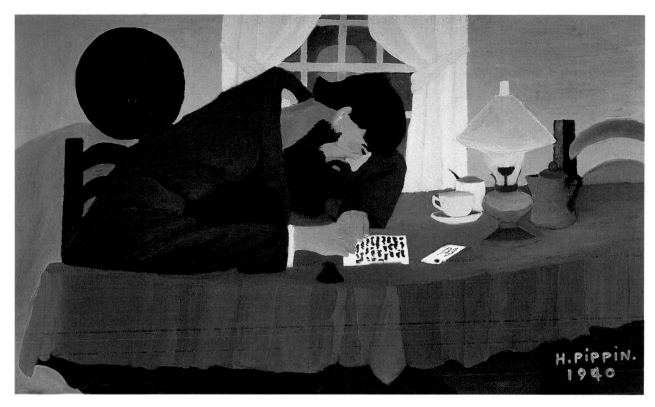

1 *Amish Letter Writer*, 1940. Oil on fabric, 12 × 20⅛ in. Collection Ann R. Feldman

daughters. As a boy, Horace showed a strong interest in drawing, winning his first set of crayons and a box of watercolors for his response to an advertising contest by an art-supply company. Goshen was home to a celebrated harness race track, and as a youngster Pippin made drawings of the horses and drivers. He attended a segregated one-room school house until 1902, when at age fourteen, he left to help support the family. Harriet Pippin died in 1908, and by 1912 Pippin had relocated to Paterson, New Jersey. Here he worked for a moving-and-storage company, where he relished the task of crating oil paintings, which first exposed him to fine art. Prior to 1917, Pippin variously toiled in a coal yard, in an iron foundry, as a hotel porter, and as a used clothing peddler.

To Horace Pippin, World War I "brought out all the art in me."[2] In 1917 the twenty-nine-year-old Pippin enlisted in the Fifteenth Regiment of the New York National Guard, serving as a corporal in what would subsequently become the 369th Colored Infantry Regiment of the 93rd Division of the United States Army (fig. 2). Landing in Brest in December 1917, Pippin and his regiment first worked laying railroad track prior to serving at the front lines in the Argonne Forest under French command. While in the trenches, Pippin kept illustrated journals of his military service. Only six drawings from this period survive (figs. 3–8). In October 1918, a German sniper shot Pippin through the right shoulder. The future painter was honorably discharged the following year, after fourteen months of service. Along with all the men in his regiment, Pippin earned the French Croix de Guerre in 1919. Twenty-six years later he applied for a Purple Heart, awarded retroactively in 1945.

In 1920, Pippin married the twice-widowed Jennie Fetherstone Wade Giles, who was four years older than the artist and had a six-year-old son. Supporting themselves on his disability check and her work as a laundress, they settled in West Chester, Pennsylvania, where Jennie owned a home with a pleasant garden (fig. 9). By 1940 they would proudly note to a reporter from *Time* that they "have turkey

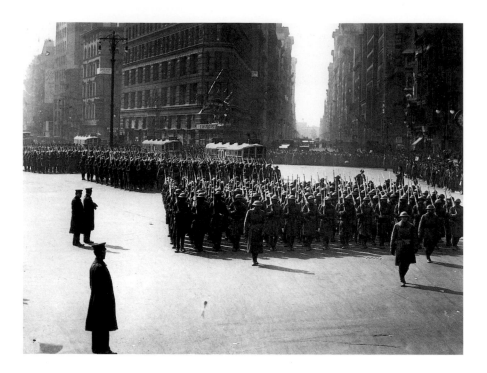

2 Photographer unknown. *369th regiment marches past New York's Flatiron Building in Victory Parade, February 1919.* National Archives, Washington, D.C. (111-SC-11912)

for Christmas, goose for New Year's and guinea fowl for their birthdays."[3] A community-spirited man, Pippin helped organize a black Boy Scout troop and a drum-and-bugle corps for the local American Legion post for black veterans, for which he also served as a commander. A reporter for the *Baltimore Afro-American* newspaper described him as "a big, genial man, plain in speech and in manner. . . . His sense of humor is subtle and provocative and [he] is profoundly religious."[4] The artist Romare Bearden, who once met Pippin at New York's Downtown Gallery, where they both showed their work, found Pippin's self commentary on his art to be animated and "very humorous."[5] In 1941 another journalist characterized Pippin as "a tall, open-faced man [who] smiles often and has a loud, unrestrained, hearty laugh."[6] Claude Clark, an African-American painter who knew Pippin in the forties, said that the artist reminded him of John Henry, the steel-driving hero of American folk song.[7] Another black artist, Edward Loper, also knew Pippin in the forties and once commented on the formative influence of the war on Pippin's demeanor:

> At that time there were certain kinds of black men who I admired and they were the kind of black guys who I think came out of the first world war. They had self respect and [Pippin] had lots of self respect. He knew he was strong. To me he was the kind of black man who wouldn't take too much smart alecky stuff from other people. Other people knew he wouldn't do that so they didn't try it with him.[8]

As therapy for his injured right arm, which he could not raise above shoulder height, Pippin began using charcoal to decorate discarded cigar boxes. He would later tell a reporter: "the boxes were pretty, but I was not satisfied with them."[9] When, in 1925, he began burning images on wood panels using a hot iron poker, he was delighted with the results: "It brought me back to my old self." Neighbors recall that Pippin enjoyed whittling and crafting decorative picture frames and jewelry boxes.[10] In 1928, at the age of forty, he expanded to oil paints, completing

his first painting *The End of the War: Starting Home* (fig. 36) in 1930. In a first-floor parlor, he painted by using his left hand to prop up his right forearm (fig. 10). Because his disability made it difficult for him to work on a large scale, his paintings rarely exceeded 25 × 30 inches. At various points in his subsequent artistic career, Pippin made preparatory pencil sketches for his compositions, some of which are extant (figs. 11, 83, 86, 96, 136). Claude Clark recalled that "When [Pippin] was doing the John Brown series he showed me the drawings [made] when he had gone to the courthouse of the period and noticed that they had a desk where they had a compartment where they kept their scrolls. And he made detailed drawings of this."[11]

Although Pippin worked on a variety of paintings and burnt-wood panels during the twenties and most of the thirties, his activities as an artist were unknown beyond his immediate circle of friends and family. To some of the shopkeepers in West Chester whose businesses he patronized, Pippin offered paintings in lieu of payment. Several shops informally displayed his work. Devere Kauffman recalls that sometime before the war, his family's furniture store, Kauffman's, agreed to exhibit a group of Pippin's small paintings that the artist had brought in to show them. The artwork was priced at fifteen dollars each and was installed in the listening booth area of their phonograph department. According to Kauffman, the only person who responded positively to the paintings was a Miss Scott, the head of the art department of what was then called the West Chester State Teachers College.[12] Another instance of Pippin's interactions with his community regards his barber, who, it was said, kept *The Buffalo Hunt* (1933, fig. 77) in his shop because his wife didn't want it in her home. When the work was borrowed back for Pippin's second show in Philadelphia and subsequently sold for $150 to the Whitney Museum in 1941, the barber reportedly was incredulous.[13]

Over fifty years after his death, it is not possible to pinpoint accurately how Pippin made the transition from obscurity to public notice within the West Chester community. Several versions have emerged that have in common the catalytic role of Chester County resident Christian Brinton (1871–1942), an "author, editor, impresario, critic, and collector [who] delighted in discovering fresh talent."[14] In 1988, high school students in an American history seminar at West Chester's Henderson High School created a self-published study on Pippin based in part on interviews with members of the African-American community who knew the artist. Two new accounts of his "discovery" emerged.

Warren Burton, who was a teacher at West Chester's Gay Street School, recalled that one day he made a house visit to meet the parents of his eighth-grade student Richard Wade, Pippin's stepson. After seeing the artist at work at his easel in the dining room, he shared news of his discovery with the school's principal, Joseph Fugett, who reportedly contacted his friend, the critic Christian Brinton.[15] It is interesting to note that in 1938 Pippin presented the Fugett family with one of his works, an unfinished painting entitled *On Guard*, a gesture that bespeaks the artist's esteem and appreciation.[16]

A second account cited by the students in 1988 came from an interview taped prior to 1983, when West Chester artist Philip Jamison recorded his talk with teacher London Jones, a friend of Pippin's. Occasionally, Mr. Jones would help out at his sister-in-law Sarah Spangler's restaurant, where one of Pippin's paintings was on display. The interviewee could not recollect definitively whether Christian Brinton was the "small white fella" who ordered "a tomato and lettuce sandwich and a cup of tea," but the man was sufficiently taken with the painting to press Jones to arrange a meeting with the painter. When Jones phoned him, Pippin reportedly exclaimed, "He must be an artist. He knows a good painting when he sees it."[17]

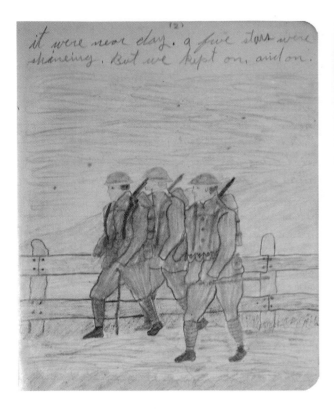

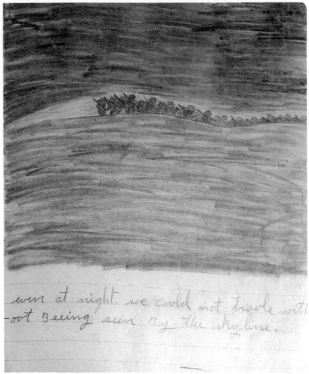

Clockwise from upper left:
3 "Three soldiers on march," from
War Diary Notebooks, [1917–18].
Graphite and colored pencil on
paper, 8⅜ × 6¾ in. Horace Pippin War
Memoirs, Letters and Photographs,
Archives of American Art,
Smithsonian Institution,
Washington, D.C.

4 "Night march," from *War Diary
Notebooks*, [1917–18]. Graphite and
black crayon on paper, 8⅜ × 6¾ in.
Horace Pippin War Memoirs, Letters
and Photographs, Archives of
American Art, Smithsonian
Institution, Washington, D.C.

5 "Bursting shells," from *War Diary
Notebooks*, [1917–18]. Graphite,
black crayon, and colored pencil on
paper, 8⅜ × 6¾ in. Horace Pippin War
Memoirs, Letters and Photographs,
Archives of American Art,
Smithsonian Institution,
Washington, D.C.

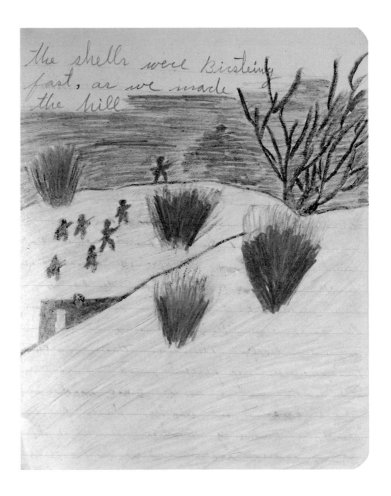

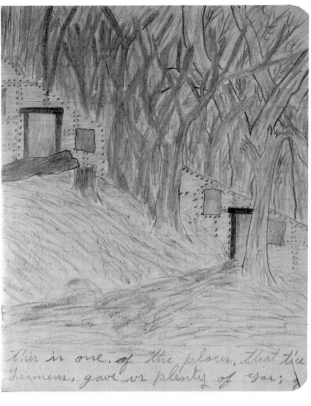

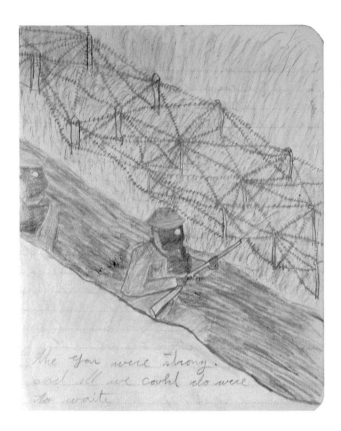

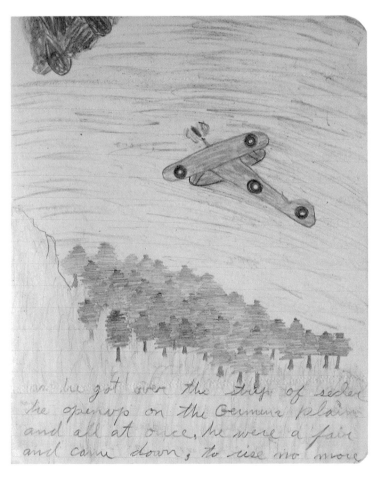

Clockwise from upper left:

6 "Soldiers with gas masks in trench," from *War Diary Notebooks*, [1917–18]. Graphite and colored pencil on paper, 8⅜ × 6¾ in. Horace Pippin War Memoirs, Letters and Photographs, Archives of American Art, Smithsonian Institution, Washington, D.C.

7 "Bunker in trees," from *War Diary Notebooks*, [1917–18]. Graphite and colored pencil on paper, 8⅜ × 6¾ in. Horace Pippin War Memoirs, Letters and Photographs, Archives of American Art, Smithsonian Institution, Washington, D.C.

8 "Airplane over trees," from *War Diary Notebooks*, [1917–18]. Graphite and colored pencil on paper, 8⅜ × 6¾ in. Horace Pippin War Memoirs, Letters and Photographs, Archives of American Art, Smithsonian Institution, Washington, D.C.

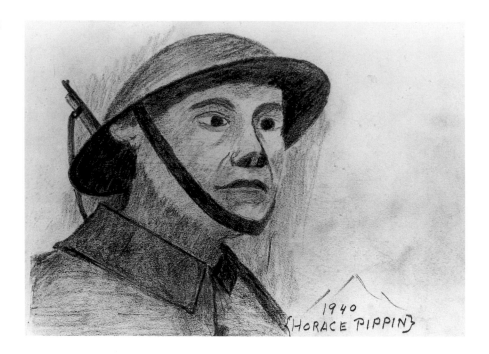

wrote to an art association patron alerting him to the opening a week away, of "our negro artist discovery, Horace Pippin," and added: "I had no difficulty in securing support for an appropriate catalogue of his work."[23] That same day Brinton wrote the *Philadelphia Tribune*, a black newspaper, about "our self-taught West Chester artistic discovery." He enclosed a typed copy of the exhibition catalogue, then on press, and outlined the events planned for the opening.

That Brinton's fears of a hostile response to Pippin's works were not altogether unfounded is evidenced by an anonymous review in a local paper that was published after the show had been open for a week. *The Coatesville Record*'s "Market Scribe" first praised the contributions of the Wyeth and Hurd family of painters and then turned his attention to Pippin, described as "a West Chester negro, who never had any artistic training." Of Pippin's two works on view, he notes that "one can be dismissed without comment, but the other, so the judges say, has a 'touch of genius.'" Yet the "Market Scribe" was unconvinced:

> In producing this picture [*Cabin in the Cotton*] Pippin has violated just about every rule of good painting, but the result, despite all this, is something that has county art circles talking. Whether he can get the same effect again with another subject is a question. This may have been an accident and then again it may mean that this young man with proper training will go places. Only time will tell.[24]

Whether the reviewer was aware that Horace Pippin was close to fifty cannot be known. Regardless, the critic's tone was deprecating and dismissive.

Two days following the close of the art association show, Pippin's solo exhibition of ten paintings and seven burnt-wood panels opened at the West Chester Community Center, located on the other side of town. It was sponsored jointly by the center and the CCAA, and the opening ceremonies included talks by such local dignitaries as Christian Brinton, N. C. Wyeth, and Dr. Leslie Pinckney Hill, president of Cheyney State Teachers College. The future civil rights activist Bayard Rustin, then a student at Cheyney State, was a featured tenor soloist. It has long

gone unnoted that the West Chester Community Center, located in the heart of the African-American community, was a hub for black cultural activity. The 1934 building that hosted Pippin's works stood, in the words of a contemporary brochure, "as a lighthouse in the heart of the Negro residential area of West Chester."[25] Founded by the nearby Cheyney State Teachers College, an historically black institution, the West Chester Community Center had been incorporated in 1919 as an interracial organization "to provide facilities for the physical, social, moral and civic development of Negroes and to promote understanding and cooperation between the Races." Various members of the African-American arts community were supportive of the center. For example, the painter Laura Wheeler Waring, an art instructor at Cheyney, served as an officer there in the 1940s. Well after he had achieved a national reputation, Pippin continued to exhibit at the center, sending two canvases to the second annual "Colored Artists of West Chester" exhibition held there in April 1945.[26]

Given the sophisticates of the white art association set, it is little wonder that news of Pippin's "discovery" would spread rapidly beyond the confines of Chester County. On September 13, 1937, Dorothy C. Miller, a curator at New York's Museum of Modern Art (MoMA), wrote to Christian Brinton for information about Pippin and his work: "I have been told that you have sponsored an exhibition of paintings by a Negro 'primitive' or naive artist."[27] That Dorothy C. Miller described Pippin as a "primitive" reflects the common usage of the term in the twenties and the thirties to refer to artists with no formal training who were "creative by instinct," in the words of the art historian who first applied the term to American paintings in 1923.[28] Tellingly, a Philadelphia commentator on Pippin's 1940 show at the Robert Carlen Gallery, noted: "What many an artist spends years learning, Pippin knows by instinct."[29] In Pippin's day, the adjective "primitive," which literally denoted the earliest stage or the beginning of things, was used to describe such diverse arenas as early American limners, French and Italian thirteenth-century painting, African art and artifacts, Northwest Coast Indian art, and contemporary unschooled artists.[30]

The benign art-world usage of such adjectives as "naive," "primitive," and "instinctive" notwithstanding, there is no question that the terms had racial overtones when employed by some commentators to describe Pippin. Periodically, Pippin's admirers forged a connection between the artist's life as an African American and the forthright, unselfconscious quality of his art. Dr. Barnes did so in 1940, when he described Pippin's works as the musical counterparts of spirituals, and N. C. Wyeth did so in his remarks at the opening of Pippin's 1937 exhibition at the West Chester Community Center. After noting that Pippin's work "ought to be protected, cherished, and encouraged," Wyeth remarked that it had "a basic African quality; the jungle is in it. It is some of the purest expression I have seen in a long time, and I would give my soul to be as naive as he is."[31] The feeling that Pippin's art was pure, and therefore unsullied by the negative and artificial components of contemporary society, can be found again a decade later, in a review by a Philadelphia art critic: "The modern world admires Pippin because it is subconsciously jealous of the natural expression of a crude, simple soul. Pippin had something most of us have lost: something that was trained out of us."[32]

According to his daughter Ann, N. C. Wyeth's remarks about Pippin's naiveté should be seen in the context of his father's career at that time. Wyeth, who was four years older than Pippin, had made his mark as an illustrator and teacher, but was nonetheless frustrated by the unequal recognition given to his own personal art work (fig. 12). The older artist, who died in 1945, a year before Pippin, remained a staunch advocate and admirer of the West Chester painter. In 1940 he wrote to

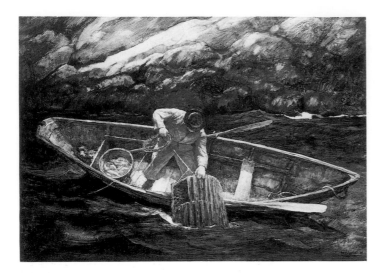

1 2 N. C. Wyeth (1882–1945). *Deep Cove Lobster Man*, c. 1938. Oil on gessoed board ("Renaissance Panel"), 16¼ × 22¾ in. Pennsylvania Academy of the Fine Arts, Philadelphia, Joseph E. Temple Fund (1939.16)

Ann about Pippin's response to her sister's painting of a death mask of the poet Keats:

> I had an astonishing time with Horace Pippin. I can't possibly tell you about it adequately now: I'll only tell you that after looking at many of mine, some of Andy's [his son, Andrew Wyeth], and Henriette's [his daughter], he looked at Carolyn's [his daughter] *Keats* with real excitement and wonderment, blew a long low whistle and said, very slowly, and solemnly, "Now, *that there's* a sensible picture!" It affected him deeply.[33]

Seven months after Dorothy C. Miller's query, West Chester's *Daily Local News* reported that Christian Brinton had sent ten of Pippin's paintings to MoMA, and that four had been selected for inclusion in their 1938 exhibition "Masters of Popular Painting," curated by Holger Cahill.[34] It is telling that Pippin made his national debut at MoMA, which demonstrated its interest in folk art during the 1930s. For example, in 1932 Holger Cahill, then acting director, organized MoMA's watershed exhibition of historical American painting and three-dimensional pieces entitled "American Folk Art: The Art of the Common Man, 1750–1900," which firmly established the importance, quality, and diversity of indigenous American artistic expression.[35] Two years earlier, while on the staff of the Newark Museum, Cahill had included the work of the living, self-taught artist Joseph Pickett from New Hope, Pennsylvania, in "American Primitives," his exhibition of contemporary folk art. In Cahill's catalogue introduction, he spoke of primitive work possessing "a directness, a unity, and a power which one does not always find in the work of standard masters."[36] Along with collector Abby Aldrich Rockefeller and dealer Edith Halpert, who would later represent Pippin in New York, Cahill was seminal in fostering a deepening appreciation of the aesthetic merits of American folk art. The obvious connection between the appreciation of Americana and an enthusiasm for the work of Horace Pippin is also evident in Juliana Force, who as the director of the Whitney Studio Club and an "avid early collector of folk art,"[37] acquired for the Whitney its first example of contemporary self-taught art—Pippin's *Buffalo Hunt*, purchased from his second one-man show at the Robert Carlen Gallery in 1941.

The inclusion of four of Pippin's canvases in MoMA's "Masters of Popular Painting," and his subsequent participation in the Museum's national touring exhibition of the same name—which traveled to Northampton, Massachusetts; Louisville, Kentucky; Cleveland, Ohio; Kansas City, Missouri; and Los Angeles, California—exposed the artist to a broad new audience. Pippin kept in touch with Christian Brinton, to whom he wrote on July 10, 1938, with details of MoMA's painting selections. There was a warm and homey aspect to Pippin's dealings with this foppish and sophisticated expert on Oriental and Russian art, whose portrait he would paint in 1940. The artist concluded his letter by saying: "My wife would like to know the date of your birthday so she can bake the cake."[38] While many in the area continued to champion Pippin's work, others, namely "Chester County artists of the conservative school," saw the untrained artist's successes as evidence of "a 'leftist' movement that has sprung up in their midst."[39] In 1938, Mrs. W. Plunket Stewart, the socially prominent wife of a well-known Chester County sportsman,

paid nearly $100 for Pippin's painting *The Admirer* (1937), which she purchased from a local show sponsored by the art association and the West Chester Garden Club. A contemporary news account recorded that the transaction roused the ire of the conventionally trained exhibitors whose work did not sell. The following year Mrs. Stewart had her portrait painted by Pippin (fig. 64),[40] and *The Admirer* entered the collection of her brother, W. Averell Harriman.

In the spring of 1939, Chester County resident and Pennsylvania Academy-trained artist Elizabeth Sparhawk-Jones[41] (1885–1968, fig. 13) contacted her friend Hudson Walker to alert him about Pippin's work. Walker, who then had a gallery in New York on 52nd Street, wrote to Sparhawk-Jones on April 13, 1939, to express his thanks for looking up Pippin: "Three Pippins arrived yesterday, and after only a cursory look, I am very enthusiastic about them."[42] Although he could not guarantee to schedule a show any time soon, he promised to let her know if he had any luck selling the work. In Walker's letter to Pippin two days later, he ended by saying, "I appreciate Miss Sparhawk-Jones' letting me know of your work, and I hope I can do something with your paintings." Sparhawk-Jones would remain an active advocate on Pippin's behalf. In 1942 she wrote the director of the Pennsylvania Academy of the Fine Arts urging him to invite Pippin to exhibit at the Academy's prestigious Annual: "For me he is one of the few real artists in our century, when he is at his best."[43] Although there is no record that Walker ever sold any of Pippin's works, he was nonetheless catalytic in Pippin's career. In 1939, Christian Brinton brought Philadelphia art dealer Robert Carlen (1906–1990) to New York to show him Pippin's work at Walker's. In December 1939, Carlen became Pippin's primary dealer.

At this stage in Pippin's life, it is interesting to note the similar trajectory of his career to that of Anna Mary Robertson Moses, called Grandma Moses (fig. 14), who along with Pippin rose to great prominence in the 1940s. A New York state resident who was twenty-eight years older than Pippin, Moses started painting late in life, as do most self-taught artists.[44] At first she showed her work at county fairs, and in 1938 she had several works in the women's exchange housed in a local drugstore in the town of Hoosick Falls. By chance they were seen by collector Louis Caldor, who brought examples to the New York art dealer Otto Kallir. In 1940 Kallir gave Moses her first exhibition at Galerie St. Etienne which was modestly titled "What a Farmwife Painted." By the time collector and writer Sidney Janis included both Pippin and Moses in his 1942 publication *They Taught Themselves*, Moses was not yet as well known as Pippin, who by then had had major exhibitions in Philadelphia, New York, Chicago, and San Francisco. Although Pippin too, painted "memory pictures" of his childhood, such as *The Milkman of Goshen* (1945, fig. 139), and the rustic charmer *Maple Sugar Season* (1941, fig. 176), it was the older woman's more idealized and sentimental vignettes of earlier, simpler times that would capture public fancy in a nation facing grim wartime realities. By the mid-forties, Grandma Moses's images, derived in part from magazine illustrations and greeting cards, were themselves made into greeting cards that were immensely popular. Although Pippin's work would be reproduced in such mass-circulation publications as *Newsweek* (1940), *Time* (1940, 1943), *Life* (1943, 1946), *Vogue* (1944), and *Charm* (1944), and his still-life painting *Victory Vase* (1942) was selected for a nationally distributed holiday greeting card, he never achieved Moses's broad pop-

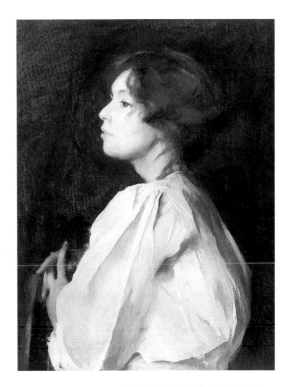

13 Alice Kent Stoddard (1855–1976). *Elizabeth Sparhawk-Jones* (1885–1968), c. 1910. Oil on canvas, 27 × 20⅛ in. Pennsylvania Academy of the Fine Arts, Philadelphia, Henry D. Gilpin Fund (1911.4)

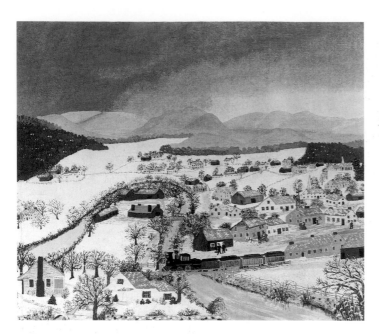

14 Grandma Moses (Anna Mary Robertson, 1860–1961). *Hoosick Falls (New York) in Winter*, 1944. Oil on composition board, 19¾ × 23¾ in. The Phillips Collection, Washington, D.C. (1392)

ular following. By contrast, Pippin's bolder compositions and color schemes and more emotionally complex and thematically sophisticated paintings, would be championed by afficionados on Philadelphia's Main Line and in New York and Hollywood, where a group of politically progressive writers, actors, and producers were familiar with his work. Such personalities as John Garfield, Ruth Gordon, Sam Jaffe, Charles Laughton, Albert Lewin, Philip Loeb, Clifford Odets, Claude Rains, and Edward G. Robinson owned Pippin's work in the forties. According to the *Daily Local News* for February 23, 1943, Harpo Marx "negotiat[ed] for the purchase of a Pippin," although there is no evidence that he actually bought one.[45]

Of the succession of men and women who believed in Pippin's art and facilitated his career, by far the most instrumental was Robert Carlen (fig. 15), who opened a gallery on the ground floor of his center city Philadelphia home in 1937. In the late twenties he had studied painting at the Pennsylvania Academy of the Fine Arts, and he liked to recall having been there at the same time as Ralston Crawford and Robert Gwathmey.[46] He married the former Alice Serber in 1935. With catholic taste and an adventurous yet discerning eye, the ebullient Carlen showed a variety of American art and folk art as well as such contemporary Europeans as Kathe Köllwitz, whose work came to him via Hudson Walker. Carlen easily communicated his infectious enthusiasms to those around him, and many of his early clients were his own family and friends. The Carlens lived directly across the street from the Leof-Blitzstein family, to whom his wife was related by marriage. The Russian-born Dr. Morris Leof and his suffragist partner, Jennie Chalfin, formed the heart of Philadelphia's free-thinking Jewish intelligentsia.[47] The talented circle of friends and relatives at their soirees included playwright Clifford Odets and musician and composer Marc Blitzstein. Mrs. Carlen's sister-in-law Madelin Blitzstein published an early article on Pippin in 1941, and Dr. Leof purchased Pippin's *Country Doctor* (1935, fig. 134). Odets, who regarded Dr. Leof as a surrogate father, would later own several Pippins, including *Country Doctor*.[48]

The business and personal relationship forged in 1939 between Horace Pippin and his dealer Robert Carlen proved an enduring bond. Carlen immediately arranged an exhibition for Pippin in his gallery, scheduled for January 1940, and introduced Pippin to the collector Dr. Albert C. Barnes, who would write the accompanying essay. Barnes, who had amassed an extraordinary art collection, was a complex, quarrelsome, self-made millionaire,[49] who since 1923 had been waging a personal war against the art establishment. In that year he had suffered public rebuke by Philadelphia's conservative art critics, who reacted with alarm when part of his avant-garde collection of modern and expressionist art was exhibited at the Pennsylvania Academy of the Fine Arts (fig. 16).[50] From then on he vowed never to admit anyone with official art connections to view his holdings. With few exceptions, the only way to see his paintings was to enroll as a student in the art appreciation classes offered by his foundation, and the admission selection process was capricious. After being introduced to the artist by Carlen, Barnes invited him to tour his art works and to become a student at his foundation.[51]

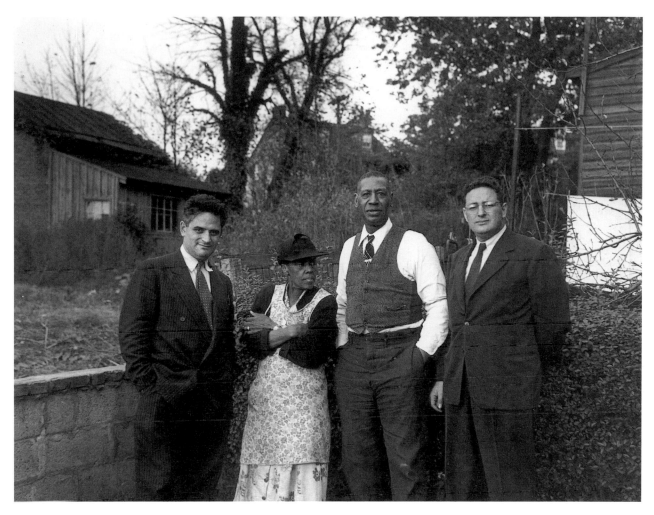

15 Arnold Newman (1918–).
*Robert Carlen, Jennie Ora Pippin,
Horace Pippin, and Arnold Newman,*
1946. Silver gelatin print, 8 × 10 in.
Collection Arnold Newman

Writers on Pippin have long wondered about the effect on Pippin as a result of his exposure to Barnes's collection of Impressionist and Post-Impressionist art. Tradition has it that Pippin was not an attentive student, dropping out after several weeks of snoozing through classes.[52] Selden Rodman recorded that Pippin reportedly criticized Matisse's palette by commenting: "That man put the red in the wrong place."[53] Claude Clarke, who himself studied at The Barnes from 1939 to 1944, recalls that Pippin, who, he says, attended classes at the foundation for five or six months, admired Renoir, once commenting with characteristic humor, "That guy Ren-oor, he was pretty good. And he left a little bit for me too." Looking at Renoir at another time, he told Violette de Mazia, Barnes's associate, "I'm going to take colors out of that man's painting and get them into mine."[54] According to another much-told anecdote, Barnes once asked the artist whose work he most favored in his collection, and Pippin said it was Renoir because the pictures were full of sunlight and because he enjoyed looking at the way Renoir depicted the nude models.[55] To Clarke, Pippin:

> was impressed by some of the things that he saw at the foundation but he felt that after he had seen enough he went back to what he was doing Sometimes Barnes would call [Pippin] to give him a suggestion and then Pippin would say to Barnes, "Do I tell you how to run your foundation? Don't tell me how to paint."

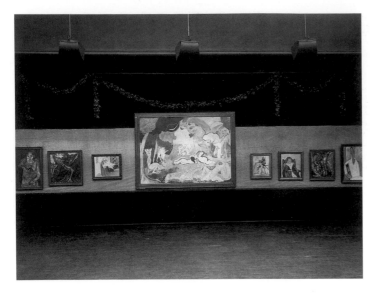

16 Photographer unknown. *Pennsylvania Academy installation photograph: 1923 exhibition "Contemporary European Painting and Sculpture" (Barnes Collection)*, 1923. Silver gelatin print, 7⅞ × 9⅞ in. Archives of the Pennsylvania Academy of the Fine Arts, Philadelphia

Although as a young man Pippin had worked crating oil paintings, it is likely that he first saw modernist abstractions in 1938, when he showed his work at MoMA. His subsequent experience at The Barnes likewise exposed him to modernism. Yet he never expressed interest in abstraction or expressionism. As with many self-taught painters, Pippin believed he never invented forms or colors and regarded himself as a realist.[56] In a conversation between Pippin and art patron Roberta Townsend, who visited his studio while he was working on one of his Holy Mountain series (1944–1946), the artist called her attention to the sky in the painting, saying: "Now those young artists [referring to students at The Barnes Foundation] worry about the sky. They argue about how it should be. It never worries me. I just paint it like it is."[57] In a similar anecdote recounted by the painter Edward Loper, who recalled going out to West Chester to visit Pippin when he was working on *West Chester, Pennsylvania* (1942, fig. 74), Pippin said:

"Ed, you know why I'm great?" I said "No," because I really wanted to know. I said "No. Why?" He says, "Because I paint things exactly the way they are. . . . I don't do what these white guys do. I don't go around here making up a whole lot of stuff. I paint it exactly the way it is and exactly the way I see it."[58]

Albert Barnes bought at least one painting from Pippin's first show at Carlen's, his associate Violette de Mazia bought another, and on his advice, the actor Charles Laughton purchased one as well (fig. 17).[59] Barnes was an irascible and complicated man whose support for Pippin was just one facet of his lifelong interest in African-American culture. Predisposed in favor of Pippin, Barnes had a deep appreciation for self-taught artists: works by the American John Kane and the Europeans Jean Hugo and the Douanier Henri Rousseau were in his collection. That Pippin's professional career was at its start, that his prices were low, and that he was an artist whose cause could be championed to great effect, were all factors that likely appealed to the collector.

Barnes manifested his deep admiration for African-American music in a variety of ways. For example, he sponsored trips to the South to collect and record black folk music.[60] He also hosted an annual choral concert of spirituals to which invitations were highly prized. At his January 1940 soiree, his guest, the photographer Carl Van Vechten, first apprised the collector that James A. Bland (1854–1911), composer of "Carry Me Back to Old Virginny," "In the Evening by the Moonlight," and "Dem Golden Slippers," was in fact an African American. When Van Vechten later informed him that Bland was buried in an unmarked grave in Merion, Barnes's own township, Barnes resolved to have the remains transferred to a small park and to erect a monument there. He wrote to Van Vechten on February 20, 1940: "We *must* have a Negro sculptor," expressing his intention of asking Horace Pippin, then a student at the Foundation, if he had ever done modeling.

When Barnes subsequently wrote the photographer that an unnamed sculptor had been obtained for the proposed monument, presumably it wasn't Horace

Pippin. With the exception of the whittled, low-relief war materiale with which he had decorated the frame of his celebrated *The End of the War: Starting Home* (fig. 36), Pippin worked only on canvases and burnt-wood panels. The project soon stalled when Barnes withdrew his efforts due to personality conflicts and the failure to obtain permission from Bland's relations to move his remains.[61]

Van Vechten, who was working on a photographic series on African-American cultural figures, was likely introduced to Pippin by Barnes. He photographed the artist at the foundation (fig. 18). As with many of the collector's associations, the friendship between Barnes and the photographer eventually cooled. In a 1954 letter to a friend, Van Vechten summed up his relationship to Barnes and his collection:

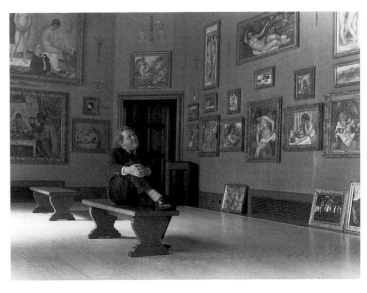

> Matisse once said to me that it was impossible to see French pictures of the periods represented without visiting this Collection. "Nowhere in France," he went on, "can anything like it be seen." I have visited the collection at least 8 times (perhaps more). At one time, indeed, I was the Doctor's "white-headed boy," due to our mutual interest in Negroes.[62]

In his dealings with gallery owner Robert Carlen, Barnes was no less mercurial. In Alice Carlen's description, the two "were both characters and understood each other as characters."[63] In addition to the work of Horace Pippin, the collector and the dealer shared other aesthetic interests, such as Pennsylvania-German furniture and folk art. Their intricate relationship is revealed in their varied correspondence between 1941 and 1943. Carlen's exceedingly polite manner and deferential attitude is evident in his letter of February 16, 1941, regarding Pippin's painting *Fishing in the Brandywine* (1932, fig. 133):

> The reason for bringing it out [to the foundation] is that Horace is very anxious for me to place these canvases, and knowing that you were especially interested in the picture to allow you to have the right to purchase it at whatever price you may care to pay.[64]

The next day Barnes responded to Carlen in an ambiguous tone: "I couldn't find room for his *Fishing in the Brandywine* and suggested to four people that they buy it, but all said they had no money to spare."

When, in June 1941, Barnes was instrumental in arranging an exhibition for Pippin at the San Francisco Museum of Art (later renamed the San Francisco Museum of Modern Art), the collector wrote the dealer that he "would not want anything but first-class examples to be shown" and indicated that he would "be very glad to help select the ones to be shown." Carlen wrote him the following day to say, with extreme courtesy, that "Any new [paintings] that Horace produces over the next few months will be submitted to you for the decision to show or not." Earlier, Carlen had likewise deferred to the collector by inviting him to participate in making selections for Horace Pippin's Guggenheim Fellowship application, "Do

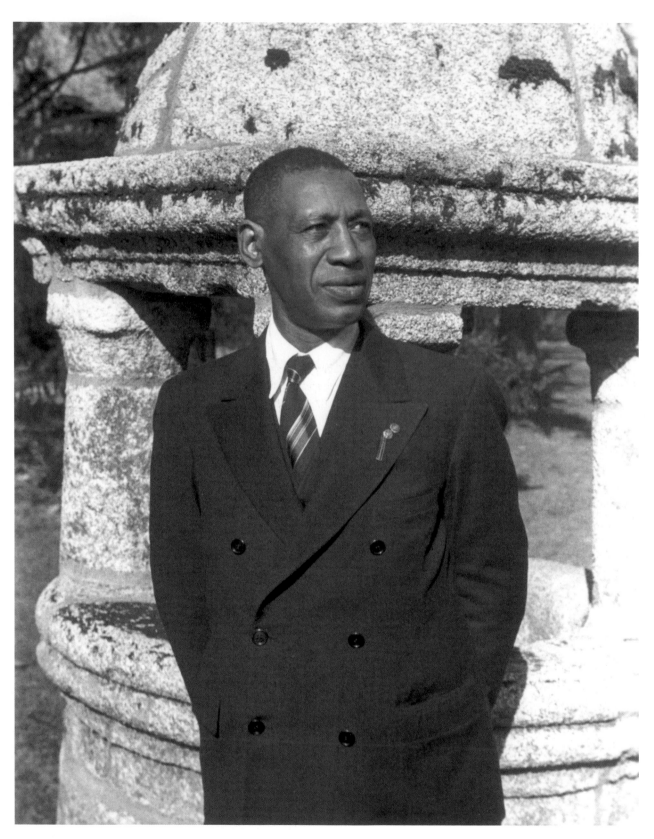

18 Carl Van Vechten (1880–1964). *Horace Pippin in front of Gothic well at the Barnes Foundation, February 4, 1940*. Silver gelatin print, 10 × 8 in. Yale Collection of American Literature, Beinecke Rare Book and Manuscript Library, Yale University, New Haven, Connecticut; reproduced with permission of the Estate of Carl Van Vechten, Joseph Solomon Executor

you think you would find a chance to help me make the selection of the paintings to be submitted?"

Carlen often wrote to share news of Pippin's career and to periodically offer Barnes goods for sale. On January 2, 1942, he let the collector know that he had sold two more Pippins, and then he itemized other art items available for sale, such as santos and retablos. The copy of this letter in the Barnes Foundation archives is marked with a penciled "no ans," indicating Barnes's impolite decision not to respond. In Carlen's penultimate letter to Barnes, written on May 25, 1943, the dealer first tried to interest him in a rare book on Pennsylvania-German pottery and then went on to note, "I just saw an exhibition of paintings by a young Negro artist Jacob Lawrence at the Downtown Galleries, N. Y. C. I thought you might [enjoy?] knowing about the show as I found it a very fine one." There is no indication that Barnes ever followed up on Carlen's lead.

According to Mrs. Carlen, the two became estranged because Barnes wanted to continue to buy Pippins at the prices quoted at the time of Pippin's first exhibition. Barnes was "irritated and angry" when Carlen, as a good dealer, raised the prices as the market for Pippin's work increased. In addition, he wanted to have the right of first refusal on all of the artist's work. Although he complied initially, Carlen soon realized he could not honor this arrangement because he needed to expand the market for Pippin by first offering the paintings to others. Barnes resented being preempted, and his dealings with Carlen soured. He subsequently criticized Carlen for exploiting his artist when the dealer secured a commission from *Vogue* in 1944.[65] In June 1946 a testy Barnes wrote Carlen to complain of the account of Pippin's discovery published in the current issue of the NAACP publication *The Crisis*, an inaccurate account in Barnes's mind, that minimized his own contribution because Carlen purportedly misinformed the reporter.[66] A few months later, following Pippin's death, Robert Carlen took the writer Selden Rodman to visit Barnes in preparation for his monograph on Pippin. The author was allowed into the foundation, but the dealer was told to "wait outside."[67]

Pippin's first exhibition at Robert Carlen's gallery, of twenty-two paintings and five burnt-wood panels, ran from January 19 through February 18, 1940. It was a triumph for both dealer and artist. The show was well reviewed, and a short feature on Pippin appeared in *Time* magazine on January 29.[68] A few days after the exhibition closed, Carlen wrote Hudson Walker: "The Pippin show has been a very fine boost for me and seems destined to carry on stronger."[69] A reporter for West Chester's *Daily Local News* asked Horace Pippin for his reactions a week after the exhibition opened:

> It sure was a surprise to me the way people like my pictures. They're responding better than I ever thought they would. The way things look now it will be a sell-out, and I won't have any pictures to bring back after the show's over. Yes, sir, the boys are doing me good. . . . I've been running back and forth to Philadelphia so much I haven't had much time to do any work in the past two weeks. I've got to get busy and get enough pictures together for another show, maybe in New York. I believe the people there will like 'em too, same as they do in Philadelphia.[70]

Looking back at his career from a vantage point six years later, Pippin told an interviewer for the *The Crisis*: "[That show at Carlen's] was my most successful show. After I'd been there, New York wanted me and Chicago wanted me, and all the rest of them wanted me."[71]

Robert Carlen served as the epicenter of a seism of interest in Horace Pippin's art. The artist's New York show was being planned even before the one in

Philadelphia closed. It is useful to recollect that in 1940 the most prestigious galleries in New York did not show contemporary American art. For example, it would be two years before Peggy Guggenheim opened her gallery Art of This Century, providing an early springboard for Jackson Pollock.72 When New York's Bignou Gallery decided to mount an exhibition of Pippin's work, it was the first time they had chosen to represent an American artist. Ever attentive to Pippin's activities, West Chester's *Daily Local News* proudly covered the October 1940 opening of the New York exhibition:

> It's a far cry from East Miner Street [the location of the West Chester Community Center] to East 57th street, and Horace Pippin has the honor to be the first American, regardless of race, to be represented by a one-man show in the exclusive New York gallery where, heretofore, only the work of such foreign masters as Renoir and Matisse was shown.73

When interviewed in his home in West Chester, Horace Pippin told the local reporter: "I was there when the pictures were hung and the exhibition was opened, and I never saw so many reporters. Everybody treated me swell—especially the press." When asked to compare the Philadelphia and New York exhibitions, Pippin said: "I've got a better assortment of paintings in this show and I look for some of them to go over big." Although his dealers did not sell as many works in New York as had been sold in Philadelphia, this well-reviewed show, in turn, opened new doors for the artist. Pippin's attitude to his subsequent fame remained philosophical. When in 1946 he was asked about his successes, he said: "Now why do I want to get up so high? Leave that to somebody else. If I don't go high, when I fall, if I do, I won't have far to go."74

Robert Carlen liked to recount that on their way home from the Bignou opening Pippin saw a particularly memorable configuration of clouds and twilight color in a stretch of the Pulaski Skyway in New Jersey that the artist would later incorporate in the background sky of *Christ and the Woman of Samaria* (1940, fig. 121).75 As a dealer, Robert Carlen was a masterful manager of Pippin's career. On January 26, 1940, just eight days after the close of Pippin's debut exhibition in his gallery, Carlen wrote to the Guggenheim Foundation to inquire if it were not too late for Pippin to apply for 1940. He referred to Pippin as an artist "whose work is as complete an expression of native American art as any ever created," who painted "strong emotional interpretations of American landscapes and American life." Prematurely, he volunteered a list of eight names of Pippin's supporters including Marc Blitzstein, Charles Laughton, and artist Waldo Pierce.76 Indeed, the deadline had passed and he had to wait to apply until the fall.

A formal application was submitted in October 1940. Pippin's brief but trenchant application statement, undoubtedly drafted with Carlen's assistance, spoke of his interest in the Southern landscape and in recording the lives of African Americans:

> It is my desire to go down South, to Georgia, Alabama, North and South Carolina, to paint landscapes and the life of the Negro people, at work and at play, and all other things that happen in their everyday living.77

Pippin, whose wife was from North Carolina, had on at least one occasion traveled south in the twenties. His burnt-wood panel *Autumn, Durham, North Carolina* (1932, fig. 59) is a later record of that visit. To support Pippin's application, Carlen offered the names of six references: Holger Cahill, director of the WPA Art Pro-

gram; Alain Locke, professor of philosophy, Howard University; Albert Barnes; Max Weber, painter; Dorothy C. Miller, assistant curator of Painting and Sculpture, MoMA; and Julius Bloch, painter. On February 4, 1941, well after the October deadline, an irrepressible Carlen wrote the director of the Guggenheim with news that he felt would lend support to Pippin's application, namely that the Barnes Foundation had purchased another painting and that Pippin's *End of the War* (fig. 36) had been acquired for the permanent collection of the Philadelphia Museum of Art. Here and in other contexts, Carlen adroitly obfuscated the fact that he himself had donated the painting to the Museum, where it was accessioned on January 28, 1941.[78]

The fall of 1940 was a propitious time for Pippin, who had passed beyond the initial support of his West Chester community and was moving full tilt into the mainstream art world. The best of his references spoke of his originality and the promise of future success. Barnes commented: "His capacity for growth is revealed in his recent work and I believe that, given the opportunity, he will become one of the most important painters of our age." Philadelphia artist Julius Bloch, who also knew Pippin personally, wrote: "Pippin is entirely original and I believe his future work will be a worthwhile contribution to the art and culture of his time." But Miller and Cahill were noncommittal. Although Cahill wrote that Pippin's project to travel south "promises very well indeed" because of "the interesting personal character" and the "deeply racial quality" of Pippin's work, Cahill nonetheless chose to rank Pippin sixth of the six references he wrote for the Guggenheim that year.[79]

Alain Locke, who that year wrote Guggenheim recommendations for three African-American artists—Wilmer Jennings, Hale Woodruff, and Horace Pippin, was equivocal:

> Frankly I am puzzled for an opinion! Pippin is a very original and in some canvases a startlingly original painter. What would come from him in terms of a Southern trip and exposure for the first time to the South and the Negro in that locale is only to be guessed at; the result might range anywhere from something stupendously new to an outright fizzle. It is a gamble, but probably a very worthwhile gamble![80]

Of the fourteen hundred applicants for fellowships in 1941, only sixty-three were named new fellows and fifteen others had their fellowships renewed. The advisory committee for applications from artists—Gifford Beal, Charles Burchfield, James Earle Fraser, Boardman Robinson, and Mahonri Young—recommended seven painters and sculptors and two photographers, including African-American sculptor Richmond Barthé. But Pippin was not among them. It may well be that Max Weber's letter complaining that his name had been given to the committee without his knowledge or consent, proved the decisive factor.[81] Horace Pippin never again applied for a Guggenheim award. Nor did he realize his proposed plan to travel south on a painting trip. Yet he would create many memorable images of the southern landscape and of black folk at work and at play.

Robert Carlen mounted his second one-man show of Pippin's work, from March 21 through April 20, 1941. It included thirteen canvases and eight burnt-wood panels. Giving him a mere ten days lead time, Carlen wrote to Albert Barnes on March 11, 1941, to ask him to write an essay for the catalogue of Pippin's forthcoming show: "As I would like to send out a catalogue to a number of collectors and museums on this show, I feel it would greatly add to the interest in this show if you would write something about Pippin's new work." Three days later Barnes respond-

ed in the affirmative and noted that he could not "find time to go to your place so the only thing to do is for you to send a number of his latest paintings to our gallery sometime tomorrow, Saturday." He planned on "think[ing] over the content of my article either Saturday afternoon or Sunday morning," and invited Carlen to collect the paintings on Monday morning.

In his finished essay Barnes asked rhetorically what might explain the changes in Pippin's work since his first show the year before. Obliquely valorizing his own role in the artist's life, Barnes noted that "only one explanation of the change seems possible: Pippin has moved from his earlier limited world into a richer environment filled with the ideas and feelings of great painters of the past and present."[82] Working both sides, Carlen sent Barnes's essay to museums, and when these institutions showed support, he wrote immediately to Barnes. Nine days after Pippin's show opened, he sent a postcard to Barnes alerting him that the Whitney Museum had just bought a Pippin, observing, "The exhibition has been drawing quite a large attendance every day and I hear it has been causing quite a bit of discussion."[83]

Pippin's next major exhibition fell in place when Alice Roullier, secretary of the Arts Club of Chicago, wrote a letter of inquiry to the Bignou Gallery. In his reply of February 11, 1941, Bignou director George Ketter said, "I am glad to learn that you are interested in this man's work, as I think he is one of the good painters in the country at this time." Pippin's works were to be shown with those of Salvador Dali and Fernand Léger from May 24 to June 14, 1941. An industrious publicist, Carlen wrote to Roullier in mid-March offering to lend photos, a copy of MoMA's *Masters of Popular Painting* catalogue, and a book of clippings. Ever mindful of the potential for press coverage, he went on to remark: "There is a fine human interest story that can be turned over to the Chicago newspapers which I am sure will prove of great interest to them especially as Chicago has so huge a Negro population and surely will be [of] interest to those readers!"[84]

Carlen sent out an announcement of the upcoming Chicago show that was quoted in the March 26, 1941, West Chester *Daily Local News*: "To be invited to exhibit there is one of the most important honors tendered to any living painter. . . . Pippin is without question on his way to being nationally recognized as one of the most original painters ever discovered." Midway through the run of his own Pippin show, he wrote again to Alice Roullier to bring her up to date about Pippin:

> I thought you would find it extremely interesting to know that this show of Pippin's recent paintings has been one of the most talked of shows for years. We have had a tremendous and greatly impressed attendance. I am certain you too will experience the same sort of reception both of his shows have had in the East. *He is undoubtedly one of the most interesting and original American painters ever discovered*, and when you see this work you will readily understand why when this work is shown it has such drawing power and stimulates a great deal of discussion."[85] [emphasis added]

A month later Carlen again wrote Alice Roullier asking her to send catalogues to Lessing Rosenwald, Mr. and Mrs. John Rockefeller, Jr., Mr. Hubachek of Chicago, and the curator of prints at the Art Institute. He also suggested she send catalogues to:

> many of the museums situated in the middle west and western part of the U.S., as I know the curators of painting in many of the museums have heard of Pippin and are interested in seeing his work, and they would make a point

of coming to see the show if they know it was being held in Chicago. The assistant curator at the Art Institute was in my gallery a few months back and I showed him several of Pippin's paintings I had here at that time. He was greatly impressed and made a note to keep this work in mind.[86]

Ever the booster, Carlen then described some of the recent publicity about Pippin and noted in a postscript that he had sold fourteen paintings out of the April show, that Barnes had acquired two new ones, and that "the Whitney Museum [acquired] one—a short time before that the Phila. Museum acquired their example. I believe this information will be of good value to your Chicago critics as to how well American art is selling today." In late May the dealer and the artist traveled to Chicago by train for the exhibition that would feature three artists. Salvador Dali (fig. 19), who also was having his first show in Chicago, was allocated the Arts Club's largest gallery. Pippin's thirty-nine paintings and burnt-wood panels were assigned two smaller rooms, and Fernand Léger's twenty-five watercolors and drawings were in the hallway. The Chicago press responded with an avalanche of coverage of the event that reflected their fascination with Dali, whose Surrealist antics always made good copy.[87] A *Chicago Herald-American* account of the tea held on the May 24 opening, first dealt with the European exhibitors and then went on to report:

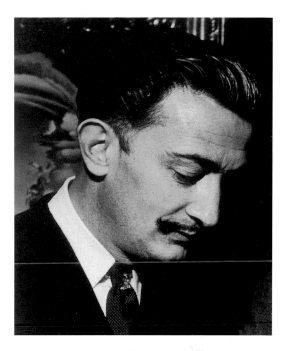

19 Photographer unknown. Detail of *Salvador Dali* (Spanish, 1904–1989), 1943. Silver gelatin print, 10 × 8 in. Salvador Dali Museum, Inc., Saint Petersburg, Florida

> There was a third guest of honor, the quiet, retiring Negro painter Horace Pippin, holding court in his little gallery among his painted lilies and homey snow scenes, but he would be the first to disclaim credit for the box office crowd. The crowd was there to see Dali and his works and they were not disappointed.[88]

Artist Claude Clark recalls that Alain Locke enjoyed recounting a tale about the meeting of Horace Pippin and Salvador Dali in Chicago:

> Dali was a little taller than Pippin. And Pippin was introduced to him. And the way Locke tells it, that he looked up at this tall guy and Dali extended his hand and Pippin says to him, "Is you an artist too?" And Locke says that Dali pulled his hand back and went over in a corner and pouted the rest of the evening. So, but Pippin didn't know people. And he just did what he was doing.[89]

Despite Carlen's anticipation of the potential curiosity on the part of Chicago's large African-American population for the "fine human interest story" of Pippin and his work, no such interviews materialized in the press. Similarly, the Art Institute of Chicago did not act to purchase any of the artist's works. Nonetheless, the experience of the Chicago exhibition was worthwhile for Pippin. A few weeks after their return to the East Coast, a voluble Carlen wrote to Albert Barnes to assess their trip:

> As you probably know Horace and I went out to Chicago for the opening of his show [at the Arts Club]. We were out there four days and Horace said he had a marvelous time. We spent quite a bit of time at the Art Institute and

20 Lucas Cranach, the Elder (German, 1472–1553). *Portrait of Margravine Hedwig of Brandenburg-Ansbach*, c. 1529. Oil on cradled panel (beechwood), 23⁹⁄₁₆ × 16⅜ in. The Art Institute of Chicago, Gift of Kate S. Buckingham (1938.310)

Horace especially enjoyed the Flemish and Dutch paintings of the 16th and 17th centuries. His favorite was Lucas Cranach, and on the train back to Philadelphia he kept commenting on the marvelous qualities that this master obtained in his canvases. Horace felt that seeing these pictures were alone worth the effort of making so long a trip. It will be interesting to see what effect, if any, these pictures will have on his work from now on.⁹⁰

There is no indication that the finely rendered, sensuous forms of the sixteenth-century German artist Lucas Cranach (fig. 20), made an impact on Pippin's subsequent work. Nonetheless, it is telling that Pippin, who understood himself to paint exactly what he saw, so enjoyed Cranach's precise style and detailed observations.

Pippin settled back into a productive period of painting. If he had once responded to a query as to why he painted by answering "Out of loneliness,"⁹¹ and at another time told a reporter that he did much of his work at night, when he was often low-spirited, when he had what his wife called "blue spells,"⁹² he was now buoyed by the new audience for his art. In August 1941, when Pippin's garden would have been at its peak, Robert Carlen wrote to Albert Barnes, "I just received a new Pippin canvas; it is a striking still life of flowers, very colorful."⁹³ In November Pippin sent a postcard to Carlen to say that he was anxious to bring his new work to his dealer as "I know you will like them, for I know of myself that I have never made any better." He concluded by requesting payment and announcing that he and his wife were invited to dinner at the home of Miss Ellen Winsor, one of his collectors who then owned *Mountain Landscape* (c. 1936, fig. 62) and *The Getaway* (1939, fig. 183).⁹⁴ In another postcard written on December 15, Pippin confides: "I am on the job. I hope to God that New York is a knock-out."

The New York to which Pippin referred was the exhibition at Edith Halpert's Downtown Gallery, entitled "American Negro Art, 19th and 20th Centuries," whose December 8 private opening was overshadowed by Pearl Harbor. In 1941 Edith Halpert was introduced to the range and quality of art by African Americans by reading Alain Locke's recent book, *The Negro in Art*, which included material on Pippin. Fired by a desire to educate the public about the strong work produced by black artists, she resolved to host a major exhibition in her gallery's new quarters on 51st Street. She set up the National Negro Art Fund to purchase art for public collections that was to be financed in part by a portion of her commissions. In addition, she proposed that her own and other New York galleries each add one contemporary black artist to their stables. Pearl Harbor and the United States's entry into World War II eclipsed Halpert's cultural work.⁹⁵ As a result of this show, however, she did add Jacob Lawrence and Horace Pippin to her roster of affiliated

artists. Pippin's visibility was greatly enhanced when art critic Robert M. Coates, writing for *The New Yorker*, reviewed the exhibition and singled him out by commenting that "It's Pippin . . . who steals the show."[96]

Claude Clark recalls that Carlen asked him and his older brother to transport Pippin's work to New York for the show. Their old Buick, with the Pippin paintings wrapped in a blanket in the back seat, was stopped by the police just outside Philadelphia. Unfortunately, Clark's brother had forgotten his driver's license, and so they were led to a police station and fined twenty-five dollars. The police raised the blanket but were uninterested in the pile of paintings underneath. The brothers were obliged to return home to pick up the license and finally arrived in New York only minutes before the exhibition's scheduled opening.[97] On January 2, 1942, Robert Carlen wrote to Albert Barnes that as a result of the Downtown Gallery's show, he had sold at least two paintings, *The Squirrel Hunter* (1940, fig. 61) and *Lilies* (1941, fig. 113): "The commission on these sales goes to the National Negro Art Fund to be used for the purchase of other Negro artists' works to be presented to schools and institutions."[98]

Pippin's next exposure to a national audience came in the spring of 1942 when, through the efforts of Albert Barnes, the painter was given a solo show at the San Francisco Museum of Art. Douglas MacAgy, the assistant curator, had been a student at the Barnes Foundation. In June 1941 the collector wrote to Robert Carlen to say that he had been asked informally by MacAgy if it were possible for his museum to host an exhibition of Horace Pippin's works. Barnes expressed the hope that Carlen would follow through on this inquiry and "give it preference to all other possible places of exhibition because three of the best students we ever had are located in San Francisco, teaching at the University of California and forming practically the working basis of the Museum."[99] Carlen accepted with alacrity and arrangements were in progress by that fall. In a letter on September 3, Carlen alerted Barnes of the forthcoming publication of Sidney Janis's book on self-taught artists, which contained a section on Pippin, and he added, "I am deeply grateful for your kind cooperation and aid in making this San Francisco show a possibility."[100] Carlen kept Barnes informed, writing him in March that he was "sending almost all of the canvases Pippin produced [in] the last three years, and there is no doubt the assembly of all of these canvases in one exhibition will be tremendously impressive."[101] Nine days later the dealer again contacted Barnes to say, "I have been writing to a number of important people living out in California asking them to do whatever they can to arouse interest in the [forthcoming] Pippin exhibition."[102] One of recipients of Carlen's entreaties was the poet Langston Hughes, who belatedly wrote the dealer from Yaddo seven months later to thank him for his letters concerning Pippin's San Francisco exhibition: "Unfortunately, I was in Chicago at the time, and so could not see the show, but I advised several of my friends in the West of it. I have had the pleasure of seeing a few Pippin paintings and found them most interesting."[103]

Carlen worked with San Francisco director Grace McCann Morley on organizing the exhibition. She had been instrumental in bringing MacAgy and his wife, Jermayne, west to San Francisco in 1941. That Morley gave Arshile Gorky an important, early show the year prior to Pippin's exhibition, is an indication of her pioneering support of the new abstract painting in both New York and San Francisco.[104] Following her winter 1942 trip east in which she missed getting to Philadelphia, Morley wrote Carlen:

> I stopped in at Mrs. Halpert's [in New York] to see whatever examples she might have of the work, especially recent, of Pippin. She has two charming flower pieces with which I was much impressed. I like this later phase of his

work very much more than earlier works which have always seemed to me somewhat lacking in color.

On April 14, the opening day of the exhibition, Morley wrote Carlen: "You would be pleased with the show I think; it looks very handsome. Pippin certainly had beautiful color. [The show] occupies a very prominent, though fairly small, gallery as galleries run. It is just as well, for his things are on the small scale." Two weeks later she wrote again to say, "The Pippin show grows on one on greater acquaintance, and I am more impressed by the fine quality of his color and the freshness and directness of his vision."[105]

Pippin's exhibition at the San Francisco Museum of Art was his sole 1942 show. The pace of public exposure quickened in 1943, during which time his paintings were exhibited in three distinct contexts: nationally prestigious surveys of contemporary fine art, a retrospective of American self-taught painters, and surveys of work by African-American artists. Not only was Pippin invited to show at the Pennsylvania Academy of the Fine Arts's annual exhibition but his painting *John Brown Going to His Hanging* (1942, fig. 57), was awarded an Academy purchase prize of six hundred dollars. It was unprecedented for an unschooled artist to win an award at the nation's oldest art museum and art school, then holding its 138th annual painting and sculpture exhibition. On February 1, Robert Carlen wrote Albert Barnes a newsy letter regarding Pippin and the activities of the Carlen Gallery:

> It also looks as though the large John Brown painting I showed you sometime ago is going to be purchased by a museum. If the purchase goes through the announcement of same is going to cause a large amount of comment when the name of the museum purchasing it is known.[106]

The Academy soon lent *John Brown* to the Corcoran Gallery of Art in March, when Pippin participated in that institution's eighteenth biennial of contemporary American oil paintings, another indication of his growing importance. In addition to the shows in Philadelphia and Washington, the Art Institute of Chicago included the artist in their fifty-fourth annual exhibition of American painting and sculpture. In an entirely different framework, Pippin made a return appearance at the Arts Club of Chicago when Sidney Janis included two of his paintings in a survey he curated entitled "American Primitive Painting of Four Centuries," marking the recent publication of his book *They Taught Themselves: American Primitive Painters of the 20th Century*.

Yet another forum for Pippin's work was the newly popular surveys of work by black artists. Both Alain Locke's 1940 book, *The Negro in Art: A Pictorial Record of the Negro Artist and of the Negro Theme in Art*, and James A. Porter's *Modern Negro Art*, published in 1943, stimulated interest in the accomplishments of black visual artists. In early January 1943, Boston's Institute of Modern Art (then affiliated with MoMA and known today as the Institute of Contemporary Art) organized with Smith College Museum of Art a traveling show, "Paintings, Sculpture by American Negro Artists," which included three of Pippin's paintings. In Philadelphia that year, Pippin was represented in two separate group shows of African-American art. One was at the Pyramid Club, an organization of black artists, which included two of Pippin's paintings in their third annual exhibition. Pippin showed five works in Robert Carlen's show "Oils, Water Colors, Prints and Sculptures by Negro Artists of Philadelphia and Vicinity."

The artist put great value on his participation in the Pyramid Club show, in large part because of the potential for a sale to Barnes, who was scheduled to give an address titled "Art of Negro Africa and Modern Negro America" at the opening

21 John W. Mosley. *Albert C. Barnes and Horace Pippin at Pyramid Club exhibition opening, Philadelphia*, 1943. Silver gelatin print, 10 × 8 in. Charles L. Blockson Afro-American Collection, Temple University, Philadelphia

ceremonies. Pippin wrote to Carlen on February 1, nearly three weeks prior to the opening: "I wish that the picture I just made will be in this show, that is if you see fit to send in one. The picture is the *Domino Game* [1943, fig. 143] so that Dr. Albert Barnes can see it. He is the main speaker at the show."[107] Although the doctor may have seen the painting at the opening (fig. 21), he did not purchase it. Days after the exhibition closed, Carlen wrote Barnes that "the Pippin painting *The Domino Players* is back from the Pyramid Club show, and I have several other small new canvases here I would like to show you." Barnes did not respond and Carlen included *Domino Players* in his April show of Negro art. Edith Halpert exhibited it in October and by December had sold it to the Phillips Collection in Washington, D.C.[108]

Although relations between the dealer and the mercurial collector were beginning to strain, Carlen continued to correspond with him. On March 31, a day before his exhibition was to open, the exasperated dealer solicited the collector's advice:

> I have been trying to get some publicity on my Negro show . . . [and] I have gotten no co-operation whatsoever. I telephoned all the Negro newspapers having offices in Philadelphia several days ago and spoke to the editors in charge and although they professed to be interested I have seen no signs whatsoever from them to date. . . . [I] feel that it would be a great shame if this show were not to be more publicized than it promises to be as I know there are many persons who would be interested in seeing it and who would be greatly impressed by the character and quality of the creative work of our local Negro artists.[109]

The copy of this letter today in the Barnes Foundation archives is marked in pencil "no reply." Happily for Carlen and his artists, the *Philadelphia Inquirer* published an illustrated article on the show shortly after it opened, drawing attention to the work of the twenty-four exhibitors, including Pippin, Claude Clark, Allan Freelon, Paul Keene, Jr., Edward Loper, Raymond Steth, and Laura Wheeler Waring.[110] There is no indication that Barnes ever came into the city to see the exhibition. The day before it closed, Carlen wrote Barnes that he had sold two more of Pippin's paintings out of the show and commented:

> This show had a very good attendance and seems to have caused quite a stir in this city from reports I have heard from people who came in to see it. It was gratifying to see this response which clearly showed a great interest especially among the Negroes of the city.[111]

During the 1940s, Pippin's relationship to Philadelphia's active community of black artists was complex. Claude Clark recounts the story of how he and his wife first encountered the West Chester resident. After seeing Pippin's work at Carlen's gallery, the Clarks decided that they wanted to meet the artist in person. They took the train to West Chester and after asking several people, were directed to his house. "Pippin opened the door and looked out at us, in a very quizzical way, very curious, and he seemed puzzled." Clark notes that he introduced himself and said that he was an artist and had come to meet him. Pippin was surprised, Clark recalls, because at that time there was a group of black artists in Philadelphia who were vocal in their hostility for the self-taught artist. Clark recalls that a black artist, well-known in Philadelphia, who "had rounded up a group of other black artists," had approached Clark to join them in their condemnation of Pippin:

> He wanted me to join them to attack Pippin, because [Pippin] was making, earning money. And they said "We went to the Academy, and we . . . have studied. He didn't study the same way we did, and he shouldn't be earning money when we're not earning money." So when I talked to Pippin, he said "I don't understand why they want to fight me." And I couldn't explain it either so I went in and we had a nice talk, and from that time on we were friendly.[112]

Friction between African-American artists who did and did not receive recognition existed within the arts communities in other locations, and did not always pit the trained against the un-trained. Jacob Lawrence recalls that, "we had a similar situation in New York. Some [black] artists were getting recognition; others were not. And it was exactly the same thing. These artists were attacked."[113]

Given the condescending, racist comments made by critics in the context of praising the self-taught painter, little wonder that some academically trained black artists resented Pippin's successes. For example, a March 1941 review of his second show at Carlen's gallery noted that "Horace Pippin . . . can claim the purchase record for Negro painters in America," and concluded:

> Pippin's work differs from that of the average American Negro painter trained in the schools. It is not a pale imitation of the white man's art. In choice of pigments and in courage of contrasts it smacks of racial origin; for, unhampered by theories of technique, he paints with no holds barred.[114]

Such critical sentiments that measured and valued African-American artists by their distance from "white man's art," were commonplace in the forties. The young

Romare Bearden ridiculed this attitude in a 1946 article entitled "The Negro Artist's Dilemma," in which he identified it as one of the concepts of critical opinion "that constantly reappear[s]" in relation to Negro artists. He derided one critic who reviewed a group show of Negro artists by commenting: "We can say this of it: the farther removed the Negro is from copying the white man's style or subject matter, the better he is." Bearden responded by pointing out that, "however disinherited, the Negro is part of the amalgam of American life, and his aims and aspirations are in common with the rest of the American people."[115]

An invidious instance of inappropriate comparisons used to praise Pippin's achievements can be found in a 1944 Baltimore Afro-American interview with Barnes. Measuring Pippin against the well-known, formally trained black painter Henry Ossawa Tanner, the collector exclaimed:

> Henry O. Tanner is a pigmy and Horace Pippin is a giant. What Tanner had to say was simply a feeble echo of what had been said by great artists several centuries ago. Tanner's work is an attenuated and diluted expression of the white man. What Pippin has to say has never been said before. Pippin carries on the work of the great artists, but he expresses himself in his own language.[116]

While it would be expected that Barnes's modernist taste would favor the self-taught over the academic, it was exceedingly cruel of him to use his cursory knowledge of African tribal characteristics to diminish Tanner in order to praise Pippin. Claude Clark recalls that "There were people who got angry with [Barnes]" for his dismissal of the earlier black artist.[117]

Perhaps no word proved more malleable in its application to Pippin than did "primitive," the adjective Dorothy C. Miller at MoMA had used to describe the artist in 1937. For some writers, it was clearly pejorative. For example, after Pippin's Cabin in the Cotton III had been awarded fourth honorable mention in the 1944 Carnegie International, a Pittsburgh critic dismissively described the painting as "amusing, as simple as a Mother Goose rhyme and as naive as a Negro spiritual. . . . Whether this particular picture is worthy of the $100 cash award is difficult to decide, as primitives are highly debatable. They are like ripe olives or mangoes—you like them or you don't."[118] Another Pittsburgh writer sought to qualify her use of "primitive" by observing that:

> [Pippin's] paintings are primitive in the best sense, gentle records of war experiences and childhood memories, of which Cabin in the Cotton is a good example. This kind of picture is as much a part of our sentimental heritage as Stephen Foster and "Dixie," with the field of cotton stretching away in meticulous rows, the log cabin, the washtubs and the sky. Each white puff, each blade of grass is carefully delineated—that's the way it was in memory, and that's the way it is![119]

It is small wonder that the press release issued by the Downtown Gallery on the occasion of Pippin's first one-man show there in the winter of 1944, sought to distance the artist from the term: "Originally hailed as a 'primitive,' his growing sophistication has gradually eliminated that label."[120]

Even Pippin's most urbane critics struggled with the label. In his 1941 review of the Downtown Gallery exhibition "American Negro Art, 19th and 20th Centuries," New Yorker critic Robert M. Coates first commented favorably but briefly on such artists as Romare Bearden, Alice Catlett, and Jacob Lawrence before discussing Pippin, his clear favorite. To Coates, Pippin was "incontestably in the very front rank of modern primitive painters, here or abroad. Indeed . . . Pippin's skill

and resourcefulness have progressed to the point at which it is hardly proper to call him a primitive at all." Coates concluded by observing:

> I suppose, until some more appropriate word can be found, "primitive" will have to be the word we use for a man like Pippin, but I imagine there are not many painters, however "finished" in style they may be, who can fail to admire the dexterity and daring he displays.[121]

Three years later, on the occasion of Pippin's first one-man show at the Downtown Gallery, Coates was still expressing his discomfort with terminology:

> I don't know what it is precisely that differentiates the "primitive" artist from what I suppose we must call the sophisticated ones. But if the distinguishing qualities of the primitive are a preoccupation with minor detail and a tendency to play fast and loose with the laws of perspective, then Horace Pippin . . . , is indeed, as he is customarily classified, a primitive. However, in the use of color and the ability to organize and synthesize a scene into a well-balanced composition, he's about as subtle and sophisticated as the next man, which sort of makes you wonder where sophistication begins and primitivism leaves off.[122]

An *Art News* critic who covered Pippin's 1944 Downtown Gallery show began her review by quoting Albert Barnes's 1941 comment that Pippin was "the most important Negro painter to appear on the American scene."[123] She went on to observe:

> It is interesting to note that the label "primitive" is absent from this analysis which compares the artist's work with that of Daumier, Cézanne, and Matisse. For like theirs, Pippin's style is simply the result of an inner vision of burning intensity. Lack of teaching has less do with it than a determination to come as close to that vision as possible.

As Pippin's national reputation grew, so did his commissions. In May 1943 Robert Carlen wrote to Albert Barnes:

> I know you will be delighted to learn that I have just gotten a commission for Pippin to make a painting for one of the most important advertising agencies in this country. It is for the Capehart series and Pippin is free to do whatever he wants in his interpretation of Stephen Foster's Folk Songs.[124]

Pippin worked quickly on his choice of "Old Black Joe," completing it a little more than a month later.[125] The painting, then titled *I's Comin'*, was reproduced in an advertisement in *Life* magazine (fig. 161). The following year Pippin received a commission from *Vogue* magazine that likely came via his New York dealer, Edith Halpert, who had extensive contacts in the literary and publishing worlds. In the absence of any extant documentation of the project, only a tentative scenario can be reconstructed. In a 1985 Archives of American Art interview with Carlen, the dealer recalled that he had brought Pippin to New York for a meeting with *Vogue*'s chief editor: ". . . we had the conference there but [Pippin] didn't understand their language . . . [their] art terms . . . and we finally agreed that he was to do a sketch . . . for *King Cotton*."[126] Coincidentally, Romare Bearden recalled that the only time he actually met Pippin was when the West Chester artist was in New York "on an assignment for a woman's magazine, and had stopped by the Downtown Gallery to see Mrs. Edith Halpert."[127]

Pippin was one of three artists invited to create images relating to cotton that would then be enlarged as backdrops for *Vogue*'s spring issue of cotton dresses. Carlen recalled that Giorgio de Chirico was one of the others, but he was unable to name the third. Since Pippin's disability prevented him from working on a painting eight feet tall, it was decided that the magazine would undertake the enlargement of his small sketch. Pippin's commissioned sketch, *Old King Cotton* (1944, fig. 159), contains three very voguish fashion plates. In a letter to Robert Carlen on February 2, 1944, Edith Halpert wrote that *Vogue* had found that it was too expensive for them to enlarge the sketch themselves and had decided instead to use a photo of the piece as an introduction for their "cotton festival layout."[128] As it turned out, the commissioned study, *Old King Cotton*, was not used by *Vogue* at all. Instead, their July 1944 issue contained a color reproduction of a new image that was compositionally related to the sketch but deleted the fashionably dressed models. This painting, which today is known as *Cabin in the Cotton IV* (fig. 158), was then titled *Old King Cotton*,[129] and was part of an eleven-page spread devoted to "New Headliners in the Arts," encompassing ballet, music, design, literature, movies, theater, and painting. This potpourri of "new" talent contained such diverse talents as the dancers Alicia Markova and Jerome Robbins; the army cartoonist Sergeant Bill Mauldin; actor Montgomery Clift; and seven painters, including Pippin.[130] The patronizing caption beneath the reproduced painting declared that the artist "combines a primitive sophistication of design with clean, happy colors," and incorrectly noted that Pippin "never saw a painting until 1940, when Dr. Barnes showed him the vast collection of the Barnes Foundation."[131]

Pippin's third major commission came from Hollywood. After deciding to include a contemporary painting in their forthcoming movie based on Guy de Maupassant's novel *Bel Ami*, the producers David Loew and Albert Lewin sent letters to twelve painters, inviting them to participate in a paid competition. Pippin—along with Ivan Albright, Eugene Berman, Paul Cadmus, Marc Chagall, Salvador Dali, Giorgio de Chirico, Max Ernst, Abraham Rattner, Stanley Spencer, Dorothea Tanning, and Pavel Tchelitchew—was asked to create a work on the subject of the Temptation of Saint Anthony. MoMA director Alfred H. Barr, Jr., Marcel Duchamp, and Sidney Janis were named as the jurors who would choose the one painting to be included in the film. Each artist would receive compensation for participating, and the winning image would be awarded an additional sum.

Anticipating the artists' skepticism about such a commercial venture, Lewin assured them of the seriousness of the producers' intentions:

> We believe not only that this project will be of benefit to our motion picture of "Bel Ami," but that it will also be a means of bringing to a great public a better appreciation of the work of contemporary artists, since we think that the use we intend to make of the paintings will be of educational value. Mr. Loew and I both love paintings, and we will do everything in our power to keep the project on a dignified plane.[132]

Lewin and Loew were part of the Hollywood set interested in bridging the gap between the fine and the popular arts. The two had met when they were both English literature students at New York University and belonged, in the description of Clifford Odets's biographer Margaret Brenman-Gibson, to the "new generation of 'civilized' film makers," interested in synthesizing art and commerce.[133] Lewin was an art collector and at that time owned Pippin's *Sunday Morning Breakfast* (1943, fig. 145).

The size of the commissioned canvas was to be no smaller than 36 x 48 inches, a scale considerably larger than Pippin normally used. He worked on the paint-

ing for four months, completing it by the jurying date of mid-January 1946.[134] In his 1947 book on Pippin, Selden Rodman noted that the artist "was having unusual difficulty with the large movie commission," and even wrote to the pope for assistance regarding the nature of Saint Anthony's temptations.[135] In an interview published shortly before the artist's death in July 1946, Pippin exclaimed to a reporter: "Hell, I'll get $500 just for being in the contest. I never heard of the temptation of St. Anthony until this contest."[136] Although Pippin was a deeply religious man, it is understandable that the artist would not necessarily have encountered Saint Anthony Abbot, an Egyptian hermit saint of the third century, whose legends were part of the traditions of the Catholic Church. In the end, Max Ernst's canvas was chosen for inclusion in the movie,[137] and Pippin's *Temptation of Saint Anthony* was one of the two finished canvases left in his studio at the time of his death.

Such commissions proved a mixed blessing to the artist. On the one hand, they were tangible acknowledgments of his growing reputation, but they also pushed him into areas of iconography and scale to which he was not accustomed. The results often reflected his physical and intellectual discomfort. Claude Clark's comments about Pippin's career and his description of the artist's working methods are germane here:

> I feel that Pippin really was exploited to the hilt in many ways. . . . I don't think he was ever fully treated as a human being . . . underneath [his appeal as a naive] . . . was this human being, who even though not the scholar that you might think of, he was certainly a thinker and he did more research than most people realize.[138]

If Pippin accepted commercial commissions that obliged him to confront subjects he might not have chosen on his own, he also responded positively—"amiably and invariably"—when, in Selden Rodman's description, "countless efforts were made, following the discovery of [Pippin's] talent, to enlist his brush in the cause of racial tolerance, international peace, Allied victory, proletarian solidarity, and the like."[139] Rodman furnished examples of four paintings whose creation was stimulated by a request from others: "a cover for Angelo Herndon's projected Negro digest[140]; a poster for *Deep Are the Roots* [1945, fig. 39]; a *Tribute to Stalingrad* [1942, fig. 37]; and *Mr. Prejudice* [1943, fig. 38]. . . ."[141] Nearly fifty years later, it is not possible to learn the circumstances precipitating these political commissions. Nonetheless, it is clear that Pippin was sympathetic to the struggle against tyranny and oppression in its many forms.

Pippin's final years brought him greater financial security but increased personal stress. His stepson joined the armed forces. His wife became quarrelsome and was often ill. A formerly plump woman, she went on a drastic diet and in the process likely became addicted to amphetamines.[142] The artist drank heavily and enjoyed the attentions of younger women. His generosity in standing rounds at his favorite bars cut into his resources. But Pippin was sustained by both the financial and emotional support of Robert Carlen, to whom he remained loyal, and by the pride of his New York state relatives in his achievements. In a letter he wrote to Carlen in August 1945, less than a year before he died, Pippin informed his dealer that *The Holy Mountain III* (fig. 129) would soon be ready. He went on to say:

> I have something more to ask you and it is about the photos of my pictures that is to send to Goshen. This will mean a lot to me if I can get them some time in September. I have a lovely letter from Goshen, telling me that all of

them wish me sincerely in my work. I look to you for it and I know it will be done, for you have never failed me yet. . . .[143]

Two weeks later Pippin wrote again to Carlen, in part to let him know that another painting had been completed, and also to request a favor:

> I am sorry to ask you for a little help at this time but it came like all troubles do and I know you will understand. My wife went to the Hospital the other day but she is home now. Now the Doctor is to see her, so if you can send me as a loan $2.00, it would help me out. . . . I am well and working every day. I am working on four more pictures now.[144]

After a fortnight Pippin contacted Carlen to inquire about payment for his paintings and went on to reveal his own loneliness to his dealer, who remained alone in Philadelphia during the summer while his family vacationed at the New Jersey shore: "My wife is not home at this time she went to Chester, Pa. for two weeks, to rest up so I am alone. I cook also. Now I know how you feel alone."[145] By the end of October, the artist was distraught:

> I am in a bad way at this time for I do not know what I am doing. This place is bad for me at this time, but I am doing the best that I can as you know. If your helpmate is bad, it makes it bad for all of them. I came to the place that I [did] not hear what she said to me so I [could] work. . . . I hope to have some work to you no later than November 5. . . . Now if you do not know af[ter] this, how important art is I put it in your hands to do what you will. No more at this time.[146]

Although he was living through some of the unhappiest times of his adult life, Pippin kept working, finding solace in his creative life. That Robert Carlen was not altogether open with Pippin's New York dealer, Edith Halpert, about the artist's productivity is clear in her letters to him inquiring about his output: "I am very curious about the Pippin situation. How come that there are no more pictures?," Halpert wrote three months after Pippin's 1944 show in her gallery. Over a year and a half later she wrote: "It seems incredible that Pippin has produced nothing since last April. Won't you let me know what is happening?"[147] Six months later Halpert again wrote Carlen to say, "Of course I feel badly about the Pippin situation. I do hope his wife improves and that he snaps out of his artistic lethargy."[148] Carlen may have felt justified for dissembling in his reports regarding Pippin's inactivity because Halpert had once tried to lure Pippin away from his gallery with promises of higher profits.[149] The truth is that Pippin's production for 1946 had not diminished from the preceding years. During the first six months of 1946 he completed five paintings. In February, his painting *The Milkman of Goshen*, won the J. Henry Schiedt Memorial Prize of three hundred dollars at the Pennsylvania Academy of the Fine Arts's 141st annual exhibition (fig. 22). Five unfinished paintings were found in his studio at the time of his death on July 6, 1946, when a housekeeper discovered he had died in his sleep. It was later determined that he had suffered a stroke. His wife, confined at the Norristown State Hospital in a state of mental confusion, died two weeks later, never learning of her husband's passing. Claude Clark recalls seeing Pippin for the last time a few months before his death: "He didn't look bad physically [or] physically out of shape to me, [yet] I have a feeling there was a certain amount of grieving there."[150] Pippin's last completed paint-

22 Photographer unknown. *Joseph T. Fraser, Jr., Secretary of the Pennsylvania Academy, awarding the J. Henry Schiedt Memorial Prize to Horace Pippin at Pennsylvania Academy's 141st annual exhibition,* 1946. Silver gelatin print, 8 × 10 in. The Schomburg Center for Research in Black Culture, The New York Public Library, Astor, Lenox, and Tilden Foundations, New York

ing was *Man on a Bench* (fig. 140), a meditative portrayal of an older African American, that is widely regarded as a spiritual self-portrait.

Pippin rose to prominence in the 1940s buoyed by several waves. The crest that first propelled him from the relative obscurity of West Chester, Pennsylvania, into the mainstream of the New York art world was the new enthusiasm for primitive artists. MoMA's 1938 exhibition "Masters of Popular Painting," which contained four of Pippin's canvases, and Sidney Janis's 1942 publication *They Taught Themselves*, which also included examples of Pippin's works, were indications of and stimuli to the growing interest in self-taught artists. Janis himself credited the new awareness of America's heritage of self-taught painters to "one of those unpredictable turns in esthetic appreciation."[151] Whether it was described as naive or folk or primitive, the instinctive work of untrained painters and sculptors was understood as honest, pure and direct, and hence valued as authentically American. During the war years when transatlantic travel was curtailed, it became both patriotic and practical to champion indigenous artistic talent.

As some have chronicled it, the history of modernism is a history of the enhanced respect for and emulation of certain elements of primitive art. Robert Goldwater's 1938 publication, *Primitivism in Modern Art*, explored the subject in great detail—from Gauguin, the Fauves, the Cubists, the German Expressionists, Klee, Miró, Dubuffet, the Dadaists, and the Surrealists, modern artists have learned by looking at the work of those whose careers lay outside of the European academic tradition.[152] In Pippin's time, astute critics prided themselves in responding to the design and color sophistication embodied in primitive work, as well as to the

primitive qualities of refined art. For example, in 1944, *New Yorker* critic Robert Coates segued directly from his discussion of Horace Pippin's "subtle and sophisticated" compositional and color skills into an analysis of the work of Milton Avery,

> a man almost anyone nowadays would recognize instantly as a sophisticate. But he too bothers little about perspective and at times makes use of naive detail, two facts which may conceivably make it difficult for the historian of five hundred years hence to classify him exactly.[153]

Sidney Janis talked about the "primitive character and [the] true primitive synthesis in the work of certain very advanced moderns, for they too embody the force and austerity of purpose that accompany any initial struggle with art forms."[154]

Several black artists gravitated toward primitivizing styles in the late 1930s. William Henry Johnson gradually abandoned an earlier academic mode to adopt, in Richard Powell's description, "a more simplified, colorful and geometric painting style" after returning to the United States from Europe in 1938.[155] In the late 1930s, the young Jacob Lawrence evolved a signature representational style of simplified perspective, flattened volumes, and elemental forms. Although Lawrence's characteristic mode of expression was already in place by the time he first became aware of Pippin's work at the Downtown Gallery in 1941, he had seen MoMA's 1937 show of the work of the self-taught black stonecutter and carver William Edmondson, a show that had, in his words, "a great impact" on him.[156] Interestingly, in his 1943 book, *Modern Negro Art*, art historian James A. Porter described Pippin's canvases as "almost the painted analogues" of Edmondson's rustic carvings.[157] In a recent interview, Jacob Lawrence noted: "the more I think, I'm sure that . . . [Pippin's] content and his form must have made some impression on me. . . . Horace Pippin would have been a person I would have looked at more than . . . others."[158] Lawrence's wife, the artist Gwendolyn Knight, reinforced this connection by observing that "[Pippin] and Jake were quite close in their perceptions."[159]

Artists who *chose* to work in a primitivizing style risked critical disapproval. In the context of remarks about Horace Pippin, commentators would take pains to point out that *he*, not the primitivizers, was the genuine article. Writing about two of Pippin's paintings that had recently been acquired by the Barnes Foundation and the Philadelphia Museum of Art, respectively, a 1941 *Art Digest* writer remarked: "Both are important because they lack the sophisticated 'primitivism' seen so often among school-trained pretenders."[160] Three years later, a feature on Pippin in *Art News* concluded by observing: "He is the true intuitive artist, standing out in a day when the primitives' cult has taught far too many people that it pays to stay innocent, for a genuineness that is beyond challenge."[161]

In addition to the new taste for primitive art, there were other factors that facilitated Pippin's rise to prominence in the 1940s. That the unschooled Pippin, with his intuitive genius for composition, color, and form could have reached an expressive power that rivaled the work of "advanced moderns," was an ingredient in his rapid recognition. Alain Locke observed that the artist possessed a "modernistically abstract talent."[162] This enthusiasm for Pippin's authoritative modern vision lay behind his inclusion in prestigious group shows of contemporary art, surveys in which he was usually the only untrained painter. In this regard, Pippin's unique contribution was compared with that of Henri Rousseau—here were two self-taught artists who were modernists by instinct.[163] And finally, interest in Pippin as an exemplar and chronicler of African-American life influenced the quickened pace of his art world recognition. If, as Alain Locke reported, the thirties were a decade when "American art was rediscovering the Negro," then Horace Pippin was in the right

23 Jackson Pollock (1912–1956).
The Key, 1946. Oil on canvas, 59 × 85
in. The Art Institute of Chicago,
through prior gift of Mr. and Mrs.
Edward Morris (1987.261)

place at the right time. For some, Pippin's winsome depictions of rural black life fulfilled stereotyped expectations of what a black artist's subject matter should be.

In April 1946, three months before Horace Pippin's death, the thirty-four-year-old painter, Jackson Pollock, exhibited his work (fig. 23) at Peggy Guggenheim's Art of This Century gallery. In its review of this show, *Art News* praised Jackson Pollock as "one of the most influential young American abstractionists." The critic Clement Greenberg equivocated in his review for the *Nation*, yet described Pollock as "the most original contemporary easel-painter under forty."[164] Pollock was on the threshold of discovering his signature mode of Abstract Expressionism, a breakthrough into an intuitive, "inner vision of burning intensity," to borrow a descriptive phrase from a 1944 review of Horace Pippin. While still extolling the virtues of instinct and fidelity to inner truths, the art audience would soon celebrate the expressive and abstract canvases of Jackson Pollock, the brash westerner, whose work had "the individual savor of its soil," to use the phrase with which Albert Barnes praised Horace Pippin in 1940. Action painting would permanently alter America's role in the international art world. Some philistines would dismiss their work, claiming that "a child of six could do it"—which is to say that it suggested the work of an untrained hand.

If, in the last decade of the twentieth century, Horace Pippin is again the subject of "one of those unpredictable turns in esthetic appreciation," in Sidney Janis's phrase, it has little to do with his status as a self-taught artist. Rather, it rests on a renewed recognition that as a painter, and as an African American, Pippin created a unique body of work of abiding significance.

ACKNOWLEDGMENTS

The author gratefully expresses her appreciation to those who read and commented on early drafts of this essay: Academy staff Susan Danly, Linda Bantel, and Frank Goodyear, and colleagues Lowery Sims, Leslie King Hammond, Ann Gibson, and Carrie Rickey. With dispatch and ingenuity, Academy librarian Marietta Boyer facilitated research in countless ways. I am greatly indebted to the superb proofreading of Susan James-Gadzinski. A special bouquet of gratitude is due project coordinator Anne Monahan, whose keen eye and insightful observations have provided invaluable support at every step of this undertaking.

JUDITH E. STEIN, curator of "I Tell My Heart: The Art of Horace Pippin," is an adjunct curator at the Pennsylvania Academy of the Fine Arts, Philadelphia.

1. The West Chester census records of 1880 encompassed a Christine Pippin, identified as a 21-year-old mulatto domestic servant in the home of Mary Haines. She would have been 29 in 1888, the year of Pippin's birth. Also listed in that census is Harriet Pippin, a 45-year-old mother of four, who would have been 53 in 1888, if the age given in the census was accurate. In a questionnaire completed by the artist, found in Robert Carlen's papers at the Archives of American Art, Horace lists his mother as "Harriet." Because Harriet was likely the one to have raised him, it is understandable that he would have referred to her as his mother, even if she were his grandmother. This fact might clarify the confusion regarding the identity of the African-American woman Horace Pippin depicted as an 1859 eyewitness in *John Brown Going to His Hanging* (fig. 57), whom he "repeatedly" identified as his mother, according to his dealer Robert Carlen; see Selden Rodman, *Horace Pippin: A Negro Painter in America* (New York: The Quadrangle Press, 1947), p. 17. Rosemary Phillips of the Chester County Historical Society kindly provided us with the census data.

2. Undated letter from Horace Pippin, Horace Pippin War Memoirs, Letters, and Photographs, Archives of American Art, Smithsonian Institution, Washington, D.C.

3. "Primitivist Pippin," *Time*, January 29, 1940, p. 56.

4. Theodore Stanford, "Call Pippin Greater than Tanner," *Baltimore Afro-American*, May 13, 1944.

5. Romare Bearden, "Horace Pippin," *Horace Pippin*, exh. cat. (Washington, D.C.: The Phillips Collection, 1977), u. p.

6. Madelin Blitzstein, "The Odds Were Against Him," *US Week*, April 21, 1941.

7. Claude Clark, interview with author, August 5, 1991.

8. Edward Loper, interview with Marina Pacini, May 12, 1989, Archives of American Art, Smithsonian Institution, Washington, D.C., p. 45.

9. This and the following quote are from Stanford, "Call Pippin Greater than Tanner."

10. Carita Ponzo and Emma Milby of 325 Gay Street, interview with author, December 4, 1992.

11. Clark, interview with author.

12. Devere Kauffman, interview with the author, December 13, 1992. Although Miss Scott brought her brother in to see Pippin's work, no sales resulted from the short exhibition.

13. William Schack, *Art and Argyrol* (New York: Thomas Yoseloff, 1960), p. 188.

14. Fiske Kimball, "The Brinton Collection," *The Philadelphia Museum Bulletin* 37 (November 1941), u.p.

15. Henderson High School, Frank Wright's American History Seminar, West Chester Area School District, *Horace Pippin, The Artist and His Work*, Chapter Four, p. 13. The reader is cautioned that the footnoted sources in this student project are not necessarily coordinated with their citation in the text.

16. Mr. Jean Fugett, Sr., interview with the author, September 10, 1992. Sadly, this painting, called *On Guard*, which was an early version of *Six O'Clock* (fig. 150) was destroyed in a house fire in the winter of 1992. Although not listed in the catalogue, it was publicly exhibited at the Brandywine Museum venue of the 1977 touring exhibition.

17. Henderson High School, *Horace Pippin*, p. 14.

18. George H. Straley, "The Nine Good Years of Horace Pippin," *County Lines*, May 1988, pp. 73–84.

19. Ann Wyeth McCoy, interview with the author, August 14, 1992. See also Selden Rodman and Carole Cleaver, *Horace Pippin: The Artist as a Black American* (Garden City, N. Y.: Doubleday and Co., 1972), pp. 70–71; and Peter Huber, "Horace Pippin," *Susquehanna Monthly Magazine*, September 1985, p. 25.

20. *Daily Local News*, June 8, 1937.

21. Significant for its possible ramifications on Pippin's subsequent subject matter was de Merlier's other exhibited submission, a painting entitled *Birmingham Meeting House*.

22. For this and all subsequent references to Brinton's correspondence, see Christian Brinton Papers, Archives of American Art, Smithsonian Insitution, Washington, D.C.; courtesy of the Chester County Historical Society, West Chester, Pennsylvania.

23. The Committee of Sponsorship that Brinton assembled included the artists N. C. Wyeth and Franz de Merlier, as well as such social figures as Mrs. Jean Kane Foulke, Mrs. E. Page Allinson, and the redoubtable Fanny Travis Cochran, ardent supporter of the rights of working women, who as a young girl in 1887 had modeled for Cecilia Beaux's *A Little Girl* (Pennsylvania Academy of the Fine Arts). Many of these same individuals would be drafted by Robert Carlen for his honorary Committee of Sponsorship for Pippin's January 1940 exhibition.

24. *The Coatesville Record*, May 29, 1937.

25. "West Chester Community Center," undated brochure in the collection of the Chester County Historical Society. The following quotation in the text is also from this brochure.

26. *Daily Local News*, April 18, 1945 reported that "Horace Pippin's *Still Life* and *Portrait of My Wife* will be of great interest as very few have seen them heretofore."

27. Letter from Dorothy C. Miller to Christian Brinton, September 13, 1937, Brinton Papers.

28. For the context of Raymond Henniker-Heaton's remarks regarding the seventeenth-century painting *Mrs. Freake and Baby Mary* in the Worcester Art Museum, see Beatrix T. Rumford's illuminating essay, "Uncommon Art of the Common People: A Review of Trends in the Collecting and Exhibiting of American Folk Art," in *Perspectives on American Folk Art*, eds. Ian Quimby and Scott Swank (New York: W. W. Norton & Co., 1980), p. 14.

29. Dorothy Grafly, quoted in "Would Stun Paris," *Art Digest*, February 15, 1940, p. 7.

30. For a philosophical discussion of the implications of the adjective "primitive" in relation to folk art, see Henry Glassie, *The Spirit of Folk Art* (New York: Harry N. Abrams, 1989), pp. 244 ff. Glassie points out that "primitive" is "not a good word," because "primitive art is distinguished on the basis of negative traits—usually the absence of writing—that are of little relevance to the creation of art," (p. 244).

31. Wyeth's remarks are quoted in "Horace Pippin Is Called A 'Discovery' At Exhibition," an unidentified clipping of a June, 1937 review of Pippin's show at the West Chester Community Center, Robert Carlen Gallery Papers, Archives of American Art, Smithsonian Institution, Washington, D.C.

32. Dorothy Grafly, *Art Outlook*, April 1, 1947, u. p.

33. Betsy James Wyeth, ed., *The Wyeths: The Letters of N. C. Wyeth 1901–1945* (Boston: Gambit, 1971), p. 803. I am grateful to Richard Boyle for bringing this reference to my attention. Carolyn Wyeth was the least conventional painter in her family, and her works have a strong emotional content. The painting that had so impressed Pippin was likely one of the several she did depicting a life mask of Keats. See, for example, *Carolyn Wyeth, Artist*, exh. cat. (Chadds Ford, Pa.: Brandywine River Museum, 1979), p. 18 and cat. no. 27.

34. *Daily Local News*, April 23, 1938.

35. The very first exhibition of American folk art was held a decade earlier, at the Whitney Studio Club in February 1924. Juliana Force, the early director of the Whitney, was a folk-art enthusiast who formed a collection of 64 folk paintings for her museum.

36. Cahill's introduction to *American Primitives* is quoted in Rumford, "Uncommon Art," p. 27.

37. *Ibid.*, p. 16.

38. Letter from Horace Pippin, not in his hand, to Christian Brinton, July 10, 1938, Archives of the Philadelphia Museum of Art.

39. George H. Straley, "Sale of Pippin's Painting Stirs County Art Leaders," *Daily Local News*, October 27, 1938.

40. Pippin had previously painted his wife's portrait (fig. 82) in 1936, and those of Paul Dague (fig. 87) and Smedley Butler (fig. 88) in 1937.

41. For an excellent introduction to the artist see A[nne] d'H[arnoncourt], "Elizabeth Sparhawk-Jones," *Philadelphia: Three Centuries of American Art* (Philadelphia: Philadelphia Museum of Art, 1976), pp. 493–494.

42. This and the following reference to Walker's correspondence are from letters in the Hudson Walker Papers, Archives of American Art, Smithsonian Institution, Washington, D.C.

43. Letter from Elizabeth Sparhawk-Jones to Joseph T. Fraser, Jr., December 6, 1942, Archives of Pennsylvania Academy of the Fine Arts. In his response three days later, a copy of which also is housed in the Academy's archives, Fraser wrote back saying: "[Pippin] is on our Philadelphia list and I have already sent him an invitation to exhibit." He concluded, in an unconsciously patronizing tone: "All too rarely does one artist root for another, and I congratulate you on your enthusiasm." Interestingly, the 1943 annual to which Fraser referred, consisted of all invited artists. The usual jurying procedure was put aside due to war conditions. Pippin's status as an invited exhibitor was a marked change from his rejection by the jury for the 1941 Annual. He had submitted the paintings *Christ and the Woman of Samaria* (fig. 121) and *Amish Letter Writer* (fig. 1), presumably at the suggest of his dealer Robert Carlen, who himself studied at the Academy. In 1941 the jury consisted of Thomas Hart Benton, John Carroll, Leon Kroll, Paul Sample and Francis Speight, and Pippin's work would have been dealt with rapidly as the jury plowed through some 2,000 submissions.

44. Regarding the late start of most self-taught painters, see Rodman, *Horace Pippin*, p. 27. Details of Moses's life are found in Otto Kallir, *Grandma Moses* (New York: Harry N. Abrams, 1973).

45. See "In Line for Pippin," *Art Digest*, April 1, 1944, p. 11: "Theatrical people are Pippin's most ardent collectors and about 13 of them are standing in line for Pippin's next paintings." A variety of public figures were attracted to Pippin's work. According to a report in the *Philadelphia Inquirer* ("Art," by C.H. Bonte, April 12, 1947), which appeared at the time of Pippin's memorial exhibition at the Art Alliance, the version of the *Holy Mountain* (fig. 171) that was left unfinished on his easel at the time of his death "was destined for the home of Henry and Clare Luce."

46. Notes from Sarah Wilson's 1988 interview with Robert Carlen in the collection of the Chester County Historical Society. The school archives at the Academy have no record of his exact attendance dates.

47. For an in-depth discussion of the Leof-Blitzstein circle see Margaret Brenman-Gibson, *Clifford Odets, American Playwright: The Years from 1906 to 1940* (New York: Atheneum, 1981), pp. 122–125.

48. For an analysis of the psychological components in the Odets/Leof relationship see Margaret Brenman-Gibson, *Clifford Odets*, pp. 122–125. Odets owned *Water Boy* (fig. 187) and *Man on a Bench* (fig. 140), which he purchased from Carlen in 1946, as well as *Saturday Night Bath* (fig. 141), and *Country Doctor* (fig. 134), the latter which he obtained from the Leof family. Regarding Odets's relationship with Carlen, see the selection of his letters to the dealer in the Carlen Papers, which reveal his catalytic role in placing Pippin's paintings in Hollywood, Calif., collections. Through the playwright's association with New York's famous Theatre Guild, Odets may well have encouraged others to collect Pippins—the actor Philip Loeb, who was the guild's general stage manager, owned *Victory Garden* (fig. 117), and guild actor Ruth Gordon owned *The Milkman of Goshen* (fig. 139).

49. In addition to William Schack's *Art and Argyrol*, see the more recent work by Howard Greenfeld, *The Devil and Dr. Barnes: Portrait of an American Art Collector* (New York: Penguin Books, 1987).

50. See for example, Dorothy Grafly, "Old Portraits Praised, Modernist Art Decried," *The North American*, April 15, 1923, who wrote "It is as if the room

were infested with some infectious scourge." See also the unpublished paper delivered by the author at the College Art Association 1988 sessions, entitled "Defining the Present in the Past: The Tradition of Contemporary Art at the Pennsylvania Academy of the Fine Arts."

51. According to the foundation's records, Pippin was registered there for the Fall 1939 and the Spring 1940 semesters.

52. Rodman, *Horace Pippin*, p. 14.

53. *Ibid.*

54. Rodman and Cleaver, *Horace Pippin*, p. 76.

55. Schack, *Art and Argyrol*, p. 289.

56. See for example, Sidney Janis, *They Taught Themselves: American Primitive Painters of the 20th Century* (New York: Dial, 1942), p. 9, who points out that Rousseau ardently desired to paint realistically, and yearned to paint like Bouguereau: "It is apparent from what [self-taught artists] say about their work that they believe they are faithfully recording reality."

57. Roberta Townsend, Statement, December 1, 1987, in the collection of the Chester County Historical Society.

58. Loper, interview with Pacini, pp. 34–35.

59. Since the printed catalogue for the exhibition cites Barnes, de Mazia, and Laughton as lenders, it should be assumed that Carlen made these sales before the show opened on January 19. Despite press reports citing Barnes's immediate purchase of several works, the collector first bought *Abraham Lincoln and his Father* (fig. 51), formally acquired for the foundation on January 18, 1940, the day prior to the public opening of the exhibition, according to the foundation's records. He bought *Six O'Clock* (also known as *Cabin Interior* and *By the Fireside*) (fig. 150) on October 18, 1940, and subsequently deaccessioned it on April 4, 1946. *Supper Time* (fig. 152) was purchased on February 17, 1941, *Christ and the Woman of Samaria* (fig. 121) three days later on February 20, and *Giving Thanks* (fig. 169) was acquired on September 22, 1942.

Violette de Mazia purchased *Birmingham Meeting House I* (fig. 69) in January 1940. It seems that Laughton bought his Pippin painting, *Cabin in the Cotton* (fig. 155), under unusual circumstances. As quoted in Robert Carlen's obituary (*Philadelphia Inquirer*, August 22, 1990), the dealer's daughter Nancy recalled: "Father loved to tell the story of when Dr. Barnes routed him out of bed one night. Dr. Barnes and his friend Charles Laughton had been drinking at Barnes' house in Merion, and Laughton wanted to buy a Pippin, right then. Father got up and took the picture out to them in the middle of the night."

60. For details regarding Barnes's support of black folk music, see Richard Wattenmaker, "Dr. Albert C. Barnes and the Barnes Foundation," *Great French Paintings from The Barnes Foundation*, exh. cat. (New York and Merion, Pa.: Alfred A. Knopf and The Barnes Foundation, 1993).

61. See Schack, *Art and Argyrol*, pp. 299–305, for a description of the events. He notes that although the Virginia legislature had once appropriated funds for a monument to Bland to be erected in Richmond, the project was dropped when it was discovered that he was a Negro. On July 15, 1946 a granite headstone was finally placed on his Pennsylvania grave by the Lions Club of Virginia.

62. *Letters of Carl Van Vechten*, selected and edited by Bruce Kellner (New Haven: Yale University Press, 1987), p. 253.

63. Alice Carlen, interview with author, July 18, 1992.

64. Letters from Albert Barnes to Robert Carlen, February 16, 1941, June 12, 1941, and June 13, 1941, Archives of The Barnes Foundation, Merion, Pa. The following text quotation is from Carlen's letter to Barnes dated January 14, 1941.

65. Schack, *Art and Argyrol*, p. 289. Writing in 1959, Schack likely got his information from Carlen himself. This commission will be discussed in the text below.

66. Letter from Barnes to Carlen, June 20, 1946, Carlen Papers.

67. Selden Rodman, interview with author, May 28, 1992.

68. "Primitivist Pippin," p. 56.

69. Letter from Robert Carlen to Hudson Walker, February 26, 1940, Walker Papers.

70. George H. Straley, [Review of Carlen show], *Daily Local News*, January 26, 1940.

71. Horace Pippin, quoted in Joseph W. Woods "Modern Primitive: Horace Pippin," *The Crisis*, June 1946.

72. For a discussion of Guggenheim and her gallery in the context of the New York art world of the 1940s, see Steven Naifeh and Gregory White Smith, *Jackson Pollock: An American Saga* (New York: Clarkson Potter, 1989), pp. 424ff.

73. This excerpt and the following two quotations from Horace Pippin are from the *Daily Local News*, Oct. 3, 1940.

74. Horace Pippin, quoted in Woods, "Modern Primitive," p. 179.

75. Clark, interview with author.

76. Letter from Robert Carlen to Henry Allen Moe, February 26, 1940, Archives of the S. J. Guggenheim Foundation, New York.

77. Horace Pippin's application statement, October 11, 1940, Archives of the S. J. Guggenheim Foundation.

78. For example, in Carlen's May 8, 1941 letter to Alice Roullier, head of the Exhibition Committee of the Arts Club of Chicago, he proudly informed her that he had recently sold 14 of Pippin's works out of his recent show and that Albert Barnes had acquired two new examples, "and the Whitney Museum one—a short time before that the Phila. Museum acquired their example," Archives of the Arts Club of Chicago, Newberry Library, Chicago. So well did Carlen veil the fact that he was the donor of *The End of the War: Starting Home*, that a news item in the February 12, 1941 *Daily Local News* reporting on the acquisition erroneously stated that "it was purchased by the Philadelphia Museum of Art." Likewise, the March 1, 1941 issue of the *Art Digest* reported that the Philadel-

phia Museum of Art had "purchased *End of the War*," p. 13.

79. The sources for the opinions of Barnes, Bloch and Cahill cited in the text are their individual "confidential report on candidate [Horace Pippin] for fellowship," in the Archives of the S. J. Guggenheim Foundation, quoted with the permission of the writers, their heirs, or their representatives.

80. Alain Locke, Confidential Report on Candidate [Horace Pippin] for Fellowship, February 9, 1941, Archives of the the S. J. Guggenheim Foundation. Locke had often been asked to write letters in support of African-American artists. For example, twelve years earlier in a letter to Guggenheim secretary Henry Allen Moe regarding the four applicants he had been called upon to commend, he confided: "It is a little embarrassing this year to have been referred to by so many candidates [Nuggent, Barthé, Hunton, and Douglas]. I quite understand that each case is considered on relative merits within its group, but it has been difficult to keep comparative judgement out of my mind." He concluded by taking the opportunity "to express my appreciation of the Foundation's helpful and fair-minded interest in promising and talented Negroes, and of [Moe's] large personal share in this policy and attitude." Letter from Alain Locke to Henry Allen Moe, November 19, 1928, Alain Locke Papers, Moorland Spingarn Research Center, Howard University, Washington, D.C.

81. Max Weber, letter to Guggenheim secretary Henry Allen Moe, December 1, 1940, Archives of the S. J. Guggenheim Foundation. Weber curtly noted that he would not lend himself "to such expedience and high pressure," and said that he felt "such methods are not in keeping with the character and aims" of the foundation. It is ironic that Weber's response may have prevented Pippin from being named a winner. In two letters to Carlen written earlier that fall, Weber strongly praised Pippin, stating that he believed that the artist deserved a Guggenheim award. But he revealed that two years previously he had decided not to write any more letters of recommendation because no candidate he had ever backed had been awarded a fellowship. See letters from Max Weber to Robert Carlen, September 23 and October 15, 1940, Carlen Papers.

82. Albert C. Barnes, "Horace Pippin Today," *Recent Paintings by Horace Pippin*, exh. cat. (Philadelphia: Carlen Galleries, March 21–April 20, 1941), u.p.

83. Letter from Carlen to Barnes, March 30, 1941, Archives of The Barnes Foundation.

84. Letter from Robert Carlen to Alice Roullier, March 14, 1941, Archives of the Arts Club of Chicago.

85. Letter from Carlen to Roullier, April 7, 1941, Archives of the Arts Club of Chicago.

86. Letter from Carlen to Roullier, May 8, 1941, Archives of the Arts Club of Chicago.

87. For example, a week before the opening, *The Chicago Daily News* of May 16, 1941, Archives of the Arts Club of Chicago, noted that the Arts Club anticipated

that the opening of the Dali show would be "the biggest crush of the year," and went on to speculate whether the tea table would have surrealistic decorations.

88. Adeline Fitzgerald, "Arts Club Tea for Salvador Dali Brings Out Big Crowd," *Chicago Herald-American*, May 24, 1941.

89. Clark, interview with author.

90. Letter from Carlen to Barnes, June 13, 1941, Archives of The Barnes Foundation.

91. Horace Pippin quoted by Julius Bloch in his letter of reference for Pippin to the Guggenheim Foundation, received October 22, 1940. Archives of the S. J. Guggenheim Foundation.

92. Straley, "The Nine Good Years of Horace Pippin," p. 76.

93. Letter from Carlen to Barnes, August 4, 1941, Archives of The Barnes Foundation.

94. Postcard from Horace Pippin to Robert Carlen, November 24, 1941, Carlen Papers.

95. For a discussion of Halpert and the "American Negro Artists" exhibition see Diane Tepfer, *Edith Gregor Halpert and the Downtown Gallery Downtown: 1926–1940; A Study in American Art Patronage*, unpublished doctoral dissertation, University of Michigan, 1989, pp. 235–239; see also June Kelly, "Romare Bearden," *The International Review of African American Art* 9 (1991), p. 22, for a reference to the exhibition in the context of Bearden's career.

96. Robert M. Coates, "The Art Galleries," *The New Yorker*, December 27, 1941.

97. Clark, interview with author.

98. Letter from Carlen to Barnes, January 2, 1942, Archives of The Barnes Foundation.

99. Letter from Barnes to Carlen, June 12, 1941, Archives of The Barnes Foundation.

100. Letter from Carlen to Barnes, September 3, 1941, Archives of The Barnes Foundation.

101. Letter from Carlen to Barnes, March 14, 1942. Archives of The Barnes Foundation.

102. Letter from Carlen to Barnes, March 23, 1942, Archives of The Barnes Foundation.

103. Letter from Langston Hughes to Robert Carlen, October 28, 1942, Carlen Papers.

104. For a discussion of Morley's and the MacAgys' role as advocates of the new abstraction, see Caroline A. Jones, *Bay Area Figurative Art, 1950–1965* (Berkeley: University of California Press, 1990), pp. 4–5.

105. Letters from Grace Morley to Robert Carlen, April 14, 1942 and April 28, 1942, Carlen Papers.

106. Letter from Carlen to Barnes, February 1, 1943, Archives of The Barnes Foundation.

107. Letter from Pippin to Carlen, February 1, 1943, Carlen Papers. [The punctuation in this letter has been edited to conform to current usage.]

108. Letter from Duncan Phillips to Edith Halpert, December 4, 1943, The Phillips Collection Papers, Archives of American Art, Smithsonian Institution, Washington, D.C. Phillips observed that he had bought the painting impulsively, breaking with his usual policy of taking art on approval: "The Pippin

Horace Pippin's Challenge to Art Criticism

CORNEL WEST

THE ART OF HORACE PIPPIN poses grave challenges to how we appreciate and assess artworks in late twentieth-century America. A serious examination of Pippin's place in art history leads us into the thicket of difficult issues that now beset art critics. What does it mean to talk about high art and popular culture? Do these rubrics help us to evaluate and understand visual artifacts? Is folk art an illuminating or oxymoronic category? Can art be more than personal, racial, or national therapy in American culture? Has the commercialization of art rendered it a mere commodity in our market-driven culture? Can the reception of the work of a black artist transcend mere documentary, social pleading, or exotic appeal?

These complex questions often yield Manichean responses—namely, self-appointed defenders of high culture who beat their breasts in the name of craftsmanship and quality and self-styled avant-gardists who call for critique and relevance. The former tend to use the monumental touchstones of the recent past—especially those of high modernism—to judge the present. The latter reject monumentalist views of art history even as they sometimes become highly paid celebrities in the art world. Pippin's work shows this debate to be a sterile exchange that overlooks much of the best art in the American grain: high-quality craftsmanship of art objects that disclose the humanity of people whose plight points to flaws in American society. Pippin's paintings are neither monumentalist in the modernist sense nor political in a postmodernist way. Rather, they are expressions of a rich Emersonian tradition in American art that puts a premium on the grandeur in the ordinary and quotidian lives of people. This tradition promotes neither a glib celebration of everyday experiences nor a naive ignorance of the tragic aspects of our condition. Pippin's democratic sensibility affirms instead what John Dewey dubbed "experience in its integrity."[1] Pippin's so-called folk art boldly exclaims with Emerson:

> I ask not for the great, the remote, the romantic; what is doing in Italy or Arabia; what is Greek art, or Provençal minstrelsy; I embrace the common, I explore and sit at the feet of the familiar, the low. Give me insight into today and you may have the antique and future worlds.[2]

This artistic affirmation of the everyday experiences of ordinary people is anti-elitist but not anti-intellectual—that is, it shuns a narrow mentality that downplays the joys and sufferings of the degraded and despised, yet it heralds high standards for how these joys and sufferings are represented in art. Pippin's paintings attempt

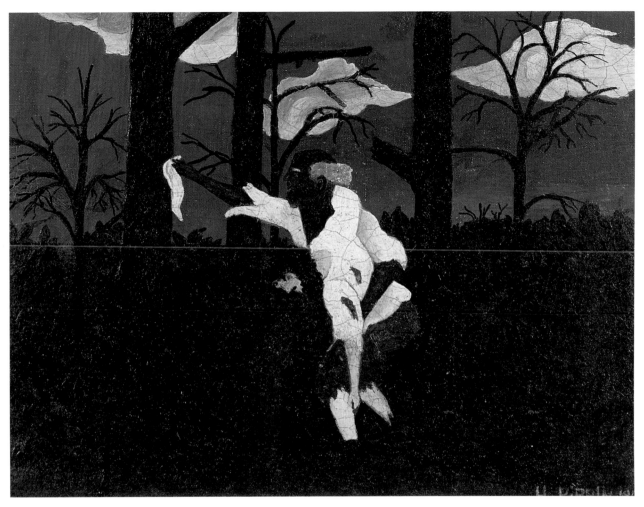

2 4 *Zachariah*, 1943. Oil on fabric, 11 × 14 in. The Butler Institute of American Art, Youngstown, Ohio (951-0-120)

to democratize (not denigrate) the aesthetic by discerning and displaying tragedy and comedy in the ordinary experiences of common folk. In this way, his work echoes the aesthetic sensibility of John Dewey.

> In order to *understand* the esthetic in its ultimate and approved forms, one must begin with it in the raw; in the events and scenes that hold the attentive eye and ear of man, arousing his interest and affording him enjoyment as he looks and listens The sources of art in human experience will be learned by him who sees how the tense grace of the ball-player infects the onlooking crowd; who notes the delight of the housewife in tending her plants, and the intent interest of her goodman in tending the patch of green in front of the house; the zest of the spectator in poking the wood burning on the hearth and in watching the darting flames and crumbling coals.[3]

We see such precious moments in Pippin's *Harmonizing* (1944), with black men *joyfully* singing on the block, or in *Domino Players* (1943), with black women *enjoying* a domino game. We also realize that Pippin's link to Abraham Lincoln is not so much to the president as emancipator of black people nor the president as hypocrite (e.g., supporter of black colonization and exportation to Central America), but rather to Lincoln as the folk hero who is believed to have said that God must have loved com-

mon folk since he made so many of them. *Abe Lincoln, The Good Samaritan* (1943) fuses this idea of Lincoln with the Christian theme of concern for the disadvantaged ("let Christianity speak ever for the poor and the low").4

Yet Pippin's Emersonian practice—which sidesteps the sterile "quality vs. diversity" debate—lends itself to abuse. A genuine artistic concern with the common easily appears as an aspiration for authenticity, especially for an art world that puts a premium on the "primitive" and hungers for the exotic. The relative attention to and support of the self-taught Pippin at the expense of academically trained black artists reflects this establishmentarian abuse. This situation is captured by Richard J. Powell in his pioneering book, *Homecoming: The Art and Life of William H. Johnson*, when he discusses the response of Alain Locke and a local critic to Johnson's new "primitive" works in the summer of 1940 at the "Exhibition of the Art of the American Negro (1851–1940)" for the American Negro Exposition in Chicago:

> For both the reviewer in Chicago and Alain Locke, Johnson's flirtation with images and forms that suggested naiveté was symptomatic of the art world's then-current fascination with self-trained "daubbers," "scribblers," and "whittlers," whose creative lives had been spent (for the most part) outside of the art world proper. One of the most celebrated of these folk artists, black American painter Horace Pippin, worked in a somewhat similar manner to Johnson, with oil paints applied in a thick, impasto consistency, and visual narratives punctuated by strong, solid areas of pure color. Schooled and dedicated artists like Johnson must have felt a little envious of these self-taught painters such as Pippin who, in only a few years, had several museum and gallery exhibitions to their credit.
>
> As Johnson's past comments about primitivism and folk culture demonstrate, he acknowledged the innate power and spirituality that emanated from the art of common people and had decided to allow that part of his own folk heritage to assert itself in his work. Although no less eager to have his own work seen and appreciated, Johnson no doubt accepted the broad appeal of those folk artists then deservedly enjoying the art world's spotlight.5

This institutional dilemma regarding white reception of Pippin's work raises crucial issues about the trials and tribulations of being a black artist in America. In Pippin's case, being a self-taught black artist in America in the Emersonian tradition complicates the matter. On the one hand, a professional envy among highly trained black (and white) artists is understandable given the limited opportunities to be exhibited—and given the history of racist exclusion of black artists in the art world. On the other hand, the absence of professional training does not mean that there is no quality in Pippin's art. Even Alain Locke (fig. 25), the elitist dean of African-American art in mid-century America, described Pippin as "a real and rare genius, combining folk quality with artistic maturity so uniquely as almost to defy classification."6 Yet the complex relation of the racial *politics* of artistic visibility to the *quality* of visible artworks requires critical scrutiny. As James Clifford rightly notes:

> The fact that rather abruptly, in the space of a few decades, a large class of non-western artifacts came to be redefined as art is a taxonomic shift that requires critical historical discussion, not celebration.7

Clifford does not have Pippin in mind here—especially since his work was recognized as art by, for example, the inclusion of four of his paintings in a 1938

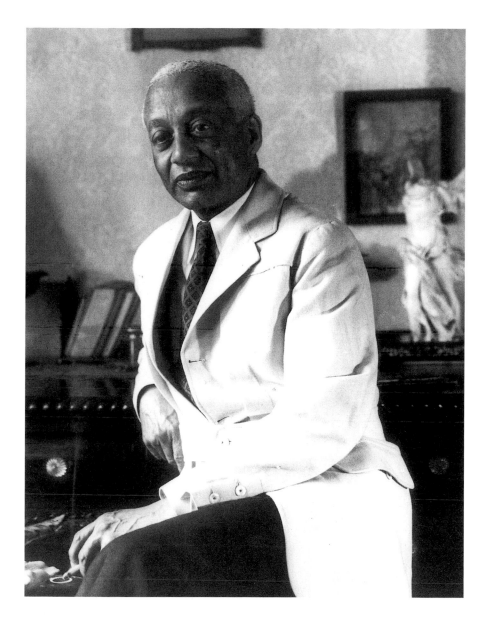

25 Photographer unknown. *Alain Locke* (1886–1954), undated. Silver gelatin print, 7 × 5 in. Moorland Spingarn Research Center, Howard University, Washington, D.C.

Museum of Modern Art exhibit called "Masters of Popular Painting."[8] But Pippin's works can easily be tarred with the brush of "primitivism," even "exoticism," so that it highlights his lack of schooling and his subject matter rather than the quality of his art. In her discussion of the "Primitivism" show at the Museum of Modern Art in 1984, Michele Wallace shows how these issues that surround the reception of Pippin's work remain alive in our time.

> Black criticism was blocked from the discussions of Modernism, which are defined as exclusively white by an intricate and insidious cooperation of art galleries, museums and academic art history, and also blocked from any discussion of "primitivism," which has been colonized beyond recognition in the space of the international and now global museum. At this juncture one is compelled to ask, "Is multiculturalism, as it is being institutionally defined, occupying the same space as 'primitivism' in relationship to Postmodernism?" For me, a response to such a question would need to include a careful scrutiny of the history of black popular culture and race relations, and

account for the sexualization of both, thus defining the perimeters of a new knowledge which I can only name, at this point, as the problem of the visual in Afro-American culture.[9]

Is a black artist like Pippin caught in a dilemma in which he may be excluded because he is black (and therefore "inferior") or may be included because he is black (and therefore "primitive")?

This question gets at the heart of what it is to be a black artist in America. It is to be caught in what I have called elsewhere "the modern Black problem of invisibility and namelessness."[10] This problem requires that black people search for validation and recognition in a culture in which white supremacist assaults on black intelligence, ability, beauty, and character circumscribe such a search. Pippin's example is instructive in that, unlike the other two celebrated mid-century black artists in this country, Richmond Barthé and Jacob Lawrence, Pippin lived and functioned outside the cosmopolitan art world. Like the early blues and jazz artists in American music, Pippin's art remained rooted in black folk culture yet also appealed to the culture industry of his day. He indeed gained significant validation and recognition from the white art establishment—but at what personal and artistic cost? Do all American artists in our market culture bear similar costs?

Unlike William H. Johnson and Beauford Delaney, Pippin did not go mad. But his wife did spend her last months in a mental institution after a breakdown. Pippin did drink heavily, but we do not know whether this was related directly to his art career. So in regard to the personal costs, our answer remains elusive. The artistic cost paid by Pippin is best summed up in this brief characterization of his career by a leading art historian in 1956:

> Horace Pippin (1888–1946), an unschooled Negro of West Chester, Pennsylvania, unfitted for labor by a war wound, turned to painting. "Pictures just come to my mind," he explained, "and I tell my heart to go ahead," an explanation of his innocent art which needs no further comment. His discovery and exploitation as a painter in 1937 did not change his art, although it was too much for him as a human being.[11]

This view of Pippin as an "innocent autodidact" chimes well with the black artist lacking sophistication and subtlety. We cannot deny the poignant simplicity of Pippin's art—yet simplicity is neither simplistic nor sophomoric. Rather, Pippin's burden of being a black artist in America required that he do battle with either primitivist designations or claims of the inferiority of his art. This struggle is best seen in the words of one of Pippin's black artistic contemporaries, William H. Johnson, quoted by Martin Puryear, the distinguished American abstract sculptor of African descent:

> I myself feel like a primitive man—like one who is at the same time both a primitive and a cultured painter.[12]

Feeling like a primitive and modern person and artist is one form of the black mode of being in a white-supremacist world, a world in which W. E. B. DuBois claimed that black people and artists are:

> Born with a veil, and gifted with second-sight in this American world—a world which yields him no true self-consciousness, but only lets him see himself through the revelation of the other world. It is a peculiar sensation, this dou-

ble-consciousness, this sense of always looking at one's self through the eyes of others, of measuring one's soul by the tape of a world that looks on in amused contempt and pity. One ever feels his twoness—an American, a Negro; two souls, two thoughts, two unreconciled strivings; two warring ideals in one dark body, whose dogged strength alone keeps it from being torn asunder.

The history of the American Negro is the history of this strife—this longing to attain self-conscious manhood, to merge his double self into a better and truer self. In this merging he wishes neither of the older selves to be lost. He would not Africanize America, for America has too much to teach the world and Africa. He would not bleach his Negro soul in a flood of white Americanism, for he knows that Negro blood has a message for the world. He simply wishes to make it possible for a man to be both a Negro and an American, without being cursed and spit upon by his fellows, without having the doors of Opportunity closed roughly in his face.[13]

This classic characterization of being black in xenophobic America means that black artists are always suspect for not measuring up to rigorous standards, or made to feel exotic in a white world that often associates blackness with bodily energy, visceral vitality, and sexual vibrancy. Pippin's art is a powerful expression of black spiritual strivings to attain self-conscious humanhood—to believe truly that one is fully human and to believe truly that whites can accept one's black humanity. This utopian endeavor indeed is crippled by black self-hatred and white contempt, yet the underlying fire that sustains it is not extinguished by them. Rather, this fire is fueled by the dogged fortitude of ordinary black folk who decide that if they cannot be truly free, they can, at least, be fully themselves. Pippin's art portrays black people as "fully themselves"—that is, as they are outside of the white normative gaze that requires elaborate masks and intricate posturing for black survival and sanity. This does not mean that behind the masks one finds the "real faces" of black folk or that beneath the posturing one sees the "true gestures" of black bodies. Instead, Pippin's art suggests that black people within the white normative gaze wear certain kinds of masks and enact particular kinds of postures, and that outside the white normative gaze black people wear other kind of masks and enact different sort of postures. In short, black people tend to behave differently when they are "outside the white world"—though how they behave within black spaces is shaped by their battles with self-hatred and white contempt.

Pippin's art reminds one of Sterling Brown's poetry or Bessie Smith's music in that all three artists rejected the two dominant models of black art in the *white* world at the time: black art as expressive of the "New Negro" and black art as protest. Instead, they built on the major paradigm of black art in the *black* world: black art as healing, soothing, yet humorously unsettling illuminations of what it means to be human in black skin in America.

Pippin's work appeared a decade or so after the celebrated Harlem Renaissance. This fascinating moment in black culture remains a highly contested one in regard to what it was and what it means. An artistic renaissance can be defined as a rebirth by means of recovering a classical heritage heretofore overlooked or ignored. Do the works of the major artists of the Harlem Renaissance—Countee Cullen, early Aaron Douglas, Jessie Fauset, Rudolf Fisher, Nella Larsen, Claude McKay, Wallace Thurman, and others—engage in such a recovery? I think not. Instead of serious and substantive attempts to recover the culturally hybrid heritage of black folk, we witness the cantankerous reportage of a black middle-class identity crisis. The Harlem Renaissance was not so much a genuine renaissance as it was a yearning for a renaissance which was aborted by its major artists owing to

their conscious distance from the very cultural creativity they desired. In this sense, the Harlem Renaissance was a self-serving construct concocted by rising black middle-class artistic figures to draw attention to their own anxieties over their individual and social identities and to acquire authority to impose their conceptions of legitimate forms of black cultural productions on black America.

The dominant theme of romanticizing the "primitivism" of poor black folk and showing how such "primitivism" fundamentally affects the plights and predicaments of refined and educated black middle-class individuals (Claude McKay's best-seller *Home to Harlem* is paradigmatic here) looms large in the Harlem Renaissance. This theme fits in well with the crisis in European and American civilization after World War I. The war was an end of a epoch—an epoch regulated by nineteenth-century illusions of the inevitable progress and perennial stability of emerging industrial societies. With the shattering of European self-confidence— as history began to be viewed no longer as a terrain for smooth amelioration but rather as a "nightmare" (Joyce) or "an immense panorama of futility and anarchy" (Eliot)—appetites for "primitivism" were whetted. With the rise of non-Western nations—Japan's victory over Russia (1905), revolutions in Persia (1905), Turkey (1907), Mexico (1911), China (1912)—ferocious nationalisms fueled machismo-driven myths of virility and vitality as seen in Woodrow Wilson's Fourteen Points and Vladimir Lenin's doctrine of national self-determination. The economic boom in the United States, facilitated by economic expansionism abroad (especially the takeover of Latin American markets from Britain after the war) and protectionism at home, ushered in mass communications (radio, phonograph, and talking film) and mass culture for the middle classes—a mass culture already saturated with black cultural products. The great talents of George Gershwin, Jerome Kern, Benny Goodman, and Paul Whiteman rest in large part on the undeniable genius of Louis Armstrong, Duke Ellington, Bessie Smith, and Ma Rainey. Lastly, the great migration of black people from the Jim and Jane Crow South to the industrial urban centers of the North produced not only social dislocation, cultural disorientation, and personal disillusionment, it also contributed to the makings of a massive political movement (Marcus Garvey's Universal Negro Improvement Association) and the refinement of the great black cultural renaissance actually taking place far away from most of the Harlem Renaissance artists and critics—the evolution of blues and jazz in New Orleans, St. Louis, Memphis, and Chicago.

Like its counterpart in France (the Negritude movement led by Leopold Senghor), the Harlem Renaissance conceived of black art as the refined expressions of the New Negro. In the exemplary text of the Harlem Renaissance, *The New Negro* (1925)— "its bible," as rightly noted by Arnold Rampersad[14]—black art is conceived to be the imposition of form on the rich substance of black folk culture. Influenced by the high modernisms of Europe and suspicious of art forms already operative in black folk culture (e.g., blues, dance, sermon, sports—none of which are examined in *The New Negro*!), Locke states:

> There is ample evidence of a New Negro in the latest phases of social change and progress, but still more in the internal world of the Negro mind and spirit. Here in the very heart of the folk-spirit are the essential forces, and folk interpretation is truly vital and representative only in terms of these.[15]

These "essential forces" of the folk are primitive, raw, coarse, and unrefined, and they require the skills of cultivated and educated artists to disclose them to the world. In the only essay on jazz in *The New Negro* by J. A. Rogers, Locke's aesthetic attitude is amplified:

Yet in spite of its present vices and vulgarizations, its sex informalities, its morally anarchic spirit, jazz has a popular mission to perform. Joy, after all, has a physical basis Moreover, jazz with its mocking disregard for formality is a leveller and makes for democracy. The jazz spirit, being primitive, demands more frankness and sincerity And so this new spirit of joy and spontaneity may itself play the role of reformer. Where at present it vulgarizes, with more wholesome growth in the future, it may on the contrary truly democratize. At all events, jazz is rejuvenation, a recharging of the batteries of civilization with primitive new vigor. It has come to stay, and they are wise, who instead of protesting against it, try to lift and divert it into nobler channels.[16]

For Rogers, jazz is not a distinct art form with its own integrity and cultivated artists. Instead, it is a primitive energy in search of political funnels that will expand American democracy. In fact, he claims that jazz is popular because, after the horrors of the war, "in its fresh joyousness men found a temporary forgetfulness, infinitely less harmful than drugs or alcohol."[17] Locke would not go this far in his therapeutic view of folk culture and his modernist conception of art, yet he and Rogers agree that popular culture is not a place where art resides; instead, it provides raw material for sophisticated artists (with university pedigrees and, usually, white patrons) to create expressions of the "New Negro."

Pippin's Emersonian sensibility rejects this highly influential view of black art—a view that shaped the crucial activities of the Harmon Foundation.[18] And although Locke recognized Pippin's genius in 1947, it is doubtful that he would have in 1925.[19] Like Sterling Brown or Bessie Smith, Pippin is less concerned about expressing the sense of being a "New Negro" and more focused on the artistic rendering of the extraordinariness of ordinary black folk then and now. The "New Negro" still seems too preoccupied with how black folk appear to the white normative gaze, too obsessed with showing white people how sophisticated they are (i.e., worthy of white validation and recognition). For Pippin, such validation and recognition is fine, yet only if it does not lead him to violate the integrity of his art or blind him to the rich experiences of ordinary black folk while trying to peddle "the black experience" to white America.

The next dominant conception of black art as protest emerged after the Harlem Renaissance collapsed, principally owing to the Depression. The great black literary artwork of protest was Richard Wright's *Native Son*. This conception of black art displaced the sophisticated and cultivated New Negro with the outraged and angry Mad Negro. Gone were the attempts to distance oneself from the uncouth, "primitive" black masses. In place of the sentimental journeys behind the veil to see how black folk live, we got the pervasive physical and psychic violence of black life turned outward to white America.

The irony of the view of black art as protest—as description of the inhumane circumstances of much of black life and as heartfelt resistance to these circumstances—is that it is still preoccupied with the white normative gaze, and it reduces black people to mere reactors to white power. Pippin's *Mr. Prejudice* (1943) contains protest elements, yet it refuses to view the multilayered character of black life as a reaction to the sick dictates of xenophobic America. Pippin's Emersonian orientation refuses to cast art as a primary agent for social change or a central medium for protest even when he shares the values of those seeking such change or promoting such protest. This kind of redemptive culturalism—the notion that culture can yield political liberation—flies in the face of Pippin's view of black art as those ritualistic activities that heal and soothe, generate laughter and unsettle dogmas with such style and form that they constitute black ways of being human. To

pursue such a conception of black art in a white world obsessed with black incapacities and atavistic proclivities means to run the risk of falling into the traps of "primitivism."

Nearly fifty years after his death, Pippin's art still reminds us of how far we have *not* come in creating new languages and frameworks that do justice to his work, account for his narrow reception, and point to the risks he took and the costs he paid. This Horace Pippin exhibition, as courageously and meticulously mounted by the Pennsylvania Academy of the Fine Arts, once again forces art criticism both to re-examine its verdict on Horace Pippin and to find the means to reconceive and reform the art world as we know it.

CORNEL WEST is Professor of Religion and Director of the Afro-American Studies Department at Princeton University, New Jersey.

1. John Dewey, *Art as Experience* (1934), in *Later Works*, ed. Jo Ann Boydston (Carbondale: Southern Illinois University Press), vol. 10, p. 278.

2. Ralph Waldo Emerson, "The American Scholar," in *Selected Writings of Ralph Waldo Emerson*, ed. William H. Gilman (New York: New American Library, 1965), p. 239.

3. Dewey, *Art as Experience*, pp. 10–11.

4. Ralph Waldo Emerson, *Emerson in His Journals*, selected and edited by Joel Porte (Cambridge: Harvard University Press, 1982), p. 136.

5. Richard J. Powell, *Homecoming: The Art and Life of William H. Johnson*, exh. cat. (Washington, D.C.: Smithsonian Institution, 1991), p. 138.

6. Alain Locke, "Horace Pippin, 1888–1946," *Horace Pippin Memorial Exhibition*, exh. cat. (Philadelphia: The Art Alliance, 1947), u.p.

7. James Clifford, *The Predicament of Culture: Twentieth Century Ethnography, Literature and Art* (Cambridge: Harvard University Press, 1986), p. 196.

8. Samella Lewis, *Art: African American* (New York: Harcourt Brace Jovanovich, 1978), pp. 105–106.

9. Michele Wallace, "Modernism, Postmodernism and the Problem of the Visual in Afro-American Culture," in *Out There: Marginalization and Contemporary Cultures*, eds. Russell Ferguson, Martha Gever, Trinh T. Minh-Ha, Cornel West (Cambridge: MIT Press, 1990), pp. 47–48.

10. Cornel West, "The Cultural Politics of Difference," in *Out There*, p. 26.

11. E. P. Richardson, *Painting in America: The Story of 450 Years* (New York: Thomas Y. Crowell Co., 1956), p. 389.

12. Martin Puryear, "Introduction" to Powell, *Homecoming*, p. XIX.

13. W. E. B. DuBois, *The Souls of Black Folk* [1903] (New York: Penguin Books, 1989), introduction by Donald B. Gibson, p. 5.

14. Arnold Rampersad, "Introduction" to *The New Negro*, ed. Alain Locke (New York: Atheneum, 1991), p. IX.

15. Alain Locke, "Foreword" to *The New Negro*, p. XXV.

16. J. A. Rogers, "Jazz at Home," in *The New Negro*, pp. 223–234.

17. *Ibid.*, pp. 222–223.

18. For Alain Locke's influence on the intellectual framework that shaped the practices of the William E. Harmon awards for distinguished achievement among Negroes and the 1928 to 1933 annual Harmon Foundation exhibitions, see the fine essay by Beryl J. Wright, "The Harmon Foundation in Context: Early Exhibitions and Alain Locke's Concept of a Racial Idiom of Expression," in *Against the Odds: African American Artists and the Harmon Foundation*, eds. Gary A. Reynolds and Beryl J. Wright, exh. cat. (Newark, N.J.: The Newark Museum, 1989), pp. 13–25. Leslie Bolling was the only "folk artist"—with no formal training (though he did attend Hampton Institute and Virginia Union University)—who exhibited with the Harmon Foundation.

19. For Locke's complex development as an art critic—especially his modernist views of African and Afro-American art, see his *Negro Art: Past and Present* (Albany, N.Y.: The Associates in Negro Folk Education, The J. B. Lyon Press, 1936). See especially his discussion of the notion of the "primitives" in African and European art, pp. 93–116.

II

THE ART IN CONTEXT

Scenes of War

JUDITH WILSON

DURING THE FIRST WORLD WAR and, again, during the Second, African Americans fought a war-within-the-war. This struggle for racial equality is a subtext of the group of works in which Horace Pippin recorded his memories of combat in Europe during World War I and imagined scenes from World War II. In two commissioned canvases from the 1940s, his *Mr. Prejudice* (1943) and *Deep Are the Roots* (1945), the contradictions inherent in black service in defense of a racist society surface as primary themes. Such concerns are not surprising, given Pippin's own military experience.

Between August 1914 and November 1918, ten million Europeans died in battle. By early 1917, food shortages in England and Russia seemed to threaten famine, while exhausted French troops began to mutiny.[1] The United States resisted Allied pleas and German provocation until April, when Woodrow Wilson finally urged Congress to declare war against Germany. "The world must be made safe for democracy," Wilson explained. The troops of this self-appointed guardian of international democracy would be racially segregated, however.

Twenty-nine-year-old Horace Pippin was an iron molder at the American Brakeshoe Company in Mahwah, New Jersey in spring 1917, when he gave his employer two weeks notice and enlisted in what was soon to be one of the war's most celebrated combat units, the 15th Regiment of the New York National Guard, a black infantry outfit (fig. 27).[2] By mid-July, the regiment was posted "about ten miles East [sic] of the Hudson River and of Poughkeepsie" at New York's Camp Whitman.[3] Then a battalion was sent to Wrightstown, New Jersey in order to build Camp Dix,[4] where Pippin was made a corporal. In October, the men of the 15th New York were stationed at Camp Wadsworth in Spartanburg, South Carolina, where their scheduled three-month-long training was sharply curtailed by local white hostility. During their brief stay at Camp Wadsworth, the black Northerners were refused service at many Spartanburg shops, and one of their officers—a Harvard-educated black attorney—was forcibly ejected from a streetcar.

On October 22, a near-riot was sparked when the owner of a local hotel assaulted the regiment's drum major, Noble Sissle.[5] In a clash of military etiquette with Southern mores, Sissle had declined to remove his field cap on entering the white establishment. The proprietor's response was to knock the cap off, then kick Sissle when he stooped to recover his headgear. Only the intervention of the regiment's famed bandleader, James Reese Europe (fig. 28),[6] prevented a group of outraged black servicemen from "rush[ing] the hotel" in retaliation. To dampen the now explosive situation at Spartanburg, the War Department ordered the regiment

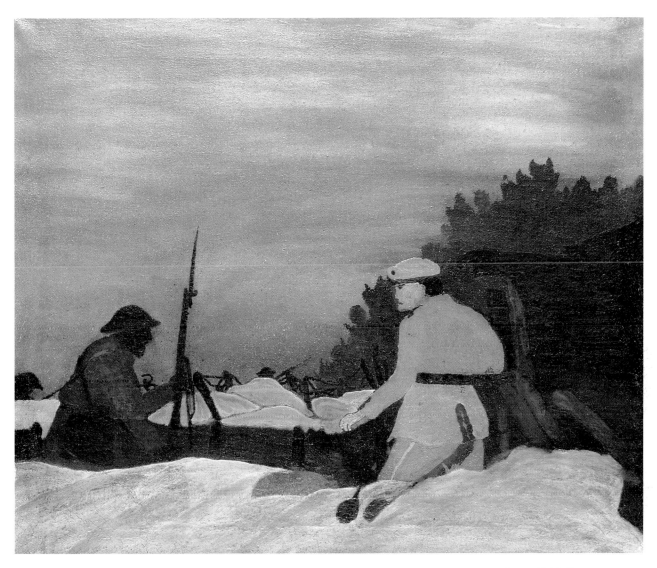

26 *Outpost Raid: Champagne Sector*, 1931. Oil on fabric, 18 × 21¼ in. Collection Maurice C. and Patricia L. Thompson

north. On November 12, after only two weeks training, the men of the 15th New York sailed for France from Hoboken, New Jersey on the *Pocahontas*.

Like so much else allotted to the nation's black troops, the *Pocahontas* was in deplorable condition.[7] One day out to sea, the dilapidated vessel was forced back to port for repairs. Under way again a few weeks later, a coal-bin fire returned the ship to Hoboken again. Putting to sea again in early December, the ship sustained further damage from a collision. As a result, two days after Christmas—over a month after its initial departure—Pippin's unit arrived in France and became the 369th Infantry Regiment. From Brest, a port on the Breton coast, the 369th Regiment traveled southeast by rail to St. Nazaire, near the mouth of the Loire, off the Bay of Biscay. There, American reluctance to assign blacks to combat duty kept the unit behind the lines for several weeks unloading ships and building roads.[8] Despite this inglorious start, Horace Pippin and his fellow members of the 369th eventually achieved an illustrious combat record.

The first U.S. soldier to be awarded France's Croix de Guerre was a member of the 369th.[9] Attached to the French Army in order to avoid placing black combat troops under U.S. Army command, the 369th Regiment was the first Allied unit to reach the Rhine. And because it was the first American regiment commanded

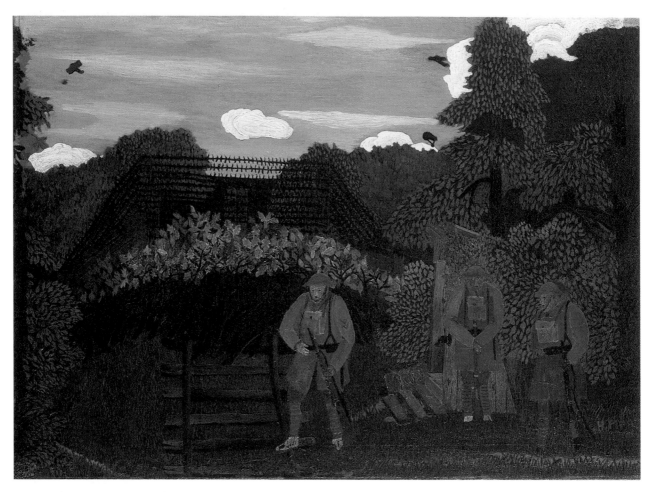

31 *Gas Alarm Outpost: Argonne*,
1931. Oil on fabric, 22 × 30 in.
Photograph courtesy Terry
Dintenfass, Inc., New York

32 Photographer unknown. *Sentry
box, warning horn for gas attack,
and camouflage gate, Bois d' Hauzy,
May 4, 1918.* National Archives,
Washington, D.C. (165-WW-127-26)

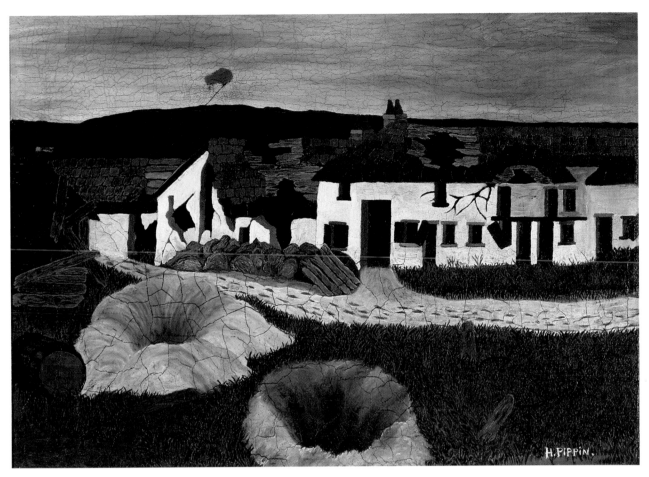

33 *Shell Holes and Observation Balloon: Champagne Sector*, 1931. Oil on fabric, 22½ × 30⅞ in. The Baltimore Museum of Art, Gift of Mrs. John Merryman, Jr. (1967.48)

achieve vivid contrasts of tone or temperature despite their somber hues. In *The End of the War*, however, sculptural qualities are stressed—a fact underscored by the painting's carved frame, which is unique in the artist's repertoire.

A medley of combat implements appears in relief on the frame's four sides. The central emblem at top and bottom is an armored tank, flanked on both sides by a bayonet and a rifle. At the top, a hand grenade and a British steel helmet are positioned at far left and right, while a pair of what could be either rifle grenades or bombs is stationed at far left and right at the bottom.[19] At the center of the frame's two sidebars, a German (Prussian or Bavarian) infantry helmet appears at left facing a French infantry helmet at right, each sandwiched between a pair of hand grenades.[20] The specificity of Pippin's rendition of these objects operates like the brown skins of the Allied troops, lending a documentary flavor to the imagined scene.

His paintings from the Second World War are different. Unlike any of his images of the previous war, *A Tribute to Stalingrad* (fig. 37), a commissioned painting, focuses on the figures of a weeping mother and three children to symbolize a battle so fierce that civilians joined the Red Army in "a desperate block-by-block and house-by-house defense" against Nazi forces whose sustained artillery bombardment eventually reduced much of the city to rubble.[21] The historical accuracy of Pippin's World War I paintings is replaced by rhetorical symbolism in *Mr. Prejudice* (fig. 38), a work that addresses the threat to wartime unity posed by the persistence of racial segregation in the United States. The painting's array of iconic figures include Miss Liberty; a Klansman; the grim-faced Mr. Prejudice, who

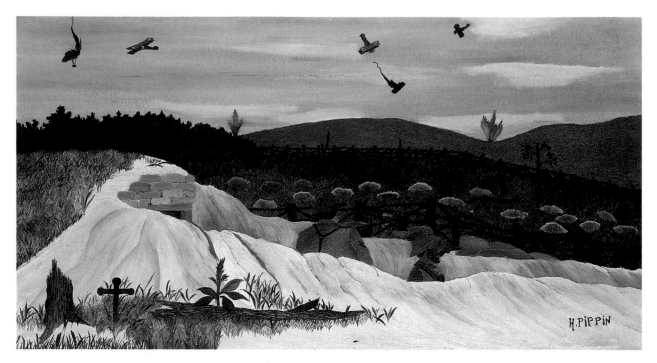

34 *Dog Fight Over Trenches*, 1935. Oil on fabric, 18 × 33⅛ in. Hirshhorn Museum and Sculpture Garden, Smithsonian Institution, Washington, D.C., Gift of Joseph H. Hirshhorn, 1966 (66.4071)

35 Photographer unknown. *Captain Winston, Lt. Lockhard and men outside dugout, signal rockets on left, May 4, 1918.* U.S. Army Military History Institute, Carlisle, Pennsylvania

drives a wedge into the giant victory "V" that floats at the center of the canvas; and a cluster of black and white laborers and servicemen—among them a black soldier whose lower legs are anachronistically swathed in World War I puttees!

The armed forces remained segregated throughout the Second World War.[22] Segregation extended to war industries, which often refused to employ blacks in anything but menial positions, as well as to the Red Cross's government-approved policy of keeping black and white blood donations separate.[23] As a result, attempts to mobilize black support for the war met with "widespread indifference, even hos-

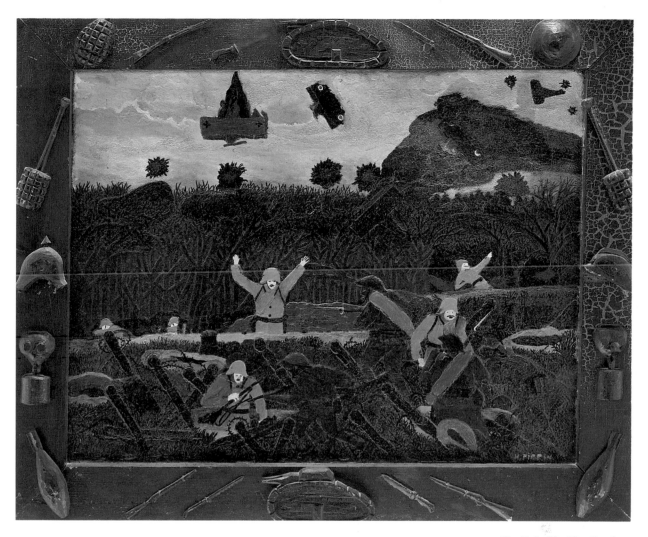

36 *The End of the War: Starting Home*, c. 1930. Oil on fabric, 25 × 32 in. Philadelphia Museum of Art, Given by Robert Carlen (41-2-1)

tility."[24] Speaking to a Midwestern black audience of several thousand, NAACP head Walter White repeated a black college student's question, "We are disenfranchised, jim-crowed, spat upon—what more could Hitler do than that?" To White's astonishment, the student's query stirred a thunderous burst of applause.[25]

Pippin's final treatment of the war theme occurs in a 1945 canvas entitled *Deep Are the Roots*, a work commissioned but not used by producer George Heller for the poster advertising the play of the same name.[26] Rather than a depiction of wartime events like *A Tribute to Stalingrad* or of war-related issues like *Mr. Prejudice*, in *Deep Are the Roots* (fig. 39) the subject is postwar race relations as they were represented in a controversial melodrama that played to packed houses in New York. *Deep Are the Roots*—a topical drama in three-acts, written by Arnaud d'Usseau and James Gow, and directed by Elia Kazan—had opened in New York on September 26, 1945.[27] During its fourteen-month Broadway run, the play garnered mixed reviews, but won the New York Newspaper Guild's Page One Award for "its courageous stand on a vital American subject."[28]

The plot pitted the aspirations of a returning black veteran, an officer decorated for his heroism, against the entrenched prejudices of the Old South. Smoldering tensions explode when the elder daughter of a bigoted ex-senator discovers her younger sister and the black veteran are in love. In the end, the aged paterfamilias is defeated and bitterly "wanders off, apparently to join the Klan," while his

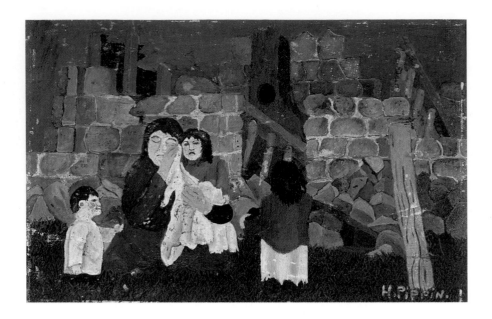

37 *A Tribute to Stalingrad*, 1942. (Also known as *The Refugees*). Oil on canvas board, 8½ × 12 in. Private collection

elder daughter gains "a new perspective on racial equality."[29] The would-be lovers part, conceding that an interracial marriage would only add to their problems, leaving them trapped on "an island" in a sea of hate.[30]

Pippin may have seen *Deep Are the Roots* during its two-week tryout in Philadelphia. Although he has simplified many elements—changing the elaborate, arched central entryway with its attached columns and entablature to a simple rectangular doorway framed by a pair of drapes, for example—Pippin's composition mirrors the general layout of the stage set (fig. 40). The uniformed lieutenant stands framed in the central doorway facing a pair of white men—the former senator seated at far right and a standing figure, probably the Northern liberal novelist who is the elder daughter's fiancé. The female who stands at left might be either of the two sisters. Unusually static for Pippin, the composition does not clearly announce its theme. Only knowledge of the play that furnishes its title helps unravel some of the painting's mysteries.

Nevertheless, when *Deep Are the Roots* is linked to the artist's previous images of black soldiers—*The End of the War* and *Mr. Prejudice*—an aggregate theme emerges. While Pippin's other war-related scenes record the Great War's murderous innovations, these paintings assert the vital role of African Americans in national defense. In doing so, however, the artist shifts from a documentary to a protest mode during the 1940s—a move that suggests his belated awareness of social realism.[31] Thus, he indicates the presence of black troops at the Armistice in *The End of the War*, a work from the early 1930s, but he depicts none of the discriminatory treatment he and his fellow black combatants had experienced throughout the war. In contrast, both *Mr. Prejudice* and *Deep Are the Roots* point to the persistence of segregation in U.S. military and civilian life two decades after outfits like the 15th New York proved itself in battle. Such mordant commentary is implicit, too, in *Barracks* (fig. 41) and its study (fig. 42), images that reveal the segregated character of World War II military quarters. Ultimately, then, Pippin's thirties canvases on the war theme describe the violence of modern warfare, while his forties war-related canvases condemn the hypocrisy of a segregated nation playing the role of international guardian of freedom.

JUDITH WILSON is Assistant Professor of Art History, McIntire Department of Art, at the University of Virginia, Charlottesville.

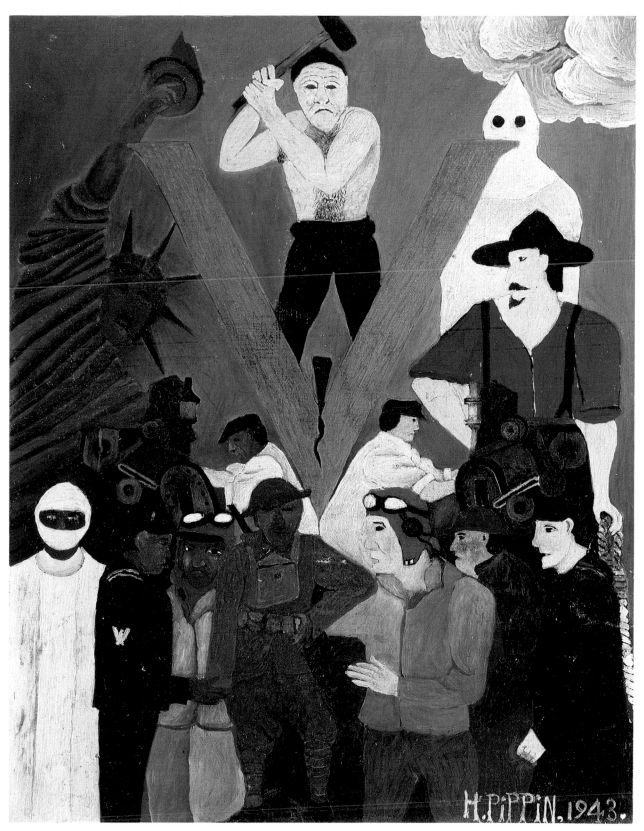

38 *Mr. Prejudice*, 1943. Oil on fabric, 18 × 14 in.
Philadelphia Museum of Art, Gift of Dr. and Mrs.
Matthew T. Moore (1984.108.1)

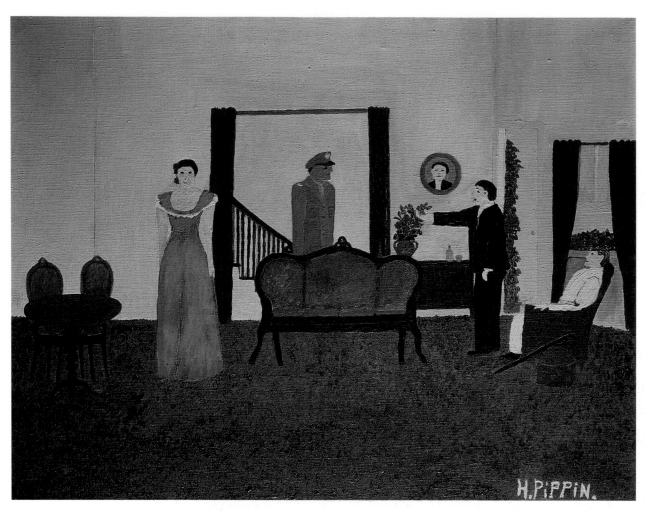

39 *Deep Are the Roots*, 1945.
Oil on fabric, 24 × 30 in. Photograph
courtesy Andrew Crispo

40 Photographer unknown. *Stage
set from "Deep Are the Roots."* From
Life magazine, October 15, 1945

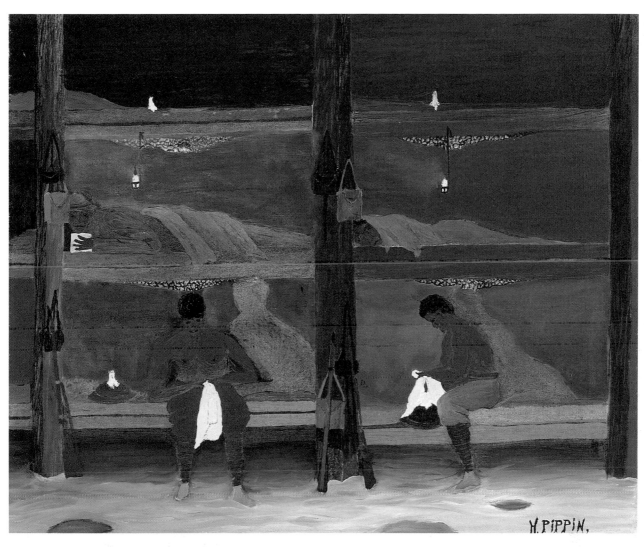

41 *Barracks*, 1945. Oil on fabric,
25¼ × 30 in. The Phillips Collection,
Washington, D.C. (1572)

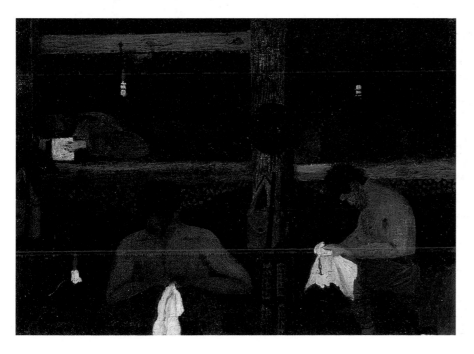

42 *Study for "Barracks,"* 1945.
Oil on canvas board, 9 × 12 in.
Collection Mr. and Mrs. Daniel W.
Dietrich II

NOTES

1. War-related deaths by starvation and disease would eventually reach approximately 20 million. Fritz Stern, "World War I," in *The Columbia History of the World*, eds. John A. Garraty and Peter Gay (New York: Harper & Row, 1981), pp. 983, 990–992. Howard Zinn, *A People's History of the United States* (New York: Harper & Row, 1980), p. 351.

2. Horace Pippin, "My Life's Story," *Three Self-Taught Pennsylvania Artists: Hicks, Kane, Pippin*, exh. cat. (Pittsburgh: Museum of Art, Carnegie Institute, 1966), u.p.

3. Arthur W. Little, *From Harlem to the Rhine: The Story of New York's Colored Volunteers* (New York: Covici Friede, 1936), p. 30. Arthur Little was a white officer of the 15th Infantry.

4. *Ibid.*, p. 42.

5. Four years later, Sissle and Eubie Blake would produce the score for *Shuffle Along*, the Broadway musical said to have ushered in the Harlem Renaissance. Nathan Irvin Huggins, *Harlem Renaissance* (New York: Oxford University Press, 1971), p. 289.

6. Musical director of several successful black shows during the 1900s, Europe had founded the Clef Club in 1910 to promote and professionalize black musicians. As conductor of the Clef Club Orchestra, which performed at Carnegie Hall in 1912, Europe almost single-handedly raised the status of black music. His polished blues and mildly syncopated renditions of standard marches and concert fare anticipated the flow of jazz into the musical mainstream during the big-band era. Desmond Arthur, "James Reese Europe," in *The Harlem Renaissance: A Historical Dictionary for the Era*, ed. Bruce Kellner (New York: Methuen, 1987), p. 117. Marshall W. Stearns, *The Story of Jazz* (New York: Oxford University Press, 1970), p. 161.

7. Unlike those in the 15th New York, the vast majority of blacks during World War I—over 88 percent—served in noncombat roles as laborers and stevedores. They were often clothed in discards, and "at one camp black soldiers were issued Civil War uniforms." They were ill-housed, and their tents lacked stoves and floors. Numerous freezing deaths were reported at Virginia's Camp Alexander during the unusually harsh winter of 1917–18. Jack D. Foner, *Blacks in the Military in American History* (New York: Praeger, 1974), p. 119.

8. John Hope Franklin, *From Slavery to Freedom: A History of Negro Americans*, 3rd ed. (New York: Vintage, 1969), pp. 460–461. Foner, *Blacks in the Military*, p. 120. Pippin, "My Life's Story," u.p. James Weldon Johnson, *Black Manhattan* (New York: Atheneum, 1972 [orig. 1930]), p. 234.

9. Franklin, *Slavery to Freedom*, p. 235.

10. Huggins, *Harlem Renaissance*, pp. 54–55. Lack of segregated r. & r. facilities was a further reason for the 369th's lengthy stay at the front. Arthur Barbeau and Florette Henry, *The Unknown Soldier* (Philadelphia: Temple University Press, 1974), pp. 135–36.

11. Franklin, *Slavery to Freedom*, p. 462. Johnson, *Black Manhattan*, p. 235.

12. Pippin, "My Life's Story," u.p.

13. David Eggenberger, *An Encyclopedia of Battles* (New York: Dover, 1985), p. 460. Stern, "World War I," p. 984.

14. Pippin, "My Life's Story," u.p.

15. *The End of the War* has been erroneously labeled Pippin's first painting. Apparently, it was his first work *on canvas*. But it was preceded by several paintings of outdoor scenes on wood panel, such as *Losing the Way* (1930) and the two versions of *The Bear Hunt* (both 1930). In a 1966 essay Leon Anthony Arkus writes, "Horace Pippin was forty-three years old when he completed his first painting, *The End of War: Starting Home*." Arkus, "Horace Pippin," *Three Self-Taught Pennsylvania Artists*, u.p.

The probable source of confusion about this is a statement by Pippin. The catalogue for the Museum of Modern Art's 1938 show "Masters of Popular Painting" quotes "a brief note" in which the artist mentions "the picture called *The Ending of the War, Starting Home* which was my first picture." Pippin quoted in Dorothy C. Miller, "Horace Pippin," *Masters of Popular Painting: Modern Primitives of Europe and America*, exh. cat. (New York: Museum of Modern Art, 1938), p. 126.

16. He had arrived at Brest on December 27, 1917 and departed from there on December 26, 1918. Pippin, "My Life's Story," u.p. Stern, "World War I," p. 991.

17. Selden Rodman, "Horace Pippin 1888–1946," in *American Folk Painters of Three Centuries*, eds. Jean Lipman and Tom Armstrong (New York: Hudson Hills Press in association with the Whitney Museum of American Art, 1980), p. 216.

18. Rudolf Arnheim, *Art and Visual Perception: A Psychology of the Creative Eye*, rev. ed. (Berkeley: University of California Press, 1974), p. 335.

19. Peter Young, ed., *The Marshall Cavendish Illustrated Encyclopedia of World War I*, vol. 7: 1916–17 (New York: Marshall Cavendish, 1984), p. 2006. These steel helmets were also worn by American infantrymen in the European theater.

20. *Ibid.*, vol. 3, p. 755. Guido Rosignoli, "The First World War and the Restless Peace 1914–1939," in *Battledress: The Uniform of the World's Great Armies 1700 to the Present*, ed. I. T. Schick (Boston: Little, Brown, 1978), pp. 202, 206. John Quick, *Dictionary of Weapons and Military Terms* (New York: McGraw-Hill, 1973), pp. 203, 373.

21. Eggenberger, *Encyclopedia of Battles*, p. 417. According to Selden Rodman, *Horace Pippin: A Negro Painter in America* (New York: Quadrangle Press, 1947), p. 4, this was a commissioned work; unfortunately, the circumstances of the commission are today unknown.

22. Desegregation of the military would not begin until mandated by a 1948 executive order issued by President Truman. According to historian Howard Zinn, the process "took over a decade to complete." Zinn, *A People's History*, p. 441.

23. *Ibid.*, pp. 406–407.

24. *Ibid.*, p. 410.

25. *Ibid.*

26. See the letter from George Heller to Robert Carlen (Oct. 18, 1945, Robert Carlen Gallery Papers, Archives of American Art, Smithsonian Institution, Washington, D.C.) in which Heller encloses a $150 payment for the painting but expresses his regret that they were unable to use it because "the consensus of opinion seemed to be that it would not adapt itself for use as a poster."

27. An article in *Life* labeled the drama "one of the most controversial plays to reach Broadway in years." Unsigned, "Theater: 'Deep Are the Roots'—Negro Hero Returns to the South," *Life*, October 15, 1945. Arnaud d'Usseau and James Gow, "Manufacturing a Problem Play," *The New York Times*, October 14, 1945. "In Last Four Weeks," *The New York Times*, October 22, 1946. Lewis Nichols, "The Play," *The New York Times*, September 27, 1945.

28. See, for example, reviews in *Life*, October 15, 1945, pp. 51–52, 54; Wolcott Gibbs, "What They Say About Dixie," *The New Yorker*, October 6, 1945; Nichols, "The Play," p. 24; "News Guild Honors Play," *The New York Times*, October 25, 1945.

29. Gibbs, "What They Say About Dixie," pp. 46–48.

30. Nichols, "The Play," p. 24.

31. It seems likely that this awareness was enhanced, if not induced, by Pippin's association with Edith Halpert's Downtown Gallery, which began with his participation in the 1941 show "American Negro Art, 19th and 20th Centuries." Encompassing a wide range of American modernists, the Halpert stable included two very prominent Social Realists, Ben Shahn and Jacob Lawrence. Ellen Harkins Wheat, *Jacob Lawrence: American Painter* (Seattle: University of Washington Press, 1986), pp. 64–65.

Re-Creating American History

RICHARD J. POWELL

HORACE PIPPIN'S PAINTINGS of historical subject matter comprise seven works dealing with two noted nineteenth-century American political figures: Abraham Lincoln (1809–1865) and John Brown (1800–1859). Lincoln (fig. 43), the sixteenth president of the United States, and Brown (fig. 44), an outspoken opponent of slavery, epitomize two ideological extremes of white American sympathy for the plight of thousands of enslaved and disenfranchised black Americans in the years just prior to and during the Civil War. Lincoln, the author of the Emancipation Proclamation, is a symbol to most Americans of government-generated benevolence and good will toward blacks. Brown, the messianic white leader of an unsuccessful 1859 black rebellion at Harpers Ferry, in what is now West Virginia, reminds us that it was possible not only to express moral outrage at the enslavement of blacks but to transform that outrage into deliberate, forceful retribution.

Although rarely paired in the way that Horace Pippin has situated them in his work, Abraham Lincoln and John Brown frequently appear in popular literature as the twin *saviours* of black Americans: Lincoln, the champion of emancipation and the spiritual father of the Reconstruction, and Brown, the patriarch of an *any-means-necessary* style of self-liberation and the progenitor of a righteous, morally grounded position on social change. With Lincoln as the "good cop" and Brown as the "bad cop" of the antislavery movement, the two often form in the minds of many people an odd, if not diametrically-opposed, partnership.[1]

Horace Pippin's interest in painting historical narratives was not unique in American art. Many artists, prior to and during Pippin's era, incorporated historical narratives into their work, often in the service of the prevailing realist agendas of their times. From Emanuel Leutze's paintings and murals in the mid-nineteenth century, to the picture book-like, historical narratives by Edwin Blashfield, Howard Pyle, and N.C. Wyeth in the late nineteenth and early twentieth centuries, representational renderings of American patriots, historical events, and renowned deeds have figured prominently in American art. Two of the better known government-sponsored artworks which, coincidentally, also portray Abraham Lincoln and John Brown, are Daniel Chester French's *Lincoln Memorial* (1915) for the nation's capital and John Steuart Curry's John Brown detail in *The Tragic Prelude* mural (1937-1942) for the Kansas Statehouse (fig. 45).[2] The Federal Arts Projects of the 1930s and early 1940s, mostly under the auspices of the Works Progress Administration, encouraged artists to create works that, apart from having an aesthetic appeal, provided audiences with pictorial history lessons. In easel paintings, murals, and outdoor, public sculptures, artists often created works that included local and national history, illuminations of significant American events, and as seen in Pippin's paintings, representations of famous historical figures.

Above, left

43 Samuel M. Fassett (active 1855–1875). *Abraham Lincoln* (1809–1865), 1859. Salt print, 7¼ × 5¼ in. National Portrait Gallery, Smithsonian Institution, Washington, D.C. (NPG.77.265)

Above

44 James Wallace Black (1825–1896). *John Brown* (1800–1859), 1859. Albumen silver print after daguerreotype attributed to Martin M. Lawrence, 8½ × 6 in. National Portrait Gallery, Smithsonian Institution, Washington, D.C. (NPG.74.76)

Pippin's interest in the historical narrative was also part of a collective, loosely consolidated historicizing movement within the black community. Black organizations of the 1930s and 1940s, like the Association for the Study of Negro Life and History, inaugurated numerous "Negro History" projects during this time, ranging from scholarly publications to community "outreach" programs. A survey of African-American life in this period reveals a flurry of historical enterprises: "Negro History" pageants at all-black churches and public schools; historical profiles of famous black Americans, presented in the form of cartoons in numerous African-American newspapers; and several, large-scale, "Negro" exhibitions and expositions, the most noteworthy in Dallas (1936), Baltimore (1939), and Chicago (1940). (Incidentally, the Chicago "Exhibition of the Art of the American Negro, 1851–1940," was one in which Pippin's work was included). The focus for much of this retrieval of history within the black community was the anticipation in 1940 of the seventy-fifth anniversary of the proclamation of the Thirteenth Amendment to the Constitution, the amendment that abolished slavery in the United States.3

With the Thirteenth Amendment as the centerpiece for these historical pursuits within the black community, it is no surprise that Horace Pippin, as well as other blacks, invested substantial energy into commemorating the lives and images of the Amendment's two philosophical architects: Abraham Lincoln and John Brown. Pippin's paintings of Lincoln and Brown join related works by African-American artists of the period, painters like Palmer C. Hayden, who included a portrait of Lincoln in the first version of his painting *The Janitor Who Paints* (1937); Jacob Lawrence, who incorporated images of Lincoln in his Frederick Douglass series (1938) and created a twenty-two panel series on the life and times of John Brown (fig. 46); and William H. Johnson, who produced narrative paintings throughout the early 1940s of both Lincoln and Brown (fig. 47).4 Like the calendar chromoliths of President John Fitzgerald Kennedy, the Reverend

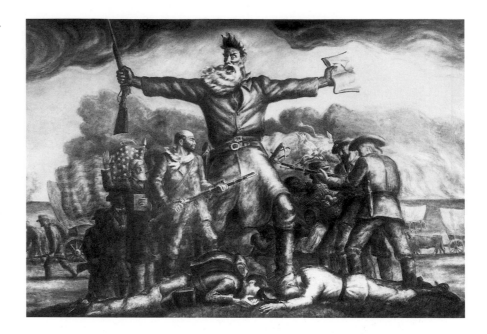

45 John Steuart Curry (1897–1946). Detail of *The Tragic Prelude*, 1937–42. Mural at Kansas Statehouse. Kansas State Historical Society, Topeka

46 Jacob Lawrence (1917–). *John Brown, after a long medita-tion, planned to fortify himself somewhere in the mountains of Virginia or Tennessee and there make raids on the surrounding plantations, freeing slaves*, 1946. Gouache on paper, 13⅝ × 19¾ in. Detroit Institute of Arts, Gift of Mr. and Mrs. Milton Lowenthal (55.354.13)

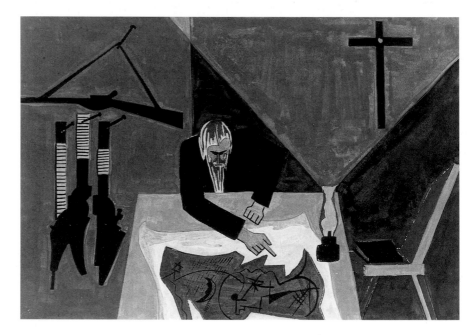

Dr. Martin Luther King, Jr., and Senator Robert F. Kennedy in the homes of many black folk during the 1960s and 1970s, reproductions of Abraham Lincoln's stoic fea-tures (figs. 48, 49) and of John Brown kissing a black baby on his way to the executioner's gallows (fig. 50) graced mantlepieces and living room walls of countless African-Amer-icans from the late nineteenth century through the Depression years.

Pippin, rather than concentrating on Abraham Lincoln's well-known physiognomy, turned his attention in two of his four Abraham Lincoln paintings to the apocryphal sto-ries and settings of Lincoln's youth. In *Abraham Lincoln and His Father Building Their Cabin on Pigeon Creek* (fig. 51), the two subjects of Pippin's painting are curiously over-shadowed by a partially built log cabin in the middleground, a foreground of tree stumps and cut-down tree trunks, and a heavily painted background of cloudy skies and a thick autumn forest. Similarly, in *Abe Lincoln's First Book* (fig. 52), Pippin surrounded the

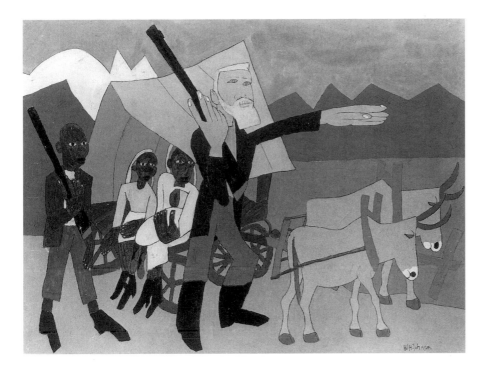

47 William H. Johnson
(1901–1970). *John Brown (or) On A
John Brown Flight*, c. 1940. Gouache
and pencil on paper, 17⅞ × 20⅞ in.
National Museum of American Art,
Smithsonian Institution,
Washington, D.C., Gift of the
Harmon Foundation (1967.59.1148)

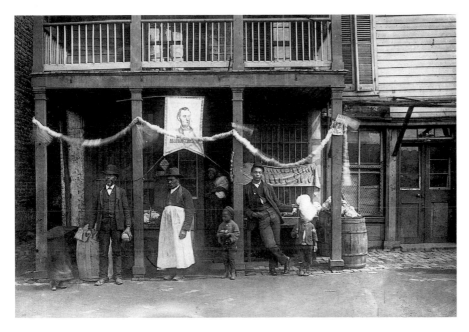

48 George Cook (1819–1902) or
Heustis P. Cook (1868–1951).
*Emancipation Day Celebration,
Richmond, Virginia, April 1888*. Print
from glass-plate negative, 5 × 8 in.
The Valentine Museum, Richmond,
Virginia, Cook Collection (1388)

white upper torso of Lincoln in a black, barely perceptible log cabin interior of modest furnishings and vernacular designs. Pippin, with the Lincoln narrative ever present in his mind, seemed intent in these two history paintings on not only telling a story of youthful industry and earnestness but also creating environments for these characterizations that bury the narratives in dense, theatrical settings.

In *Abe Lincoln, The Great Emancipator* (fig. 53) and *Abe Lincoln, The Good Samaritan* (fig. 54), Pippin created more familiar portraits of Lincoln, representations that convey his legendary generosity and magnanimity in easily read body gestures. However, missing from these two works—as well as from the other two Lincoln paintings—are any references to the principal objects of Lincoln's legislative benevolence, namely, black

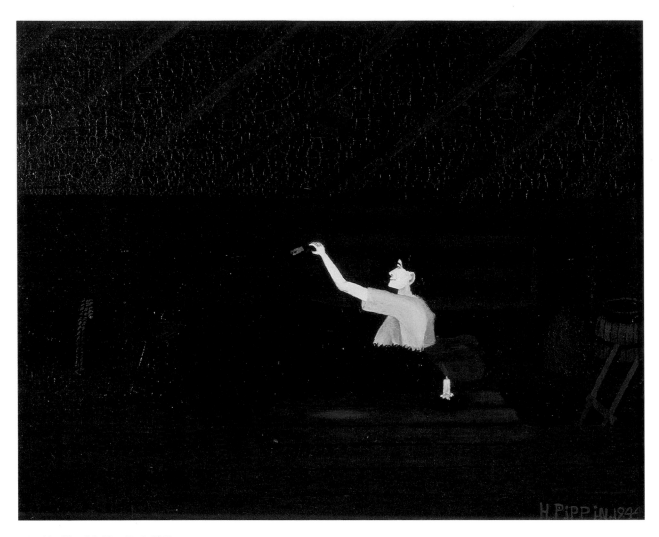

52 *Abe Lincoln's First Book*, 1944.
Oil on fabric, 24 × 30 in. The
Carnegie Museum of Art,
Pittsburgh, Gift of Mr. and Mrs.
James L. Winokur (68.20)

his mother, who, he alleged, was a witness that day to Brown's hanging. Harriet
Irwin Pippin (1834, Charlestown, West Virginia–1908, Goshen, New York) was a like-
ly witness to Brown's execution that December day in 1859. Pippin's implication that
he—via a blood relative—was part of this historic event, demonstrated his deep sense
that the shifting tides of history *did* impact profoundly upon him as well as other black
Americans.[8]

But beyond a fascination with history proper, Pippin's historical subjects, in fact,
may have reflected his own fascination with American popular culture. In looking at
the Abraham Lincoln and John Brown paintings and the period in which they were
produced, one is reminded of two very popular motion pictures of that era: *Abe Lin-
coln in Illinois* (1939) and *Santa Fe Trail* (1940). The title role in *Abe Lincoln in Illi-
nois* and the role of John Brown (in *Santa Fe Trail*) were both played with much dra-
matic flair by actor Raymond Massey to widespread critical acclaim (fig. 58).[9] Although
we cannot be certain if Pippin ever saw these two films, at the very least we can argue
that he, like the films' producers, was smitten by these twin avatars of nineteenth-century
black emancipation. And also like the films' producers, Pippin sensed that Lincoln and
Brown were worthy subjects for the artistic imagination, cut from the same broad, ide-
ological cloth. That Pippin was not entirely divorced from American movie culture
is confirmed by his dealer, Robert Carlen, who was instrumental in selling Pippin's
works to a number of important Hollywood art collectors (John Garfield, Ruth Gor-
don, Charles Laughton, Clifford Odets, Edward G. Robinson, and others).[10]

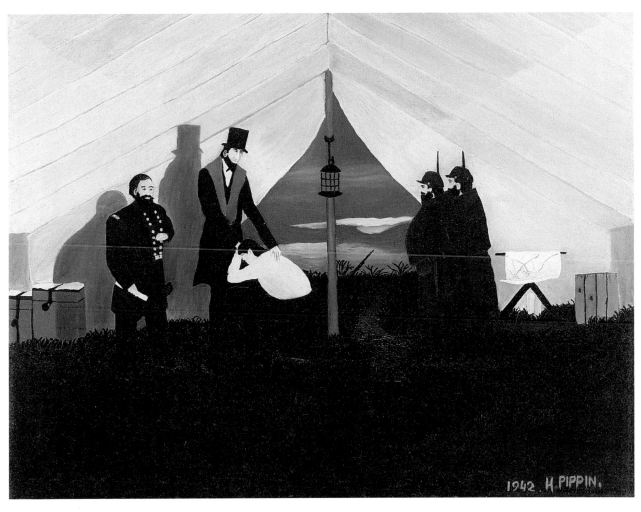

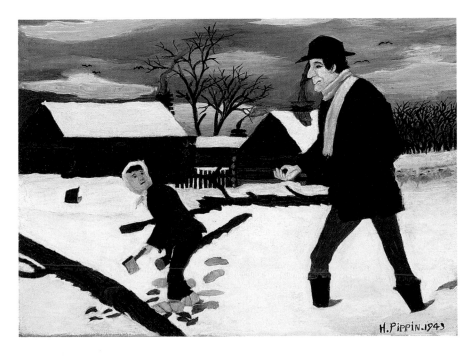

53 *Abe Lincoln, The Great
Emancipator*, 1942. (Also known as
*Abraham Lincoln, The Great
Emancipator, Pardons the Sentry*).
Oil on fabric, 24 × 30 in. The
Museum of Modern Art, New York,
Gift of Helen Hooker Roelofs (142.77)

54 *Abe Lincoln, The Good
Samaritan*, 1943. Oil on canvas
board, 9 × 12 in. Pennsylvania
Academy of the Fine Arts,
Philadelphia, Bequest of David J.
Grossman in honor of Mr. and Mrs.
Charles S. Grossman and Mr. and
Mrs. Meyer Speiser (1979.1.5)

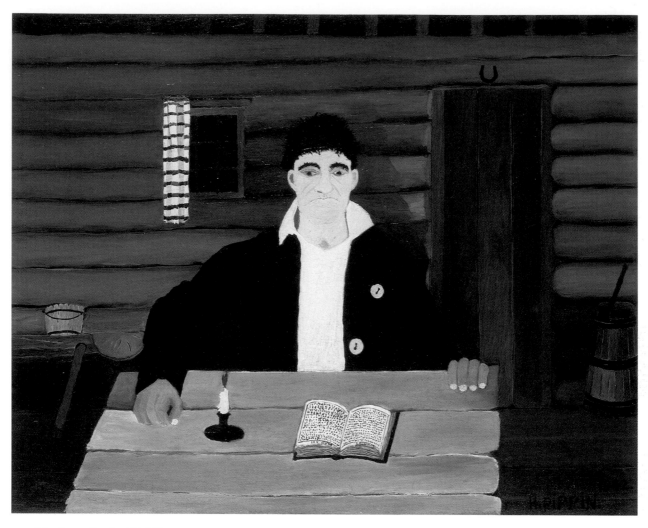

55 *John Brown Reading His Bible*,
1942. Oil on canvas board, 16 × 20 in.
The Crispo Collection, Charleston,
South Carolina

Another possible consideration in looking at the Abraham Lincoln and John Brown paintings was Pippin's desire—either conscious or otherwise—to create works that would indulge his overwhelmingly white, affluent, and racially tolerant clientele. The profiles inferred from black American accounts of historic figures such as Abraham Lincoln—that he was powerful, honest, benevolent, and sympathetic to black people and black concerns—and John Brown—that he was religious, combative, divinely inspired, and an activist in regards to black liberation—could be construed (from Pippin's perspective) to resonate with the profiles of collector Albert C. Barnes, art dealer Robert Carlen, and art critic Christian Brinton. Although it seems that none of the historical paintings was specifically commissioned by any of these people, their respective roles in Pippin's relatively short but successful art career cast looming, influential shadows over these and other works. And while we have no hard evidence that Pippin catered to the expectations of his wealthy and powerful white patrons, it would not be too far fetched to suggest that the very nature of the relationship and of the personalities involved led Pippin to paint in order to please his clientele.

But rather than portraying Pippin as a mere foil for calculated, accommodating motives in art, this scenario frees him from the *folk yoke* of artistic intuition and professional helplessness and, instead, places him among other twentieth-century moderns, who operate within the slippery territories of symbolism, reportage, inner expression, and the business of art. One need only look at the contemporary "insider/

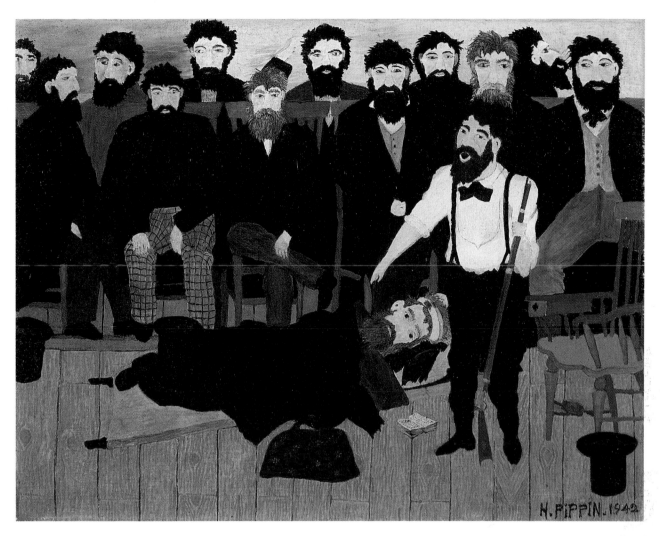

56 *The Trial of John Brown*, 1942. Oil on fabric, 16⅛ × 20⅛ in. The Fine Arts Museums of San Francisco, Gift of Mr. and Mrs. John D. Rockefeller, 3rd (1979.7.82)

outsider" artist—like the Rev. Howard Finster, for example—to understand where Pippin may have stood in relationship to his own work and to the greater art world, in around 1940.[11]

Do Pippin's paintings of Abraham Lincoln and John Brown emanate purely from a deep sense of the historical, or do they spring from his perspective as an observer in a society that concurrently was reexamining its national myths, heroes, and villains? Are these paintings merely *folk* portraits of larger-than-life *folk* heroes by an uneducated *folk* artist, or are they encoded representations of a kind of white paternalism toward blacks, which Pippin willingly and knowingly benefitted from during his brief, brilliant career? All of the above, some of the above, or none of the above? Given the strange mixture of benevolent management, enforced naiveté, and creative control by Pippin's several handlers, we may never know the precise answers to these questions. But there is little doubt that the works themselves, with their compositional profundity and thematic punch, raise the art of history painting to a new level: a level that incorporates the observations of a middle-aged, unlettered black artist, whose elemental technique and directness of vision belie the complexities of re-creating history, via painting, in America at the time of the Second World War.

RICHARD J. POWELL is Andrew W. Mellon Assistant Professor of Art History at Duke University, Durham, North Carolina.

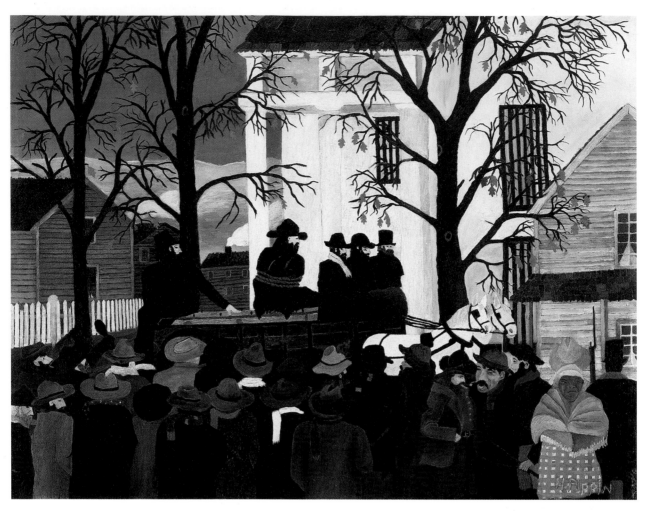

57 *John Brown Going to His
Hanging*, 1942. Oil on fabric, 24 × 30
in. Pennsylvania Academy of the
Fine Arts, Philadelphia, John
Lambert Fund (1943.11)

58 *Raymond Massey as John
Brown in "Santa Fe Trail,"* Warner
Brothers, 1940. Directed by Michael
Curtiz. Museum of Modern Art, New
York, Film Stills Archive

1. Stephen B. Oates discusses the frequent pairing of these two figures of nineteenth century American history in *Our Fiery Trial: Abraham Lincoln, John Brown, and the Civil War Era* (Amherst: University of Massachusetts, 1979).

2. For an excellent study of WPA art programs and Depression-era aesthetics in America, see Marlene Park and Gerald Markowitz, *New Deal for Art* (Hamilton, N. Y.: Gallery Associates of New York State, Inc., 1977). For a discussion of how historical figures (like John Brown) were often rendered in government-sponsored art projects, see M. Sue Kendall, *Rethinking Regionalism: John Steuart Curry and the Kansas Mural Controversy* (Washington, D.C.: Smithsonian Institution, 1988).

3. J. O. Thomas, *Negro Participation in the Texas Centennial Exposition* (Boston: Christopher Publishing House, 1938); *Contemporary Negro Art*, exh. cat. (Baltimore: Baltimore Museum of Art, 1939); Tanner Art Galleries, *Exhibition of the Art of the American Negro, 1851–1940*, exh. cat. (Chicago: American Negro Exposition, 1940); and *Seventy-Five Years of Freedom in Commemoration of the Proclamation of the 13th Amendment to the Constitution of the United States of America* (Washington, D.C.: Library of Congress, 1943).

4. For examples of these artists' historical paintings, see Alain Locke, *The Negro in Art* (Washington, D.C.: The Association in Negro Folk Education, Inc., 1940), p. 43; Ellen Harkins Wheat, *Jacob Lawrence, American Painter* (Seattle: Seattle Art Museum, 1986), pp. 81, 82; and Adelyn D. Breeskin, *William H. Johnson, 1901–1970* (Washington, D.C.: Smithsonian Institution, 1971), pp. 148–150, 152.

5. Carl Sandburg, *Abraham Lincoln: The Prairie Years* (New York: Harcourt, Brace, and Company, 1926) and Carl Sandburg, *Abraham Lincoln: The War Years* (New York: Harcourt, Brace, and Company, 1939).

6. Pippin's first biographer, Selden Rodman, also noted this eerie, foreboding quality in the artist's painting of John Brown, writing that "Pippin understood the meaning of that conflict Brown's candle was to ignite." Selden Rodman, *Horace Pippin. A Negro Painter in America* (New York: Quadrangle Press,

1947), p. 18. Depression-era audiences were inspired by Sandburg's Lincoln biographies, as well as by Stephen Vincent Benét's celebrated work *John Brown's Body* (Garden City, N. Y.: Doubleday, Doran & Co., 1928).

7. Days after Brown's attack on Harpers Ferry, investigators found a carpetbag, which belonged to Brown, full of correspondence between him and the alleged supporters of his attack. For an in-depth discussion of Brown and the historical circumstances that revolved around this scene in Pippin's painting, see Thomas J. Fleming, "Verdicts of History III: The Trial of John Brown," *American Heritage* 18 (August 1967), pp. 28–33, 92–100.

8. Rodman, *Horace Pippin*, p. 17.

9. That black Americans, circa 1939, were certainly aware of the racial implications of at least *Abe Lincoln in Illinois*, was affirmed by the star of the film, actor Raymond Massey, who stated that blacks picketed and protested the racial segregation policies of the nation's movie houses at the Washington, D.C. premiere of the film. For a description of the protest and the circumstances surrounding both *Abe Lincoln in Illinois* and *Santa Fe Trail*, see Raymond Massey, *A Hundred Different Lives: An Autobiography* (Boston: Little, Brown, 1979), pp. 247–262.

10. In the Robert Carlen Gallery Papers (at the Archives of American Art, Smithsonian Institution, Washington, D.C.) one can find numerous letters between Carlen and various Hollywood actors, directors, and producers pertaining to Pippin's art.

11. The difference, of course, is that the Rev. Howard Finster is white and Horace Pippin was black, and Pippin's relationship with Carlen, Barnes, and Brinton always had a racial dimension, as well as one of class and economics. Nonetheless, John Michael Vlach's study of the problematic terminologies and criticisms of American "folk painting" includes a discussion on the twentieth-century phenomenon of the technically naive yet business-savvy artist, most evident in the art and life of Anna Mary Robertson Moses (1860–1961), popularly known as "Grandma" Moses. *Plain Painters: Making Sense of American Folk Art* (Washington, D.C.: Smithsonian Institution Press, 1988), pp. 143–160.

Landscapes, Portraits, and Still Lifes

LYNDA ROSCOE
HARTIGAN

WHETHER SAMPLING OR MASTERING a variety of subjects, representational artists often become identified with a particular set of images. An artist's experience, intent, and talent help to shape that perception, as do the expectations and values of popular, commercial, and critical audiences over time.

The cruelty of war and the optimism of peace emerge from Horace Pippin's own accounts as indelible, dominant concerns and, by inference, his preferred subjects among all those he explored. During his lifetime, however, his statements did not direct attention solely to his war scenes or latter-day interpretations of the Peaceable Kingdom. Indeed, Pippin lived to see most of his works quickly sold to private collectors and museums, implying contemporary interest in the full range of his subject matter. The relative accomplishment or significance of his diverse subjects was a secondary concern during the 1940s when voices such as Albert C. Barnes and Alain Locke emphasized the naive and the recollected as the artist's viewpoint, and the American and African American as the source of his sense of design.

Selden Rodman's 1947 chronicle of Pippin's evolution assessed specific works in terms of form rather than subject. Rodman also established for subsequent generations the years 1942 to 1944 as the artist's "high tide" of integrating form and color in efforts that included the John Brown trilogy, *The Crucifixion*, and still lifes, as well as diverse views of African-American life and the Holy Mountain series.

Even as this sense of apogee still exists, its focus has noticeably changed since the 1970s to emphasize both the form and cultural content of Pippin's African-American genre scenes and religious subjects as his greatest achievements. Undoubtedly, the increasing attention devoted to African-American art and twentieth-century folk art over the past two decades has contributed to this shift in emphasis. In the process, however, Pippin's landscapes, portraits, still lifes, and unpeopled interiors have receded in estimation and understanding—an event that has effectively masked the internal logic of Pippin's overall body of work.

In 1940 fellow artist Julius Bloch noted Pippin's "extraordinary" love of nature: "When we went out-doors he was constantly looking at and studying trees, the foliage of branches, and the distant revealing landscape on the other side of the valley. He loves the way it all 'softly melts away.'"[1] Although Pippin had sketched the French landscape during World War I, he did not recall it for his burnt-wood panels and oil paintings during the 1930s. Instead, he turned to the American landscape familiar to him—largely rural Pennsylvania from the Brandywine River Valley to the Pocono Mountains.

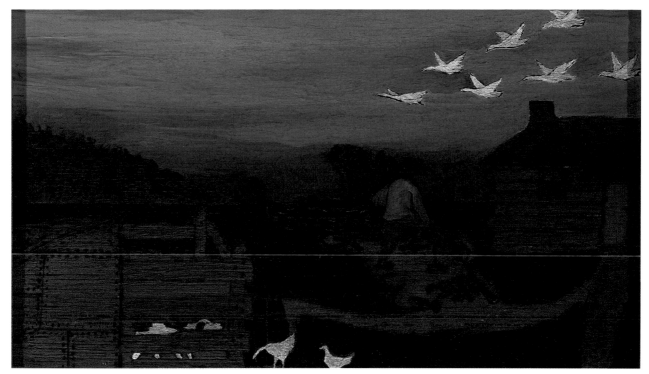

59 *Autumn: Durham, North Carolina*, 1932. (Also known as *Autumn Scene Near Durham, N. C.*). Oil on burnt-wood panel, 20 × 12 in. Private collection

Seasonal and atmospheric effects figure prominently in Pippin's approximately two dozen landscapes.[2] Shocks of corn and tawny, thinning leaves evoke an appropriately autumnal setting in *The Squirrel Hunter* (fig. 61), while statuesque evergreens cast dusk's lengthening, cool shadows across *Mountain Landscape* (fig. 62). The bluster, glint, and chill of blanketing snow, however, were Pippin's favorite challenge, to judge from the prevalence of winter scenes created primarily during the first decade of his career. The barrenness of the earliest example—*Losing the Way* (1930, fig. 131)—could be attributed to his struggle to devise a manageable technique. By 1939, the nocturnal starkness mastered in *The Getaway* (1939, fig. 183) instead makes it clear that Pippin's winter was a season of somber, rural solitude when the Brandywine River Valley's "shorn hills and skeletal trees are reduced to shades of brown and grey."[3]

Equally apparent is Pippin's attention to regional features, which have traditionally been attributed to pictorial sources rather than direct experience of his environment. The rural scenario featured in *The Getaway*, for example, has been identified with calendar imagery as well as Winslow Homer's painting, *The Fox Hunt* (fig. 63), yet neither source has been proven. Alternatively, it is worth noting that in 1939 Pippin painted two works that could easily be considered complementary—*The Getaway* and *Coming In* (fig. 64), the portrait of Mrs. W. Plunket Stewart, his patron and a fox hunter prominent in the area. Chester County was, and still is, home to a healthy fox population, hunted every autumn across the valley's flat meadows and rolling hills and left to its own marauding devices during other seasons.

In *The Getaway*, the fox runs along what could be any of many streams in the adjoining Chester and Delaware Counties. It is most likely the latter's Brandywine River or Creek, already pictured in *Fishing in the Brandywine: Early Fall* (1932, fig. 133), itself a reference to the local fishing enjoyed by Pippin and his wife.[4] "While shot guns are banging and squirrels are dropping in the woodlands about Birmingham" is only one of numerous accounts of Chester County's long history

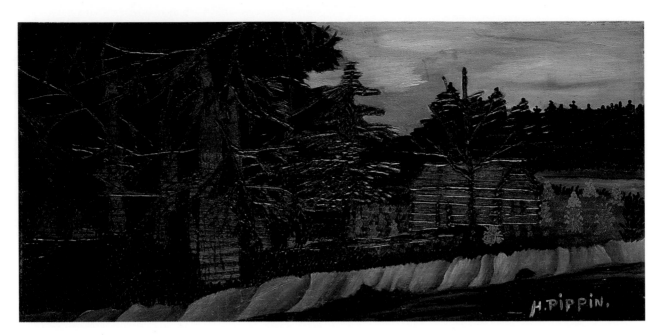

60 *Fall Landscape*, 1940. Oil on burnt-wood panel, 10 × 19⅝ in. Hirshhorn Museum and Sculpture Garden, Smithsonian Institution, Washington, D.C., Gift of Joseph H. Hirshhorn, 1966 (66.4070)

of hunting and fishing (fig. 66).[5] Pippin's own love of the outdoors readily drew him to ice fishing, trapping, bear hunting, duck shooting, and "maple sugaring" as fitting subjects for his landscapes, especially during the 1930s.

The Old Mill (fig. 68) features a structure still standing during Pippin's time as witness to once bustling wood or stone mills that had processed everything from flour to gunpowder along the ribbony Brandywine, an important millstream since the colonial period. And intriguingly enough, recent conservation examination has revealed that *The Old Mill* may represent Pippin's efforts to rework and overpaint an earlier, similarly rural scene.[6]

Nowhere is the artist's regional sensitivity more evident than in his four paintings of the Birmingham Meeting House between 1940 and 1942 (figs. 69–72). In 1940 the Meeting celebrated the 250th anniversary of its founding by English immigrant and Quaker William Brinton in Birmingham, Pennsylvania, approximately four miles southwest of West Chester (fig. 73). The anniversary received local and national coverage, but the Meeting House's place in history had been assured since 1777 when American and British forces under Generals Washington and Howe clashed on its grounds overlooking the valley during the Battle of the Brandywine.[7] At different points both sides sheltered their wounded inside the building and buried their dead in its walled graveyard.

Few area residents escape knowledge of this landmark's legacy, and the Birmingham Meeting House and its environs became a frequent subject among generations of local artists. By 1940, contact with the Chester County Art Association, other artists, and art critic Christian Brinton (1870–1942) no doubt introduced Pippin to the subjects associated with what has more lately been described as the "Brandywine tradition"—the poetic or postcard realism favored by writers, landscape painters, and illustrators in the area since the mid-nineteenth century.[8]

Although Pippin's affinity for regional landscape subjects ties him closely to the Brandywine tradition, he did not emulate its romanticizing style. Characteristically, he synthesized the key details that lend the Meeting House its structural and natural dignity. Erected and expanded between 1763 and 1815, the building is a compact, rustic study in contrasts. The frontal exterior combines locally quarried fieldstone and mottled gray-green serpentine, set off by oatmeal-colored mortar and

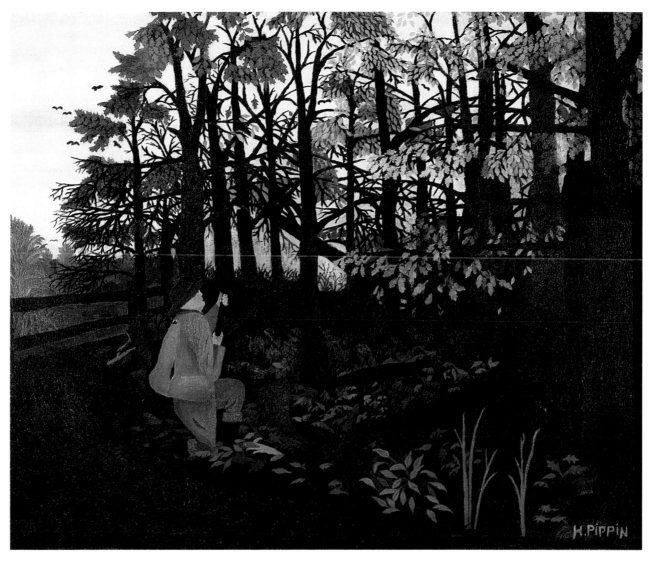

61 *The Squirrel Hunter*, 1940. Oil on fabric, 25 × 30 in. Private collection

white, wood-frame doors and windows. In 1940 full-grown hemlocks and spruces to the rear and white oak, ash, and Kentucky coffee trees to the front and sides discriminately loomed around the meeting house. In all four paintings, Pippin focused on the front of the building, while varying the distance, angle, and season of each expressively shaded view. Three of the works incorporate a section of the historic graveyard's stone wall to the left, while the white overhang at the far right alludes to a wood-frame addition of 1940. In the version depicting late summer, an "upping" block, once used to mount horses, and telephone cables juxtapose the site's past and present. Throughout the series, nature envelops the meeting house in a sober tranquillity eerily akin to that popularly associated with Quaker life. Each vantage is telescoped through the property's Kentucky coffee trees—strong, dark trunks and compound leaves with many fine leaflets, densely green through spring and summer, pale yellow in fall.9 The series then is as much a study of nature as architectural portrait.

Pippin's notice of the regional also extended to the urban view afforded by his small hometown, West Chester. *West Chester Court House* (1940) and *West Chester, Pennsylvania* (1942) are directly related to his earlier site-specific, seasonal landscapes such as *Teachers College Powerhouse, Winter* (by 1937), as well as the

73 C. H. Thomas (1890–1938). *Birmingham Friends Meetinghouse, Birmingham Township, Pennsylvania*, c. 1930. Silver gelatin print, 4¾ × 6⅝ in. Chester County Historical Society, West Chester, Pennsylvania

erected the nineteen-foot monument of a flag-draped soldier to honor its veterans of the Grand Army of the Republic. Pippin's use of miniature flags around the monument's base reflects its place in civic and patriotic events, including the parades that have traditionally filed past the court house. Pippin, an active war veteran, regularly attended these celebrations, while local newspapers often called attention to benchmarks such as the seventy-fifth anniversary of the Civil War's end in 1940.

Three scenes executed between 1933 and 1936—*The Buffalo Hunt* (fig. 77), *The Blue Tiger* (1933), and *The Lady of the Lake* (1936)—have often been grouped with Pippin's landscapes, yet even today they are defiant in their distance from the direct observation that usually underwrote his expressive realism. Falling early in his career, these works may reflect an emerging artist's use of popular imagery, yet they suggest no readily apparent, direct models, and Pippin's use of pictorial, literary, theatrical, and cinematic sources remains insufficiently documented. Some considerations are tantalizing nonetheless.

Since the nineteenth century an extensive roster of American and European artists have expressed their romantic or documentary interest in the American West in paintings, sculptures, drawings, prints, and photographs, and the buffalo has often played a prominent role in these works. How coincidental that early twentieth-century illustrators trained or active in the Brandywine River Valley have made a considerable contribution to the gallery of Western as well as wilderness imagery. The works of N. C. Wyeth, Frank Schoonover, Philip Goodwin, Harvey Dunn, and Oliver Kemp—to name but a few—were widely disseminated not only through popular magazines such as *Collier's, Harper's, Scribner's,* and the *Saturday Evening Post,* but through illustrations for books, calendar reproductions, and other forms of pictorial advertising well into the 1930s.[13]

Even more accessible during Pippin's lifetime were the books and serials of Zane Grey, Hollywood's favorite resource for formulaic Westerns from the 1920s through the 1940s. *The Thundering Herd,* Grey's 1925 novel devoted to buffalo hunting, includes, for example, a chilling vignette of close-range slaughter by a buffalo hunter crouched behind trees and a log. The book inspired an immensely popular film of the same title, made in 1925 and remade in 1933. Whatever his source, Pippin took immediate licence by choosing the winter season, when Native Americans and whites rarely hunted buffalo, a fact echoed by visual and literary artists whose interpretations were seldom set in winter.

The Lady of the Lake (fig. 78) features Pippin's only nude subject, chaste in representation and rustic in setting. Was he enticed by images of Pennsylvania's mountain resorts derived from calendars and advertisements or even Maxfield Parrish's then wildly popular, neoromantic scenes of waterside women? Was he aware of the Lady of the Lake as a character who first appeared in Arthurian legend, subsequently inspired adaptations by diverse authors, and provided the title for a 1931 British film also distributed in America?[14]

American illustrators, including the Brandywine Valley's Howard Pyle and N. C. Wyeth, had favored the Arthurian legend as a source since the turn of the century. Pippin's interpretation, however, seems to fall more in line with the heroine around whom Sir Walter Scott created "Lady of the Lake," his 1810 romantic

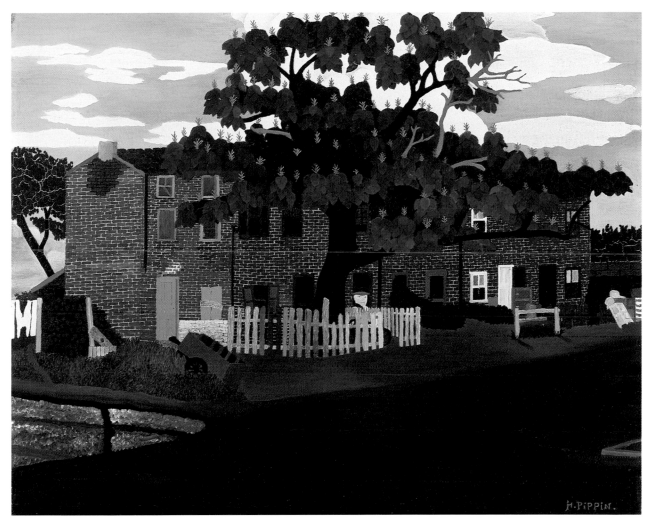

74 *West Chester, Pennsylvania*, 1942. Oil on fabric, 29⅜ × 36⅜ in. Wichita Art Museum, Kansas, Roland P. Murdock Collection (M51.44)

poem set in the Scottish Highlands. In Scott's first canto, verses XVII through XIX describe a hunter's glimpse of a tartan-clad, raven-haired maiden in a boat "Like monument of Grecian art,/In listening mood, she seem'd to stand,/The guardian Naiad of the strand." Verse XXV details the maiden's entry into a chieftain's log lodge nestled from sight near the lake and surrounded by a bower of vines and plants. In Pippin's interpretation, a canoe, Indian-style blanket, log cabin, rose trellis, and bricolage planters suggest that he mined a variety of resources close to home: Pennsylvania's landscape and Native American history, regional hunting lodges descended from the log cabins introduced centuries before by Swedish settlers along the lower Delaware River, and even his own garden.

The Blue Tiger (fig. 79) remains the most enigmatic member of this trio. That the habitats of tigers and bears overlap in northern and southern Asia diminishes the confrontation's quixotic first impression. Recent conservation has revealed, however, that Pippin had originally painted a white tiger with gray shading, quickly stirring speculation about his manipulation of actual facts of nature and pictorial sources. Both the setting and one-on-one mortal combat call to mind, for example, N. C. Wyeth's 1919 illustration of the battle at Glenn's Falls for the Charles Scribner's Sons edition of James Fenimore Cooper's novel, *The Last of the Mohicans* (fig. 80), or the 1861, admittedly rare, Currier and Ives lithograph, *The Tight Fix*, after Arthur F. Tait's series of paintings, *The Life of the Hunter* (fig. 81).[15]

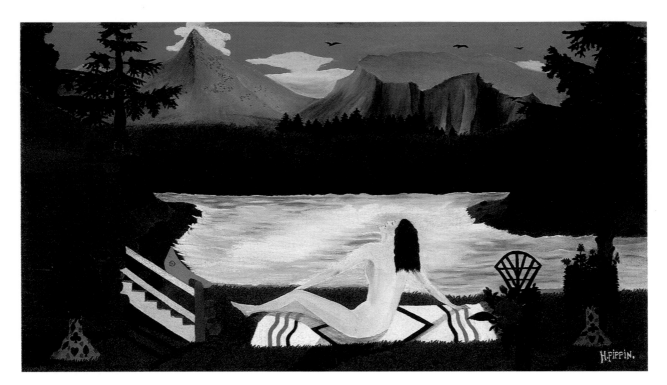

78 *The Lady of the Lake*, 1936. Oil on fabric, 20½ × 36 in. The Metropolitan Museum of Art, New York, Bequest of Jane Kendall Gingrich, 1982 (1982.55.1)

a serious nature. Her body looms while her head seems small in this close, tight view, perhaps more suggestive of her stocky build than contemporary viewers realized.

Over the next two years Pippin executed portraits of Paul Bartram Dague (1898–1974) and Smedley Darlington Butler (1881–1940). The three men shared the brotherhood of war veterans, for Dague and Butler were active respectively in the Charles F. Moran Post of the American Legion in Downingtown and the Bernhard Schlegel Post in West Chester, while Pippin joined area black veterans in the Nathan Holmes Post, which he commanded for a time.

Dague (fig. 85) had been a private in the U.S. Marine Corps during World War I. His distinguished history of public service in Pennsylvania began in 1925 with the state's Department of Highways. Between 1936 and 1946 he was Chester County's deputy sheriff and sheriff, after which he represented the area as its Republican Congressman from 1947 to 1966. Pippin and Dague crossed paths frequently because of their American Legion activities, the evident basis for the preparatory drawing (fig. 86) and the Dague portrait (fig. 87). Startling indeed is the effect of the painting's sharp palette, blank white face, and hunched body, and Dague's wife and the Legion Post allegedly found the image unflattering.[18]

Pippin's desire to honor his civic-minded friend was nonetheless sincere. A detail as simple as the Delaware Valley ladderback chair evokes the regional context of Dague's public career and family history. The gavel suggests that he had some authority at a meeting or similar circumstance since it is the symbol of a post commander in the American Legion, here represented by the insignia on the rectangular block. Dague held no office in his local Legion post at the time, although his Marine Corps dress uniform, complete with a rainbow-hued World War I Victory medal and a Marine Corps marksmanship medal, establishes his exemplary military service. Equally sincere was Pippin's attempt to convey the fact of skin color rather than its connotations; he used white paint straight from the tube to depict caucasian subjects throughout his career. When donating the portrait to the

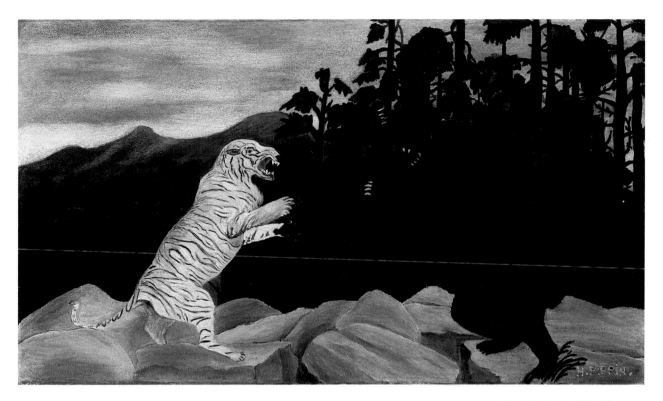

79 *The Blue Tiger*, 1933. Oil on fabric, 16 × 28 in. Private collection

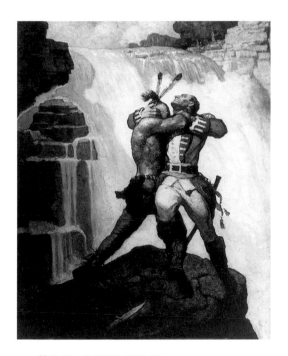

80 N. C. Wyeth (1882–1945). *The Battle at Glenn's Falls.* From *The Last of the Mohicans* by James Fenimore Cooper (Charles Scribner's Sons, 1919). Charles Scribner's Sons, New York

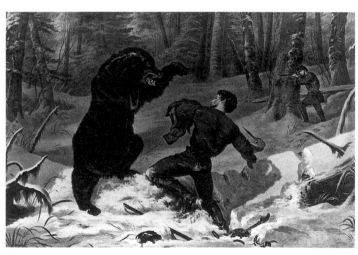

81 Nathaniel Currier (1813–1888) and James Merritt Ives (1824–1895). *The Life of a Hunter: A Tight Fix*, 1861. Chromolithograph after painting by A. F. Tait, 18⅛ × 27 in. Heritage Plantation of Sandwich, Massachusetts

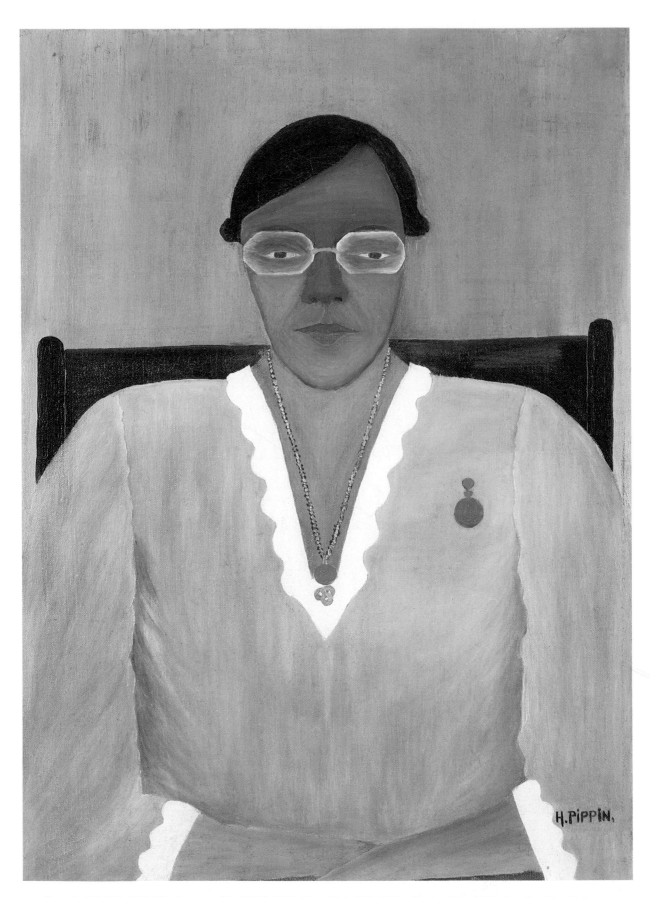

82 *Portrait of My Wife*, 1936. (Also known as *The Artist's Wife*). Oil on fabric, 23¾ × 16¾ in. Courtesy Terry Dintenfass, Inc., New York

83 *History of Case* (Jennie Ora
Pippin), undated. Pencil on paper,
11 × 8½ in. Private collection

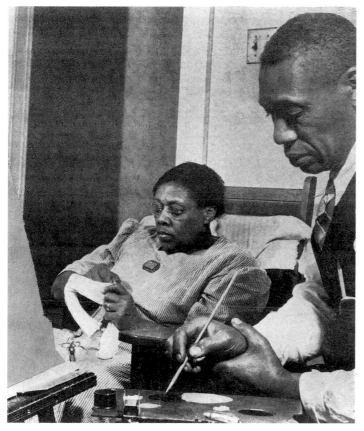

84 Photographer unknown.
The artist paints, his wife mends.
The canvas on which he is working
is a portrait of Marian Anderson,
c. 1940. From unidentified periodical.
Chester County Historical Society,
West Chester, Pennsylvania

85 Photographer unknown. *Paul Dague*, undated. Silver gelatin print, 4⅝ × 3¼ in. Chester County Historical Society, West Chester, Pennsylvania

86 *Paul B. Dague*, c. 1937. Pencil on paper, 9¼ × 6¾ in. Collection Vincent B. Murphy, Jr.

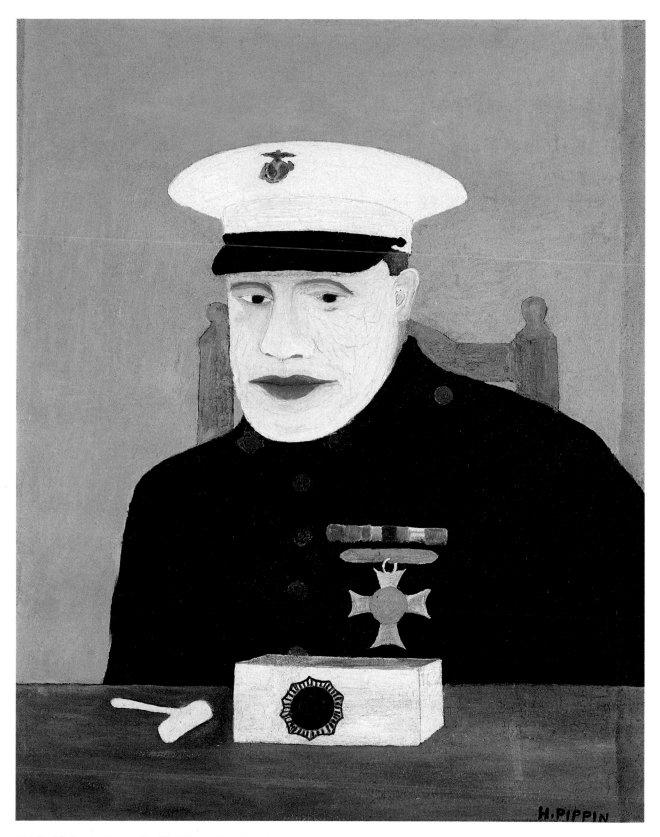

87 *Paul B. Dague, Deputy Sheriff of Chester County*
(1898–1974), 1937. Oil on fabric, 20 × 16 in. Chester
County Historical Society, West Chester, Pennsylvania
(1985.512)

Chester County Historical Society in 1948, Dague professed recognition of the portrait "as a symbol of the complete lack of racial consciousness which ever marked our long years of association together."[19]

Descendent of pre-Revolutionary Quakers and son of a Congressman, Brigadier General Smedley Butler retired to his hometown, West Chester, in 1931 (fig. 88). Locally and internationally, he was known as an outspoken career military man, from his first skirmishes during the Spanish-American War to his command of Marine Corp forces in China in the late 1920s. Rather than working from memory as he may have for Dague's portrait, Pippin used a "single column cut" newspaper photograph to capture a closer likeness of the aquiline-featured Butler (fig. 89).[20] Profiled outdoors, the highly decorated general cuts the distinguished figure associated with this favorite hometown hero as he marched regularly in West Chester's parades. The graphically rendered clouds—aligned like so many medals—suggest Pippin's evolving sense of form as counterpoint and even visual pun.

The portrait, however, had been done before the two men met on August 2, 1938, when the painting was presented to Butler's Bernhard Schlegel Post of the American Legion. The *Daily Local News* reported that Butler told the artist, "It's got me. You've got the nose, all right . . . But you haven't got all my medals on me. You've only got ten and I have nineteen." The newspaper account also noted Pippin's explanation for using "plenty of storm clouds on the horizon" rather than a domestic setting because Butler "was always looking for trouble" during his military days.[21]

Despite contradictory explanations of Pippin's discovery and allusions to a cooled relationship, it was nonetheless art critic Christian Brinton (fig. 90), who inspired his most ambitious and successful portrait (fig. 91). Although Pippin had asked the critic for a photographic likeness in 1938, it may not be coincidence that Brinton's portrait and the first painting of the Birmingham Meeting House were done in 1940.[22] Brinton was directly descended from the founder of the Birmingham Meeting, while his family's quarry had provided the serpentine from which the meeting house is built. A mere half mile separated the historic site and the "Quarry House" where Pippin visited Brinton, himself actively involved in the Meeting's anniversary celebration.

Area residents often made more of "Tiny" Brinton's spats, blue beret, and old roadster than his worldwide studies of modern, Russian, and Oriental art or his efforts on behalf of local artists. The short, white-haired Dr. Brinton was a determined, intelligent personality with penetrating eyes, rosy complexion, and theatrical flair.[23] Pippin neatly caught several of those qualities but chose to emphasize his subject's stature as an authority rather than his reputation for the flamboyant. No hint exists of Brinton's exotically decorated house or his international art collection favoring the Russian. Instead, this incisive portrait is set in his library of some three thousand volumes.

Pippin's interest in the heroes and civil rights of African Americans is usually associated with the nineteenth century. Several works executed during the early 1940s, however, dispel that notion: two portraits of Marian Anderson (from 1941), *Water Boy* (1943), a now unlocated painting in tribute to barrier-breaking athlete and performer Paul Robeson, and *Man Seated Near Stove* (fig. 92), in which a framed rendering of two black fighters alludes to the African-American contribution to professional boxing since the early twentieth century.[24] Although infrequently noted, a noosed black figure swings from a tree in the backgrounds of *Holy Mountain II* (1944, fig. 128) and *III* (1945, fig. 129), while the phrase "what is doing in the south today" appears in Pippin's explication for the series.

In 1939 Marian Anderson (1902–1993, fig. 93), a native Philadelphian and internationally renowned operatic singer, gave her historic concert at the Lincoln

9 2 *Man Seated Near Stove*, 1941.
Oil on burnt-wood panel, 10 × 10 in.
Private collection

Memorial. Her triumph over the racial discrimination that barred her from singing at Constitution Hall was shared by the millions who listened to its radio broadcast or followed its massive news coverage. In March 1941 she became the first African American to receive the Philadelphia Bok Award as the city's outstanding citizen of the year.

Allegedly, Robert Carlen took Pippin to hear Anderson sing in Philadelphia's Fairmount Park, where she appeared on July 18, 1940. Pippin's reported lack of interest does not ring true to his cultural attentiveness.[25] Equally unclear is the sequence of Pippin's two portraits. According to Selden Rodman's 1947 publication, the larger, oval version (fig. 94) was done in 1940 and repainted in 1941 (fig. 95). The much smaller example (fig. 97) is indebted to a newspaper photograph of Anderson and was no doubt inspired by her March 1941 award, since Philadelphia newspapers photographed the painting in progress that same month for their coverage of Pippin's second one-person show at the Carlen Gallery (fig. 84).[26]

The larger portrait is a cameo of Anderson robed, reminiscent of her origins in Philadelphia's black church choirs and symbolic of her love of spirituals, which her concerts helped to legitimize and popularize. Pippin's active church life, which included teaching Sunday school and singing in the choir, predisposed him to depicting Anderson's church ties. The insistent shadows and oval format of the portrait suggest the spotlit performance of a woman who stood her ground. The smaller work is a more self-conscious representation of the dignified Anderson singing in stage costume.

Pippin's efforts to capture likenesses culminated in two self-portraits (figs. 98, 99), a sequence in direct contrast to that of many beginning artists who attempt self-portraiture to explore their emerging creative identity or because they lack

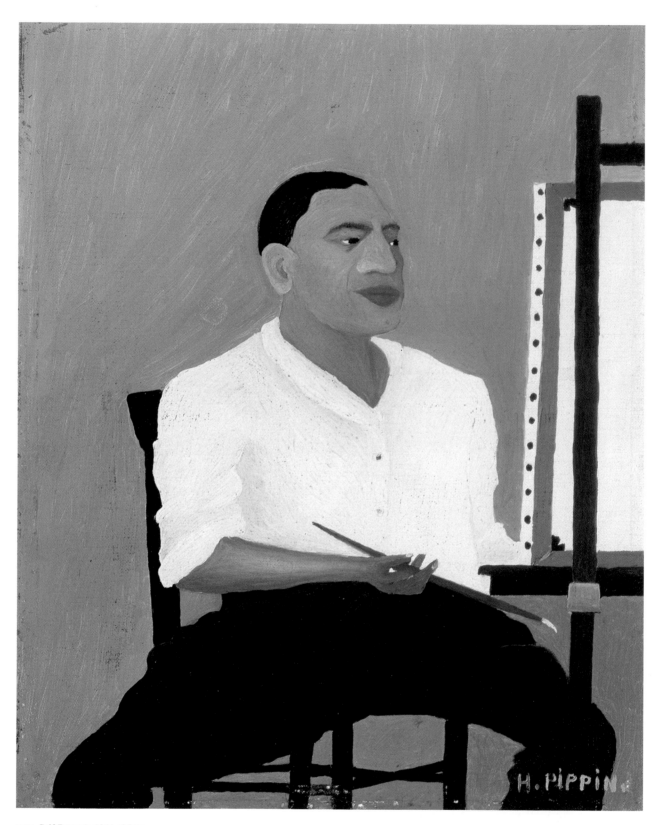

98 *Self-Portrait*, 1941. Oil on
canvas board, 14 × 11 in. Albright-
Knox Art Gallery, Buffalo, New York,
Room of Contemporary Art Fund,
1942 (RCA: 42.2)

99 *Self-Portrait (II)*, 1944. Oil on canvas board, 8½ × 6½ in. The Metropolitan Museum of Art, New York, Bequest of Jane Kendall Gingrich, 1982 (1982.55.7)

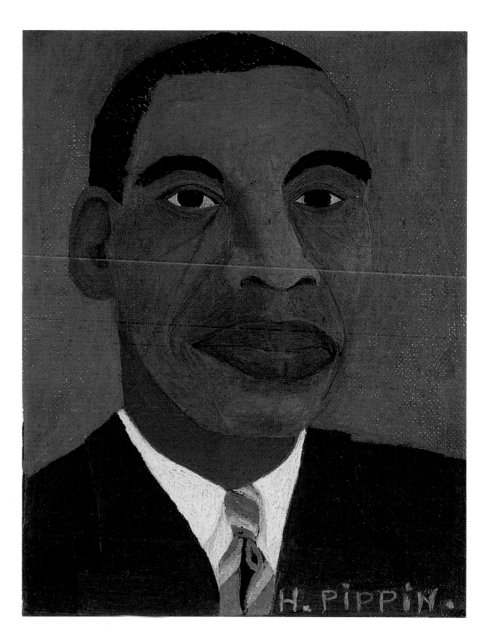

100 Freudy, New York. *Mr. and Mrs. W. Plunket Stewart at a kennel meet with Cheshire Hounds*, c. 1935. Silver gelatin print, 6 × 8 in. Chester County Historical Society, West Chester, Pennsylvania

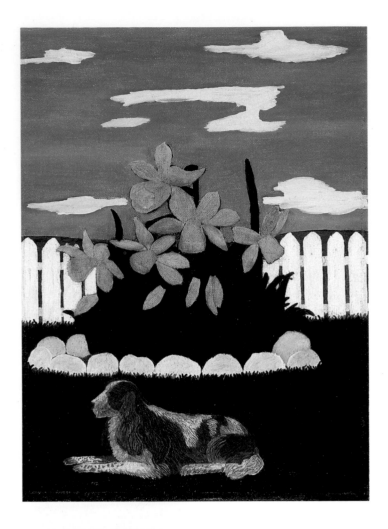

101 *Giant Daffodils*, 1940. Oil on canvas board, 13¹⁵⁄₁₆ × 10 in. Pennsylvania Academy of the Fine Arts, Philadelphia, Bequest of David J. Grossman, in honor of Mr. and Mrs. Charles J. Grossman and Mr. and Mrs. Meyer Speiser (1979.1.2)

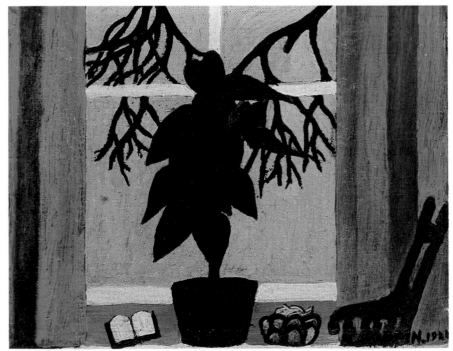

102 *Potted Plant in Window*, 1943. Oil on fabric, 7 × 9 in. Brandywine River Museum, Chadds Ford, Pennsylvania, Gift of Mr. and Mrs. Edgar Scott (81.34)

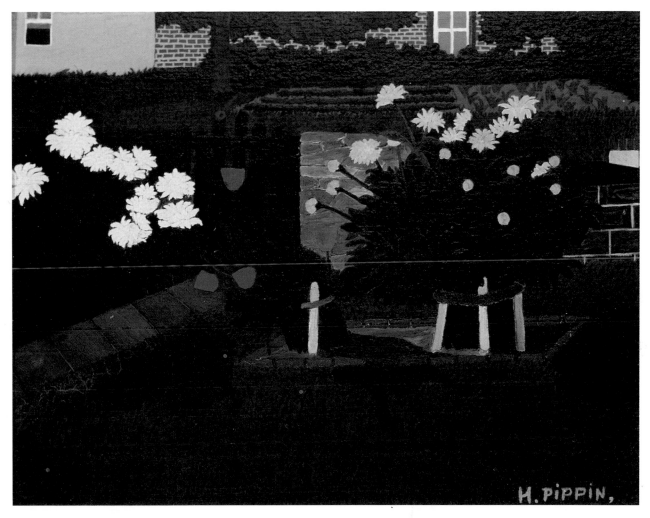

103 *My Backyard*, 1941. Oil on
canvas board, 11 × 14 in. Private
collection

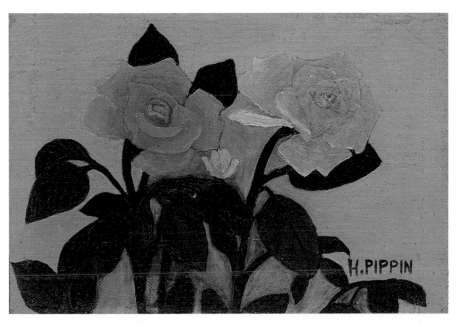

104 *Two Pink Roses*, 1940. Oil on
fabric, 6¾ × 9⅝ in. Collection Marjorie
and Herbert Fried

105 Cyclamen, 1941. Oil on canvas board, 8 × 10 in. Private collection

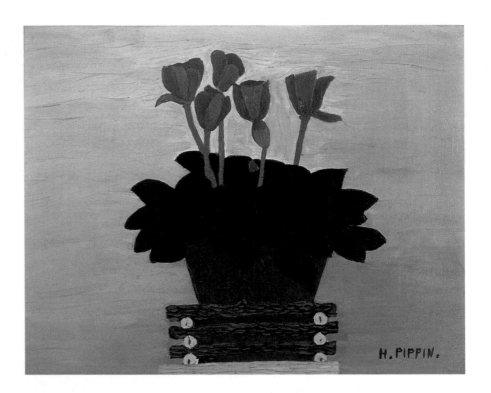

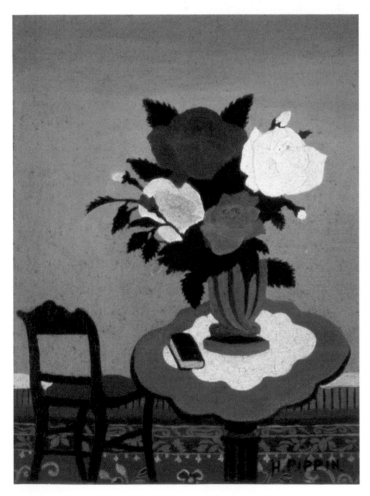

107 *Pink Flowers*, 1941. (Also known as *Pink Cyclamen*). Oil on canvas board, 10 × 14 in. Pennsylvania Academy of the Fine Arts, Philadelphia, Bequest of David J. Grossman, in honor of Mr. and Mrs. Charles J. Grossman and Mr. and Mrs. Meyer Speiser (1979.1.4)

106 *Roses with Red Chair*, 1940. Oil on fabric, 14 × 10 in. Photograph courtesy Janet Fleisher Gallery, Philadelphia

108 *Roses in a Jar*, 1940. (Also known as *Flowers and Books*). Oil on canvas board, 14½ × 11⅞ in. Private collection

109 *Spring Flowers with Lace Doily*, 1944. (Also known as *Vase of Flowers*).Oil on canvas board, 14 × 10 in. Private collection

floral motifs before 1940.[29] *The Admirer* could well be the transitional work in an evolution that had logically begun in 1935 with a larger, genre-oriented sense of neighborhood in *After Supper, West Chester* and culminated in more personalized vignettes derived from his garden and home throughout the 1940s.

Gardening was not uncommon in West Gay Street's narrow backyards and the open areas flanking the duplex units and row houses. Neighbors readily recall the animation with which the Pippins discussed selections and designs for their two gardens, one grown in their backyard essentially for pleasure from spring to late fall since the 1920s and another to which they drove.[30] *Giant Daffodils* (fig. 101) and *My Backyard* (fig. 103) afford glimpses of their carefully arranged and maintained plantings during the early 1940s. Although neither work provides an overview of the yard—where Pippin also spent a great deal of time painting—its old-fashioned intimacy and effort are nonetheless clear.

Pippin brought those same qualities indoors both literally and figuratively. Although Robert Carlen asserted that Pippin worked from paper flowers, potted plants and freshly cut flowers were regularly kept in the house, and his still-life paintings were stocked with his garden's flowers and greenery, from roses and zinnias to daisies and gladiolas.[31] Whether a still life features an unpretentiously potted cyclamen or a casual bouquet of roses dressed up by a vase, the dignity of detail granted to each petal, blossom, and leaf reflects the knowledge and spirit of a gardener's touch rather than scientific scrutiny or self-conscious pictorial research and emulation.

Since the 1940s the accessories and settings of Pippin's still lifes have been described as Victorian, as have a handful of his interior scenes dominated by over-

110 *Summer Flowers with Two Chairs*, 1944. (Also known as *Love Letter [Summer Flowers]*). Oil on fabric, 8½ × 11½ in. Private collection

111 *Flowers with Hat and Cane*, 1945. (Possibly known as *Flower Piece*). Oil on fabric, 9 × 11 in. Private collection

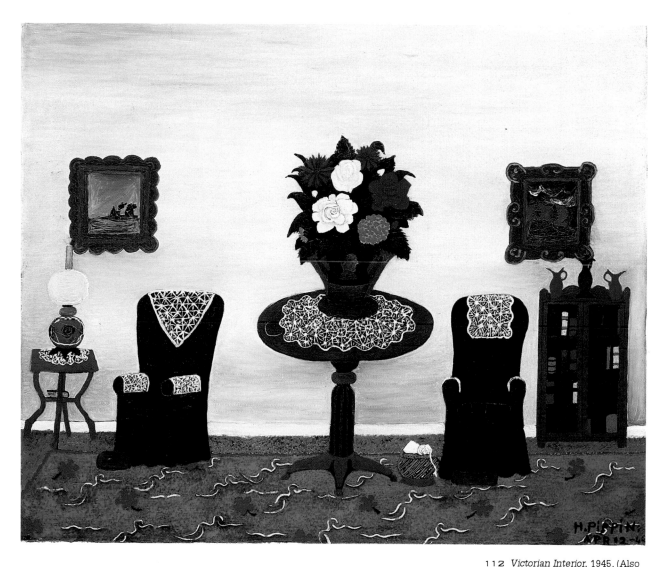

112 *Victorian Interior*, 1945. (Also known as *Victorian Interior II*). Oil on fabric, 25¼ × 30 in. The Metropolitan Museum of Art, New York, Arthur H. Hearn Fund, 1958 (58.26)

sized floral arrangements rather than people. The term's choice has been attributed to both the artist and his dealer Robert Carlen, but its origin remains unknown, as does the extent to which Carlen encouraged the usually independent Pippin to paint such works. Traditionally, the paintings have been characterized as a poor black man's rendering of the life-style of the affluent white, whether furtively glimpsed in households serviced by his mother in Goshen, New York, or directly observed during visits to the grand houses of private collectors in Philadelphia, along the Main Line, or in Chester County. And one must hesitate to assume that Pippin's sensitive distillation of furniture styles and details owes much to the recollection of what may well be apocryphal—exposure to fine furniture and pictures during his childhood in Goshen and his youthful employment by a New Jersey household storage and moving company. Unraveling the dynamic of these works is, in effect, as challenging as understanding the diverse connotations attached to the term Victorian itself.

Doilies decorating table tops, as in *The Love Note* (1944, fig. 188), or decorated glass oil lamps and antimaccassars protecting furniture, as in *Victorian Interior* (fig. 112), are emblematic of the old-fashioned fussiness popularly associated with the Victorian era, not only today but even in the 1930s and 1940s. It is this middle-class, if not lower-middle-class, sense of the old-fashioned and the homey,

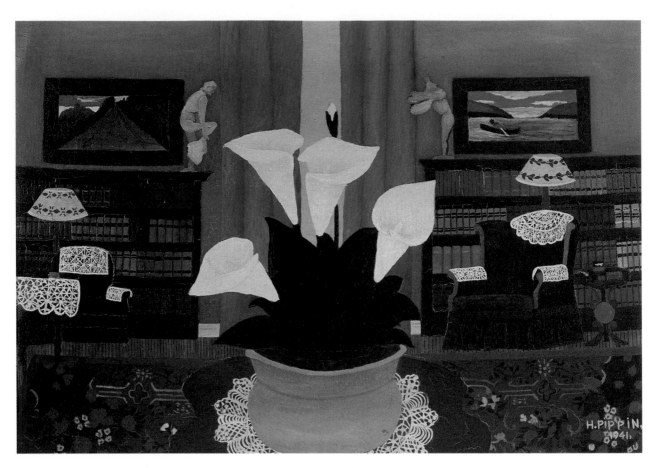

113 *Lilies*, 1941. Oil on fabric,
19½ × 27½ in. Private collection

however, that hints at something awry in interpretive quarters. So, too, does the curiously non-Victorian amalgam of furnishings in most of the still lifes and related interiors—eighteenth-century-style tilt-top tables and candle stands, sidechairs with Neoclassical crestrails, Art Deco figurative sculpture, and mass-produced, even crude, ceramics and glassware widely available after the 1920s.

The Victorian era's melange of styles is ostensibly linked by elements of the ornate, the romantic, the picturesque, and the exotic, all of which are noticeably missing from Pippin's works described as Victorian. His exposure to affluent Victorian settings in and around Philadelphia, may, in fact, have been quite limited, if the architectural and decorative styles of some of his patrons' residences are taken into consideration. Brooklawn, the estate of his patron Mrs. W. Plunket Stewart, was considered an eighteenth-century showcase, for example, while Willowbrook Farm of patron Mrs. John D. M. Hamilton in Paoli, Pennsylvania, may have been Colonial Revival, with some Moderne furnishings, based on the style of the room Pippin faithfully captured in *The Den* (1945, fig. 189). *Lilies* (fig. 113)—the first expansive still-life interior of 1941—and *Victorian Parlor* (fig. 114) may also be based on specific settings, yet the calla lilies, Art Deco statues, and curtain treatments speak to the modern rather than the Victorian.

The Pippin home has often been described as sparse and neat (fig. 115). Modest lace curtains contributed to this impression, as did the doilies and other coverings crocheted by Jennie Ora Pippin to protect and enhance their inexpensive, "pseudo-Victorian" furniture.[32] Details such as pipes, books, sewing baskets, and paired armchairs impart an "at home," "male/female" presence to the settings of the garden-derived still lifes, as in *Red, Yellow, and White Roses* (fig. 116). That some

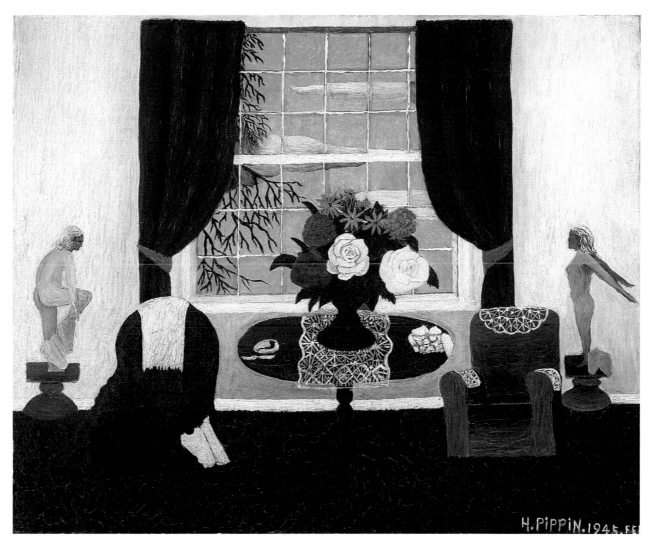

114 *Victorian Parlor*, 1945. (Also known as *Victorian Interior I*). Oil on fabric, 20 × 24 in. The Metropolitan Museum, New York, Bequest of Jane Kendall Gingrich, 1982 (1982.55.5)

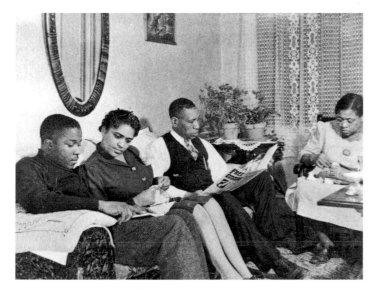

115 Photographer unknown. *Horace and Jennie Ora Pippin with Richard and Elizabeth Wade, in living room at 327 West Gay Street*, c. 1943. From *Horace Pippin: A Negro Painter in America* by Selden Rodman

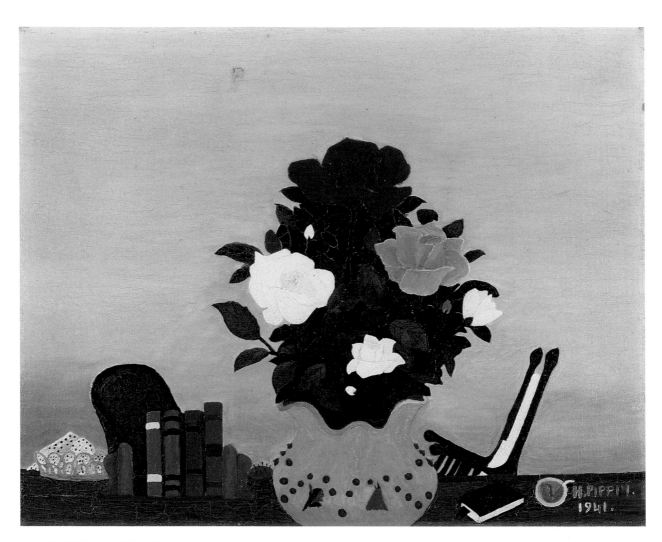

116 *Red, Yellow, and White Roses*,
1941. Oil on fabric, 16⅝ × 20⅛ in.
Collection Mrs. Robert Montgomery

of Pippin's family, neighbors, and acquaintances have reacted to the unpeopled interiors and still lifes as his attempts to picture if not embellish his own home is diametrically opposed to the traditional reading of these works.33 Although it is difficult to ascertain the degree to which autobiographical domesticity and observation of other life-styles have been interwoven in these works, it is nonetheless clear that the Victorian umbrella has shaded several scenarios.

Even wartime disruption figures prominently as a staging element for several of the still lifes and "Victorian" interiors. *Victory Vase* of 1942 (fig. 186) and *Victory Garden* of 1943 (fig. 117) acknowledge World War II two years before Pippin deplored its violence in the Edenic setting of the Holy Mountain series. Both *Victory Vase* and *Victory Garden* were products of the community victory gardens that sprang up across the country to meet wartime shortages and calls to rally the domestic front, a call to which the Pippins and other Chester County residents responded.34 Complete with bayonets and trenches, the figurative vignette on the "victory" vase resonates with Pippin's World War I memories, while the container's imaginatively insistent V-shape finds a quietly humorous echo in the V twice woven into the doily.

Pippin's concern for harmony in the face of war was very much rooted, however, in his own time, and the dates of key events of World War II, recorded on at least five paintings between 1944 and 1946, register that concern. The date entered

117 *Victory Garden*, 1943. Oil on fabric, 10 × 12 in. Collection Marjorie S. Loggia

on *Victorian Interior*—April 12, 1945—corresponds to Eisenhower's arrival at the Elbe River not far from Berlin and the Russian Army's march toward Vienna, which fell the next day. The presence of that date dispels the painting's studied domestic tranquillity yet echoes Pippin's attention to time, marked by clocks in many of his genre and historical works to both matter-of-fact and evocative effect.

Horace Pippin insisted that he "have all the details that are necessary" to "paint it exactly the way it is and exactly the way I see it."[35] Similarly, we need to retrieve these details to locate the reality of Pippin's works, from landscapes to still lifes, from portraits to life's interiors. Equally crucial is valuing these diverse subjects for their autobiographical, regional, and cultural underpinnings—underpinnings that link them irrevocably to Pippin's more celebrated paintings of war, spiritual harmony, and African-American life.

ACKNOWLEDGMENTS
I would like to acknowledge Mona Foad, my intern at the National Museum of American Art, and Beverly Shepherd, Pamela Powell, Margaret Bleeker Blades, and Marian Strode, staff of the Chester County Historical Society, West Chester, Pennsylvania, for their diligent, timely, and good-spirited assistance.

LYNDA ROSCOE HARTIGAN is Associate Curator of Painting and Sculpture at the National Museum of American Art, Washington, D.C.

1. Julius Bloch, Journal, June 15, 1940, Archives of American Art, Smithsonian Institution, Washington, D.C. Bloch chose the word "extraordinary."

2. This estimated number includes Pippin's early scenes of outdoor activities, which I consider landscapes.

3. Richard J. Boyle, "Connection with a Place: The Collection of the Brandywine River Museum," in *Brandywine River Museum: Catalogue of the Collection 1969–1989* (Chadds Ford, Pennsylvania: Brandywine Conservancy, 1991), p. 12.

4. Emma Milby, interview with the author, June 1992. Emma Milby—a former West Chester neighbor of the Pippins—noted the couple's interest in fishing for fun and food.

5. *Daily Local News*, October 17, 1913. Beverly Shepherd of the Chester County Historical Society confirmed the variety of outdoor activities prevalent in the area since the late nineteenth century and still pursued during Pippin's lifetime.

6. Mills in the Brandywine River Valley have been the subject of paintings since the nineteenth century. *Gilpin's Mill on the Brandywine*, 1830, attributed to Thomas Doughty (Brandywine River Museum) is one of the best-known examples. Judith E. Stein, curator of "I Tell My Heart," now dates *The Old Mill* to c. 1940 rather than its previously attributed date of 1930. The painting was purchased from Pippin's first exhibition at the Carlen Gallery in January 1940, but was undated on the checklist. It remained in the same collector's possession for over forty years. A recent conservation examination has revealed the presence of a touch of phthalocyanine green, a pigment which was introduced in 1938. Thus the painting must have been executed after 1938. It is possible that the composition itself dates from earlier in Pippin's career because a layer of yellowed varnish has been found under the visible surface, suggesting that the current image covers an earlier, similar composition. A corner of the sticker attached to the lower left of the painting bears a touch of white pigment, raising the possibility that the hidden image was once exhibited and numbered.

7. National coverage of the anniversary included Berenice Mueller Ball, "The Old Birmingham Meeting," *American Collector* 9 (October 1940).

8. Thomas Bostelle, interview with the author, June 1992. Active as a Chester County artist since the 1930s, Bostelle recalls that many local artists have considered the Meeting House and its site obligatory subjects and that Pippin was well aware of this attitude. Area artist Henry C. Pitz is most often credited with coining the concept of a "Brandywine Tradition," largely because of his book, *The Brandywine Tradition* (Boston: Houghton Mifflin Company, 1969).

9. I would like to acknowledge Richard Brigham and Mrs. Edward Brinton, members of the Birmingham Meeting, for discussing the building and its property. According to Mrs. Brinton, the Kentucky coffee tree is a deciduous North American tree that has flat, pulpy pods containing seeds used by colonists as a coffee substitute.

10. Sam Riccardo, interview with the author, July 1992. According to Riccardo, who was one of Pippin's neighbors during the early 1940s, *Harmonizing* is set on the corner of West Gay Street and Hannum Street; he also identified the site of *West Chester, Pennsylvania. Teachers College Powerhouse, Winter* may refer to the grounds of West Chester State Teachers College or Cheney State Teachers College, a black institution.

11. Bostelle, interview with the author.

12. Riccardo, interview with the author.

13. Although Pippin may not have worked directly from examples by area illustrators, one wonders if he saw N. C. Wyeth's *Alaskan Mail Carrier* in any of its massively distributed reproductions, from posters to wall hangings; the image features the standing figure of a man who has killed wolves in the snow.

14. The internationally known director Michael Balcon made *Lady of the Lake* in 1931. Its relevance to Pippin's work warrants investigation.

15. Suggestions that African or African-American folklore or music inspired *The Blue Tiger* have not been borne out by research. Pippin's familiarity with Chinese or Indian folktales or visual arts is undocumented and unlikely.

16. Selden Rodman and Carole Cleaver, *Horace Pippin: The Artist as a Black American* (Garden City, N.Y.: Doubleday and Co., 1972), p. 66. Rodman mentions a small sketch on paper of Pippin's wife, which has recently been located (fig. 83).

17. Bloch, Journal, June 15, 1940.

18. Rodman and Cleaver, *Horace Pippin*, p. 65.

19. Letter from Paul Dague to Chester County Historical Society, August 16, 1948. Collection of the Chester County Historical Society, West Chester, Pa.

20. "Butler Portrait: Too Few Medals, Too Much Blue," *Sunday Local News*, October 4, 1987. Butler's notice of an insufficient number of medals is mildly ironic, since he was known during his military career for having turned down medals when he thought his actions had not warranted their award.

21. *Ibid.*

22. Letter from Horace Pippin to Christian Brinton, July 10, 1938. Christian Brinton Papers, Archives of American Art, Smithsonian Institution, Washington, D.C.; courtesy Chester County Historical Society. Pippin did not elaborate upon why he wanted the photograph.

23. Bostelle, interview with the author.

24. "Water Boy" was an African-American work song transcribed by white Southerner Avery Robinson after hearing it sung by a black chain gang, probably during the early 1920s. In New York in April 1925, Robeson's performance of African-American spirituals and work songs such as "Water Boy" launched his career as a concert artist.

25. Selden Rodman, *Horace Pippin: A Negro Painter in America* (New York: The Quadrangle Press, 1947), pp. 15–16.

26. See for example, "'No Holds Barred' in Pippin Paintings," *Philadelphia Record*, March 23, 1941, Chester County Art Association Papers, Archives of

American Art, Smithsonian Institution, Washington, D.C.

27. Milby and Riccardo, interviews with the author.

28. George H. Straley, "Sale of Pippin's Painting Stirs County Art Leaders," *Daily Local News*, October 27, 1938, Brinton Papers.

29. *Ibid.*

30. Transcribed conversation between Emma Milby and Chester County art collector Roberta Townsend, December 1987, courtesy Roberta Townsend.

31. In an untaped interview conducted by West Chester painter Philip Jamison in 1987, Robert Carlen asserted that Pippin used paper flowers purchased at Woolworth's as props for his still lifes. In her interview with the author in June 1992, Emma Milby described the Pippins' custom of keeping flowers indoors.

32. Milby and Bostelle, interviews with the author. Bostelle characterized the furnishings as "pseudo-Victorian." He has suggested that the Pippins, like many working-class people in the area, purchased their furniture from Joe Pagnotta's West Chester store, which had offered plush and factory imitations of Victorian furniture since the post-Civil War era.

33. Ibid. Beverly Shepherd, Chester County Historical Society, interview with the author, June 1992. She recalls that Pippin acquaintances who visited the Society's 1988 Pippin exhibition candidly offered the observation that the floral still lifes and "Victorian" interiors represented Pippin's home. The strongest opinion to this effect was voiced by Pippin's daughter-in-law Elizabeth Wade in an interview with Sarah Wilson, January 1988.

34. Milby and Shepherd, interviews with the author.

35. Pippin quoted in *Philadelphia Evening Bulletin*, March 31, 1942, Robert Carlen Gallery Papers, Archives of American Art, Smithsonian Institution, Washington, D.C., and paraphrased by African-American painter and teacher Edward Loper in Loper's interview with Marina Pacini, May 1989, Archives of American Art, Smithsonian Institution, Washington, D.C.

Biblical and Spiritual Motifs

RICHARD J. POWELL

IN TEN PAINTINGS Horace Pippin explored biblical subject matter and spiritual themes. Although this work comprises a relatively small number (in comparison to Pippin's overall artistic production of over one hundred works of art), several of these paintings—like the Holy Mountain series—are considered some of Horace Pippin's very best works and represent an important, but rarely discussed, aspect of African-American visual expression: namely, modern religious art.

When one normally thinks of African-American religious art, the turn-of-the-century paintings of the expatriate artist Henry Ossawa Tanner immediately come to mind. If one were to think of modernist approaches to biblical subjects, then the works of African-American artists William H. Johnson, Allan Rohan Crite, or Romare Bearden might be more appropriate. Still, if one were to stretch the imagination and consider more community-based religious works, then an artist like James Van Der Zee might surface, as seen in his staged and photo-negative manipulated church altar and funeral parlor photographs of the 1920s and 1930s.

118 Elsie Anna Wood. *The Miracle of the Loaves and the Fishes*, 1950. Chromolithograph, 6¼ × 4⅞ in. Collection Robert A. Harman

It is unlikely that Pippin was familiar with paintings by any of these black artistic ancestors and relatives.[1] Nor would he have been cognizant of their European and Euro-American counterparts, artists like Georges Rouault, Albert Pinkham Ryder, and other painters of religious subjects. Instead, his notions of religious art principally came from the common, mass-produced chromoliths that have illustrated Bibles, church vestibules, and African-American homes since the advent of inexpensive color lithography (fig. 118).[2] As noted in the following description of decorations found in African-American homes, Pippin's early concept of art would have certainly come from these select, Judeo-Christian themes and visual narratives:

> Most of the pictures found [in African-American homes] were of a religious character, the subjects being such as St. John on the Isle of Patmos, Angels descending to the tomb of Christ, Daniel in the Lion's Den, Joseph with Christ in his arms, The Resurrection, The Fall of Jericho, and the Believer's Vision. . . .[3]

Pippin, who grew up in the African Methodist Episcopal Church, would have been familiar with these and other printed

119 *Christ (Crowned with Thorns)*,
1938. (Also known as *Head of
Christ*). Oil on fabric, 15¾ × 18½ in.
The Howard University Gallery of
Art, Washington, D.C.

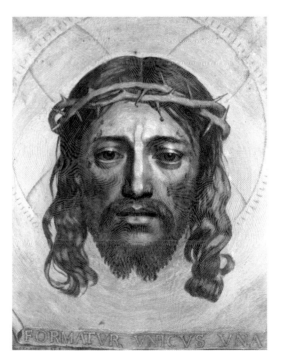

120 Claude Mellan (French,
1598–1688). *The Sudarium of Saint
Veronica*, 1649. Engraving, 17⅛ ×
12⅜₆ in. Grunwald Center of Graphic
Arts, University of California, Los
Angeles, Purchase (1962.33.1)

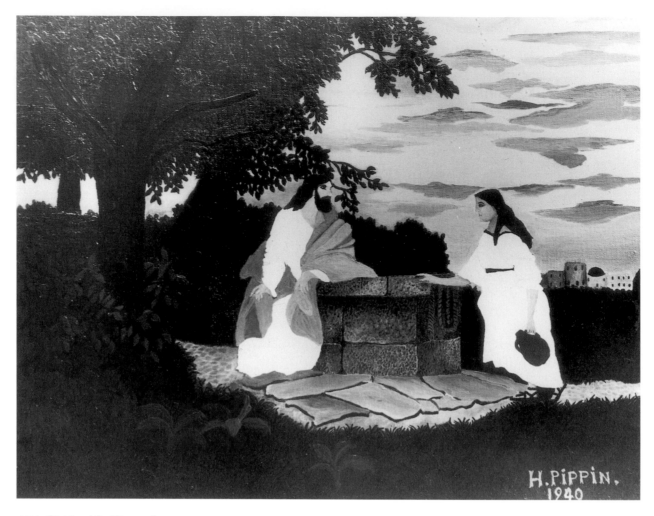

121 *Christ and the Woman of Samaria*, 1940. Oil on fabric, 19⅞ × 24¼ in. The Barnes Foundation, Merion, Pennsylvania (no. 986)

religious images. This familiarity with mass-produced religious pictorials manifested itself in his own artistic imagination as well. In one of Pippin's written accounts of his youth, he recalled designing a crayoned series of religiously themed illuminated muslin doilies for sale at a Sunday school festival. Unfortunately, the purchaser of these fragile doilies made the fatal mistake of washing them, which resulted in the obliteration of Pippin's youthful, visual testament![4]

As a mature artist, Pippin turned to oil on canvas to create his religious works. While the subject and tenor of these paintings varied, Pippin essentially concentrated on two general themes for this body of work: the life and death of Jesus Christ; and the image of the "Holy Mountain," as described in the Old Testament.

Christ (Crowned with Thorns) (fig. 119), which is the first of these religious paintings, is as powerful and hypnotic as any Renaissance or Baroque image of the suffering Christ. In fact, Claude Mellan's engraving *The Sudarium of Saint Veronica* (fig. 120)—one of the more popular sources for the *Ecce Homo* theme in Western art—shares Pippin's use of a frontal, masklike visage for the thorn-wearing, tormented Christ.[5] *Christ (Crowned with Thorns)* was originally purchased by Alain Locke, a Howard University professor of philosophy, the spiritual father of the Harlem Renaissance, and an African-American "culture broker" of sorts, during the 1930s and 1940s. Given Locke's early appreciation for African and African-American art, one can understand why he responded so positively to this stark, dramatic painting.[6]

By today's standards, Pippin's depiction of Jesus as a white man might seem odd, given Pippin's African-American background as well as his affiliation with the A. M. E. Church. However, it would have been unusual for Pippin or any other black artist in 1940 to paint Jesus as of any race other than white. In contrast to today's atmosphere of black pride and cultural nationalism among African Americans, the attitudes of most blacks in 1940 concerning physical ideals of beauty and dignity categorically excluded African physiognomy. With the exception of a few black artists (like William H. Johnson and Allan Rohan Crite), whenever biblical figures were depicted in art, they were almost always of European ancestry. Knowing that this Eurocentric mode was the ideal image, one can look at Pippin's *Christ and the Woman of Samaria* (fig. 121) and fully understand its conservative, even reactionary stance.

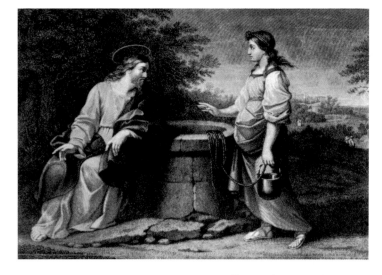

122 Unidentified artist. *Christ and the Woman of Samaria*. Engraving found in Pippin's papers after his death. From *Horace Pippin: A Negro Painter in America* by Selden Rodman

The Woman Taken in Adultery (1941) and *Christ Before Pilate* (1941), although similarly restrained, exude an individual expressivity through provocative compositional devices and juxtapositions of color. Both paintings present their New Testament narratives of Jesus Christ in shallow, *tableau vivant*-like settings. In *The Woman Taken in Adultery* (fig. 185), Pippin framed the ever popular maxim "He who is without sin, cast the first stone" (John 8: 1–11) within a brilliant patchwork of cloaked figures and an off-white background. Correspondingly, Pippin's strategic placement of black, white, the gray scale, and a rainbow of colors in *Christ Before Pilate* (fig. 123) effectively steer one's eye from one principal actor in the scene to another, thus advancing his adjunct message of religious persecution, the horrors of the police state, and the dangers of a "mob mentality." With this subtext as an added thematic backdrop, Pontius Pilate's resemblance in this painting to the Nazi leader Adolf Hitler may not be entirely coincidental. In both paintings, the unprecedented depiction of Jesus Christ as having a darker complexion than either the white backgrounds or the other *white* people in the pictures raises interesting questions, perhaps unanswerable, about Pippin's formal and/or conceptual motives.

On the surface, Pippin's *The Crucifixion* (fig. 124) does not differ significantly from the prevailing crucifix images found in traditional Western art. Pippin's Christ, while a product of his untutored eye, nevertheless conveys a Northern Renaissance-like sense of anguish and moral outrage, in the style of Matthias Grünewald (fig. 125). Also like Grünewald, Pippin interjected into this holy scene a touch of evil, barely perceptible as a disembodied devil's head in the lower left quadrant of the painting.

Pippin's emphasis in *The Crucifixion* on the blood of Christ—ruby red drops and rivulets shown against a near black background and his pink flesh—recalls the bloody finale of *The Blood of Jesus* (1941), a popular, independent black film of that same era. In this instance, the resemblance between the painting and the film probably has less to do with Pippin's direct appropriations from it, than with a shared African-American and fundamentalist perspective on the crucifixion.[7]

The *Temptation of Saint Anthony* (fig. 126), one of Pippin's last religious paintings apart from the Holy Mountain series (1944–1946), has more in common with "The Temptation of Christ" theme. Painted in 1946, the year of Pippin's death,

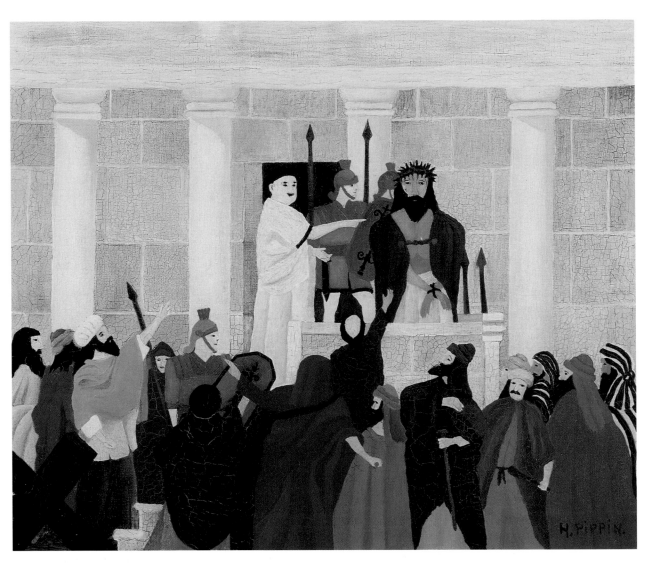

123 *Christ Before Pilate*, 1941.
(Also known as *Behold the Man*). Oil
on fabric, 20 × 24 in. Collection Janet
and Joseph Shein

the *Temptation of Saint Anthony* invokes the setting and characterizations most
often associated with Saint Matthew's description of Jesus's forty days in the wilder-
ness. The emotional contrast here between the austere, alpine-like landscape and
the two demonic figures—one standing in a literal "valley of death" and the other
standing opposite the reclining Saint Anthony—is unsettling. Part of this painting's
unsettling mood may be derived from the fact that the *Temptation of Saint Antho-
ny*, unlike many of the other religious paintings by Pippin, was a *commissioned*
rather than a *self-generated* subject. Understandably, Pippin's greater familiarity
with New Testament accounts of the temptation of Christ replaced the more apoc-
ryphal stories of Saint Anthony's various entrapments.[8]

The Holy Mountain series (figs. 127–129, 171) was painted between 1944 and
1946: a period in which Pippin achieved widespread recognition as an artist. Fre-
quently, these and other paintings were featured in major exhibitions spotlighting
the talents of American, Negro, and/or Contemporary artists, although the nonaca-
demic or "folkloric" aspects of Pippin and his work certainly played into the posi-
tive reception as well. Robert Carlen's role during these years as the chief advocate
for not only Horace Pippin's paintings, but for the Peaceable Kingdom paintings
of the itinerant Quaker artist Edward Hicks (1770–1849), explains to a great extent

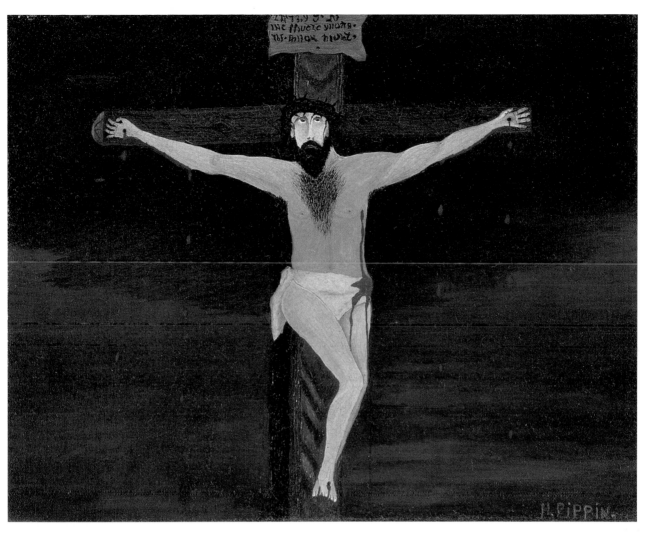

124 *The Crucifixion*, 1943. Oil
on fabric, 16 × 20 in. The Menil
Collection, Houston (79-14 DJ)

125 Matthias Grünewald
(German, c. 1475/80–1528). *The
Small Crucifixion*, c. 1511–20. Oil on
wood, 24¼ × 18⅜ in. National Gallery
of Art, Washington, D.C., Samuel H.
Kress Collection (1961.9.19)

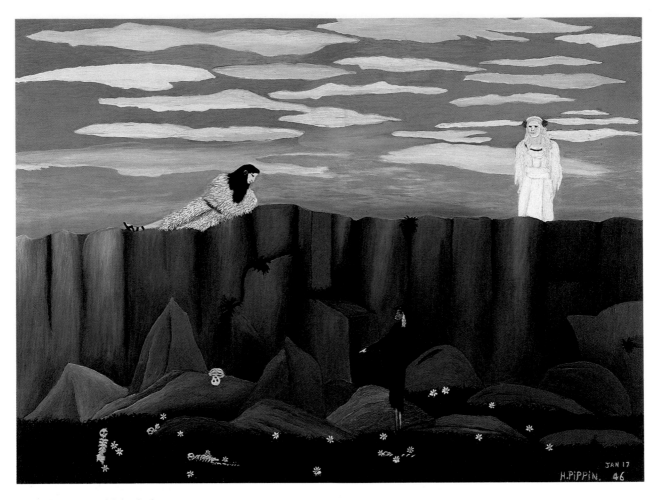

126 *Temptation of Saint Anthony*,
1946. Oil on fabric, 36 × 48 in.
Collection Ann and James Harithas

why Pippin's Holy Mountain series emerged at this time with such a strong, visual presence.

Between 1820 and 1849, Edward Hicks painted the Peaceable Kingdom theme at least sixty times and possibly over one hundred times (fig. 130). Adapted from preexisting engravings and paintings, and based largely on biblical and historical narratives, the Peaceable Kingdom paintings essentially illustrate verses from the Old Testament book of the Prophet Isaiah:

> The wolf shall also dwell with the lamb,
> and the leopard shall lie down with the kid;
> and the calf and the young lion and the fatling
> together; and a little child shall lead them.
> And the cow and the bear shall feed; their
> young ones shall lie down together: and the lion
> shall eat straw like the ox.
> And the suckling child shall play on the
> hole of the asp, and the weaned child shall put
> his hand on the cockatrice's den.
> They shall not hurt nor destroy in all my
> holy mountain: for the earth shall be full of
> the knowledge of the LORD, as the waters cover
> the sea. (Isaiah 11: 6–9)

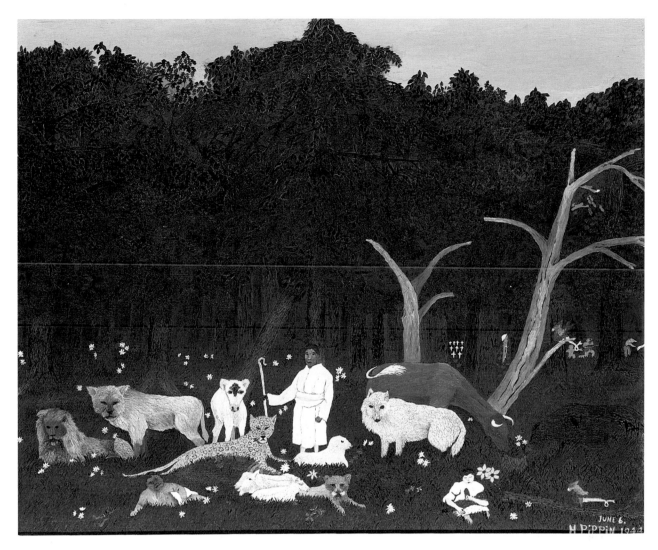

127 *The Holy Mountain I*, 1944. Oil on fabric, 30 × 36 in. Collection Camille O. and William H. Cosby, Jr.

Isaiah's prophecy of world peace and Edenic harmony in nature was a perfect theme for an artist like Hicks, who lived and worked during a period when American society was undergoing much spiritual self-discovery and reassessment. Hicks's depiction of wild and domesticated animals grazing and relaxing together, along with cherubic children and peripheral scenes of Indians and colonists signing peace treaties and conducting religious services, all conveyed to nineteenth-century audiences the dreamy, otherworldly aspects of this Old Testament text. But Edward Hicks, being a Quaker, no doubt painted these fantastic scenes with at least some sense of an attainable pacifist model and/or peace-loving ideal in mind. 9

Pippin, after being introduced to Hicks's Peaceable Kingdom paintings by Robert Carlen, created his own painted concepts of nonviolence and complete accord in the universe. However, Pippin's paintings are only superficially similar to Hicks's work. Apart from a fairly consistent use of children, and real and imaginary animals, Pippin's three renditions of Isaiah's vision situated the idea of peace and harmony within the concept of a spiritual, yet vital and fundamental "Holy Mountain." Taking his title for this series from chapter 11, verse 9 of Isaiah, Pippin encapsulated the notion of the world being a "holy mountain" and "full of knowledge" in the recurring image of thick grass, errant wildflowers, and a dense forest. Somewhat like the African-American interpretations of white Protestant hymns,

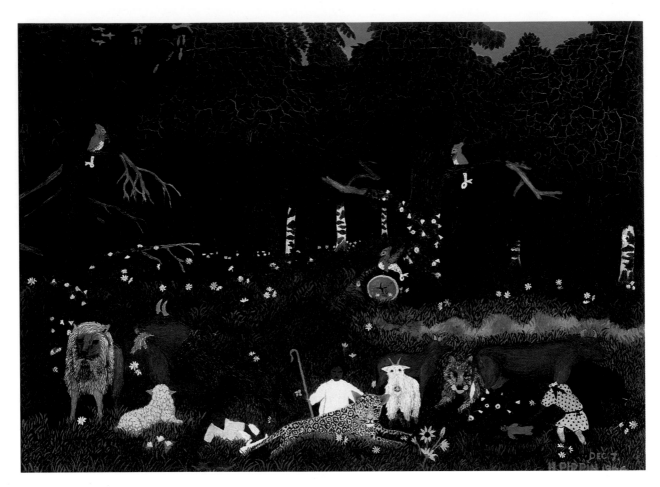

128 *The Holy Mountain II*, 1944.
(Also known as *The Kingdom of
God*). Oil on fabric, 23 × 30 in.
Private collection

Pippin's Holy Mountain series invested the Old Testament prophesy of Isaiah and
the Quaker vision of Hicks with a specificity and meaning all their own.[10]

A shepherd of African ancestry, wearing white flowing robes and holding a
shepherd's crook, is the most obvious alteration to Hicks's formula.[11] The shepherd,
a symbol throughout the Bible for divine leadership and benevolence, takes on an
added meaning here, in that humanity has a special, shepherd-like responsibility
to the *whole* of nature. In *The Holy Mountain I*, this shepherd figure bears such a
striking resemblance to Horace Pippin himself that one is inclined to interpret this
self-portrait as a kind of modern *sacra conversazione* or, in the mode of many
African-American spirituals and gospel songs, singing (or "testifying") in the first
person.[12]

In addition to the shepherds, all of the Holy Mountain paintings have—in
the implied, distant forest of each scene—silhouetted images of soldiers, airplanes,
bombs, and crosses that resemble grave markers. Pippin, choosing not to leave these
pictorial elements up to an open interpretation, described them as the "little ghost-
like memor[ies]" of World War I and of life in "the [segregated] south." In the con-
text of Isaiah's vision, one can translate Pippin's statement to mean that the specters
of discord and destruction are never very far removed from the concepts of peace
and harmony.[13]

Pippin stressed this ideological dialectic between war and peace even further
with the dates on each of his Holy Mountain paintings. "June 6," the date which
appears on *The Holy Mountain I*, corresponds with D-Day, or the day during the
Second World War that the Allied forces landed on the coast of Normandy. "Dec

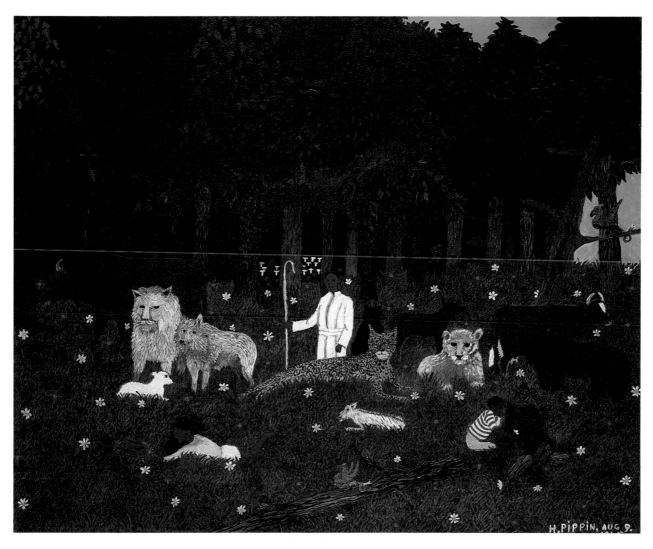

129 *The Holy Mountain III*, 1945. Oil on fabric, 25 × 30¼ in. Hirshhorn Museum and Sculpture Garden, Smithsonian Institution, Washington, D.C., Gift of Joseph H. Hirshhorn, 1966 (66.4069)

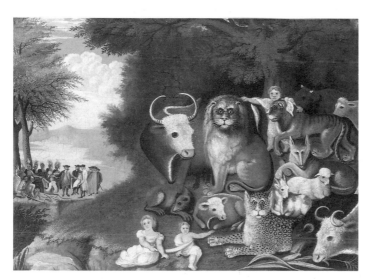

130 Edward Hicks (1780–1849). *The Peaceable Kingdom*, c. 1833. Oil on canvas, 17⅞ × 23¹⁵⁄₁₆ in. Pennsylvania Academy of the Fine Arts, Philadelphia, John S. Phillips bequest, by exchange (acquired from the Philadelphia Museum of Art, originally the 1950 bequest of Lisa Norris Elkins) (1985.17)

7," which appears in the lower right corner of *The Holy Mountain II*, commemorates the third anniversary of the Japanese sneak attack on Pearl Harbor. "Aug 9," the date on *The Holy Mountain III*, makes reference to the day when the United States dropped the atomic bomb on Nagasaki. These significant (and some might even say, infamous) dates of World War II, interjected into Pippin's idyllic scenes of peaceful coexistence in the world, underscored his frequently quoted statement about the Holy Mountain paintings, that "all [of this is what] we are going through now. But there will be peace."[14]

Beyond the assorted inhabitants of Pippin's Holy Mountain, the land itself figures prominently in each of the three paintings. In *The Holy Mountain III*, the various creatures seem to be little more than appendages to the vast, richly textured expanses of foliage in the picture. In contrast to Hicks's placid and calm Peaceable Kingdom, nature in Pippin's Holy Mountain series is pulsating, alive, and clearly "full of the knowledge of the LORD" (Isaiah 11: 9). As the title *Holy Mountain* implies, the land lives up to its reputation, as suggestive in the red, crucifix-like flowers scattered throughout the grassy foreground.

In a description of his discovery of popular painting in Haiti, Pippin's first biographer, Selden Rodman, stated that prior to his first encounter with Haitian art, his "eyes had just been opened to the genius of popular art by a self-taught painter [Pippin] in rural Pennsylvania."[15] Around 1946, the year that Horace Pippin began (but did not finish) the last of his Holy Mountain paintings, a group of self-taught black artists in Haiti—Castera Bazile, Wilson Bigaud, Philome Obin, and others—began painting religious themes. Like Pippin's biblical and spiritual motifs, their images of Jesus Christ, the saints, and religious ceremonies were also inspired by popular prints and an African-American aesthetic. Although unaware of Pippin's existence, their work embraced a perspective to which Pippin had held steadfast throughout his career: to "paint things exactly the way they are."[16] In artistic matters pertaining to the spiritual, however, this dictum necessitated that these Haitian artists, like Pippin, paint not only what they *saw*, but also what their hearts and souls *felt*. In numerous ways, their tradition of colorful, unencumbered narratives and "holy," spirit-charged images is indeed linked to their artistic predecessor and "good shepherd," Horace Pippin.

RICHARD J. POWELL is Andrew W. Mellon Assistant Professor of Art History at Duke University, Durham, North Carolina.

1. Pippin's indifference toward his fellow African-American artists is discussed in Romare Bearden's "Horace Pippin," in *Horace Pippin*, exh. cat. (Washington, D.C.: The Phillips Collection, 1977), u.p.

2. Peter C. Marzio recounts the cultural impact of color lithography in the United States in *The Democratic Art, Chromolithography 1840–1900: Pictures for a 19th Century America* (Boston: David R. Godine, 1979).

3. Jerome Dowd, "Art In Negro Homes," *The Southern Workman* 30 (February 1901), p. 91.

4. Horace Pippin, "Notebooks," c. 1920. Horace Pippin War Memoirs, Letters, and Photographs, Archives of American Art, Smithsonian Institution, Washington, D.C.

5. For a discussion of *The Sudarium of Saint Veronica*, see Alvin L. Clark, Jr., *From Mannerism to Classicism: Printmaking in France, 1600–1660* (New Haven: Yale University Art Gallery, 1987), p. 47.

6. Alain Locke, *The Negro in Art* (Washington, D.C.: Associates in Negro Folk Education, 1940), p. 134. In his essay and biographical notes on "The Negro as Artist," Locke wrote that Pippin's "naive but masterly juxtapositions of color and his lovely decorative patterns have placed him in the forefront of contemporary primitives."

7. In one of the most controversial scenes from *The Blood of Jesus* (a film by Spencer Williams), the protagonist —who, for much of the film, is having an out-of-body experience while lying on her deathbed —stands at the foot of a large wooden cross, where the blood (from the crucified Jesus) literally drips and splatters over her face and body. For a discussion on the crucifixion theme in African-American art, see: Richard J. Powell, "'In My Family of Primitiveness and Tradition:' William H. Johnson's *Jesus and the Three Marys*," *American Art* 5 (Fall 1991), pp. 20–33.

8. A comparison of this work and the circumstances surrounding the temptation of Jesus Christ is subtly alluded to by Pippin in the following statement: "The devil had him up in the cloud, then . . . St. Anthony landed on the edge of a rocky cliff. There . . . he had come to the greatest temptation of all, that is to . . . either to give up everlasting life, [or] obtained everlasting life, for at this time he felt as if every bone in his body were broken . . . that Death would be better." (Letter from Horace Pippin to Robert Carlen, January 18, 1946. Robert Carlen Gallery Papers, Archives of American Art, Smithsonian Institution, Washington, D.C.) For more information on the commissioning of the *Temptation of Saint Anthony*, see Judith E. Stein's essay in this catalogue.

9. The two major works on Edward Hicks are Eleanore Price Mather and Dorothy Canning Miller, *Edward Hicks: His Peaceable Kingdoms and Other Paintings* (Newark: University of Delaware Press, 1983) and Alice Ford, *Edward Hicks: His Life and Art* (New York: Abbeville, 1985).

10. For a discussion of Afro-American adaptations of Euro-American hymns and spiritual songs, see Paul Oliver, "Spirituals," in *The New Grove Gospel, Blues, and Jazz* (New York: W. W. Norton and Co., 1986), pp. 1–22.

11. Pippin's image of a robe-wearing shepherd of African ancestry recalls similar characterizations from the very popular Broadway play (1930) and, later, motion picture (1936) *The Green Pastures*. Marc Connelly's fantasy script arranged for an "all-Colored cast" to play each of the biblical roles in this theatrical piece, including "De Lawd" himself. For vintage photographs of *The Green Pastures,* see Langston Hughes and Milton Meltzer, *Black Magic: A Pictorial History of the Negro in American Entertainment* (Englewood Cliffs, N.J.: Prentice-Hall, 1968), pp. 114–116.

12. Lawrence Levine discusses this marked shift, in much twentieth-century African-American blues and gospel music, from a more distant, third person voice to a more personalized, first person voice, in *Black Culture and Black Consciousness* (New York: Oxford University Press, 1977), pp. 174–189.

13. Letter from Horace Pippin to Robert Carlen, reprinted in Selden Rodman, *Horace Pippin: A Negro Painter in America* (New York: Quadrangle Press, 1947), p. 20.

14. Pippin in Rodman, *Horace Pippin*, p. 20. I am especially grateful to Lynda Roscoe Hartigan and Judith E. Stein for bringing these significant dates to my attention.

15. Selden Rodman, *Where Art is Joy, Haitian Art: The First Forty Years* (New York: Ruggles de Latour, 1988), p. 21.

16. Horace Pippin quoted by Edward Loper, interview with Marina Pacini, May 12, 1989, Archives of American Art, Smithsonian Institution, Washington, D.C.

At Work and at Play

JUDITH WILSON

PIPPIN'S GENRE PAINTINGS fall into three categories: outdoor activities, scenes of everyday life, and subjects derived from popular culture. His depictions of outdoor activities include some of his earliest extant works. *Losing the Way* (1930) and *The Bear Hunt (I)* and *(II)* (both 1930) show Pippin beginning to apply pigment to the burnt-wood panels the artist said he first made "in the winter of 1925."[1] They are spare works that barely hint at the mastery of color he would achieve a decade later in *The Squirrel Hunter* (1940).

Already, though, in *Losing the Way* (fig. 131) the artist demonstrates a remarkable flair for design. The painting shows a man walking beside a covered wagon drawn by a single horse; the man is in search of a lost path through a landscape blanketed with snow. While the subject is visual disorientation, the artist carefully guides the viewer through the scene. Note the play of rhyming convex curves that leads the eye from a small snowy hillock at upper right to the rippling contours of the wind-bloated wagon cover, then descends to the twin domes of the man's hat and the horse's collar, and finally flows down through the profiled horse's head. From there, one's gaze ultimately drops to the emphatic countercurve of the fallen tree bough, then is pulled up again by a pair of echoing concave curves where land and sky meet at upper left. The overall effect is reminiscent of Chinese landscape paintings in which a lyric understatement replaces detailed description.

The majority of Pippin's outdoor genre pieces are hunting or fishing scenes. In addition to stalking bear and shooting squirrel, his gallery of hunters also trap game—*Trapper, Pocono Mountains* (by 1937)—and bag fowl—*Duck Shooting* (fig. 132). In two instances, titles reveal general locations. A creek in southeastern Pennsylvania, near West Chester, furnished the site for *Fishing in the Brandywine: Early Fall* (fig. 133), while a mountain range in northeastern Pennsylvania provided the setting for *Trapper, Pocono Mountains*.

Other examples of his outdoor genre paintings show aspects of rural life with which Pippin might have grown familiar either around 1898, when his mother left Goshen to work in a "country" hotel, or around 1902–3, when the fourteen-year old youth was employed as a farmhand at James Gavin's summer resort.[2] In *Country Doctor* (fig. 134) Pippin lauds the dedication of rural physicians. One of his most elegant compositions, this nocturnal snow scene combines the brilliant design sense of *Losing the Way* with a subtle rendering of tonal variation.[3] *Maple Sugar Season* (1941) displays much less formal sophistication—a lapse that may reflect the relative intractability of its medium—oil on burnt-wood. But it nonetheless records its subject with a charming candor.

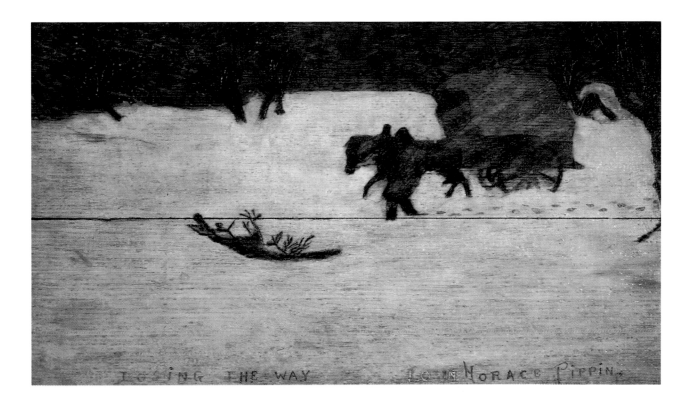

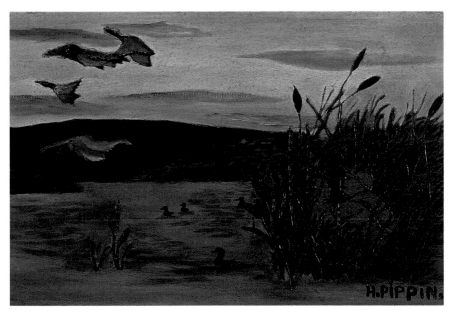

131 *Losing the Way*, 1930.
(Originally titled *Country Doctor Lost in the Snow*; also known as *Lost in the Woods: Going Home*).Oil on burnt wood panel, 12⅟₁₆ × 20⅝₁₆ in. The State Museum of Pennsylvania, Harrisburg (64.22)

132 *Duck Shooting*, 1941. Oil on burnt-wood panel, 9½ × 14½ in. Collection Marvin and Alice Sinkoff

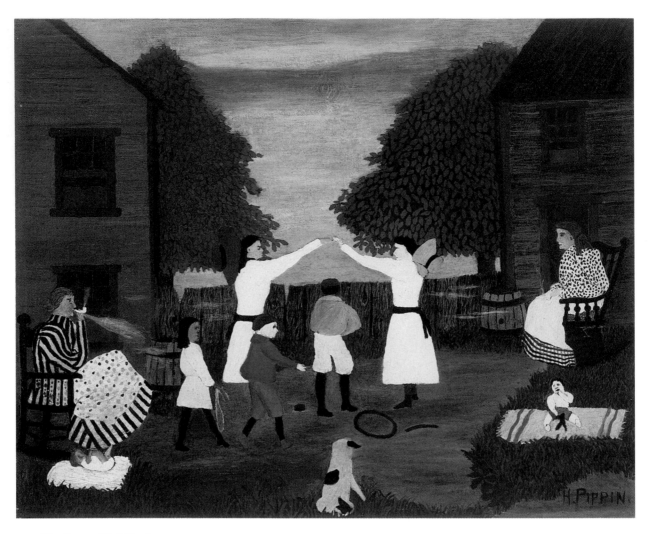

135 *After Supper, West Chester,*
c. 1935. Oil on fabric, 19 × 23½ in.
Collection Leon Hecht and Robert
Pincus-Witten

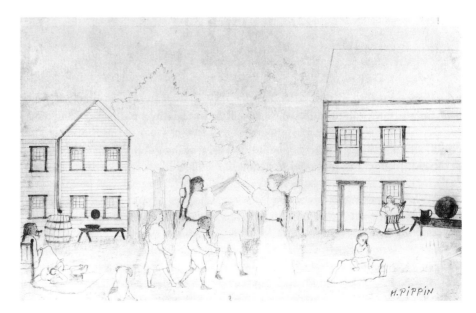

136 *After Supper, West Chester*, c. 1935. Pencil on
cardboard, 14 × 22⅛ in. The Metropolitan Museum of Art,
New York, Bequest of Jane Kendall Gingrich, 1982
(1982.55.8)

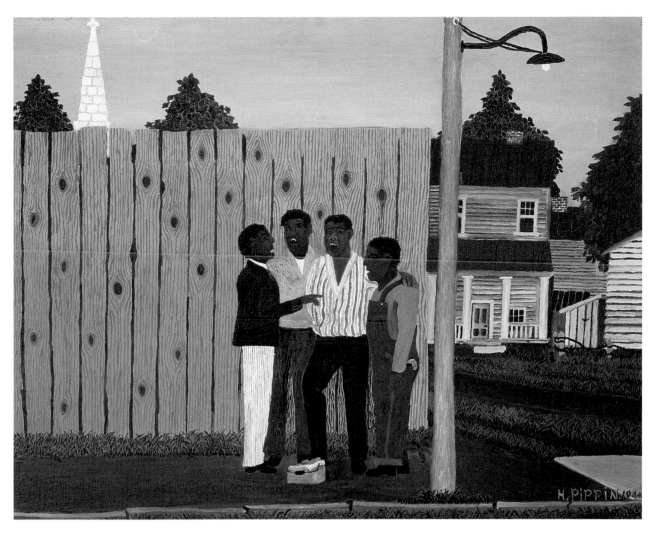

137 *Harmonizing*, 1944. Oil on fabric, 24 × 30 in. Allen Memorial Art Museum, Oberlin College, Ohio, Gift of Joseph and Enid Bissett, 1964 (64.26)

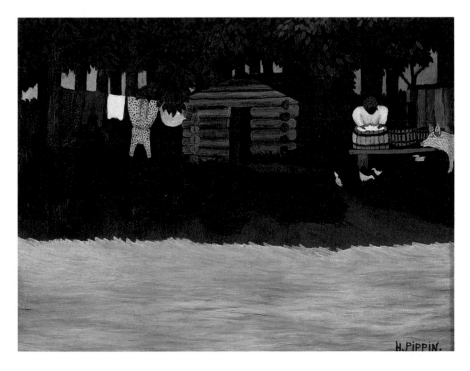

138 *The Wash*, c. 1942. Oil on fabric, 13½ × 17½ in. Private collection

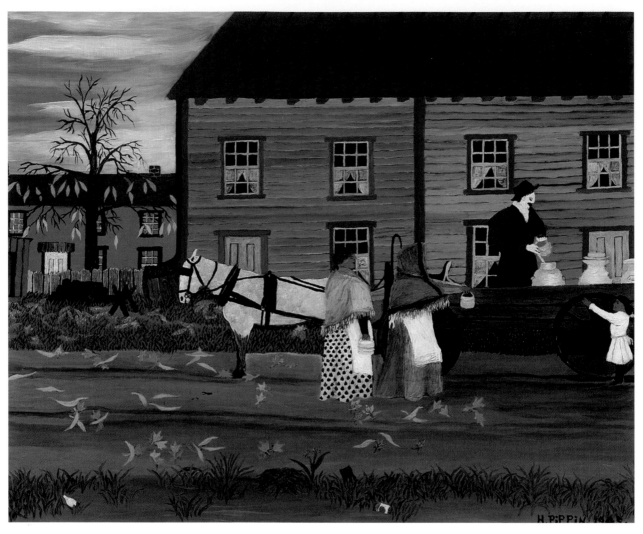

139 *The Milkman of Goshen*, 1945. Oil on fabric, 24 × 31 in. Private collection

U.S. black population located below the Mason-Dixon line prior to 1900, Northern blacks "tended to be relatively invisible to the white masses" at this time.[6] And judging by an early twentieth-century review of Paul Laurence Dunbar's *Sport of the Gods*, a 1902 novel concerning black life in New York City, middle and upper-class whites were equally oblivious to the North's few black inhabitants: "It is a. . . whole stratum of society of which all of us are densely ignorant and of whose very existence most of us are wholly unaware," the anonymous white reviewer confessed.[7] Thus, Pippin's domestic interiors offer rare glimpses of a little-known group, the African-American residents of small Northeastern cities prior to the great migrations of the early twentieth century.

Pippin painted at least eight domestic interiors. Each picture shows family members engaged in routine activities in a single multipurpose room.[8] The 1941 version of *Saturday Night Bath* (fig. 141) focuses on a kneeling mother and the child whose back she is busy scrubbing as he squats in a wooden wash tub. In *Asleep* (fig. 142), two children lie side by side in a small bed in the corner of a room. The most famous of these works, *Domino Players* (fig. 143) features four figures grouped around a kitchen table—a gray-haired matron who smokes a clay pipe as she plays dominoes with a younger woman opposite her, a bored-looking boy seated between the pair, and a third woman who observes the game as she sits close by, but not

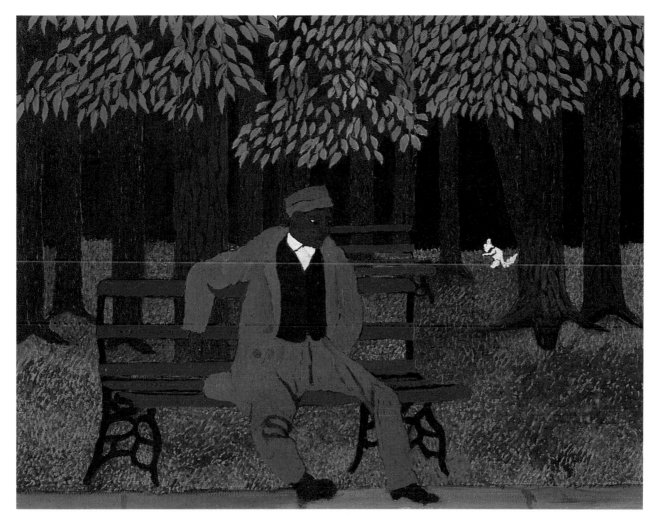

140 *Man on a Bench*, 1946. (Also known as *The Park Bench*). Oil on fabric, 13 × 18 in. Collection Mr. and Mrs. Daniel W. Dietrich II

directly beside, the table and pieces a quilt. Interestingly, Pippin told his dealer Robert Carlen that *Domino Players* represented a scene from his own childhood, showing the artist as a young boy in the company of his female relatives.9 In *Saying Prayers* (fig. 144), two barefoot children—a girl and a boy—in their nightclothes crouch at their mother's knees reciting their bedtime prayers. Unlike any of the other works in this category, *Sunday Morning Breakfast* (fig. 145) depicts a family group that includes a father, seen either putting on or taking off his shoes (i.e., either preparing to depart or having just arrived), while his wife serves breakfast to the little girl and boy who sit at the table. On a winter's evening, the mother in *Interior* (fig. 146) sits resting and smoking a pipe, while one of her children is seated on the floor cradling a doll and the other stands at a table, probably reading by candlelight. In *Christmas Morning, Breakfast* (fig. 147), a woman serves a stack of pancakes to a lone male child, perched at a table a few feet away from the gaily decorated Christmas tree beneath which lay several presents. And, finally, the 1945 *Saturday Night Bath* (fig. 148) repeats the general subject of the 1941 version but adds a number of new details—such as the dog at left—and records the scene at a greater distance, displaying a wider expanse of the room.

Despite the relative economy of his style, Pippin always manages to supply significant details, often revealing substantial information about his subjects' material life. In several instances, such as the 1941 *Saturday Night Bath* and *Asleep*, large patches of plaster have fallen from the walls exposing bare boards, and in many of

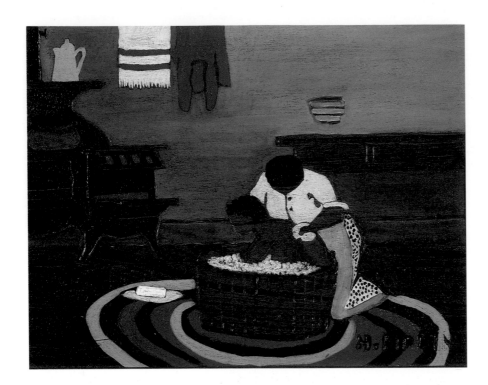

141 *Saturday Night Bath*, 1941.
(Also known as *Saturday Night*). Oil
on burnt-wood panel, 8½ × 11½ in.
Private collection

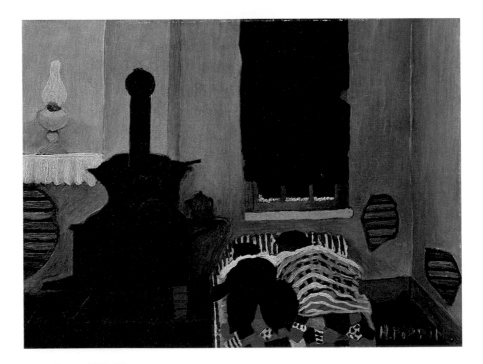

142 *Asleep*, 1943. Oil on canvas
board, 9 × 12 in. The Metropolitan
Museum of Art, New York, Bequest
of Jane Kendall Gingrich, 1982
(1982.55.3)

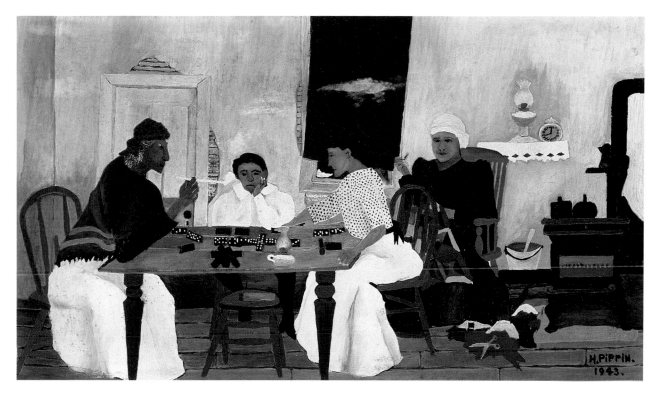

143 *Domino Players*, 1943. (Also known as *Dominoes*). Oil on composition board, 12¾ × 22 in. The Phillips Collection, Washington, D.C. (1573)

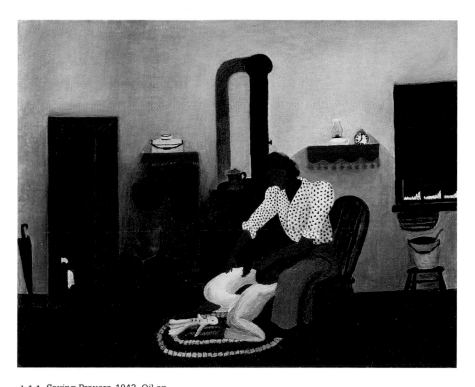

144 *Saying Prayers*, 1943. Oil on fabric, 16 × 20⅛ in. Brandywine River Museum, Chadds Ford, Pennsylvania, The Betsy James Wyeth Fund (80.4)

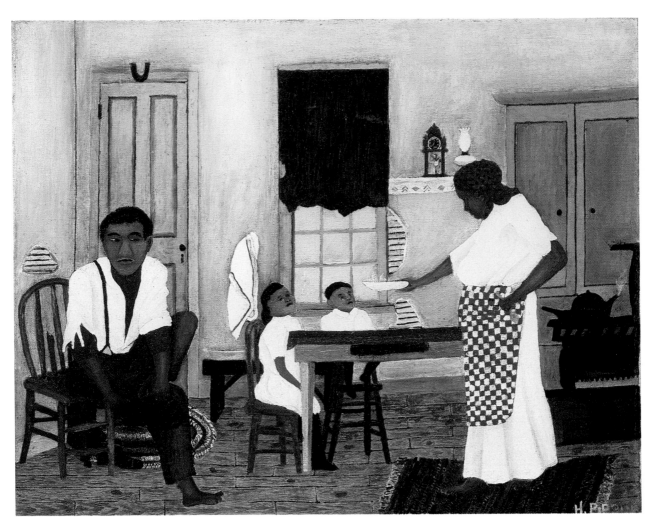

145 *Sunday Morning Breakfast*, 1943. Oil on fabric, 16 × 20 in. Private collection, courtesy Galerie St. Etienne, New York

the paintings, a single window is forlornly draped with a torn curtain or shade. Except for the rooms seen in *Domino Players* and *Asleep*, the furnishings always include a few brilliant hued rag rugs scattered over the wood plank floor. A child's playthings—a toy train in the 1945 *Saturday Night Bath*, a doll and some kind of stuffed animal in *Interior*—can sometimes be seen. A recurring element in all of these images is a squat, black wood-burning stove. Source of heat (the children's bed is placed beside it on a snowy night in *Asleep*, while their mother warms her feet by propping them inside one of its oven doors in *Interior*), as well as sustenance, it looms in the background, an ever-present symbol of domestic well-being.

One group of Pippin's domestic interiors is less familiar, a subcategory composed of works that might be labeled "historical genre." They represent household scenes set in the past and are inhabited by white, as well as black, figures. *The Hoe Cake* (fig. 149), for example, depicts a black subject—a barefoot, headwrapped woman stooping to bake a small circle of cornmeal over an open fire. Like *Six O'Clock* (fig. 150) and *Quaker Mother and Child* (fig. 151)—both works containing white subjects—it shows an open hearth where, in later times, a wood stove would be. And, like *Six O'Clock* and the unfinished *Family Supper (Saying Grace)* (fig. 153), it features an interior in which the walls consist of unplastered lengths of wood.

Two of these historical images—*Six O'Clock* and *Quaker Mother and Child*—can be linked to *Domino Players* to demonstrate Pippin's appreciation of

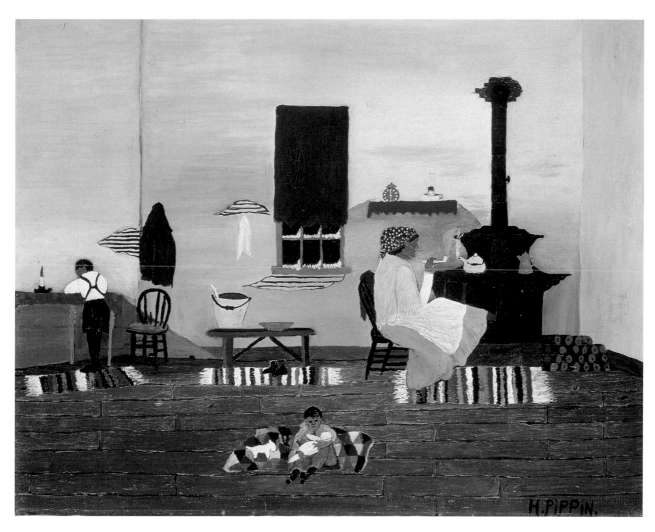

146 *Interior*, 1944. (Also known as *Interior of Cabin*). Oil on fabric, 24⅛ × 29¾ in. National Gallery of Art, Washington, D.C., Gift of Mr. and Mrs. Meyer P. Potamkin in honor of the Fiftieth Anniversary of the National Gallery of Art (1991.42.1)

a traditionally female art form, needlework. The woman seated by the hearth in *Six O'Clock* is embroidering while she simultaneously keeps watch over a teapot suspended above the flames and the infant on a fur rug on the floor beside her. In the other two pictures, both the Quaker mother and the African-American woman who sits watching her companions play dominoes are busy piecing quilts. The color sequences remain consistent in the Quaker quilter's design. But they shift unpredictably—from bands of white, white, brown, red to red, brown, white, green—in the borders framing the pinwheel motif seen on the African-American quilt. This tendency to enliven pattern through the deliberate use of irregularity is thought to be an African-derived trait, and is often seen in quilts made by African Americans (fig. 154).[10] Thus, *Domino Players* documents the persistence of African aesthetic preferences during the late nineteenth century and their geographical diffusion as Southern blacks moved north.

While human interactions with Nature and the conduct of ordinary social life inspired Pippin's first two types of genre scenes, a variety of pop cultural artifacts apparently gave rise to the third. The painting that prompted his discovery by Christian Brinton and N. C. Wyeth, *Cabin in the Cotton I* (fig. 155), is the earliest example.[11] Pippin probably based his composition on a 1932 film of the same name by Michael Curtiz, future director of *Casablanca*.[12] The artist seems to have borrowed his composition from the movie's opening and closing credit sequences, in

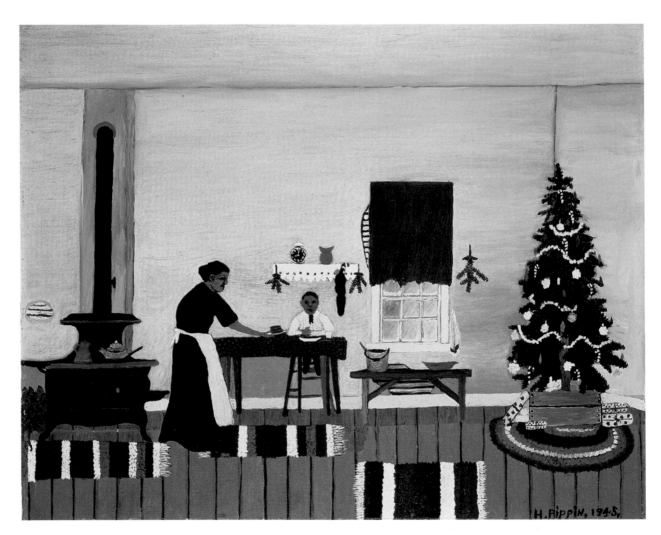

147 *Christmas Morning,
Breakfast*, 1945. Oil on fabric, 21 ×
26¼ in. Cincinnati Art Museum,
Edwin and Virginia Irwin Memorial
(1959.47)

which the titles float over a tableau featuring a rustic cabin at the edge of a sea of
cotton. The film's source was a 1931 novel of the same name by Harry Harrison
Kroll, who merged two contemporary literary trends—regionalism and social
protest—in a melodramatic tale about the clashing interests of Southern planters
and poor white tenant farmers. That the theme of the book and film held special
significance for Pippin can be surmised from his return to it in 1944, when he paint-
ed three more versions (figs. 156-158).[13]

It seems curious and revealing that, in *Cabin in the Cotton III*, Pippin made
central a peripheral member of the film's cast—the black musician we see in the
canvas, stationed outside the cabin strumming a banjo. In the movie, the actor
Clarence Muse plays a blind, guitar-playing singer who is led through the streets
by a young boy. Appearing only briefly and at intervals throughout the drama, the
blind man functions as both Tiresias and Greek chorus for this modern morality
play. The woman smoking her pipe at left in the canvas appears nowhere on screen.

Southern black males are represented in all of Pippin's works derived from
pop culture. Two—*Old Black Joe* (fig. 160) and *Water Boy* (fig. 187), both 1943—
are drawn from musical sources. Written in 1860, Stephen Foster's "Old Black Joe"
was the debt-ridden songwriter's lament for lost youth and plea for release from
life's woes, placed in the mouth of a venerable black servant. A fusion of traits drawn
from minstrelsy and the period's genteel sentimental ballads, the song proved to be
Foster's greatest and last success. Seventy-five years after his death, it gained a new

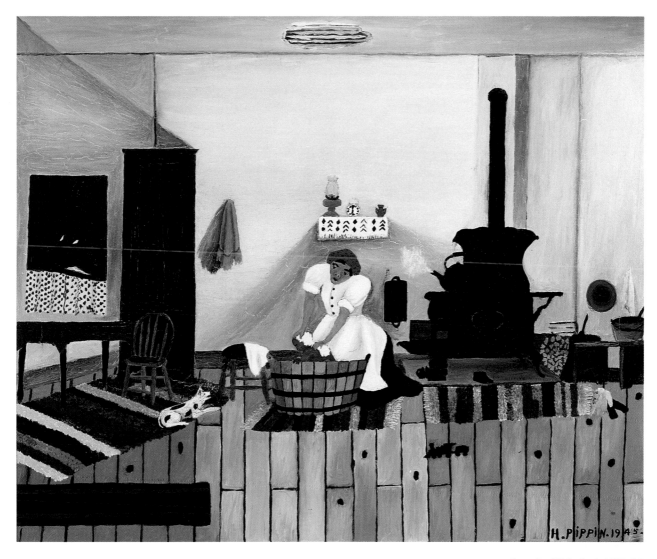

148 *Saturday Night Bath*, 1945. Oil on fabric, 25¼ × 30¼ in Collection Mrs. Eunice W. Johnson

audience when performed by Al Jolson in the 1939 film *Swanee River*, an apocryphal musical biography of Foster, with Don Ameche in the lead role, released in Technicolor by Twentieth-Century Fox.[14]

At the center of Pippin's *Old Black Joe*, seated on one of the artist's signature split-log benches[15] in an enormous daisy-dotted field of grass, the elderly servant peers forlornly at the viewer. A former coachman,[16] he is now reduced to such minor household tasks as tending the small girl who picks flowers at the canvas's far right edge. A long lead is tied, at one end, around her waist; the opposite end is wrapped around the walking stick on which Joe leans. A woman, presumably the child's mother, stands on the colonnaded porch of a stately plantation manor in the background at left, while a snow white field of cotton stretches back to the horizon and rolls from the side of the house to the picture's opposite right edge. Like heavenly mountains, huge billowing clouds tower above the horizon. Thus, the artist skillfully evokes the song lyrics:

> Gone are the days when my heart was young and gay,
> Gone are my friends from the cotton fields away,
> Gone from the earth to a better land I know,
> I hear their gentle voices calling "Old Black Joe."[17]

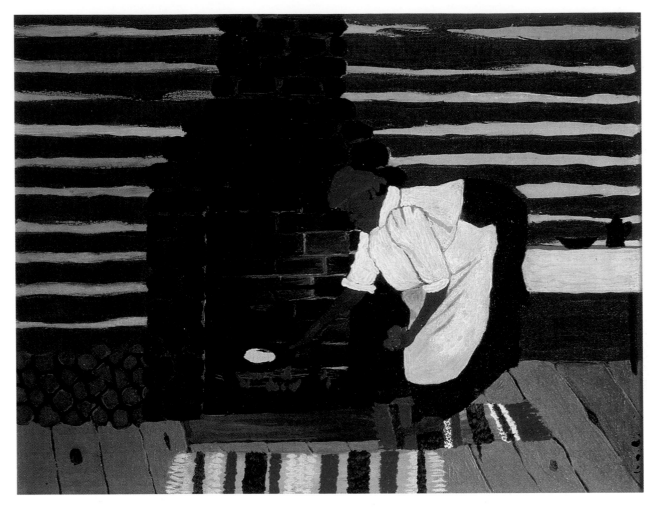

149 *The Hoe Cake*, c. 1946. Oil on
fabric, 14 × 18 in. New Jersey State
Museum, Trenton, Purchase
(FA1986.13)

The painting was commissioned by the Capehart Division of Farnsworth Television & Radio Corporation for the Capehart Collection, a group of works by contemporary artists used to advertise such products as the Capehart-Panamuse, a console-style AM-FM radio featuring a Chippendale cabinet. A portfolio sold by dealers of Capehart equipment reproduced works in the collection. Pippin's *Old Black Joe* appears in a full page *Life* magazine ad (fig. 161) in which the accompanying promotional copy stresses the cathartic powers of music—its ability to soothe "the careworn" and invigorate "the brave"—a persuasive selling point in the midst of the Second World War.[18] Yet, the artist has deftly sidestepped the written text's cloying sentimentality, presenting instead a subtle meditation on the moral economy of slavery—its reduction of grown men to the status of children, its production of wealth by trading human lives for bales of cotton, and its exchange of black labor for divine promissory notes.

"Water Boy," on the other hand, was a traditional African-American convict work song that had been set to music in 1922 by Avery Robinson. Three years later, fresh from his back-to-back triumphs in Eugene O'Neill's controversial plays *All God's Chillun Got Wings* and *The Emperor Jones*, Paul Robeson included the song in a concert of spirituals and work songs that launched his career as a vocalist and marked the first time such music had been performed publicly in a nonchoral form. The song would subsequently become a standard feature of Robeson's concert repertoire, and he recorded it several times.[19] Pippin may have heard Robeson

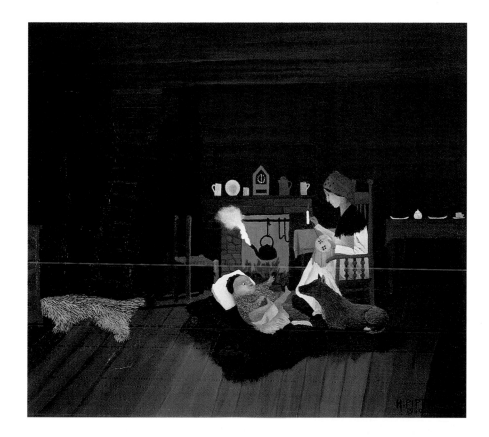

150 *Six O'Clock*, 1940. (Also known as *Cabin Interior*, *By the Fireside*, *Waiting*). Oil on fabric, 25 × 28 in. Private collection

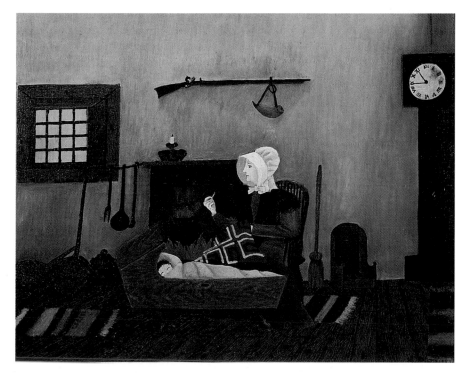

151 *Quaker Mother and Child*, c. 1944. Oil on fabric, 16 × 20 in. Museum of Art, Rhode Island School of Design, Providence, Jesse H. Metcalf Fund (44.094)

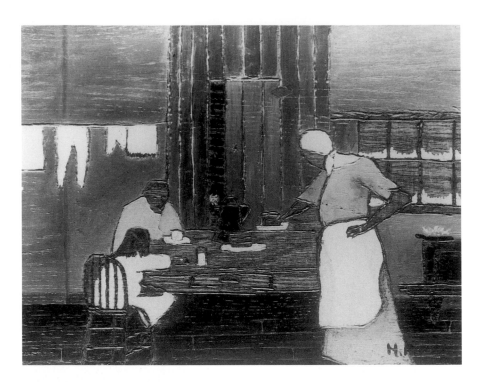

152 *Supper Time*, 1940. Oil on burnt-wood panel, 11¹⁵⁄₁₆ × 15 in. The Barnes Foundation, Merion, Pennsylvania (no. 985)

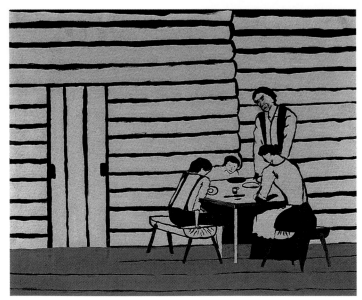

153 *Family Supper (Saying Grace)*, 1946. Unfinished oil on fabric, 18 × 22 in. The Metropolitan Museum of Art, New York, Bequest of Jane Kendall Gingrich, 1982 (1982.55.4)

154 Joanna Pettiway, Alabama. *Pinwheel Quilt*, Collection Maude Southwell Wahlman

155 *Cabin in the Cotton I*, 1935.
Oil on fabric, 18 × 33 in. The Art
Institute of Chicago, In memoriam:
Frances W. Pick from her children
Thomas F. Pick and Mary P. Hines
(1990.417)

on one of his many concert tours and/or known one of his recorded versions of
"Water Boy." In any case, the eponymous painting bore the subtitle *A Dedication
to Paul Robeson* when it was exhibited in the artist's spring 1944 show at The Down-
town Gallery.[20]

The final example of Pippin's use of popular culture as a thematic source is
the nineteenth-century abolitionist tear-jerker *Uncle Tom's Cabin*. Initially serial-
ized in an abolitionist newspaper, *The National Era*, the Harriet Beecher Stowe
novel finally appeared in book form on March 20, 1852. Three thousand copies sold
that day.[21] A year later, the book's sales in the United States had reached a then
unprecedented 300,000, while "approximately one million copies [were] sold in
Great Britain during the same period."[22] By 1855, *Uncle Tom's Cabin* was available
in seventeen European languages. As Hugh Honour has observed, "[n]o book had
previously. . . reached so wide a public in so short a time."[23]

While Stowe's book reached record audiences, it has been estimated that for
every one person who would read the novel, "perhaps as many as fifty people would
eventually see *Uncle Tom's Cabin*, the play."[24] As early as January 1852, almost three
months before *The National Era* ran the final installment of the serialized *Uncle
Tom*, a stage version written "by an offended proslavery Baltimorean" opened at the
Baltimore Museum.[25] By the end of the year, two other dramatic versions—one
produced by P. T. Barnum—could be seen in New York City and traveling the-
ater troupes had brought the play to Salt Lake City, Cleveland, and Detroit.[26] "In
1879," according to A. M. Drummond and Richard Moody, "*The New York Dra-
matic Mirror* listed the routes of forty-nine traveling 'Tom' companies. Twenty years
later this number had increased ten-fold." As late as "the summer of 1927 there were
still a dozen companies on the road." In addition to these numerous dramatiza-
tions, the book in its early years spawned a lantern-slide presentation and a diora-
ma. A century after its theatrical debut, *Uncle Tom's Cabin* was said to have had
"over a million performances" and to have "drawn more Americans into the the-

NOTES

1. Pippin, quoted in Dorothy C. Miller, "Horace Pippin," *Masters of Popular Painting: Modern Primitives of Europe and America*, exh. cat. (New York: The Museum of Modern Art, 1938), p. 125.

2. Horace Pippin, "My Life's Story," *Three Self-Taught Pennsylvania Artists: Hicks, Kane, Pippin*, exh. cat. (Pittsburgh: Museum of Art, Carnegie Institute, 1966), u.p.

3. *Country Doctor* shares with *Losing the Way* not only a frugal, almost abstract style of composition reminiscent of Chinese paintings and Japanese woodcuts, but also a common motif—snow as an obstacle to human activity—and a specific compositional element—the small, horse-drawn covered wagon that appears in both paintings.

4. I have omitted *The Wash* (c. 1942, fig. 138) from this chronology, because it may deserve a category of its own. While it definitely is an outdoor scene of everyday life, such features as the log cabin, farm animals (a hog at far right and ducklings nearby on the grass), as well as the riverine setting appear in none of the other outdoor daily life paintings by Pippin I know. Thus, I suspect the image is meant to represent a period prior to the artist's lifetime—perhaps based on the reminiscences of one or more of his parents, grandparents, or other relatives.

5. For examples of Pippin's work concerned with racial themes, see the discussion of Pippin's *Uncle Tom* below, as well as discussions of his war-related canvases, *Mr. Prejudice* (1943) and *Deep Are the Roots* (1945). His numerous depictions of white subjects include such genre paintings as *The Squirrel Hunter* and *Country Doctor* (both previously discussed), *Six O'Clock* (1940) and *Quaker Mother and Child* (c. 1944) (discussed below), in addition to historical paintings dealing with Abraham Lincoln and John Brown, and portraits of such figures as his mentor Christian Brinton and the retired Marine Corps officer, Major General Smedley D. Butler.

6. William Julius Wilson, *The Declining Significance of Race: Blacks and Changing American Institutions* (Chicago: University of Chicago Press, 1980), pp. 63, 65.

7. Unsigned review, *The Bookman* 23 (April 1906), quoted in Gilbert Osofsky, *Harlem: The Making of a Ghetto*, 2nd ed. (New York: Harper Torchbooks, 1971), p. 41.

8. In stating that "Pippin spent the better part of his indoor life [in Goshen] in the kitchen" and that "[i]n many black homes the kitchen was the only room," Rodman stressed a single function of such multipurpose rooms. But given the evidence supplied by the group of domestic interiors discussed here, it seems clear that the paintings depict a space in which bathing (*Saturday Night Bath*, 1941), sleeping (*Asleep*, 1943), domino playing or opening the presents beneath a Christmas tree (*Christmas Morning, Breakfast*, 1945) are as apt to occur as cooking or eating (*Sunday Morning Breakfast*, 1943). Selden Rodman "Horace Pippin" in *American Folk Painters of Three Centuries*, eds. Jean Lipman and Tom Armstrong (New York: Hudson Hills Press in association with the Whitney Museum of American Art, 1980), p. 213.

Furthermore, if it is correct to assume that all of Pippin's works of this type represent the same dwelling, then one painting indicates this residence has at least *two* rooms. In *Saying Prayers* (1943), a bed is visible through an open doorway leading off the main room.

9. Nancy Carlen, interview with Judith E. Stein, August 7, 1991.

10. For further discussion of the range and implications of such aesthetic practices, see Robert Farris Thompson, "From the First to the Final Thunder: African-American Quilts, Monuments of Cultural Assertion," in Eli Leon, *Who'd A Thought It: Improvisation in African-American Quiltmaking*, exh. cat. (San Francisco Craft and Folk Art Museum, 1988), pp. 12–21; and Maude Southwell Wahlman, *Signs and Symbols: African Images in African-American Quilts* (New York: Penguin U. S. A., 1993).

11. Leon Anthony Arkus, "Horace Pippin 1888–1946," *Three Self-Taught Pennsylvania Artists: Hicks, Kane, Pippin*, exh. cat. (Pittsburgh: Museum of Art, Carnegie Institute, 1966), u.p. Rodman in *American Folk Painters*, p. 216.

12. John Gillett, "Michael Curtiz," *Cinema—A Critical Dictionary: The Major Film-makers, Vol. 1: Aldrich to King*, ed. by Richard Roud (New York: Viking, 1980), p. 243. I base this speculation partly on the fact that Pippin, like the film's makers, dropped the initial article of the title of Harry Harrison Kroll's novel, *The Cabin in the Cotton*, and partly on the possibility that his limited education may have left the artist disinclined to read novels.

13. Selden Rodman, *Horace Pippin: A Negro Painter in America* (New York: Quadrangle Press, 1947), p. 87. Rodman lists *Old King Cotton* (fig. 159) as a study for *Cabin in the Cotton IV* (fig. 158). Both works are related to a commission for *Vogue* magazine, discussed by Judith E. Stein elsewhere in this catalogue.

14. Deems Taylor, Foreword, pp. 7–8; John Tasker Howard, "Stephen Collins Foster," pp. 11–12; Howard, "Old Black Joe" (historical note), p. 135; Stephen C. Foster, "Old Black Joe," pp. 135–136, all in Deems Taylor, *et al., A Treasury of Stephen Foster* (New York: Random House, 1946). Gilbert Chase, *America's Music: From the Pilgrims to the Present*, rev. 2nd ed. (New York: McGraw-Hill, 1966), pp. 297–298. Frank S. Nugent, "Swanee River," in *The New York Times*, December 30, 1939.

15. Such benches also appear in Pippin's *Uncle Tom* (1944), discussed below, and his unfinished *Family Supper (Saying Grace)* (1946).

16. According to Stephen Foster's granddaughter, Mrs. A. D. Rose, "Joe" was "a servant in the home of Jane ["Jeanie with the Light Brown Hair"] McDowell in the days when [Foster] was courting her." In addition to "some household duties, such as admitting visitors in the evenings," Joe "drove Jane's [physician] father on his rounds." Howard, "Old Black Joe," in Taylor, *Stephen Foster*, p. 135.

17. Foster, in Taylor, *Stephen Foster*, pp. 135–136.

18. "Song of the Soil" [advertisement], *Life*, November 15, 1943, p. 24.

19. Roger Lax and Frederick Smith, *The Great Song Thesaurus*, 2nd ed. (New York: Oxford University Press, 1989), p. 408. Marie Seton, *Paul Robeson* (London: Dennis Dobson, 1958), pp. 30–36. Ron Ramdin, *Paul Robeson: The Man and His Mission* (London: Peter Owen, 1987), pp. 46, 58, 61. Carol J. Oja, ed., *American Music Recordings: A Discography of 20th-Century U.S. Composers* (Brooklyn, New York: The Institute for Studies in American Music for the Koussevitsky Music Foundation, 1982), p. 252.

20. *H. Pippin*, exh. announcement (New York: The Downtown Gallery, February 15–March 11, 1944). Judith E. Stein believes *Water Boy* is probably the unspecified painting cited by Rodman (*Horace Pippin*, p. 4) that was commissioned by Angelo Herndon; see her discussion of it elsewhere in this catalogue.

21. A. M. Drummond and Richard Moody, "The Hit of the Century: Uncle Tom's Cabin—1852–1952," in *Educational Theatre Journal* 4 (December 1952), p. 315. Tremaine McDowell, "The Negro in the Southern Novel Prior to 1850," in *Images of the Negro in American Literature*, eds. Seymour L. Gross and John Edward Hardy (Chicago, University of Chicago Press, 1966), p. 69.

22. Thomas F. Gossett, *Uncle Tom's Cabin and American Culture* (Dallas: Southern Methodist University Press, 1985), p. 239.

23. Hugh Honour, *The Image of the Black in Western Art*, Vol. IV: *From the American Revolution to World War I*, Part 1: *Slaves and Liberators* (Cambridge: Harvard University Press, 1989), p. 200.

24. Gossett, *Uncle Tom's Cabin*, p. 260. I am extremely grateful to Margherita M. Desy for drawing my attention to the "Tom Show" phenomenon and directing me to the extensive literature on the subject.

25. Drummond and Moody, "Uncle Tom's Cabin," p. 316. Edward G. Fletcher, "Illustrations for Uncle Tom," in *The Texas Quarterly* 1 (Spring 1958), p. 168.

26. Drummond and Moody, "Uncle Tom's Cabin," p. 319.

27. *Ibid.*, pp. 315, 320, 321.

28. Donald Bogle, *Toms, Coons, Mulattoes, Mammies and Bucks: An Interpretive History of Blacks in American Film* (New York: Bantam, 1973), pp. 1, 3, 6.

29. Gossett, *Uncle Tom's Cabin*, p. 383. *The Reel South and Other Worlds*, program (Charlottesville: Virginia Festival of American Film, October 29–Nov. 1, 1992), p. 30.

30. Stowe, quoted in James F. O'Gorman, "Billings, Cruikshank, and *Uncle Tom's Cabin*," *Imprint* 13 (Spring 1988), p. 13.

31. O'Gorman, *ibid.*

32. *Ibid.*, pp. 13–14, 16–17. Indeed, during the mid-nineteenth century, according to Margherita M. Desy, both the chapter sixteen and twenty-two "Tom and Eva" scenes inspired Staffordshire figurines, German needlepoint patterns, American cast metalware candelabra, and the main card for the German game of "Onkel Tom's Hutte". Desy's invaluable study of this class of objects, known as "Uncle Tomitudes," encompasses only the 1852–55 period, however. Thus, it is unclear whether Horace Pippin could have seen similar objects a half century or so later. Margherita M. Desy, "'Uncle Tomitudes:' The Commercial Immortalization of *Uncle Tom's Cabin*," unpublished M.A. thesis, George Washington University, 1991; pp. 5, 54, 57–58, 61, 63, 67–68, 171–173, 186–188, 193.

33. Abraham A. Davidson, *The Story of American Painting* (New York: Harry N. Abrams, 1974), p. 23.

34. David C. Driskell, *Two Centuries of Black American Art* (New York: Alfred A. Knopf, 1976), p. 69. Both Davidson and Driskell's remarks exemplify what John Michael Vlach has lamented as "the expectations held for so-called primitives." Chief among these is the belief that their visions are either timeless or perpetually stuck in the past. Such notions seem not unrelated to what James Clifford, in a discussion of First World attitudes toward Third World cultures, has called the "salvage paradigm"—i.e., "a desire to rescue 'authenticity' out of destructive historical change," which Clifford links to Raymond Williams's conception of pastoral nostalgia. Vlach, *Plain Painters: Making Sense of American Folk Art* (Washington, D.C.: Smithsonian Institution Press, 1983), p. 151. Clifford, "Of Other Peoples: Beyond the 'Salvage' Paradigm," in *Dia Art Foundation: Discussions in Contemporary Culture, Number One*, ed. Hal Foster (Seattle: Bay Press, 1987), pp. 121–122. Williams, *Culture and Society: 1780–1950* (New York: Columbia University Press, 1983), pp. 258–260.

III

TECHNIQUE

Materials and Techniques

MARK F. BOCKRATH &
BARBARA A. BUCKLEY

WRITINGS ABOUT HORACE PIPPIN to date have contained occasional references to his methods of painting that have been gleaned from a few comments by the artist and from anecdotes by his contemporaries. In these accounts, comparatively little information was gained from discussions with the artist himself, or from direct observation of him at work by others. The myth arose that Pippin was an unsophisticated technician whose understanding of artists' materials was rudimentary until he received the guidance of professionals in the art establishment. It is true that Pippin's methods were often unconventional, but as these methods were continually evolving, generalizing about them is difficult and can be misleading.

It is hoped that this essay will help to put these random observations into the context of the artist's entire career by comparing previously published statements with data compiled from recent examinations of the paintings themselves. Over sixty paintings were examined by the authors and other conservators in the course of this investigation, utilizing visual examination techniques in conjunction with infrared reflectography, optical microscopy, and x-radiography when possible. Collecting and correlating technical data on Pippin's paintings should give curators and collectors a starting point for their own investigations of known Pippin paintings, newly discovered works, and possible forged ones.

As an artist, Pippin was challenged by the circumstances of his life. He had to overcome the physical limitations of his injured right arm, his inability early in his career to purchase expensive artists' materials, his lack of academic training in painting and drawing, and the difficulty of finding time to paint after finishing his work as a handyman. Pippin met these challenges with imagination and determination, solving technical and aesthetic problems in a very creative and individual way.

HORACE PIPPIN'S WORKING METHODS
In a discussion of his painting technique, Pippin was quoted by Dorothy C. Miller in the 1938 catalogue for "Masters of Popular Painting: Modern Primitives of Europe and America:"

> The pictures which I have already painted come to me in my mind, and if to me it is a worthwhile picture, I paint it. I go over that picture in my mind several times and when I am ready to paint it I have all the details that I need. I take my time and examine every coat of paint carefully and to be sure that the exact colors which I have in my mind is satisfactory to me. Then I work my foreground from the background. That throws the background away from the foreground. In other words bringing out my work. The time it takes to

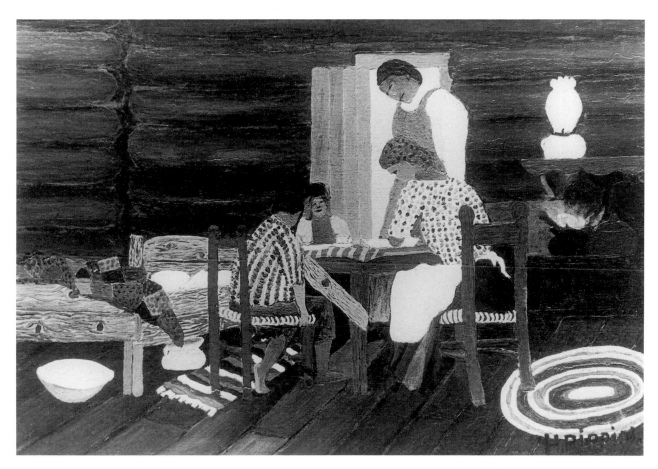

169 *Giving Thanks*, c. 1942. Oil on fabric, 10¹⁵⁄₁₆ × 14¹³⁄₁₆ in. The Barnes Foundation, Merion, Pennsylvania (no. 990)

make a picture depends on the nature of the picture. For instance the picture called *The End of the War: Starting Home* which was my first picture. In that picture I really couldn't do what I wanted to do, but my next pictures I am working my thought more perfectly.[1]

Indeed, *The End of the War: Starting Home* (c. 1930) is the artist's thickest painting, with numerous repaintings done over several years that create a bas-relief effect. Pippin's application of multiple paint layers often takes on sculptural qualities. Although not nearly as thick as *The End of the War: Starting Home*, Pippin's portrait *Major General Smedley D. Butler* (1937) has a bas-relief quality to the paint where the artist has simply scraped a line into the thick paint to indicate the line of the cheek. *Potted Plant in Window* (1943) is painted flatly with black outlines around the forms. It is the thickness of the leaves that lends them three-dimensionality by casting shadows from the low relief of the paint. In addition, Pippin's layering of paint is often very literal. For example, in painting a bed in *Giving Thanks* (fig. 169), it appears that Pippin painted each layer of bed clothes as an individual layer, adding each layer as if he were making the bed.

Pippin often began his paintings by drawing on the support with pencil, carefully drawing outlines of the forms in the design. This pencil underdrawing is visible at the edges of forms in many paintings and appears with some frequency when his paintings are examined with an infrared vidicon camera.

The paintings left unfinished in Pippin's studio at the time of his death give us further insights into his working methods. The unfinished *Table and Two Chairs* (fig. 170) is fully developed in grisaille, with no color applied to the canvas. *The Holy Mountain IV* (fig. 171) was begun with some pencil drawing to which changes

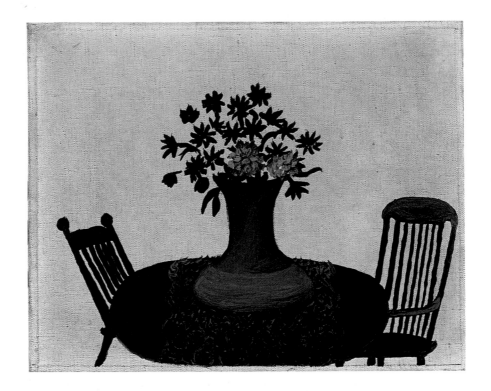

had been made. Pippin had also begun a black contour painting on the animals. Thin washes of color, blue-green in the sky, gray in the mountains, and green in the foreground have been laid in. Black outlines to forms are sometimes also seen in the finished layers of his paintings. For example, the Ku Klux Klan figure in *Mr. Prejudice* (1943) is outlined. *Domino Players* (1943) also uses black outlines in which the paint application follows the outlines of the shapes. It is clear from his 1938 description of his working methods that Pippin's intent was to paint a painting with realistic depth and three-dimensionality. In contrast to the traditional academic method of modeling by blocking in large masses of light and dark and then gradually refining details, Pippin's work has the flatness characteristic of academically untrained painters wherein forms are indicated in flat, bordered shapes, and to which surface details are added. For example, in the unfinished painting from the Holy Mountain series, the sky was begun with a flat blue color over which clouds would have been painted. The clouds, sky, and trees are not painted simultaneously in an *alla prima* wet-into-wet blocking-in method, but are underpainted in flat tones that anticipate a labored application of multiple paint layers.

In painting grass or trees, Pippin's use of repeated small strokes of dark green over thinner layers of green—to indicate blades of grass or the leaves on a tree— produces an overall pattern of intense, undifferentiated color, which belies spatial recession. Likewise, in interior scenes such as *Amish Letter Writer* (1940), since the range of values remains close throughout the painting, the bright, flat colors restrict the design to a two-dimensionality despite attempts at perspective in the lines of the table.

Perhaps anticipating the effect of cropping that a frame has on the outer edges of a painting and wishing to preserve the entire design without losing any of it to the frame, Pippin began in the 1940s to leave an unpainted ¼-inch white border of exposed ground on the edge of many of his paintings. Often a pencil line is visible around the inner edge of the white border showing that Pippin ruled off the area in which he was to paint the design.

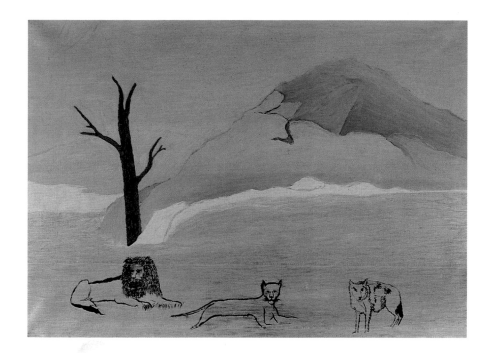

1 7 1 *The Holy Mountain IV*, 1946. Unfinished oil on fabric, 26 × 36 in. The Metropolitan Museum of Art, New York, Bequest of Jane Kendall Gingrich, 1982 (1982.55.3)

Pippin's production was greater in the 1940s than in the 1930s due to his increased reputation as an artist; he was selling more paintings and therefore could afford to paint more. Sales of his paintings could now supplement his veteran's disability pension, making him less dependent on income gained from his handyman work. By the 1940s there appear references to the artist working on several paintings at one time. Robert Carlen wrote on April 7, 1941, to Miss Alice Roullier, chairman of the Exhibition Committee at the Arts Club of Chicago, that "at the present time Pippin is working on several new canvases to be included in your show."[2] On August 21, 1945, Pippin wrote to Carlen telling him that he was "working every day," had one painting completed, and was working on four more.[3] He nevertheless painted slowly and averaged only about ten to twelve paintings per year throughout his career.

Pippin never had a proper artist's studio, although he wished for an addition to his house where he could work in private. Thomas Bostelle, a Chester County artist who painted Pippin's portrait in the basement of his parents' home in 1939, remembered that Pippin told him how fortunate he was to have his own space in which to paint.[4] He continued to paint in the front room of the ground floor of his West Chester house, one half of a three-story brick twin house. According to Selden Rodman, the artist worked largely at night with an overhead light bulb as illumination.[5]

Pippin's injured right arm, which was useless to him when he first came home from the war, seemed to grow stronger with time, perhaps as the damaged nerves healed. The artist found a way to hold the brush in his right hand, allowing him control during lengthy work sessions. Rodman states that "Pippin would paint as long as seventeen hours at a stretch, holding the wrist of his injured right arm in the fist of his left hand, thus controlling his motion to suit the tiny brushes and brush-strokes which he 'advanced from side to side of the canvas' until the proper balance of masses and colors had been achieved."[6] This method must have afforded the artist a great deal of control since his brush strokes vary from tiny rows of grass blades to long sweeping strokes in clouds, such as in *The Elk* (fig. 172).

WOOD SUPPORTS

Pippin used wood panels much less often than he used stretched fabrics or canvas boards, and the source for the panels varied from rough planks to furniture parts. The two versions of *The Bear Hunt* (figs. 173, 174) are from the same thick plank of wood. The grain patterns of the softwood boards match up, indicating that they were once a single board that was sawed in half before it was painted. The artist used one side of the plank for one painting and the other side of the plank oriented upside down for the second work. *Untitled (Winter Scene)* (fig. 175), an undated burnt-wood panel, is painted on a thin pine box lid with rounded corners and nail holes along the vertical edges. *Losing the Way* (1930) is painted on the reverse side of a raised oak panel from a door or a furniture case. The late burnt-wood panels of 1941 are on joined oak panels whose edges are sometimes molded or that show dowels or dowel holes, indicating that the panels are table extensions. Artist Claude Clark remembered that when he "first saw [Carlen] with Pippin they were going about Philadelphia, at the time he was doing the burnt wood panels, and they were buying leaves, you know those extensions to the old oak tables... from antique shops —wherever they could get them."7

The panels used by Pippin were never primed before he burned or painted them. The table extensions still had their original varnished finish on them. Pippin's burnt lines and paint combine with the deep color of the varnished wood to create the design. Only on one occasion noted by the authors did Pippin use a thick (⅜-inch) pressed wood or composition board panel whose screen pattern is evident on its reverse for *Domino Players*. This panel was primed with a thin white ground and has wooden strips tacked along its edges.

THE "BURNT-WOOD" PANELS

Pyrography, or the use of wood-burning tools to incise designs into a wood panel, is an ancient technique that experienced a revival at the turn of the century. Wood-burning tools of various shapes and sizes were available from artists' supplies catalogues. F. Weber & Co. of Philadelphia, for example, published *A Guide to Pyrography or Woodburning for the Use of Students and Amateurs* in 1900. Pippin's use of wood-burning techniques were said to involve a hot poker from his fireplace, however, and the artist considered it to be his own invention. Rodman and Cleaver describe the technique: "Holding the handle as firmly as he could in his stiff right hand, and balancing the rod on his knee, he took the extra leaf from the golden oak table and with his agile left hand maneuvered the panel against the smoking iron tip."8 This laborious technique results in roughly drawn lines. However, considering that he was using the tip of a poker rather than a wood-burning pen, the lines are relatively fine. The burnt lines were easier to make in the direction of the grain than across it. For example, in the hard pine or spruce panels used in the *Bear Hunt* paintings early in the artist's career, the lines are smoother in the horizontal direction, which is parallel to the grain of the wood; they are shorter and more choppy across the grain where the poker burned the soft sections of the wood but was resisted by the lines of hardened resin in the grain. There are no accounts of the artist using commercial wood-burning kits to produce his burnt-wood paintings, though they were widely available at the time. Perhaps Pippin was simply unaware of the existence of such kits, leading him to believe that the technique was his own invention and necessitating the use of a poker to burn lines.

Pippin's method of creating the burnt-wood panels was to draw the design in pencil first onto the wooden support, subsequently burning in the line with the hot poker. Probably due to the difficulty of working detailed lines with the poker, there are often more pencil lines than there are burnt lines. Sometimes pencil lines used for details were left unburnt as in *The Old Mill* (c. 1940), where the vertical boards

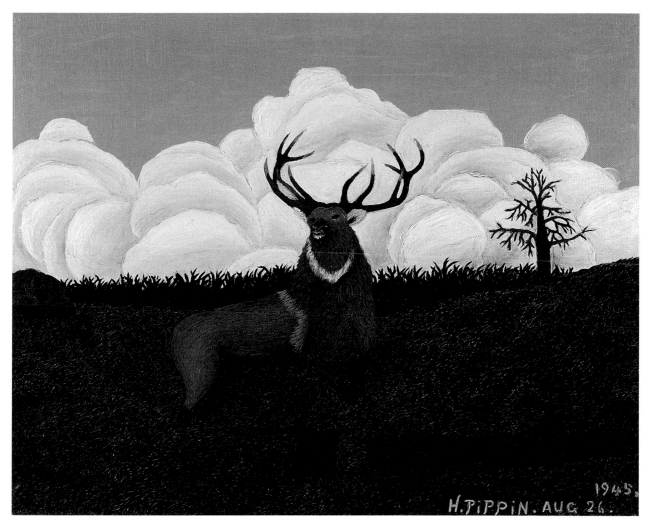

172 *The Elk*, 1945. (Also known as
The Moose, *The Moose II*, and *The
Stag*). Oil on fabric, 18⅛ × 22¹³⁄₁₆ in.
Pennsylvania Academy of the Fine
Arts, Philadelphia, Bequest of David
J. Grossman, in honor of Mr. and
Mrs. Charles J. Grossman and Mr
and Mrs. Meyer Speiser (1979.1.7)

of the building at the far right are indicated in pencil. Pippin then painted the panels with a typically restricted palette of white, a few earth colors, and perhaps small amounts of red, blue, or green. The burnt lines are generally left as visible outlines but are sometimes overpainted by the artist, as in *Fall Landscape* (1940), where burnt lines are reinforced by a deep red paint.

Fabric Supports

Writers on Pippin often mention his use of cotton muslin fabric for his early works, such as *Shell Holes and Observation Balloon: Champagne Sector* (1931), *The Blue Tiger* (1933), and *Abraham Lincoln and His Father Building Their Cabin on Pigeon Creek* (1934). In fact, these works are painted not on muslin but on an even more finely woven cotton fabric similar to a bedsheet. Pippin rarely used this fabric, however, and generally seems to have used good-quality linen or cotton canvases of a moderate weight even in the 1930s before meeting his dealer, Robert Carlen, who said that he stretched and primed cotton and later linen canvas for use by the artist.[9]

Both before and after Pippin met Carlen, commercially stretched and grounded canvases appear. The same is true for noncommercially stretched and grounded canvases. The support for *Dog Fight Over Trenches* (1935) is the earliest traditional canvas that appears. It is a medium weight two-over-one "basket weave" fabric, estimated to be a cotton canvas. This type of canvas appears on three other paintings examined for this study: *Portrait of My Wife* (1936), *The Getaway* (1939), and

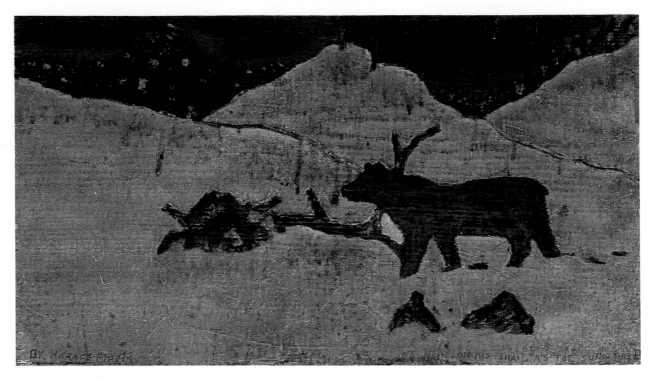

173 *The Bear Hunt (I)*, 1930. Oil on
burnt-wood panel, 11¾ × 20½ in.
Chester County Historical Society,
West Chester, Pennsylvania, Gift of
Alice Redfield Williams, in memory
of her mother-in-law, Mary Vaughan
Merrick Williams (1989.11)

Coming In (1939). A plain-weave cotton and later linen canvas was generally cho-
sen for stretched fabric supports. The support for the unfinished *Table and Two
Chairs* is a lightweight plain-weave canvas that has a commercially prepared
ground layer. The tacking edges for this painting are unevenly cut and the tacks
are unevenly spaced, suggesting that the canvas was stretched by Carlen or Pippin
from a roll of preprimed canvas.

Stretchers on these paintings vary from simple mortise-and-tenon stretchers
to commercially made mitred mortise-and-tenon stretchers. On the painting *Mr.
Prejudice* the manufacturer's red stamp can be noted on the mitred mortise-and-
tenon stretcher: "Anco, Inc./ Glendale." The Anco-type stretchers seem to have
been most used by Pippin, and many of the more elaborately made stretchers
appear to be replacements by restorers. The *Lady of the Lake* (1936) was the only
painting that was noted to be on a nonkeyable strainer, which was original to the
painting.

CANVAS BOARDS
Canvas boards, made of lightweight plain-weave cotton fabric with white priming
and mounted to cardboard as a support for sketching, have been available since the
turn of the century.[10] Pippin used these panels frequently in the 1940s, usually for
small paintings but occasionally on larger works such as *West Chester Court House*
(1940), which measures 22 × 28 inches. Some of the canvas boards, such as the one
on *The Warped Table* (1940), are stamped: "Art School/Canvas Board" on their
reverse. On the painting *Asleep* (1943) the stamp reads: "Weber Art School/Canvas
Board/Made in U.S.A."

Pippin cut down a canvas panel to a smaller size to use for *Chester County
Art Critic* (1940). These canvas boards must have had advantages for Pippin, who
enjoyed painting on both solid and flexible supports, and who may have found the
lightweight panels less heavy and cumbersome alternatives to wood panels, which
do not appear as supports for his work after 1941.

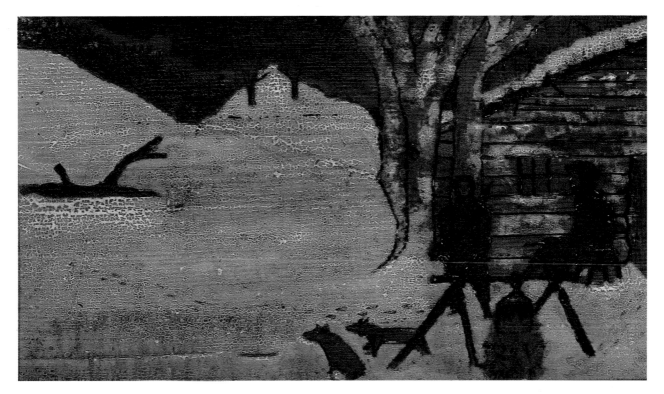

174 *The Bear Hunt (II)*, 1930. (Also known as *The Bear Hunt*). Oil on burnt-wood panel, 11⅞ × 20½ in. Private collection

GROUND LAYERS

Pippin's paintings on fabric generally are done on white or pale gray grounds, but some paintings on fabric have no grounds. Paintings done on wood panels were never primed and generally allow passages of exposed wood color to function as part of the design. Several paintings on unprimed canvas by Pippin appear in the 1930s, including *The Getaway, Coming In, Country Doctor* (1935), and *Portrait of My Wife*. The unprimed canvas of *The Getaway* allowed the oil color to soak through and show as stains on the reverse of the canvas. Fabrics with white or pale gray ground layers appear in the 1930s as well and are the usual case in the 1940s. An unusual thin black ground layer appears on *Shell Holes and Observation Balloon: Champagne Sector, The Blue Tiger*, and *Abraham Lincoln and His Father Building Their Cabin on Pigeon Creek*. This ground layer remains soft and has tar-like characteristics.

Fabrics from the 1940s often have smooth, commercially prepared grounds that extend onto the tacking edge. The canvas panels all have this type of ground layer. As noted previously, Robert Carlen said that he stretched and primed canvases for Pippin. These paintings would not show the primed tacking edges that the commercially primed fabrics have, as an artist will generally stretch the canvas first and then apply the ground or priming layer. In the 1940s there are some canvases that were prepared in this way. *Mountain Landscape* (c. 1936) was painted on a canvas with a pale gray preprimed ground layer. This is the earliest use by Pippin of a preprimed ground noted by the authors.

PIPPIN'S PALETTE

In Pippin's early works, the palette tends toward simple, often muted color combinations. In the exhibition catalogue *Masters of Popular Painting*, published by the Museum of Modern Art in 1938, Dorothy C. Miller quotes Pippin: "*How I Paint*; The colors are simple such as brown, amber, yellow, black, white and

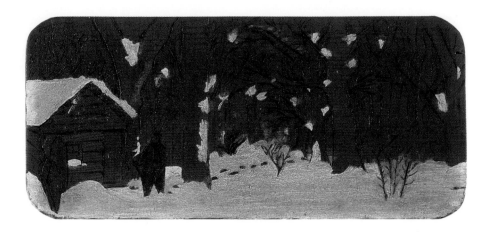

green."[11] In very early works such as the burnt-wood panel *The Bear Hunt (I)*, the colors are limited to a white that has since yellowed, a brown of exposed wood, dark green, and black. The color scheme of *The Blue Tiger* is restricted to grays, black, and dark green for the most part. Later works from the 1940s employ brighter colors, perhaps as a result of Pippin's access to a greater variety of paints supplied by Carlen, or his study of Impressionist paintings at the Barnes Foundation in 1940. Rodman and Cleaver relate a story about the influence of the Impressionist works at the Barnes on Pippin. "Pointing to Renoir on another occasion, Pippin told Miss de Mazia 'I'm going to take colors out of that man's painting and get them into mine.'"[12] Although not used in the Impressionist manner, these brightened colors on Pippin's palette include the purple found in *Christ and the Woman of Samaria* (1940), *The Woman Taken in Adultery* (1941), and *Mr. Prejudice*.

Optical microscopy by the authors of pigments from Pippin's paintings in the collection of the Pennsylvania Academy of the Fine Arts, all of which date from the 1940s, show that the artist's palette included zinc white; titanium white; ivory black; cerulean blue; cadmium red; red, yellow, and brown earth colors, such as ochres, umbers and siennas; zinc yellow; an organic red lake, such as rose madder or alizarin crimson; and phthalocyanine green. Dark greens in foliage appear throughout all periods of his work. Viridian green is found in the foliage of *The Blue Tiger* of 1933. Phthalocyanine, or monastral green, invented in 1938, was found in the grass of *The Elk*, 1945. This dark green is very similar in appearance to viridian. A receipt from William I. Meil, Artist and Drawing Materials store, dated March 31, 1944, shows paints purchased by Robert Carlen for Pippin that include Permalba® white, cadmium red deep, cadmium red, cadmium yellow, green (unidentified), cobalt violet, and ivory black.[13] Permalba® white, a mixture of titanium and zinc whites, was introduced in 1921 by F. Weber & Co. as a substitute for lead white.[14] Microscopy of white pigments from the Academy's paintings confirms this mixture.

Thomas Bostelle remembers that there were two stores at that time in West Chester where artists' supplies could be purchased, Rubenstein's, a stationery store, and Fath's. Bostelle recalls purchasing F. Weber & Co. tube paints from Rubenstein's and it could be assumed that Pippin also bought his art supplies there.[15] Pippin undoubtedly purchased and used artists' materials before Robert Carlen began to supply him with art materials, however limited they may have been. Robert Carlen said that Pippin acquired some paint left over from house painters in his neighborhood for use in his paintings.[16] The colors of his early works—white, black, earth colors, deep greens, and pale blues—are indeed common house painters' colors. But since pigments employed in these paints would be similar to those found

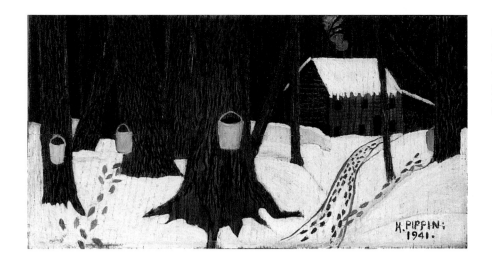

176 *Maple Sugar Season*, 1941. (Also known as *Maple Sugaring*). Oil on burnt-wood panel, 6⅞₆ × 11¹⁵⁄₁₆ in. Pennsylvania Academy of the Fine Arts, Philadelphia, Bequest of David J. Grossman, in honor of Mr. and Mrs. Charles J. Grossman and Mr. and Mrs. Meyer Speiser (1979.1.6)

in artists' colors, there is no easy way of determining when Pippin began to use artists' paints or whether he ever actually used house paints. As observed by Tania Boucher,[17] house paints have a thinner consistency and would be handled by an artist much differently than would artists' tube paints, which have a thicker paste vehicular consistency and therefore a different appearance in their application. Pippin may possibly have used the house paint as an extender for his artists' paint, for example, mixing leftover black house paint with tube paints. A difference in saturation of his black paint can often be seen, with glossy and matte areas in black passages. Examination of the paintings with ultraviolet light sometimes shows the black paint to have an unexpected fluorescence. For example, in *Abe Lincoln, The Good Samaritan* (1943), the black paint has a dark yellow ochre fluorescence. *Asleep* (1943) was noted to have areas of an orange fluorescence in the darks of the painting, but in this case it was reported to have been caused by local varnishing of the paint with a resin different than the overall natural resin varnish.

Pippin may also have simply been using a cheaper grade of tube paints in which wax or nondrying oils were added. According to the conservator's report, the black paint of *Saying Prayers* (1943) is readily soluble in solvents and still remains tacky. This painting is framed with glass, and the museum has noted that the blacks exude a gas that leaves a ghost image on the glass, which has to be periodically cleaned. The ready solubility of many of his paints also indicates that he was mixing incompatible media with his paint. For example, when examined with magnification, the leaves in the upper left of *Abraham Lincoln and His Father Building Their Cabin on Pigeon Creek* reticulated or beaded slightly when they were applied, as if water-based media had been applied over oil (although in all other respects the paint appears to be oil based). A similar phenomenon was also noted on *Victorian Interior* (1945), where the artist's paint had a tendency to reticulate when in contact with the ground layer. Reticulation was not noted between the layers of the paint itself, which seemed to be compatible. Further analytical studies with a concentration on the artist's media would be necessary to come to a better understanding of the paint that Pippin used.

SURFACE COATINGS

Paintings by Pippin that have not been obviously treated by restorers appear in both varnished and unvarnished states; no evidence exists to suggest that the artist had a preference for one over the other. Early works such as *Losing the Way* and the Bear Hunt paintings were very thickly varnished, perhaps by the artist and perhaps with

a commercial woodworking varnish rather than artist's varnish. Artist's varnishes available commercially in Pippin's time would have included those of natural resins, such as dammar and mastic. In addition, the acrylic resin varnish, "Synvar," was introduced in the 1930s by F. Weber & Co. in Philadelphia for artists' use.

PIPPIN'S SIGNATURE STYLES

The majority of Pippin's paintings are signed, invariably in the lower right corner. Generally, the signatures are in the form "H. PiPPiN" with the letters in a combination of upper and lower cases. *Losing the Way* and *The Bear Hunt (I)* are signed with the full name "Horace Pippin" in addition to a short narrative description. Sometimes a comma or period follows the artist's last name or the date. The "i"'s are almost always dotted as in a lower case letter, although the "i"'s in *Maple Sugar Season* (fig. 176) are not. The letter "p" appears occasionally in lower-case form. The artist dated his paintings with some frequency, especially in the 1940s. Paintings from 1944 and 1945 occasionally are dated with a day and month as well as the year, often commemorating an important date such as the third anniversary of the December 7, 1941, attack on Pearl Harbor in *The Holy Mountain II* or in *The Holy Mountain III* the date of August 9, 1945, on which Nagasaki was bombed.

The artist sometimes embellished his signatures with branched forks on the ends of some letters (figs. 177, 178). While these twiglike letters appear in *Dog Fight Over Trenches* and *Shell Holes and Observation Balloon: Champagne Sector*, this type of signature most frequently appears in the 1940s. Although his signature was generally painted in black, Pippin also sometimes used bright colors such as yellow, pumpkin, or green. Some signatures are painted with one color over another for contrast. For example, *My Backyard* (1941) is signed with bright green over dark green. Pippin also signed his paintings twice on several occasions after making changes to the work. For example, on *Losing the Way* the *pentimenti* of the first signature is now visible.

Artist's Changes

Pippin made numerous alterations to his paintings as the works progressed. Some of these changes are visible as *pentimenti* revealing lower paint layers. Others are visible in areas of traction crackle, and still others are found only when the painting is examined with an infrared vidicon camera or with x-radiography.

Pippin refined shapes and outlines or made more major alterations of the composition by changing large design elements. In *Giant Daffodils* (1940) the wide, rounded boards of the present fence cover the original narrower picket fence, which was painted out by the artist (fig. 179). The design change was evident when the painting was viewed with an infrared vidicon camera (fig. 180). Another change which can be seen with the aid of the infrared vidicon camera is on *The Bear Hunt (II)* (fig. 174) and is located in the area of the bushes at the center left (fig. 181). In the infrared detail it can be seen that the artist burned in a much sparser group of bushes and overpainted the extra pencil lines (fig. 182). Ridges of paint in the otherwise smooth background of *Portrait of My Wife* reveal picture frames in the upper corners that were painted out by the artist, probably when he repainted the background color from dark green to olive. Extensive changes were made in *The Getaway* (fig. 183) and the original design is visible on the reverse of the unprimed canvas where the colors have bled through (fig. 184). The composition on the reverse is a mirror image of the one on the front with several exceptions. The artist had originally placed a small standing dog where the larger fox now runs, and the image of the dog is evident on the reverse. Also evident on the reverse are brighter blue colors in the sky than are now visible on the front and red underlayers to what are now the yellow-gray clouds. The gray buildings on the right of the painting were once the same red color as the small, distant buildings at the center of the design.

Pippin frequently made changes to affect color as well as design and composition. Rather than simply refining a color's value, he often created a completely different hue. For example, the portrait *Paul B. Dague, Deputy Sheriff of Chester County* (1937) shows various blue and blue-gray colors under its bright yellow background. With time, Pippin seemed also to realize that the layering of colors could result in different color effects, which is a very sophisticated concept for a nonacademic painter. The background of *Mr. Prejudice* was started with a thin green color. This was overpainted with a bright blue and then a bright pink layer, resulting in

179 Detail of *Giant Daffodils*, fence at right, 1940

a purplish color. A dark gray underlayer is visible in cracks in the olive grass in *Shell Holes and Observation Balloon: Champagne Sector*, and *pentimenti* of grass appear under the shell holes. Rather than a change in composition *per se*, however, this seems to be an example of how Pippin often constructed his paintings by very literally painting one layer over another.

The artist changed the size of some of his paintings by cutting them down on one or more edges. Larger changes were probably made to improve the composition, but smaller changes may have been made to allow the painting to fit into an existing frame. Four paintings on canvas boards that the authors examined were cut down by Pippin. These canvas boards would, of course, have been easy to reduce in size with a utility knife. *Self-Portrait* (1941) was reduced slightly along the top and right edges. Violette de Mazia of the Barnes Foundation described how the artist cut down *Victory Vase* (1942) from a horizontal composition to a nearly square one by removing extraneous background on both vertical edges of the composition "after this organizational problem was pointed out to the artist."[18]

CONSERVATION PROBLEMS WITH PIPPIN'S PAINTING TECHNIQUE
In many cases Pippin's unusual painting methods have resulted in disfigured paint surfaces with attendant conservation problems. In paintings in which the artist applied multiple paint layers, wide traction cracks often form, sometimes revealing lower paint layers. Thickly applied paint also results in areas of wrinkling. One frequently encounters gloss variations in Pippin's paint with some areas of slick, shiny paint and other areas of very matte and even whitened paint. This phenomenon is often very disfiguring, especially on unvarnished paintings, and it makes it difficult to distinguish the true colors in the design. Dark colors become sunken and unsaturated, thus difficult to differentiate from one another, as in black branches against dark green foliage. This phenomenon is sometimes misunderstood as a discoloration of the dark green pigment. Pippin frequently painted passages with

dark colors that are so close in value to each other that, although distinct when fresh, are difficult to distinguish now that their surfaces have aged.

Some early works by the artist were thickly varnished and the extreme yellowing and extensive cracking of these films are now very disfiguring. It is difficult—and sometimes impossible—for conservators to remove grime and discolored varnish from Pippin's works, and the painting has to remain somewhat yellower than the artist intended. The problem is that his paint is often readily soluble in cleaning solvents, probably due to Pippin's oil medium, which does not form hard films.

FRAMES

The question of framing appropriate to Pippin's paintings is elusive, with few clues from acquaintances of the artist or owners of his works. It is known that Pippin did provide frames for his paintings prior to his contact with Robert Carlen, but most of his own frames were later replaced either by dealers or the new owners. Philip Jamison, the owner of *Major General Smedley D. Butler,* said that the frame on this painting was probably chosen by Pippin himself. A photograph of Pippin with the framed painting in an April 26, 1941, newspaper article shows that the frame has cast composition decoration that has since been removed and that in the photograph already has some areas of deterioration.[19] The decoration was removed before it was purchased by the present owner. And indeed, Jamison felt that it was a turn-of-the-century frame that Pippin could have easily purchased at a yard sale or second-hand shop. The frame was constructed of a pine carcass of simple molding embellished with gilded cast compo ornamentation in leaves and fluted moldings. Mrs. Samuel L. Feldman, owner of *Amish Letter Writer,* recalled that the original dark-stained, rough-wood frame of that painting, since replaced, was made by the artist. The Bear Hunt paintings on wood panels originally may not have been framed; holes for mounting hardware on the panels suggest that they were to be hung by hardware alone.

181 Detail of *The Bear Hunt (II)*, bushes at center, 1930

One notable example of the artist's framing appears in the frame for *The End of the War: Starting Home*, which was made by the artist. It is made from a wide flat molding that was embellished with carved tanks; grenades; rifles; bayonets; gas masks; bombs; and German, French, and American helmets. The large motives are affixed to the frame with nails and glue, while the smaller motives are applied to the frame with bent nails. The added motives are chip carved and whittled and have a dark stain. This is the only known extant example of a frame made by Pippin.

A letter from Pippin to his first dealer in New York, Hudson Walker, dated April 17, 1939, expresses the artist's regrets that he had not sent along his own frames to an exhibition of his works at Walker's gallery.[20] Walker presumably framed these paintings. Albert Barnes reframed Pippin's paintings when they were purchased. Barnes wrote to Robert Carlen on February 20, 1940, "the frame from the painting (*Woman of Samaria*) can be returned to Mr. Pippin if you will call at the gallery and get it."[21]

Robert Carlen, for his part, frequently framed Pippin's work in antique frames in styles that varied from gilded Federal period frames to figured maple folk-art frames of a slightly later period. Carlen also framed Pippin's paintings in contemporary frames. To some degree the frame choice must have depended on the client's taste and budget. A postcard from Carlen to Barnes of April 30, 1941, states that he was ordering "two stock frames" for paintings he was offering to Barnes.[22]

Other frame styles seen on Pippin's works include carved reproduction Renaissance and Baroque frames and frames of the gray-painted, rough wood popular in the 1940s and 1950s. In short, dealers and owners have framed Pippin's works in what they thought made them look best, with no consistent choice of style.

FORGERIES OF PIPPIN

John Ollman of Janet Fleisher Gallery of Philadelphia, who has sold Pippin's work and who knew Robert Carlen, has asserted that there are a great many forgeries of Pippin's work in existence.[23] There are two major types of counterfeit Pippins. The

182 Infrared vidicon detail of *The Bear Hunt (II)*, bushes at center, 1930

first consists of paintings made to imitate Pippin's work in style and subject matter. These works were done in the 1940s after Pippin's fame rose and for a short period after his death. Another type of forgery consists of primitive paintings by other artists to which Pippin's signature has been added. While this type of forgery would be easiest to accomplish, it would also be the easiest to discover. Ollman states that this type of forgery is still being done.

Some of the early forgeries were done in the Pottstown area just north of West Chester. These forgeries were attempted recreations of the artist's work and were made as deliberate deceptions. Other forgeries have come from northern New Jersey. According to Ollman, some forgeries were sent out of the Philadelphia area to states far away, where collectors might be less familiar with Pippin's work. These paintings sometimes find their way back to Philadelphia and New York where art dealers such as Robert Carlen and Ollman have denied their authenticity. The forgeries are sometimes easy to question due to their uncharacteristic subject matter, unusual supports, or paint application that fails to imitate the laborious layering and distinctive brushwork of Pippin's paint surfaces. As our knowledge of Pippin increases both technically and art historically, this type of forgery should also become easier to determine.

ACKNOWLEDGMENTS
The authors gratefully acknowledge the following for their help: Judith E. Stein and Anne Monahan, of the Pennsylvania Academy of the Fine Arts, for their insights and information about Horace Pippin; Robin Beckett, former conservation assistant of the Pennsylvania Academy for the preparation of the manuscript; Mrs. Robert Carlen, Thomas Bostelle, Tania Boucher, Philip Jamison, Edward Flax, and John Ollman for interviews generously granted to the authors; and the conservation, curatorial, and registrarial staffs of the Philadelphia Museum of Art, Hirshhorn Museum and Sculpture Garden, The Metropolitan Museum of Art, The Phillips Collection, The Baltimore Museum of Art, The Museum of Fine Arts

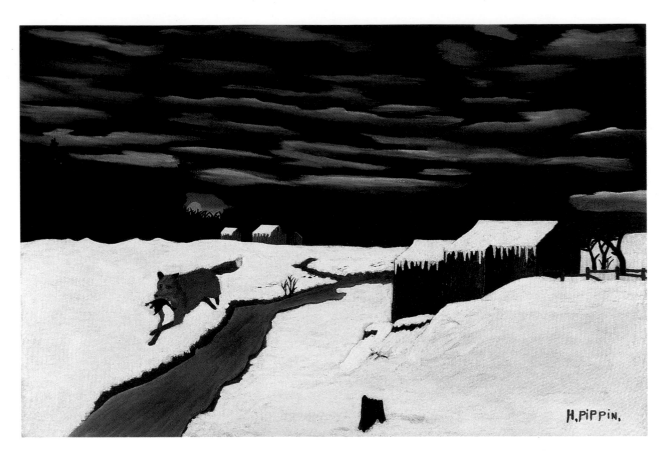

183 *The Getaway*, 1939. (Also known as *The Fox [The Get-a-way]*). Oil on fabric, 24⅝ × 36½ in. Collection Mr. and Mrs. Daniel W. Dietrich II

184 *The Getaway*, reverse

(Boston), Chester County Historical Society, Brandywine River Museum, Albright-Knox Art Gallery, The Barnes Foundation, Art Institute of Chicago, and the Inter-museum Laboratory (Oberlin, Ohio) for allowing the authors to examine paintings and conservation files related to Horace Pippin.

MARK F. BOCKRATH is Chief Conservator at the Pennsylvania Academy of the Fine Arts, Philadelphia. BARBARA A. BUCKLEY is a painting conservator in private practice in West Chester, Pennsylvania.

1. Dorothy C. Miller, *Masters of Popular Painting: Modern Primitives of Europe and America*, exh. cat. (New York: Museum of Modern Art, 1938), pp. 125–26.

2. Letter from Robert Carlen to Alice Roullier, April 7, 1941, The Arts Club of Chicago Archives, Newberry Library, Chicago, Ill..

3. Letter from Horace Pippin to Robert Carlen, August 21, 1945, Robert Carlen Gallery Papers, Archives of American Art, Smithsonian Institution, Washington, D.C.

4. Thomas Bostelle and Tania Boucher, interview with authors, August 2, 1992.

5. Selden Rodman, *Horace Pippin: A Negro Painter in America* (New York: Quadrangle Press, 1947), pp. 3–4.

6. *Ibid.*, pp. 3–4.

7. Claude Clark, interview with Judith E. Stein, August 5, 1991.

8. Selden Rodman and Carole Cleaver, *Horace Pippin: The Artist as a Black American* (Garden City, N. Y.: Doubleday and Co., 1972), p. 62.

9. Robert Carlen, interview with Catherine Stover, June 28, 1985, Archives of American Art, Smithsonian Institution, Washington, D.C.

10. Rutherford J. Gettens and George L. Stout, *Painting Materials, A Short Encyclopaedia* (New York: Dover Publications, 1966), p. 221, and Edward Flax, vice president of Martin/F. Weber Co., interview with authors, August 6, 1992.

11. Miller, *Masters of Popular Painting*, p. 125.

12. Rodman and Cleaver, *Horace Pippin*, p. 76.

13. Receipt, March 31, 1944, Carlen Papers.

14. Ralph Mayer, *The Artist's Handbook*, 5th edn. (New York: Viking Penguin, 1991), p. 53, and Edward Flax, interview with authors.

15. Bostelle and Boucher, interview with authors.

16. Carlen, interview with Stover, pp. 19–20.

17. Bostelle and Boucher, interview with authors.

18. Violette de Mazia, "E Pluribus Unum, Part III," *The Barnes Foundation Journal of the Art Department*, 8 (Spring, 1977), p. 42.

19. Pippin scrapbook, Chester County Historical Society, West Chester, Pa.

20. Letter from Horace Pippin, not in his hand, to Hudson Walker, April 17, 1939, Archives of the Philadelphia Museum of Art, Archives of American Art/Carl Zigrosser Collection.

21. Letter from Albert C. Barnes to Robert Carlen, February 20, 1940, Archives of The Barnes Foundation, Merion, Pa.

22. Letter from Carlen to Barnes, April 30, 1941, Archives of The Barnes Foundation.

23. John Ollman of Janet Fleisher Gallery, interview with authors, July 1, 1992.

IV

RESOURCES & REFERENCES

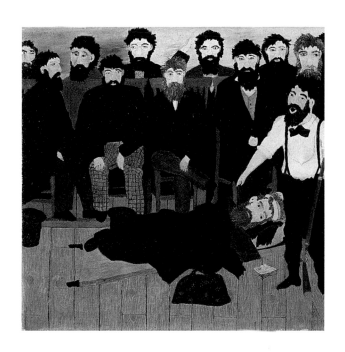

Chronology

1888 Horace Pippin born in West Chester, Pennsylvania, on February 22 to Harriet Johnson Pippin and Horace Pippin.*

1891 Harriet Irwin Pippin (1834–1908) and children—Christine (1855–1925), Daniel (1872–1898), Robert (1874–1908), Bertha (b. 1878?), and Horace—move to Goshen, New York. Son Joseph (1862–1902) remains in West Chester.

1898 In contest sponsored by art supply business, Pippin wins box of crayons with which he draws religious subjects. Moves to country with mother when she finds work at a hotel.

1899 Mother takes position as domestic in Middletown, New York.

1902 After completing the eighth grade, works on farm of James Gavin, who encourages interest in art. Mother's illness forces him to return to Goshen, where he holds short-term jobs.

1905 Hired as porter at St. Elmo Hotel, where he works for seven years.

1908 Harriet Pippin dies in June.

1912 Leaves Goshen to work as mover at Fidelity Storage Company, Paterson, New Jersey, where he occasionally crates oil paintings.

1914 Becomes iron molder at American Brakeshoe Company, Mahwah, New Jersey.

1917 In July enlists in 15th regiment of New York National Guard (later known as Army's 369th infantry regiment), which trains through December at Fort Dix, New Jersey, and Camp Wadsworth, South Carolina, and arrives in France on December 27. Attached to French army, this African-American regiment engages in battles of Belleau Wood and Argonne Forest. Pippin makes numerous drawings during war service of which one notebook survives.

1918 In October, sniper shoots Pippin in right shoulder, leaving him unable to raise arm to shoulder height. On Christmas Day, he leaves France on hospital ship.

1919 Arrives in New York on January 5. Awarded *croix de guerre* by French government. On May 22, receives honorable discharge and disability pension.

1920 On November 21, marries Jennie Ora Fetherstone Wade Giles, twice-widowed mother of six-year-old Richard Wade, and moves into her home in West Chester, Pennsylvania. To supplement disability pension, works as handyman and delivers laundry that his wife takes in. Decorates cigar boxes in spare time.

1925 In winter makes first burnt-wood panels. Travels to Durham, North Carolina, and is named commander of West Chester's Nathan Holmes American Legion Post, a position he holds through 1927.

1928 Begins first oil painting, *The End of the War: Starting Home.*

1930 Completes *The End of the War: Starting Home.* During next decade makes one to four paintings a year.

1937 Enters two paintings in sixth annual exhibition of Chester County Art Association. N. C. Wyeth and Christian Brinton, both prominent in the association, arrange for Pippin's first one-man exhibition at West Chester Community Center, an institution providing cultural and social opportunities for local African Americans. Makes portraits of two distinguished Chester County veterans, Major General Smedley D. Butler and Paul B. Dague.

1938 Museum of Modern Art includes four of Pippin's works in traveling exhibition "Masters of Popular Painting." Paints first religious subject, *Christ (Crowned with Thorns).*

1939 In April, at behest of Chester County artist Elizabeth Sparhawk-Jones, sends three paintings to New York dealer Hudson Walker. Walker and Pippin attempt business relationship but abandon it by November. In December Robert Carlen of Robert Carlen Galleries, Philadelphia, becomes his dealer and introduces him to collector Dr. Albert C. Barnes. Enrolls in art classes at Barnes Foundation for fall 1939 and spring 1940 semesters. Paints *Coming In*, a portrait of patron Mrs. W. Plunket Stewart.

1940 In January Carlen mounts first Pippin exhibition at his Philadelphia gallery, for which Barnes writes catalogue introduction. Show sells out early, thanks in part to publicity surrounding the purchase of *Abraham Lincoln and His Father Building Their Cabin on Pigeon Creek* (1934) by Barnes and *Birmingham Meeting House I* by his assistant Violette de Mazia. Barnes encourages actor Charles Laughton to buy *Cabin in the Cotton I* (1935). As part of his extensive documentation of African Americans in the arts, Carl Van Vechten photographs Pippin. In September Pippin becomes first American to be given individual exhibition at New York's prestigious Bignou Gallery. In October Barnes buys *Six O'Clock*, which he later sells. Alain Locke includes four of Pippin's paintings in his book *The Negro in Art: A Pictorial Record of the Negro Artist and of the Negro Theme in Art.* With support of Carlen, Pippin resumes work on burnt-wood panels and dramatically expands annual production to fifteen paintings, including first table-top still lifes: *Roses in a Jar, Roses with Red Chair,* and *The Warped Table.*

1941 In January *Christ and the Woman of Samaria* (1940) and *Amish Letter Writer* not accepted for Pennsylvania Academy annual exhibition. Carlen donates *The End of the War: Starting Home* to Philadelphia Museum of Art; in March mounts second Pippin exhibition at his gallery, with catalogue essay by Barnes, who purchases *Supper Time* and *Christ and the Woman of Samaria*. In April Whitney Museum of American Art buys *The Buffalo Hunt* (1933). In May Arts Club of Chicago mounts solo show. In December Edith Gregor Halpert of Downtown Gallery, New York, begins to represent Pippin in New York and includes his work in exhibition "American Negro Art, 19th and 20th Centuries." Pippin produces ten burnt-wood panels and eleven paintings on canvas board or fabric, including first self-portrait and *Lilies*, first depiction of interior of a patron's home.

1942 In April San Francisco Museum of Art mounts one-man exhibition. Albright-Knox Art Gallery, Buffalo, New York, purchases *Self-Portrait*. In September, Barnes purchases *Giving Thanks*. Pippin completes eleven paintings, including John Brown series.

1943 In February Pennsylvania Academy purchases *John Brown Going to His Hanging* from its annual exhibition. In April Carlen includes Pippin in "Oils, Water Colors, Prints and Sculptures by Negro Artists of Philadelphia and Vicinity." In May Pippin receives commission from Capehart Collection, Capehart, Indiana, to interpret Stephen Foster's song "Old Black Joe;" completed by October, the painting is featured in *Time* and *Life* magazines as part of Capehart's national advertising campaign for radios. Phillips Collection, Washington, D.C., purchases *Domino Players* (1943) in December. Pippin completes eleven paintings.

1944 In February Halpert mounts Pippin exhibition at Downtown Gallery. Museum of Art of Rhode Island School of Design buys *Quaker Mother and Child*. *Cabin in the Cotton III* receives honorable mention at Carnegie Institute's annual invitational exhibition. Commissioned by *Vogue* magazine to create a work for publication, Pippin makes both *Old King Cotton* and *Cabin in the Cotton IV*. He completes fifteen paintings, including first two of Holy Mountain series, and last four of Cabin in the Cotton series.

1945 Pippin applies for and receives Purple Heart awarded retroactively for World War I combat wound. He is the only African American among twelve artists commissioned by United Artists to interpret the temptation of Saint Anthony. To promote the play "Deep Are the Roots," producer George Heller commissions painting of same name for a poster which is never made. Pippin completes thirteen paintings.

1946 Awarded J. Henry Schiedt Memorial Prize in Pennsylvania Academy's annual exhibition. On March 18 commits wife to Norristown State Hospital. On July 6 dies in sleep of stroke; wife dies two weeks later. Leaves five completed paintings and five unfinished ones.

*Because there is no birth certificate for Horace Pippin, this information is taken from a biographical sketch that he prepared for *Who's Important in Art*, 1946 (Carlen Papers, Archives of American Art). Research has raised questions about this information. Neither Horace Pippin, Sr., nor Harriet Johnson Pippin appears

in the records of West Chester, Pennsylvania, or Goshen, New York, but Harriet Irwin Pippin appears in the records of both towns. Her obituary in Goshen's *Independent Republican* lists Horace Pippin as her son, yet the West Chester census of 1880 indicates that she was a 53-year-old widow at the time of his birth. Perhaps Harriet Pippin's advanced childbearing age prompted Rodman and Cleaver to name her daughter, Christine Pippin (29 years of age in 1888) as Pippin's mother in *Horace Pippin: The Artist as a Black American* (Garden City, N. Y.: Doubleday and Co., 1972). The death certificates of Christine Pippin Green, Daniel Pippin, and Robert Pippin name George Pippin as their father.

Exhibition History of Horace Pippin

This exhibition history is as complete as possible through 1947, when two memorial exhibitions were held. Exhibitions after 1947 are included if they feature more than one Pippin work. An asterisk following an entry's publication indicates that it is listed in the selected bibliography. Karen Love Cooler compiled initial data for this exhibition history, based largely on material contributed by Lynn Moody Igoe.

1937

May 23–June 6
Sixth Annual Exhibition. The Chester County Art Association (co-sponsored by School Board of West Chester), The Art Centre, West Chester, Pa. Catalogue. (2 works)

June 8–July 5
Horace Pippin: Paintings and Burnt Wood Panels. The Chester County Art Association and the West Chester Community Center, West Chester, Pa. Checklist. (17 works)

1938

April 27–June 27
Masters of Popular Painting. Museum of Modern Art, New York, in collaboration with the Grenoble Museum. Other venues: Smith College Museum of Art, Northampton, Mass.; Louisville Art Association, Ky.; Cleveland Museum of Art, Ohio; William Rockland Nelson Gallery of Art, Kansas City, Mo.; Houston Museum of Fine Art, Tex.; Los Angeles Museum of History, Science and Art; San Francisco Museum of Art. Catalogue.* (4 works)

October
Flowers in Art. The Chester County Art Association and West Chester Garden Club, The Art Centre, West Chester, Pa. (1 work)

1940

January 19–February 18
Horace Pippin. Carlen Galleries, Philadelphia. Checklist.* (27 works)

July 4–September 2
Exhibition of the Art of the American Negro (1851–1940). Tanner Art Galleries, American Negro Exposition, Chicago, Ill. Assembled by Alonzo J. Aden with the cooperation of the Harmon Foundation and the W.P.A. Catalogue. (1 work)

September 30–October 12
Paintings by Horace Pippin. Bignou Gallery, New York. Checklist. (24 works)

1941

March 21–April 20
Recent Paintings by Horace Pippin. Carlen Galleries, Philadelphia. Checklist.* (21 works)

Through May 20
South Side Art Centre, Chicago. (1 work)

May 23–June 14
Horace Pippin. The Arts Club of Chicago. Checklist. (39 works)

August 5–September 3
They Taught Themselves. San Francisco Museum of Art. (1 work)

December 9–January 3, 1942
American Negro Art, 19th and 20th Centuries. The Downtown Gallery, New York. Catalogue.* (3 works)

1942

April 14–May 3
Paintings by Horace Pippin. San Francisco Museum of Art. (31 works)

September 22–October 10
American Art, 1942. Downtown Gallery, New York. Checklist. (1 work)

1943

January 5–30
Paintings, Sculpture by American Negro Artists. The Institute of Modern Art, Boston. Other venue: Smith College Museum of Art, Northampton, Mass. Catalogue. (3 works)

January 24–February 28
One-Hundred and Thirty-Eighth Annual Exhibition of Painting and Sculpture. Pennsylvania Academy of the Fine Arts, Philadelphia. Catalogue. (1 work; $600 purchase prize)

February 19–28
Third Annual Exhibition. The Pyramid Club, Inc.,
 Philadelphia. Catalogue. (2 works; 1st prize)
March 21–May 2
*Eighteenth Biennial Exhibition of Contemporary
 American Oil Paintings.* Corcoran Gallery of Art,
 Washington, D.C. Catalogue. (1 work)
April 1–30
*Oils, Water Colors, Prints and Sculptures by Negro
 Artists of Philadelphia and Vicinity.* Carlen
 Galleries, Philadelphia. (5 works)
October 5–30
American Art, 1943: Eighteenth Annual Exhibition.
 Downtown Gallery, New York. Checklist.
 (2 works)
October 14–December 12
Painting in the United States, 1943. Carnegie
 Institute, Pittsburgh. Catalogue. (1 work)
October 28–December 12
*The Fifty-fourth Annual Exhibition of American
 Paintings and Sculpture.* The Art Institute of
 Chicago. Catalogue. (1 work)
November 2–27
American Primitive Painting of Four Centuries. The
 Arts Club of Chicago. Checklist. (1 work)

1944
January 7–February 14
American Painters of the Present Day. Museum of
 Art, Rhode Island School of Design, Providence.
 (5 works)
January 23–February 27
*One-Hundred and Thirty-Ninth Annual Exhibition
 of Painting and Sculpture.* Pennsylvania
 Academy of the Fine Arts, Philadelphia.
 Catalogue. (1 work)
February 15–March 11
Horace Pippin: Exhibition of Paintings. The
 Downtown Gallery, New York. Checklist.
 (25 works)
April 2–30
*Third Annual Exhibition of Paintings, Sculptures,
 and Prints by Negro Artists.* Exhibition Gallery,
 Atlanta University, Ga. Checklist. (1 work)
April 11–May 3
*American Negro Art: Contemporary Painting and
 Sculpture.* The Newark Museum, N.J.
 Catalogue. (1 work)
April 11–June 1
Religious Art of Today. Dayton Art Institute, Ohio.
 Catalogue. (2 works)
July 4–September 4
American Battle Painting, 1776–1918. National
 Gallery of Art, Washington, D.C. Other venue:
 Museum of Modern Art, New York. Catalogue.
 (1 work)

October 12–December 10
Painting in the United States, 1944. Carnegie
 Institute, Pittsburgh. Catalogue. (1 work; 4th
 honorable mention)
December 3–22
Seven American Painters. Mead Museum, Amherst,
 Mass. (organized by the Museum of Modern Art,
 New York). Other venues: Hamline University,
 Saint Paul, Minn.; Norton Gallery and School of
 Art, West Palm Beach, Fla.; Agnes Scott College,
 Decatur, Ga.; Arts and Crafts Club, New
 Orleans, La. (4 works)

1945
Circulating Exhibition. American Federation of
 Arts, New York. (1 work)
January 3–February 11
The Negro Artist Comes of Age. Albany Institute of
 History and Art, N.Y. Other venues: Albright Art
 Gallery, Buffalo; Munson-Williams-Proctor
 Institute, Utica, N.Y.; The Brooklyn Museum,
 New York; Museum of Art, Rhode Island School
 of Design, Providence. Catalogue.* (3 works)
January 19–February 25
*One-Hundred and Fortieth Annual Exhibition of
 Painting and Sculpture.* Pennsylvania Academy
 of the Fine Arts, Philadelphia. Catalogue. (1
 work)
January 22–February 12
Contemporary American Paintings. Society of the
 Four Arts, Palm Beach, Fla. Checklist. (1 work)
March 18–April 29
*Nineteenth Biennial Exhibition of Contemporary
 American Oil Paintings.* Corcoran Gallery of Art,
 Washington, D.C. Catalogue. (1 work)
April 1–29
*Fourth Annual Exhibition of Paintings, Sculptures,
 and Prints by Negro Artists.* Exhibition Gallery,
 Atlanta University, Ga. Checklist. (1 work)
April 22–29
*Second Annual Exhibition of Colored Artists of West
 Chester.* West Chester Community Center, Pa.
 (2 works)
August–September
Small Oils by Contemporary Eastern Artists. Fine
 Arts Gallery, San Diego, Calif. Checklist. (1
 work)
October 11–December 9
Painting in the United States, 1945. Carnegie
 Institute, Pittsburgh. Catalogue. (1 work)
October 20–January 28, 1946
Artists Look Like This. Philadelphia Museum of Art.
 (at least 1 work)
October 25–January 1, 1946
*The Fifty-sixth Annual American Exhibition of
 Paintings.* The Art Institute of Chicago.
 Catalogue. (1 work)

November 27–January 10, 1946
*Annual Exhibition of Contemporary American
 Painting.* Whitney Museum of American Art,
 New York. Catalogue. (1 work)
December 18–January 27, 1946
*The Encyclopedia Britannica Collection of
 Contemporary American Paintings.* Carnegie
 Institute, Pittsburgh. (1 work)

1946
January 26–March 3
*One-Hundred and Forty-First Annual Exhibition of
 Painting and Sculpture.* Pennsylvania Academy
 of the Fine Arts, Philadelphia. Catalogue.
 (1 work; J. Henry Schiedt Memorial Prize)
June–July
Exhibition of 200 Years of American Painting.
 Organized by the National Gallery of Art,
 Washington, D.C. Venue: Tate Gallery,
 London. (1 work)
September 13–October 21
Prize Winners, 1945–46. Addison Gallery of
 American Art, Phillips Academy, Andover, Mass.
 Catalogue. (1 work)
December 14–January 6, 1947
*Three Negro Artists: Horace Pippin, Jacob Lawrence,
 Richmond Barthé.* Phillips Memorial Gallery,
 Washington, D.C. Catalogue. (18 works)
*The Temptation of St. Anthony: Bel Ami
 International Competition and Exhibition of New
 Paintings by Eleven American and European
 Artists, 1946–1947.* Organized by American
 Federation of Arts, traveled through 1947. (1
 work)

1947
January 26–March 2
*One-Hundred and Forty-Second Annual Exhibition
 of Painting and Sculpture.* Pennsylvania
 Academy of the Fine Arts, Philadelphia.
 Catalogue. (1 work)
April 8–May 4
Horace Pippin Memorial Exhibition. The Art
 Alliance, in collaboration with Robert Carlen of
 the Robert Carlen Gallery, Philadelphia.
 Catalogue.* (65 works)
September 29–October 11
Memorial Exhibition: Horace Pippin, 1888–1946. M.
 Knoedler & Co., Inc., New York. Checklist.
 (33 works)

1953
June–October
International Center, Washington, D.C. (2 works)

1954
July 17–September 19
Amerikanische Malerei. Kunstmuseum, Lucerne,
 Switzerland (organized by S. I. T. E. S., traveled

through 1955 under the auspices of U. S. I. A.).
 Other venues: Museum of Applied Arts, Vienna;
 Municipal Museum, Dortmund, Germany;
 America House, Munich; Liljevalch Gallery,
 Stockholm; Kunstnernes Haus, Oslo; Manchester
 City Art Gallery, England; Whitechapel Gallery,
 London; Edinburgh, Scotland; Trier Museum,
 Germany. Catalogue. (4 works)

1958
June 28–July 27
American Primitve Paintings. The Parrish Art
 Museum, Southampton, N.Y. (organized by S. I.
 T. E. S, traveled through 1959). Other venues:
 Shreveport, La.; Indianapolis, Ind.; Chattanooga,
 Tenn.; Birmingham, Ala.; Iowa; The Fine Arts
 Gallery of San Diego, Calif.; Louisville, Ky.
 Catalogue. (5 works)
October 25–November 30
*Twentieth Century American Paintings and
 Sculpture from Philadelphia Private Collections.*
 Pennsylvania Academy of the Fine Arts,
 Philadelphia. Checklist. (11 works)

1961
February 7–April 9
Das Naive Bild der Welt. Staatliche Kunsthalle
 Baden-Baden, Germany. Other venues:
 Historische Museum, Frankfurt, Germany;
 Kunstverein, Hanover, Germany. Catalogue.
 (6 works)

1964
July 10–September 6
Lusthof der Naïeven. Museum Boymans-van
 Beuningen, Rotterdam, The Netherlands. Other
 venue: *Le Monde Des Naïfs,* Musée National
 d'Art Moderne, Paris, France. Catalogue.
 (2 works)

1966
January 27–March 6
Horace Pippin. Peale House Gallery, Pennsylvania
 Academy of the Fine Arts, Philadelphia.
 Checklist. (24 works and memorabilia)
October 21–December 4
*Three Self Taught Pennsylvania Artists: Hicks, Kane,
 Pippin.* Museum of Art, Carnegie Institute,
 Pittsburgh. Other venue: The Corcoran Gallery
 of Art, Washington, D. C. Catalogue.* (40 works)

1967
October 16–November 5
The Evolution of Afro-American Artists: 1800–1950.
 Great Hall, City College, New York (organized by
 the City University of New York in cooperation
 with the Harlem Cultural Council and New York
 Urban League). Catalogue.* (3 works)

1969
December 5–28
Afro-American Artists: 1800–1969. The Museum of
the Civic Center, School District of
Philadelphia. (2 works)

1970
February 9–March 10
*Five Famous Black Artists: Romare Bearden, Jacob
Lawrence, Horace Pippin, Charles White, Hale
Woodruff.* The Museum of the National Center
of Afro-American Artists, Roxbury, Mass.
Catalogue.* (7 works)
September 9–November 29
Twentieth Century Folk Art. Museum of American
Folk Art, New York. (2 works)

1972
February 22–March 11
*Four American Primitives: Edward Hicks, John Kane,
Anna Mary Robertson Moses, Horace Pippin.*
ACA Galleries, New York. Catalogue.*
(20 works)
October 11–November 12
A Pennsylvania Heritage. William Penn Memorial
Museum, Harrisburg, Pa. (4 works)

1974
February 22–March 24
*Four Delaware Valley Primitives: Henry Braunstein,
Ida E. Jones, Edward Charles Kimmel, Horace
Pippin.* Delaware Art Museum, Wilmington.
Catalogue.* (14 works)
November 1–January 12, 1975
Die Kunst der Naiven, Themen and Beziehungen.
Haus der Kunst, München, Germany. Other
venue: Kunsthaus Zurich, Switzerland.
Catalogue. (2 works)

1975
September 30–November 29
Masterpieces of American Folk Art. Monmouth
Museum, Lincroft, N.J. (organized with the
Monmouth County Historical Association,
Freehold, N.J.). Catalogue. (2 works)

1976
September 30–November 21
Two Centuries of Black American Art. Los Angeles
County Museum of Art, California. Other
venues: The High Museum of Art, Atlanta;
Museum of Fine Arts, Dallas; The Brooklyn
Museum, New York. Catalogue.* (6 works)

1977
February 25–March 27
Horace Pippin. The Phillips Collection,

Washington, D. C. Other venues: Terry
Dintenfass Gallery, New York; Brandywine River
Museum, Chadds Ford, Pa. Catalogue.*
(47 works)

1979
January 10–February 25
The David J. Grossman Bequest. Pennsylvania
Academy of the Fine Arts, Philadelphia.
Catalogue.* (7 works)

1980
February 26–May 13
American Folk Painters of Three Centuries. Whitney
Museum of American Art, New York.
Catalogue.* (5 works)
April 13–May 10
*Two Pennsylvania Artists: Henry O. Tanner, Horace
Pippin.* The HUB Gallery (sponsored by the Paul
Robeson Cultural Center), Pennsylvania State
University, University Park. Catalogue.*
(14 works)

1985
September 14–November 10
Hidden Heritage: Afro-American Art, 1800–1950.
Bellevue Art Museum, Bellevue, Wash. (traveled
thorough 1988 under the auspices of the Art
Museum Association of America) Other venues:
The Bronx Museum of the Arts, N.Y.; California
Afro-American Museum, Los Angeles;
Wadsworth Atheneum, Hartford, Conn.; The
Mint Museum of Art, Charlotte, N.C.; San
Antonio Museum, Tex.; The Toledo Museum,
Ohio; The Baltimore Museum of Art, Md.;
Pennsylvania Academy of the Fine Arts,
Philadelphia; Oklahoma Museum of Art;
Oklahoma City. Catalogue.* (4 works)

1986
March 30–June 15
Naiveté in Art. Setagaya Art Museum, Tokyo, Japan.
Other venue: Tochigi Prefectural Museum of
Fine Arts, Utsunomiya, Japan. Catalogue.
(2 works)

1988
January 30–June 12
Horace Pippin: A Chester County Artist. Chester
County Historical Society, West Chester, Pa.
Catalogue.* (16 works).

1989
October 4–November 2
Horace Pippin. Terry Dintenfass, Inc., New York.
(13 works)

List of All Known Pippin Works

Oil on fabric describes paintings on canvas, linen, and muslin. Dimensions are in inches; height precedes width.

* indicates works exhibited at the Pennsylvania Academy; subsequent venues may not include all works.

War Diary Notebooks, [1917–1918]*
graphite, black crayon, and colored pencil on
 paper, 8⅜ × 6¼
Horace Pippin War Memoirs, Letters, and
 Photographs, Archives of American Art,
 Smithsonian Institution, Washington, D.C.

The Bear Hunt (I), 1930*
oil on burnt-wood panel, 11¾ × 20½
Chester County Historical Society, West Chester,
 Pennsylvania, Gift of Alice Redfield Williams,
 in memory of her mother-in-law,
 Mary Vaughan Merrick Williams (1989.11)

The Bear Hunt (II), 1930*
(also known as *The Bear Hunt*)
oil on burnt-wood panel, 11⅞ × 20½
Private collection

The End of the War: Starting Home, c. 1930*
oil on fabric, 25 × 32
Philadelphia Museum of Art,
 Given by Robert Carlen (41-2-1)

Losing the Way, 1930*
(originally titled *Country Doctor Lost in the Snow;*
 also known as *Lost in the Woods: Going Home*)
oil on burnt-wood panel, 12⁄₁₆ × 20⁵⁄₁₆
The State Museum of Pennsylvania, Harrisburg
 (64.22)

Gas Alarm Outpost: Argonne, 1931
oil on fabric, 22 × 30
Private collection

Outpost Raid: Champagne Sector, 1931*
oil on fabric, 18 × 21¼
Collection Maurice C. and Patricia L. Thompson

*Shell Holes and Observation Balloon: Champagne
 Sector*, 1931*
oil on fabric, 22½ × 30⅞
The Baltimore Museum of Art,
 Gift of Mrs. John Merryman, Jr. (1967.48)

Autumn: Durham, North Carolina, 1932*
(also known as *Autumn Scene Near Durham, N. C.*)
oil on burnt-wood panel, 20 × 12
Private collection

Fishing in the Brandywine: Early Fall, 1932
(also known as *Fishing in the Brandywine: Early
 Spring*)
oil on fabric, 24 × 34
Collection Mrs. Michael I. Sovern

The Blue Tiger, 1933*
oil on fabric, 16 × 28
Private collection

The Buffalo Hunt, 1933*
oil on fabric, 21¼ × 31
The Whitney Museum of American Art, New York,
 Purchase (41.27)

*Abraham Lincoln and His Father Building Their
 Cabin on Pigeon Creek*, 1934
oil on fabric, 16¼ × 20¼
The Barnes Foundation, Merion, Pennsylvania
 (No. 978)

After Supper, West Chester, c. 1935*
pencil on cardboard, 14 × 22⅛
The Metropolitan Museum of Art, New York,
 Bequest of Jane Kendall Gingrich, 1982
 (1982.55.8)

After Supper, West Chester, c. 1935*
oil on fabric, 19 × 23½
Collection Leon Hecht and Robert Pincus-Witten

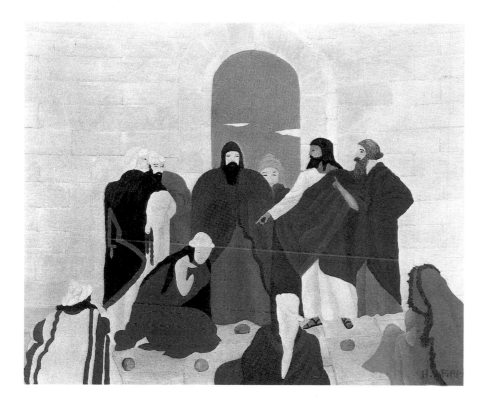

185 *The Woman Taken in Adultery*, 1941. Oil on fabric, 20 × 24 in. From *Horace Pippin: A Negro Painter in America* by Selden Rodman

Cabin in the Cotton I, 1935*
oil on fabric, 18 × 33
The Art Institute of Chicago,
 In memoriam:
 Frances W. Pick from her children Thomas F.
 Pick and Mary P. Hines (1990.417)

Country Doctor, 1935*
(also known as *Night Call*)
oil on fabric, 28⅛ × 32⅛
Museum of Fine Arts, Boston,
 Abraham Shuman Fund (1970.47)

Dog Fight Over Trenches, 1935
oil on fabric, 18 × 33⅛
Hirshhorn Museum and Sculpture Garden,
 Smithsonian Institution, Washington, D.C.,
 Gift of Joseph H. Hirshhorn, 1966 (66.4071)

The Lady of the Lake, 1936*
oil on fabric, 20½ × 36
The Metropolitan Museum of Art, New York,
 Bequest of Jane Kendall Gingrich, 1982 (1982.55.1)

The Moose (I), 1936
(also known as *Landscape with Elk*)
oil on fabric, 24 × 36
Last known in collection of Joseph Shapiro,
 Philadelphia, 1947

Mountain Landscape, c. 1936*
(also known as *Lush Valleys*)
oil on fabric, 23 × 39½
Courtesy Terry Dintenfass, Inc., New York

Portrait of My Wife, 1936*
(also known as *The Artist's Wife*)
oil on fabric, 23¾ × 16¾
Courtesy Terry Dintenfass, Inc., New York

Highland Dairy Farmhouse, Winter, by 1937
oil on burnt-wood panel
Now under *The Old Mill*, c. 1940

Hunting Lodge, Pocono Mountains, by 1937
oil on burnt-wood panel
Last known in West Chester Community Center
 exhibition, 1937

Teachers College Powerhouse, Winter, by 1937*
oil on burnt-wood panel, 9⅜ × 15½
Private collection

Trapper, Pocono Mountains, by 1937
oil on burnt-wood panel
Last known in West Chester Community Center
 exhibition, 1937

Trout Fishermen, by 1937
oil on fabric [?]
Last known in West Chester Community Center
 exhibition, 1937

The Admirer, 1937
oil, 24 × 30
Lost from the collection of
 Mr. & Mrs. W. Averell Harriman, Washington,
 D.C.

*Major General Smedley D. Butler, U.S.M.C.,
 Retired (1882–1940)*, 1937*
oil on fabric, 19 × 25
Collection Mr. and Mrs. Philip Jamison

*Paul B. Dague, Deputy Sheriff of Chester County
 (1898–1974)*, 1937*
oil on fabric, 20 × 16
Chester County Historical Society, West Chester,
 Pennsylvania (1985.512)

Paul B. Dague, c. 1937*
pencil on paper, 9¼ × 6¼
Collection Vincent B. Murphy, Jr.

On Guard, by 1938
unfinished oil, 32 × 18
Destroyed by fire, 1991

Christ (Crowned with Thorns), 1938*
(also known as *Head of Christ*)
oil on fabric, 15¾ × 18½
The Howard University Gallery of Art, Washington,
 D.C.

Coming In, 1939*
(also known as *Portrait of Mrs. W. Plunket Stewart*
 [d. 1948])
oil on fabric, 24 × 36
Collection Mrs. Robert Carlen

The Getaway, 1939*
(also known as *The Fox [The Get-a-way]*)
oil on fabric, 24⅜ × 36½
Collection Mr. and Mrs. Daniel W. Dietrich II

Amish Letter Writer, 1940*
oil on fabric, 12 × 20⅛
Collection Ann R. Feldman

Birmingham Meeting House I, 1940*
oil on fabric, 22 × 36
The Regis Collection, Minneapolis, Minnesota

Birmingham Meeting House in Late Summer, 1940*
(also known as *Birmingham Meeting House II*)
oil on canvas board, 16 × 20
Hirshhorn Museum and Sculpture Garden,
 Smithsonian Institution, Washington, D.C.,
 Gift of Joseph H. Hirshhorn, 1966 (66.4072)

Chester County Art Critic, 1940*
(also known as *Portrait of Christian Brinton
 [1870–1942]*)
oil on canvas board, 21½ × 16
Philadelphia Museum of Art,
 Gift of Christian Brinton (41-79-139)

Christ and the Woman of Samaria, 1940
oil on fabric, 19⅞₆ × 24¼
The Barnes Foundation, Merion, Pennsylvania
 (no. 986)

Fall Landscape, 1940
oil on burnt-wood panel, 10 × 19⅝
Hirshhorn Museum and Sculpture Garden,
 Smithsonian Institution, Washington, D.C.,
 Gift of Joseph H. Hirshhorn, 1966 (66.4070)

Giant Daffodils, 1940*
oil on canvas board, 13¹⁵⁄₁₆ × 10
Pennsylvania Academy of the Fine Arts,
 Philadelphia, Bequest of David J. Grossman, in
 honor of Mr. and Mrs. Charles J. Grossman and
 Mr. and Mrs. Meyer Speiser (1979.1.2)

The Old Mill, c. 1940*
(painted over *Highland Dairy Farmhouse,
 Winter*, by 1937)
oil on burnt-wood panel, 10 × 20
Private collection

Portrait of a Soldier, 1940*
pencil on paper, 6⅝ × 9⅛
Collection Dr. and Mrs. Harmon Kelley

Portrait of a Woman (Marian Anderson), 1940*
pencil on paper, 6½ × 8⅝
Collection Dr. and Mrs. Harmon Kelley

Roses in a Jar, 1940*
(Also known as *Flowers and Books*)
oil on canvas board, 14½ × 11⅞
Private collection

Roses with Red Chair, 1940
oil on fabric, 14 × 10
Private collection

Six O'Clock, 1940*
(also known as *Cabin Interior, By the Fireside,
 Waiting*)
oil on fabric, 25 × 28
Private collection

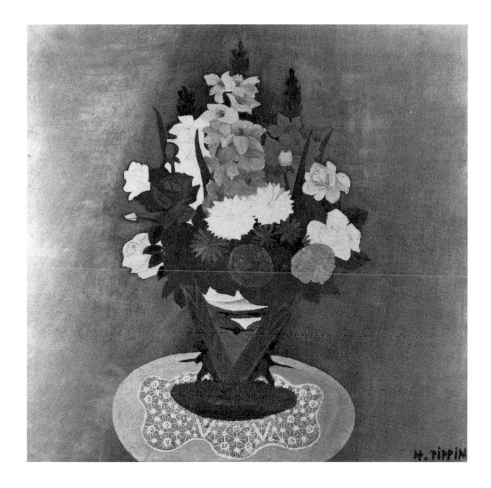

186 *Victory Vase*, 1942. Oil on fabric, 20 × 19 in. From *H. Pippin*, exh. checklist, Downtown Gallery, New York, 1944

The Squirrel Hunter, 1940*
oil on fabric, 25 × 30
Private collection

Supper Time, 1940
oil on burnt-wood panel, 11⅝⁄₁₆ × 15
The Barnes Foundation, Merion, Pennsylvania
 (no. 985)

Two Pink Roses, 1940*
oil on fabric, 6¾ × 9⅝
Collection Marjorie and Herbert Fried

The Warped Table, 1940*
oil on canvas board, 12 × 16
Pennsylvania Academy of the Fine Arts,
 Philadelphia, Bequest of David J. Grossman,
 in honor of Mr. and Mrs. Charles J. Grossman
 and Mr. and Mrs. Meyer Speiser (1979.1.1)

West Chester Court House, 1940*
(also known as *Courthouse—West Chester,*
 Pennsylvania)
oil on canvas board, 22 × 28
Pennsylvania Academy of the Fine Arts,
 Philadelphia, Bequest of David J. Grossman,
 in honor of Mr. and Mrs. Charles J. Grossman
 and Mr. and Mrs. Meyer Speiser (1979.1.3)

Amish Store, 1941
oil on burnt-wood panel, 12 × 12
Stolen from collection of Mrs. H. Gates Lloyd,
 Haverford, Pennsylvania, by 1960

Birmingham Meeting House III, 1941*
oil on canvas board, 16 × 20
Private collection

Christ Before Pilate, 1941*
(also known as *Behold the Man*)
oil on fabric, 20 × 24
Collection Janet and Joseph Shein

Cyclamen, 1941*
oil on canvas board, 8 × 10
Private collection

Duck Shooting, 1941*
oil on burnt-wood panel, 9½ × 14½
Collection Marvin and Alice Sinkoff

Fishing Through Ice, 1941*
oil on burnt-wood panel, 11 × 14
Collection Mr. and Mrs. Charles G. Sunstein

Lilies, 1941*
oil on fabric, 19½ × 27½
Private collection

Man Seated Near Stove, 1941*
oil on burnt-wood panel, 10 × 10
Private collection

Maple Sugar Season, 1941*
(also known as *Maple Sugaring*)
oil on burnt-wood panel, 6⅜ × 11⅝₆
Pennsylvania Academy of the Fine Arts,
 Philadelphia, Bequest of David J. Grossman,
 in honor of Mr. and Mrs. Charles J. Grossman
 and Mr. and Mrs. Meyer Speiser (1979.1.6)

Marian Anderson I (1902–1993), 1941*
oil on fabric, 18 × 12
Collection Ann and James Harithas

Marian Anderson II, 1940, repainted 1941*
oil on fabric, 23 × 19 oval
The Schomburg Center for Research in Black Culture,
 Art and Artifacts Division, The New York Public
 Library, Astor, Lenox, and Tilden Foundations

My Backyard, 1941*
oil on canvas board, 11 × 14
Private collection

Pink Flowers, 1941*
(also known as *Pink Cyclamen*)
oil on canvas board, 10 × 14
Pennsylvania Academy of the Fine Arts,
 Philadelphia, Bequest of David J. Grossman,
 in honor of Mr. and Mrs. Charles J. Grossman
 and Mr. and Mrs. Meyer Speiser (1979.1.4)

Red, Yellow, and White Roses, 1941*
oil on fabric, 16⅛ × 20⅛
Collection Mrs. Robert Montgomery

Saturday Night Bath, 1941*
(also known as *Saturday Night*)
oil on burnt-wood panel, 8½ × 11½
Private collection

Self-Portrait, 1941*
oil on canvas board, 14 × 11
Albright-Knox Art Gallery, Buffalo, New York,
 Room of Contemporary Art Fund, 1942
 (RCA: 42.2)

The Trapper Returning Home, 1941*
(also known as *Snow Scene*)
oil on burnt-wood panel, 9⅝ × 16⅝
Collection Rose W. Kaplan

The Whipping, 1941*
(also known as *The Whipping Post*, 1940)
oil on burnt-wood panel, 9 × 11½
Reynolda House Museum of American Art,
 Winston-Salem, North Carolina

The Woman Taken in Adultery, 1941
oil on fabric, 20 × 24
Private collection

Abe Lincoln, The Great Emancipator, 1942*
(also known as *Abraham Lincoln, The Great
 Emancipator, Pardons the Sentry*)
oil on fabric, 24 × 30
The Museum of Modern Art, New York,
 Gift of Helen Hooker Roelofs (142.77)

Birmingham Meeting House IV, c. 1942*
oil on canvas board, 18 × 25
Private collection

Giving Thanks, c. 1942
oil on fabric, 10⅝₆ × 14⅝₆
The Barnes Foundation, Merion, Pennsylvania
 (no. 990)

John Brown Going to His Hanging, 1942*
oil on fabric, 24 × 30
Pennsylvania Academy of the Fine Arts,
 Philadelphia, John Lambert Fund (1943.11)

John Brown Reading His Bible, 1942*
oil on canvas board, 16 × 20
The Crispo Collection, Charleston, South Carolina

The Trial of John Brown, 1942*
oil on fabric, 16⅛ × 20⅛
The Fine Arts Museums of San Francisco,
 Gift of Mr. and Mrs. John D. Rockefeller, 3rd
 (1979.7.82)

A Tribute to Stalingrad, 1942*
(also known as *The Refugees*)
oil on canvas board, 8½ × 12
Private collection

Victory Vase, 1942
oil on fabric, 20 × 19
Private collection

The Wash, c. 1942*
oil on fabric, 13½ × 17½
Private collection

West Chester, Pennsylvania, 1942*
oil on fabric, 29⅝ × 36⅝
Wichita Art Museum, Kansas,
 Roland P. Murdock Collection (M51.44)

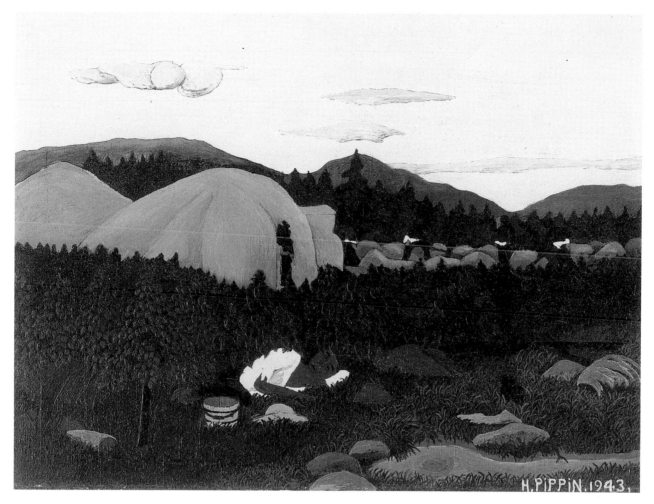

187 *Water Boy*, 1943. (Also known as *Water Boy—A Dedication to Paul Robeson*).
Oil on fabric, 18 × 24 in. Photograph courtesy Los Angeles County Museum of Art

Abe Lincoln, The Good Samaritan, 1943*
oil on canvas board, 9 × 12
Pennsylvania Academy of the Fine Arts,
 Philadelphia, Bequest of David J. Grossman,
 in honor of Mr. and Mrs. Charles S. Grossman
 and Mr. and Mrs. Meyer Speiser (1979.1.5)

Asleep, 1943*
oil on canvas board, 9 × 12
The Metropolitan Museum of Art, New York,
 Bequest of Jane Kendall Gingrich, 1982
 (1982.55.3)

The Crucifixion, 1943*
oil on fabric, 16 × 20
The Menil Collection, Houston (79-14 DJ)

Domino Players, 1943*
(also known as *Dominoes*)
oil on composition board, 12¾ × 22
The Phillips Collection, Washington, D.C. (1573)

Mr. Prejudice, 1943*
oil on fabric, 18 × 14
Philadelphia Museum of Art,
 Gift of Dr. and Mrs. Matthew T. Moore
 (1984.108.1)

Old Black Joe, 1943
(also known as *I's Comin'*)
oil on fabric, 37 × 31 framed
Private collection

Potted Plant in Window, 1943*
oil on fabric, 7 × 9
Brandywine River Museum, Chadds Ford,
 Pennsylvania, Gift of Mr. and Mrs. Edgar Scott
 (81.34)

Saying Prayers, 1943*
oil on fabric, 16 × 20⅛
Brandywine River Museum, Chadds Ford,
 Pennsylvania, The Betsy James Wyeth Fund
 (80.4)

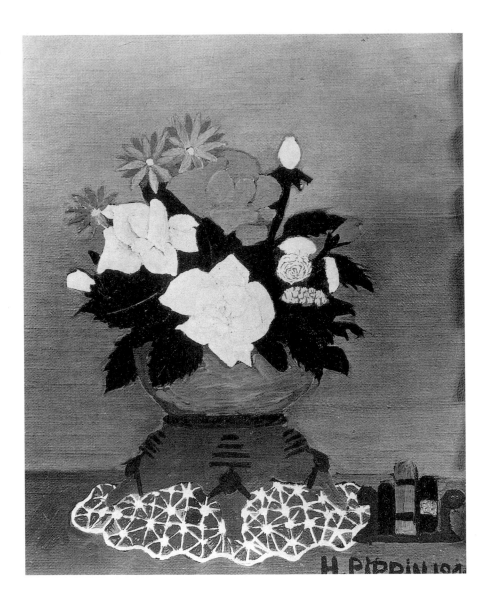

188 *The Love Note*, 1944. Oil on canvas board, 10 × 8 in. From *Horace Pippin: A Negro Painter in America* by Selden Rodman

Sunday Morning Breakfast, 1943*
oil on fabric, 16 × 20
Private collection, courtesy Galerie St. Etienne,
 New York

Victory Garden, 1943*
oil on fabric, 10 × 12
Collection Marjorie S. Loggia

Water Boy, 1943
(also known as *Water Boy—
 A Dedication to Paul Robeson*)
oil on fabric, 18 × 24
Last known in collection of
 Natural History Museum of Los Angeles County,
 Gift of Dr. William R. Valentiner (48.20);
 lost by 1965

Zachariah, 1943*
oil on fabric, 11 × 14
The Butler Institute of American Art,
 Youngstown, Ohio (951-0-120)

Abe Lincoln's First Book, 1944*
oil on fabric, 24 × 30
The Carnegie Museum of Art, Pittsburgh,
 Gift of Mr. and Mrs. James L. Winokur (68.20)

Cabin in the Cotton II, 1944
oil on fabric, 24 × 20
Private collection

Cabin in the Cotton III, 1944*
oil on fabric, 23 × 29¼
Private collection

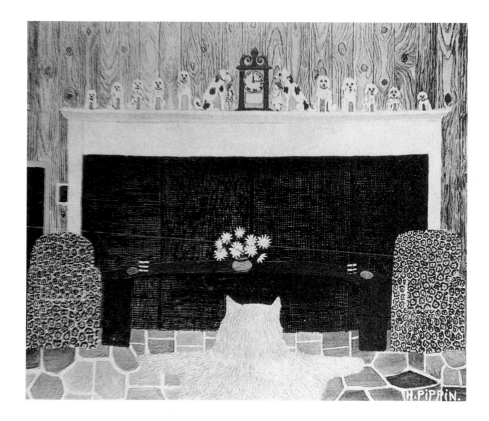

189 *The Den*, 1945. Oil, 20 × 24 in. From *Horace Pippin: A Negro Painter in America* by Selden Rodman

Cabin in the Cotton IV, 1944*
oil on fabric, 16 × 27⅛
Wellesley College Museum, Massachusetts
 Gift of Mr. and Mrs. Sam Jaffe (Adele Hillman,
 Class of 1939) (1956.27)

Harmonizing, 1944*
oil on fabric, 24 × 30
Allen Memorial Art Museum, Oberlin College,
 Ohio, Gift of Joseph and Enid Bissett, 1964 (64.26)

The Holy Mountain I, 1944
oil on fabric, 30 × 36
Collection Camille O. and William H. Cosby, Jr.

The Holy Mountain II, 1944*
(also known as *The Kingdom of God*)
oil on fabric, 23 × 30
Private collection

Interior, 1944*
(also known as *Interior of Cabin*)
oil on fabric, 24⅛ × 29¾
National Gallery of Art, Washington, D.C.,
 Gift of Mr. and Mrs. Meyer P. Potamkin in
 honor of the Fiftieth Anniversary of the National
 Gallery of Art (1991.42.1)

The Love Note, 1944
oil on canvas board, 10 × 8
Private collection

Old King Cotton, 1944*
(also known as *Old Queen Cotton*)
oil on canvas board, 12½ × 17¾
Robert Brady Museum, Cuernavaca, Mexico

Quaker Mother and Child, c. 1944*
oil on fabric, 16 × 20
Museum of Art, Rhode Island School of Design,
 Providence, Jesse H. Metcalf Fund (44.094)

Self-Portrait (II), 1944*
oil on canvas board, 8½ × 6½
The Metropolitan Museum of Art, New York,
 Bequest of Jane Kendall Gingrich, 1982 (1982.55.7)

Spring Flowers with Lace Doily, 1944
(also known as *Vase of Flowers*)
oil on canvas board, 14 × 10
Private collection

Summer Flowers with Two Chairs, 1944*
(also known as *Love Letter [Summer Flowers]*)
oil on fabric, 8½ × 11½
Private collection

Uncle Tom, 1944*
oil on fabric, 10 × 12¾
Fort Wayne Museum of Art, Indiana,
 Gift of Larry Eberbach (1984.11)

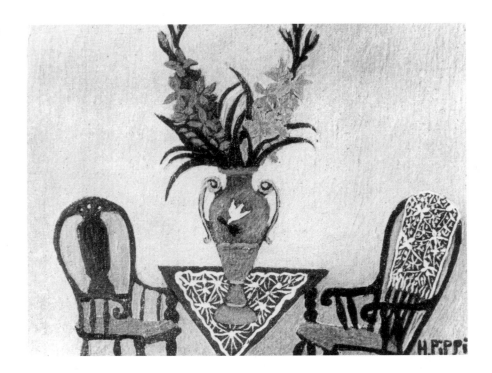

190 *Flower*, 1945. (Possibly known as *Still Life with Chairs* and/or *Flower Piece*). From *Art Digest*, August 1945.

Study for "Barracks," 1945*
oil on canvas board, 9 × 12
Collection Mr. and Mrs. Daniel W. Dietrich II

Barracks, 1945*
oil on fabric, 25¼ × 30
The Phillips Collection, Washington, D.C. (1572)

Christmas Morning, Breakfast, 1945*
oil on fabric, 21 × 26¼
Cincinnati Art Museum,
 Edwin and Virginia Irwin Memorial (1959.47)

Deep Are the Roots, 1945
oil on fabric, 24 × 30
Private collection

The Den, 1945
oil, 20 × 24
Sold by Berry Hill Galleries, New York,
 to Japanese collector, c. 1985

The Elk, 1945*
(also known as *The Moose, The Moose II,*
 and *The Stag*)
oil on fabric, 18⅝ × 22¹³⁄₁₆
Pennsylvania Academy of the Fine Arts,
 Philadelphia, Bequest of David J. Grossman,
 in honor of Mr. and Mrs. Charles J. Grossman
 and Mr. and Mrs. Meyer Speiser (1979.1.7)

Flower, 1945
(possibly known as *Still Life with Chairs* and/or
 Flower Piece)
Last known in collection of Miss E. de Meuron, 1945

Flowers with Hat and Cane, 1945*
(possibly known as *Flower Piece*)
oil on fabric, 9 × 11
Private collection

The Holy Mountain III, 1945*
oil on fabric, 25¼ × 30¼
Hirshhorn Museum and Sculpture Garden,
 Smithsonian Institution, Washington, D.C.,
 Gift of Joseph H. Hirshhorn, 1966 (66.4069)

The Milkman of Goshen, 1945*
oil on fabric, 24 × 31
Private collection

Saturday Night Bath, 1945
oil on fabric, 25¼ × 30¼
Collection Mrs. Eunice W. Johnson

Still Life with Chairs, 1945
(possibly known as *Flower* and/or *Flower Piece*)
oil, 8 × 10
Last known in collection of Mrs. Edward Titus,
 New York, 1947

Victorian Interior, 1945*
(also known as *Victorian Interior II*)
oil on fabric, 25¼ × 30
The Metropolitan Museum of Art, New York,
 Arthur H. Hearn Fund, 1958 (58.26)

Victorian Parlor, 1945*
(also known as *Victorian Interior I*)
oil on fabric, 20 × 24
The Metropolitan Museum of Art, New York,
 Bequest of Jane Kendall Gingrich, 1982 (1982.55.5)

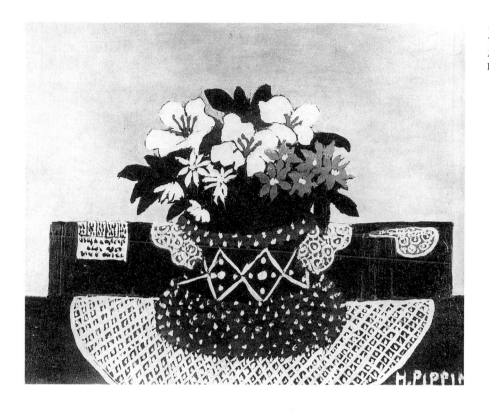

Family Supper (Saying Grace), 1946*
unfinished oil on fabric, 18 × 22
The Metropolitan Museum of Art, New York,
 Bequest of Jane Kendall Gingrich, 1982
 (1982.55.4)

Flowers, 1946
unfinished black paint on canvas, 8 × 10
Last known in collection of Mr. and Mrs. David
 Flood, Philadelphia, 1947

Flowers with Doilies and Two Chairs, 1946
oil, 8 × 10
Sold at auction by Mr. Charles Chaplin,
 Haverford, Pennsylvania

Flowers with Four Doilies, 1946
oil, 9 × 11
Last known in collection of Mrs. A. J. Borowsky,
 Philadelphia, 1947

The Hoe Cake, c. 1946*
oil on fabric, 14 × 18
New Jersey State Museum, Trenton, Purchase
 (FA1986.13)

The Holy Mountain IV, 1946*
unfinished oil on fabric, 26 × 36
The Metropolitan Museum of Art, New York,
 Bequest of Jane Kendall Gingrich, 1982
 (1982.55.3)

Man on a Bench, 1946*
(also known as *The Park Bench*)
oil on fabric, 13 × 18
Collection Mr. and Mrs. Daniel W. Dietrich II

Table and Two Chairs, 1946*
(also known as *Chairs*)
unfinished oil on fabric, 9 × 11
The Metropolitan Museum of Art, New York,
 Bequest of Jane Kendall Gingrich, 1982
 (1982.55.6)

Temptation of Saint Anthony, 1946*
oil on fabric, 36 × 48
Collection Ann and James Harithas

History of Case (Jennie Ora Pippin), undated
pencil on paper, 11 × 8½
Private collection

Still Life, undated
on board, 15¼ × 31½
Auctioned at Parke-Bernet, April 15, 1970

Still Life, undated
no medium, 9 × 11
Auctioned at Parke-Bernet, October 22, 1969

Untitled (Winter Scene), undated*
oil on burnt-wood panel, 7¾ × 16¼
Collection Anne Strick

Selected Bibliography

Because there are few significant sources on Horace Pippin, this bibliography lists those that include specific, if limited, discussions in English of Horace Pippin and/or illustrations of his works, or place him in a broader context. Other catalogues and checklists are noted in the exhibition history. The best sources for contemporary clippings about Pippin are the Robert Carlen Gallery Papers of the Archives of American Art, and the Chester County Historical Society, West Chester, Pennsylvania, both of which have scrapbooks that include not only Philadelphia newspapers, but also those from New York, Pittsburgh, and the West Chester area. Karen Love Cooler compiled initial data for this bibliography, based largely on material contributed by Lynn Moody Igoe.

BOOKS

Baigell, Matthew. *Dictionary of American Art*. London: John Murray, 1980.

Bearden, Romare and Henderson, Harry. *Six Black Masters of American Art*. Garden City, N.Y.: Doubleday and Co., 1972.

————. *A History of African-American Artists: From 1972 to the Present*. New York: Pantheon Books, 1993.

Bennett, Ian. *A History of American Painting*. London: Hamlyn, 1973.

Bihalji-Merin, Oto. *Modern Primitives: Masters of Naïve Painting*. Translated by Norbert Guterman. New York: Harry N. Abrams, 1959.

Bishop, Robert. *Folk Painters of America*. New York: E. P. Dutton, 1979.

Cederholm, Theresa Dickason. *Afro-American Artists: A Bio-bibliographical Directory*. Boston: Trustees of the Boston Public Library, 1973.

Dover, Cedric. *American Negro Art*. Greenwich, Conn.: New York Graphic Society, 1960.

Eliot, Alexander. *Three Hundred Years of American Painting*. New York: Time, 1957.

Falk, Peter Hastings, ed. *Who Was Who in American Art*. Madison, Conn.: Southview Press, 1985.

Fine, Elsa. *The Afro-American Artist*. New York: Hacker Art Books, 1982.

Ford, Alice. *Pictorial Folk Art: New England to California*. New York: The Studio Publications, 1949.

Garraty, John A. and James, Edward T., eds. *Dictionary of American Biography*. Text by Carole Cleaver. Supplement 4, 1946–1950. New York: Charles Scribner's Sons, 1974.

Hammond, Leslie King. *We Wear the Mask: The Ethos of Spirituality in African American Art, 1750 to the Present*. New York: Abbeville Press, 1994.

Hemphill, Herbert W., Jr. and Weissman, Julia. *Twentieth-Century American Folk Art and Artists*. New York: E. P. Dutton and Co., 1974.

"Horace Pippin." *American Art Analog*, vol. 3. New York: Chelsea House, 1986.

Igoe, Lynn Moody and Igoe, James. *250 Years of Afro-American Art: An Annotated Bibliography*. New York: R. R. Bowker Co., 1981.

Janis, Sidney. *They Taught Themselves: American Primitive Painters of the 20th Century*. New York: The Dial Press, 1942.

Johnson, Jay and Ketchum, William C., Jr. *American Folk Art of the Twentieth Century*. New York: Rizzoli International, 1983.

[Kirwin, Liza]. *The Papers of African American Artists*. Washington, D.C.: Archives of American Art, Smithsonian Institution, 1989.

Lewis, Samella. *Art: African American*. Los Angeles: Hancraft Studios, 1990.

Locke, Alain. *The Negro in Art: A Pictorial Record of the Negro Artist and of the Negro Theme in Art*. 1940. Reprint. New York: Hacker Art Books, 1971.

Logan, Rayford W. and Winston, Michael R., eds. *Dictionary of American Negro Biography*. Text by Carole Cleaver Rodman. New York: W. W. Norton & Co., 1982.

Lyons, Mary E. *Starting Home: The Story of Horace Pippin, Painter*. New York: Charles Scribner's Sons, 1993.

Opitz, Glenn B., ed. *Mantle Fielding's Dictionary of American Painters, Sculptors and Engravers*. 1926. Reprint. Poughkeepsie, N.Y.: Apollo, 1983.

Parks, James Dallas. "Artists," in *Encyclopedia of Black America*. W. Augustus Low and Virgil A. Clift, eds. New York: McGraw-Hill, 1981.

Pitz, Henry C. *The Brandywine Tradition*. Boston: Houghton Mifflin Company, 1969.

Porter, James A. *Modern Negro Art*. 1943. Reprinted with new preface. New York: Arno Press and The New York Times, 1969.

Price, Vincent. *The Vincent Price Treasury of American Art*. Waukesha, Wis.: Country Beautiful Corporation, 1972.

Rodman, Selden. *Horace Pippin: A Negro Painter in America*. New York: Quadrangle Press, 1947. Includes Horace Pippin, "My Life's Story."

Rodman, Selden and Cleaver, Carole. *Horace Pippin: The Artist as a Black American*. Garden City, N.Y.: Doubleday and Co., 1972.

Rosenak, Chuck, and Rosenak, Jan. *Museum of American Folk Art Encyclopedia of Twentieth-Century American Folk Art and Artists*. New York: Abbeville Press, 1990.

Salzman, Jack and O'Meally, Robert, eds. *Encyclopedia of African American Culture and History*. Text by Judith E. Stein. New York: Macmillan Publishing Co., forthcoming.

Schack, William. *Art and Argyrol: The Life and Career of Dr. Albert C. Barnes*. New York: Thomas Yoseloff, 1960.

CATALOGUES

ACA Galleries. *Four American Primitives: Edward Hicks, John Kane, Anna Mary Robertson Moses, Horace Pippin*. Text by Andrew Crispo. New York, 1972.

Albany Institute of History and Art. *The Negro Artist Comes of Age: A National Survey of Contemporary American Artists*. Essay "Up Till Now" by Alain Locke. Albany, N.Y., 1945.

The American Federation of Arts. *The Temptation of Saint Anthony: Bel Ami International Art Competition*. Essay "Competition and Exhibition" by Harriet and Sidney Janis; statements by artists. Washington, D.C., 1947.

The Art Alliance. *Horace Pippin Memorial Exhibition*. Text by Alain Locke. Philadelphia, 1946.

Brandywine Conservancy. *Brandywine River Museum Catalogue of the Collection*. Text by Marianne Richter. Chadds Ford, Pa., 1991.

Cahill, Holger; Gauthier, Maximilien; Cassou, Jean; Miller, Dorothy C.; and others. *Masters of Popular Painting: Modern Primitives of Europe and America*. New York: The Museum of Modern Art, 1938.

Carlen Galleries. *Horace Pippin Exhibition*. Text by Albert C. Barnes. Philadelphia, 1940.

————. *Recent Paintings by Horace Pippin*. Text by Albert C. Barnes. Philadelphia, 1941.

The Center Gallery of Bucknell University. *Since the Harlem Renaissance: 50 Years of Afro-American Art*. Text by Joseph Jacobs. Lewisburg, Pa., 1985.

The City University of New York in cooperation with Harlem Cultural Council and New York Urban League. *The Evolution of Afro-American Artists: 1800–1950*. Text by Carroll Greene, Jr. New York, 1967.

Delaware Art Museum. *Four Delaware Valley Primitives: Henry Braunstein, Ida E. Jones, Edward Charles Kimmel, Horace Pippin*. Text by Cynthia Bell. Wilmington, Del., 1974.

Dewhurst, C. Kurt; MacDowell, Betty; and MacDowell, Marsha. *Religious Folk Art in America: Reflections of Faith*. New York: E. P. Dutton and Co., in association with the Museum of American Folk Art, 1983.

Dickson, Harold, E. *Masterworks by Pennsylvania Painters in Pennsylvania Collections*. University Park, Pa.: Museum of Art, The Pennsylvania State University, 1972.

Downtown Gallery. *American Negro Art, 19th and 20th Centuries*. Text by Edith Gregor Halpert. New York, 1941.

Driskell, David C. *Hidden Heritage: Afro-American Art, 1800–1950*. Organized by the Bellevue Art Museum, Bellevue, Wash. San Francisco: The Art Museum Association of America, 1985.

————, with catalogue notes by Leonard Simon. *Two Centuries of Black American Art*. Los Angeles: Los Angeles County Museum of Art, and New York: Alfred A. Knopf, 1976.

Geldzahler, Henry. *American Painting in the Twentieth Century*. New York: Metropolitan Museum of Art, 1965.

Kallir, Jane. *The Folk Art Tradition: Naïve Painting in Europe and the United States*. New York: Galerie St. Etienne and The Viking Press, 1981.

Lipman, Jean and Armstrong, Tom, eds. *American Folk Painters of Three Centuries*. Text by Selden Rodman. New York: Hudson Hills Press in association with the Whitney Museum of American Art, 1980.

Lipman, Jean; Bishop, Robert; Warren, Elizabeth V.; and Eisenstat, Sharon L. *Five Star Folk Art: One Hundred American Masterpieces*. New York: Harry N. Abrams, in association with the Museum of American Folk Art, 1990.

Millhouse, Barbara B., with the assistance of Robert Workman. *American Originals: Selections from Reynolda House, Museum of American Art*. New York: Abbeville Press/The American Federation of Arts, 1990.

Museum of Art, Carnegie Institute. *Three Self-Taught Pennsylvania Artists: Hicks, Kane, Pippin*. Text by Leon Anthony Arkus. Pittsburgh, 1966.

Museum of the National Center of Afro-American Artists. *Five Famous Black Artists: Romare Bearden, Jacob Lawrence, Horace Pippin, Charles White, Hale Woodruff*. Roxbury, Mass., 1970.

Nash, Steven A., with Katy Kline, Charlotte Kotik, and Emese Wood. *Albright-Knox Art Gallery: Painting and Sculpture from Antiquity to 1942*. New York: Rizzoli, 1979.

Pennsylvania Academy of the Fine Arts. *The David J. Grossman Bequest to the Pennsylvania Academy of the Fine Arts, 1978*. Text by Ann Friedman. Philadelphia, 1979.

The Pennsylvania State University. *Pennsylvania Painters: Centennial Exhibition*. Text by Harold E. Dickson. University Park, Pa., 1955.

————. Paul Robeson Cultural Center. *Two Pennsylvania Artists: Henry O. Tanner, Horace Pippin*. Text by Harry Henderson. University Park, Pa., 1980.

Philadelphia Museum of Art. *Philadelphia: Three Centuries of American Art*. Text by Anne d'Harnoncourt. Philadelphia, 1976.

The Phillips Collection. *Horace Pippin*. Text by Romare Bearden. Washington, D.C., 1976.

Simpson, Marc; Mills, Sally; and Saville, Jennifer. *The American Canvas: Paintings from the Collection of the Fine Arts Museums of San Francisco*. Text by Sally Mills. New York: Hudson Hills Press in association with The Fine Arts Museums of San Francisco, 1989.

Strazdes, Diana, and others. *American Paintings and Sculpture to 1945 in the Carnegie Museum of Art*. New York: Hudson Hills Press in association with the Carnegie Museum of Art, 1992.

Walker Art Center. *Reality and Fantasy 1900–1954*. Minneapolis, 1954.

Wilson, Sarah J. *Horace Pippin: A Chester County Artist*. West Chester, Pa.: Chester County Historical Society, 1988.

PERIODICALS

Bearden, Romare. "The Negro Artist's Dilemma." *Critique: A Review of Contemporary Art*, Nov. 1946, pp. 16–22.

Blitzstein, Madelin. "The Odds Were Against Him." *US Week*, April 26, 1941, pp. 12–13.

Breuning, Margaret. "Pippin, Primitive, Has Vitality and Charm." *Art Digest* 18 (March 1, 1944), p. 13.

Coates, Robert M. "The Art Galleries." *The New Yorker*, Oct. 12, 1940, p. 81.

————. "The Art Galleries: Negro Art." *The New Yorker*, Dec. 27, 1941, p. 52.

————. "The Art Galleries." *The New Yorker*, Feb. 26, 1944, p. 65.

————. "The Art Galleries." *The New Yorker*, Oct. 11, 1947, p. 67.

de Mazia, Violette. "What to Look For in Art." *The Barnes Foundation Journal of the Art Department* 1 (Autumn 1970), pp. 21–22.

————. "Expression." *The Barnes Foundation Journal of the Art Department* 5 (Autumn 1974), pp. 5–7, 31–32, plate 16.

————. "Naïveté." *The Barnes Foundation Journal of the Art Department* 7 (Autumn 1976), pp. 63, 67, 69, plate 14.

————. "E Pluribus Unum—Cont'd: Part III." *The Barnes Foundation Journal of the Art Department* 8 (Spring 1977), p. 42, plate 37.

Eldredge, Charles C. "The Paintings at Reynolda House, Museum of American Art, Winston-Salem, North Carolina." *The Magazine Antiques* 142 (Nov. 1992), pp. 692–703.

"Ex-Porter's One-Man Show." *Newsweek*, Oct. 7, 1940, pp. 52–53.

Faison, S. Lane, Jr. "'Primitive' Painter." *The Nation*, Feb. 28, 1948, pp. 253–54.

Forgey, Benjamin. "Horace Pippin's 'personal spiritual journey.'" *Art News* 76 (Summer 1977), pp. 74–75.

Frost, Rosamund. "Pippin: Through Eyes of Innocence." *Art News* 43 (March 1–14, 1944), pp. 20–21.

Grafly, Dorothy. *Art Outlook*, April 1, 1947.

Hayes, Bartlett H., Jr. "Self-Taught Painter." *New York Times Book Review*, Oct. 26, 1947, section 7, p. 7.

"Horace Pippin." *Vogue*, July 1944, p. 91.

Huber, Peter. "Horace Pippin." *Susquehanna Magazine*, Sept. 1985, pp. 25–26.

"In Line for Pippin." *Art Digest* 18 (April 1, 1944), p. 11.

Karlins, N. F. "The Peaceable Kingdom Theme in American Folk Painting." *The Magazine Antiques* 109 (April 1976), pp. 738–41.

Klein, Jerome. "Art the Hard Way." *Friday* (January 17, 1941), pp. 22–23.

Lipman, Jean. "The Peaceable Kingdom by Three Pennsylvania Primitives." *Art in America* 45 (Fall 1957), p. 29.

Locke, Alain. "The Negro in the Arts." *United Asia: International Magazine of Asian Affairs* 5 (June 1953), pp. 177–81.

Madoff, Steven. "Reviews: Horace Pippin, Terry Dintenfass Gallery." *Artforum* 15 (Summer 1977), pp. 76–77.

Moorman, Margaret. "Reviews: Horace Pippin, Terry Dintenfass." *Art News* 89 (Feb. 1990), pp. 157–58.

"Museums Buy Pippin." *Art Digest* 15 (March 1, 1941), p. 13.

"Negro Primitive Finds Peace After War." *Art Digest* 15 (Oct. 1, 1940), p. 7.

Nemser, Cindy. "Three Primitive Pennsylvanians: Hicks, Kane, Pippin." *Arts Magazine* 40 (Sept./Oct. 1966), pp. 30–32.

Pippin, Horace. "Horace Pippin Explains His Holy Mountain." *Art Digest* 19 (April 1, 1945), p. 44.

"Pippin: Pennsylvania's Modern Primitive." *Art News* 39 (Oct. 5, 1940), pp. 11, 16.

"Primitivist Pippin." *Time*, Jan. 29, 1940, p. 56.

Ratcliff, Carter. "Review of Exhibitions, New York: Horace Pippin at Dintenfass." *Art in America* 65 (Sept./Oct. 1977), pp. 118–19.

"Speaking of Pictures." *Life*, Feb. 4, 1946, p. 12.

Stevens, Mark. "Pippin's Folk Heroes." *Newsweek*, Aug. 22, 1977, pp. 59–60.

Straley, George H. "The Nine Good Years of Horace Pippin." *County Lines* 11 (May 1988), pp. 73–84.

The Studio 121 (Jan. 1941), p. 29.

Tannenbaum, Judith. "Arts Reviews: Horace Pippin." *Arts Magazine* 51 (June 1977), p. 42.

Woods, Joseph W. "Modern Primitive: Horace Pippin." *The Crisis* 53 (June 1946), pp. 178–79, 189.

"Would Stun Paris." *Art Digest* 14 (Feb. 15, 1940), p. 7.

UNPUBLISHED PAPERS

The Arts Club of Chicago Archives. Newberry Library, Chicago, Ill.

Julius Bloch Papers. Journal. Archives of American Art, Smithsonian Institution, Washington, D.C.

Christian Brinton Papers. Archives of American Art, Smithsonian Institution, Washington, D.C.

Robert Carlen Gallery Papers. Archives of American Art, Smithsonian Institution, Washington, D.C. Includes Horace Pippin correspondence and clippings scrapbook.

Edward Loper Papers. Interview with Marina Pacini, May 12, 1989. Archives of American Art, Smithsonian Institution, Washington, D.C.

Horace Pippin: The Artist and His Work. Report by Henderson High School, 11th Grade American History Seminar. West Chester, Pa.: West Chester Area School District, 1988.

Horace Pippin clippings scrapbook. Chester County Historical Society, West Chester, Pa.

Horace Pippin War Memoirs, Letters, and Photographs. Archives of American Art, Smithsonian Institution, Washington, D.C.

Paintings Index

Page numbers in bold italics refer to illustrations.